Warwickshire County Council

OLIVE

PRINCESS OF CUMBERLAND (1772-1834)

A ROYAL SCANDAL

OLIVE

PRINCESS OF CUMBERLAND
(1772-1834)

A ROYAL SCANDAL

Miles Macnair

BREWIN BOOKS

BREWIN BOOKS
56 Alcester Road,
Studley,
Warwickshire,
B80 7LG
www.brewinbooks.com

Published by Brewin Books 2011

A CIP catalogue record for this book is available
from the British Library.

ISBN: 978-1-85858-481-2

Printed in Great Britain
by T J International Ltd.

Contents

Acknowledgements .i

Illustrations .iii

Preface .v

Introduction .vii

 1. The young Olive .1

 2. An affair with the Prince of Wales – and echoes of an earlier one11

 3. The impoverished Earl of Warwick and the last years of Dr James Wilmot . .22

 4. Edward Duke of Kent and 'The Grand Old Duke of York'30

 5. Books and a half told secret .39

 6. The love life of Henry, Duke of Cumberland .49

 7. One Wedding and Four Funerals .59

 8. Crisis in the Royal Succession .72

 9. Journalism, Reform and Theatricals .80

10. Another Royal Cousin and finding a Benefactor .86

11. Great Expectations and Crucial Documents .93

12. Triumph and Tribulation .110

13. A flurry of Weddings and another Petition .132

14. A convoluted Quartet .141

15. Astrology, Longitude and Libel .148

16. A Regal Funeral .156

17. Olive's mysterious brother, T D W Dearn – and his adopted daughter161

18. Lavinia's story and the 'Trial of the Century' .169

19. The Twists in the Tail .185

Appendix A. Wilmot family tree .194

Appendix B. Descendant tree of King George II .196

Appendix C. The letters of Edward, Duke of Kent, in the Bodleian Library198

Appendix D. The Will of King George III, June 2, 1774200

Appendix E. The legendary children of Prince George & Hannah Lightfoot . .201

Bibliography .205

Index .207

Acknowledgements

FIRST AND foremost, I wish to recognise the huge debt of gratitude that I owe to Richard Price, a direct descendant of Olive, for collaborating with me in compiling this book, for his generosity in granting me access to his private papers and for sharing with me the fruits of his own research over the last forty years. Both of us wish to acknowledge the helpful research done by earlier generations of Olive's descendants, particularly A. R. Bennett and his daughter Valerie – and the secretarial assistance of Annie Price.

I also wish to thank most sincerely all the following people; my publishers, Alan and Alistair Brewin; Charles Mosley for sharing some of his vast knowledge of Royal and aristocratic pedigrees; Anthony Camp for editorial comments and revisions; Margaret Shepard for giving me the benefit of her own researches into Olive's documents; Anthony West, Peter Gibson and Pat Ryves for details of their ancestry; Sheila Mitchell and Michael Kreps for helpful conversations about Hannah Lightfoot; Lawrie Butler (FIBIS) for his detailed research into the Ritso family in India; Alan Lloyd-Davies for intelligence about St Peter's church, Carmarthen; Alan Russett for information on the Serres family; David Ferdinando of the Royal Masonic Trust for access to their portrait of Anne Horton, plate 11. Also David Wilson for painting the portrait of Olive reproduced on the cover and that of Thomas Dearn in plate 21.

From archivists and curators at numerous libraries and record offices I have universally received courteous help and assistance, including the National Archives, the Warwick Record Office (WRO), the Royal Academy, Ealing Central Library and the Guildhall Library, London. I am particularly grateful to the officers at the Bodleian Library, Oxford, for permission to examine the original letters of Edward Duke of Kent and the Earl of Warwick, held in their Modern Manuscripts Dept.

I have received wise and generous encouragement from Prof. Tom Winnifrith and Gerard Noel for which I am humbly grateful.

Finally, my enduring love and thanks go to my wife Juliette, who has had to live in a ménage-a-trois with Olive for the last five years and who has helped me to see the female perspective on her remarkable story. This book is dedicated to Juliette.

Pictorial credits
(Author or Richard Price unless otherwise stated.)

Illustrations

Plates section

St John's, Warwick, where Olive spent her early childhoodPlate 1

The Rectory, Barton-on-the-Heath, Olive's home as a teenagerPlate 2

Castle Hill Lodge, the home of Edward Duke of Kent and his mistress,
Madame St. Laurent ...Plate 3

Dr James Wilmot D.D. ..Plate 4

Olive, 'Miss Wilmot', sketched by Sir Joshua Reynolds in 1790Plate 5

Classical landscape painted by Olive circa 1805Plate 6

Hannah Lightfoot, the second of possibly three portraits by Sir Joshua
Reynolds circa 1758 ...Plate 7

George Greville, 2nd Earl of WarwickPlate 8

Edward Duke of Kent, George III's fourth son, father of Queen VictoriaPlate 9

Frederick Duke of York, Commander-in-Chief of the Army, with Mrs Clarke .Plate 10

Anne Horton, Duchess of Cumberland and the mother of OlivePlate 11

Another portrait of Anne Horton, Duchess of CumberlandPlate 12

Olive's visiting card, as sent to Lady Anne HamiltonPlate 13

Olive, painted around 1820, when she adopted the title of Duchess of
Lancaster ...Plate 14

Olive's father and mother; Henry Duke of Cumberland, the brother of
George III, with his Duchess, Anne Horton (nee Lutterell)Plate 15

Olive's 'birth certificate', the controversial document that appeared to
show that her mother had also been called 'Olive'Plate 16

The collapse of the Earl of Chatham in the House of LordsPlate 17

Sir Gerard Noel MP ..Plate 18

Lady Anne Hamilton ...Plate 19

Cartoon of the return of Queen Caroline, 1821Plate 20

Thomas Downes Wilmot Dearn, Olive's brotherPlate 21

Wine and cake sent to Olive by Edward Duke of Kent from the christening
of Princess Victoria ..Plate 22

Olive's legitimate daughter, Lavinia Ryves, 1866Plate 23

Olive's illegitimate daughter, Caroline Dearn, in old agePlate 24

Figures within text

Letter in the handwriting of Dr. James Wilmot, 1784. (chapter 3)

One of the covers opened by Olive and Edward Duke of Kent in 1819. (chapter 11)

The second cover, possibly the one containing the 'marriage certificate' of Hannah Lightfoot and Prince George. (chapter 11)

The marriage certificate of Prince George and Hannah Lightfoot, April 1759. (chapter 11)

The Will of King George III. (chapter 11)

Letter in the handwriting of William Fitzclarence ('Fitz'). (chapter 12)

Sketch of Edward Duke of Kent, drawn by Olive in the last year of her life. (chapter 15)

Hand-written note by the Attorney General, January 1866. (chapter 18)

Cover

Olive, painting based on Plate 14; King George III; Queen Charlotte; Hannah Lightfoot.

Preface

I FIRST encountered Olive while researching an earlier project on William James (1771-1837), the great, but neglected transport pioneer of the early 19th century. William James's first aristocratic patron was the eccentric, spendthrift George Greville, 2nd Earl of Warwick – of the second foundation – and it was while delving into the Warwick archives that I came across his voluminous correspondence with Olive Wilmot Serres. Their relationship appeared to be complex, emotionally ambiguous and financially tortuous while at the same time hinting at secrets involving Matters of State and the Royal family. This was the launching pad for a fascinating trail of biographical detection.

This book is not the first to be written about Olive, but it is the first biography to make definite conclusions about her claims to be a legitimate child of the Royal bloodline, based on recently discovered sources. Previous authors have been ambivalent on this crucial issue, as shown in the title of the most authoritative study published in the 20th century; 'Princess or Pretender?', by Mary L Pendered and Justinian Mallet, 1939. [1] These authors did not have access to vital documents that were only placed in the National Archives at Kew in 1967, in particular the files accumulated by the Home Office and by the office of the Attorney General. Thus the crucial role played by Sheriff Joseph Parkins is restricted to one isolated footnote. Nor were they able to tap the documents then held privately at Warwick Castle, now accessible at the Warwick County Record Office.

Since 1939, two further books have been published which make Olive the main subject of study or a character with an important, though subordinate, role. Both are quite rare, having been published privately rather than by a mainstream house.

The first is 'Princess Olive', by Margaret Shepard, 1984. [2] This slim, erudite and well researched book by an amateur historian, constructs Olive's life in flashback from the 'Great Trial' of 1866, in which her daughter tried to obtain legal acknowledgment of her mother's claims to be a legitimate niece of King George III, claims that were denied her during her lifetime. It duplicates much of Pendered & Mallett, though without being influenced by that work.

The second book, 'Sporting the Oak', by Paul Donovan, 2005, [3] is primarily a biography of Thomas Downes Wilmot Dearn, written by the proprietor of an art gallery, whose main interest lay in the artistic and architectural achievements of his

subject. Crucially, this book was written with the co-operation of Richard Price, a direct descendant of Olive and the guardian of private family information which showed for the very first time that Thomas Dearn was, in fact, Olive's blood brother. Richard Price is my collaborator in this present book.

Finally, mention should be made of the last two chapters in Charles Gattey's entertaining book about 'the lives and loves of George III's siblings' – 'Farmer George's Black Sheep'. [4] These give a very fair account of the key stages in the battles waged by Olive – and her daughter – to legitimise her claims, concluding that even after 'exposure', pretenders leave 'a feeling that there might be some truth hidden under the overlying inventions'.

Just like Olive herself, all previous authors have encountered one major stumbling block in unravelling the truth about her true parentage. This impasse involved one of the many documents that came into Olive's hands with apparently respectable provenance. I believe that I have discovered the key to unlocking this enigma.

1 Published by Hurst and Blackett. Justinian Mallett was the pen name of Evans Lewin, a direct descendant of Olive, who was able to introduce some personal information from one side of the family.
2 Published by P. Drinkwater, Shipston-on-Stour, Warwickshire. ISBN 0-946643-02-4
3 Published by Christine Swift Books, Egerton. ISBN 0-9542524-2-X
4 Published by the Kensal Press, 1985 ISBN 0-946041-23-7

Introduction

THIS BOOK sets out to resolve, for the first time, two of the most intriguing conundrums of British history; and to expose a very serious miscarriage of justice.

The thread that runs through the story, sometimes stitching it together, at other times threatening to snap and tear all the pieces apart, is the life of a quite extraordinary woman called Olive Wilmot, later Serres, who claimed to be a niece of King George III and 'Princess of Cumberland'. But who was she really? Was she a true Princess of the Royal bloodline or was she a self-deluding fantasist? History has condemned Olive to the role of an imposter and branded her with the scars of fraud and forgery but these are, I contend, gross injustices. I believe that a re-examination of the evidence, combined with new material that has never been published before, reveals a very different outcome, while explaining the motives behind those people who went out of their way to deny her a fair hearing.

Olive, a strikingly beautiful, feisty and highly sexed lady was in her lifetime an artist, novelist and journalist, as well as being a courtesan and mistress, and in all these fields she showed real talent. She was a less successful wife and mother: she invited scandal and positively encouraged it. Furthermore, she inherited crucially important State Papers and she became privy to even darker secrets about the Royal Family. She was not only physically attractive but also highly intelligent and, a rarity for a woman in her time, extraordinarily well educated. She could be wilful and perverse and would still send shockwaves through the Establishment many years after her death. So, to fit in with this spirit of perversity, we shall start at the end – a great court-case in June 1866, which was, at the time, called the 'Trial of the Century'.

The scene is the court of Divorce and Matrimonial Causes in London. The case was brought by an impoverished old lady, Mrs Lavinia Ryves, who was Olive's eldest daughter. Her counsel was a very minor lawyer called Dr J. Walter Smith, assisted by the equally insignificant Mr D. M. Thomas. Lavinia's case was that her mother had been the *legitimate* niece of King George III, that she had been entitled to the Royal status she had claimed during her later life – plus the money and honours that went with it – and that these should, therefore, have passed to her daughter. And Lavinia had over seventy documents and letters that she would produce to prove her case and substantiate her own claims.

The defendant was no less a figure than the Attorney General, the Government's senior law officer. He was supported by the Solicitor-General and, significantly, Queen Victoria's own personal barrister. Sitting in judgement was the equally formidable array of the Lord Chief Justice, Sir Alexander Cockburn, with, on one side of him, Lord Chief Baron Pollock and on the other, Judge Sir James Wilde.

Why on earth had all this legal firepower been wheeled out to answer the claims of this elderly, but one has to say extremely formidable, lady? Why did the then Prince of Wales, later to become King Edward VII, attend the court on virtually every day of the long proceedings? And why was Lavinia driven from court in a coach bearing the Royal coat of arms? Readers will have to wait to find the answers, but it will not spoil the outcome if we consider that the Establishment had every reason to believe that those documents might expose some very uncomfortable truths, facts that might embarrass the Monarchy and even raise some pertinent questions about the legitimacy of the Royal Succession.

The case hinged on precisely who had been Olive's parents. This was a question that had not concerned Olive for the first forty three years of her life. She accepted – increasingly reluctantly – her humble origins as the daughter of a Warwickshire artist and his wife, and she was merely flattered when two of the sons of King George III sought her friendship. And by one of whom she promptly had a child. The bombshell came in 1815, when the Earl of Warwick, accompanied by Edward Duke of Kent (later to be the father of Queen Victoria), told her that her father had in reality been one of the King's own brothers, Henry Duke of Cumberland. What was not made clear, however, was who her mother had been, nor whether she was legitimate or illegitimate. She was sworn to secrecy while her interests were looked after 'behind the scenes', but all too soon the two key people who could tell her the true facts of her pedigree were dead. For the rest of her life she had to battle to find the answers on her own.

As in all the best detective mysteries, we have to trace Olive's footsteps as she sifted through a raft of enigmatic clues, some from unimpeachable sources, some self-contradictory, some shrouded in myth, while others led down blind alleys or turned out to be deliberate red-herrings.

It is, however, an undisputed fact that the parish register for the church of St Nicholas in Warwick contains the following record for April 15, 1772;

Baptised – Olive, daughter of Robert and Anna-Maria Wilmot.

The entry gives neither the date nor the location of Olive's birth and, like so many things in her life, it might not have told the whole truth …

Chapter 1

The young Olive

OLIVE SPENT her early childhood in some luxury, living at the large and imposing mansion called St John's in Warwick, a few hundred yards from Warwick Castle. [1] **(Plate 1)** The household consisted of her parents Robert and Anna-Maria Wilmot, their son Thomas, born in 1767, and her widowed grand-mother, Sarah Wilmot. Olive's grandfather, Thomas Wilmot, had died in 1760; he had been a distinguished, extrovert character, known locally as 'Beau Wilmot', dressing himself flamboyantly in purple velvet with silver buttons and holding the prestigious post of Treasurer to the County of Warwick for 27 years. This 'onerous and full time office' demanded a person of independent means, being virtually unpaid. He is believed to have practised as a solicitor, [2] while another source of income was an inn called the Three Tuns, converted by Thomas Wilmot from one of Lord Archer's properties in Smith Street.

The Wilmots claimed descent from John Wilmot, 2nd Earl of Rochester, who had been a notable figure in the court of Charles II. That family retained their status at Court and Sir Edward Wilmot was the physician to King George III in the early days of his reign, while the then Earl of Warwick was John Wilmot's great-great-grandson, via the female line. The claims by Olive's family to a noble antecedent were in fact wrong, though they did come from an old Worcestershire family who may have shared common stock with John Wilmot two generations earlier in the 16th century – they shared the same coat of arms. [3] As we will see later, it seems that the next Earl of Warwick, George Greville, acknowledged Olive's family as some sort of cousins. Through another, genuine cousin Lady Elizabeth Cookes-Winford, the Warwick Wilmots were related to both Lord Archer of Umberslade and the 5th Earl of Plymouth, whose daughter married the Marquis of Downshire. It would be this lady who later launched Olive into high-society.

Away from St John's, Olive had two aunts. The elder, also called Olive Wilmot, had left home in 1754 when she was 26 to marry a naval officer, William Payne. [4] (This coincidence of names will lead to some horrendous complications later on.) The younger aunt, Sarah Wilmot, had also married a ship's officer by the name of Read. In addition, Olive had some first cousins up in London, other grandchildren of her grandfather Thomas Wilmot by his first wife, Mary Downes. One of these was called Eleanor Wilmot and she was a whole generation older than Olive, having been

born around 1740. She and Olive would never meet, but Eleanor Wilmot and her husband Thomas Dearn will have major roles to play in a later chapter.

Of more immediate and even greater significance to our story was Olive's uncle, Dr. James Wilmot DD, Robert Wilmot's elder brother, who was then in the apparently rather lowly status of Rector to the Warwickshire market-town of Alcester, an appointment that was in the gift of the Earl of Warwick. Dr. James Wilmot is such a crucial character in Olive's future life that it is helpful to understand his background in rather more detail.

When Olive was born in 1772, Dr. James Wilmot was in his forties.[5] **(Plate 4)** He had been up at Trinity College, Oxford, gaining an MA in 1748; he was ordained as a priest in December 1752 and was then granted a Doctorate in Divinity in 1760. He was appointed as a Fellow of the College – later the Senior Fellow – and as such, he would have been expected to remain celibate. He was tall, handsome and very popular, gaining the nicknames of 'Jemmy Right' and 'Jemmy Wise'. 'Whether he was in London or the country, he constantly mixed in the most exalted company'. [6] Among his contemporaries, he could number Edward Thurlow (later Lord Chancellor), John Dunning (later the Solicitor General and another key figure in Olive's story), Thomas Wharton (who would become the Poet Laureate), Henry Bathurst and Henry Beauclerc(k) as close friends.

Unknown to the infant Olive, there were two great mysteries surrounding Dr. James Wilmot, gossip that reverberated around certain sections of London society. The first linked his name to the controversial 'Letters of Junius'. These had been published since 1767 in the pages of the Public Advertiser, lambasting the King's chief ministers. There is a sermonising tone to these famous letters; the author condemns corruption, immorality and the use of arbitrary power by Government, while he tries to educate the public in their constitutional rights. He is an ardent supporter of the great Parliamentarian William Pitt (the Elder), while vilifying the Duke of Grafton, then Prime Minister, for excluding Pitt from office. He campaigns for the principle of free-speech. He takes up the cause of John Wilkes, not because he agrees with his anti-monarchist tirades, but because of the way his popular re-election to Parliament – by a large majority – was overturned and the seat awarded to a certain Colonel Lutterell, who he singles out for particular opprobrium.

Whoever 'Junius' really was, and this debate still rages, his sources were powerful people with an inside-track to Government. Perhaps he was merely acting as a funnel, editing intelligence gleaned from a number of sources who would wish to remain anonymous. The structure of the letters echoes that of Tacitus, implying that the author had a classical education, and his pulpit style suggests that he might even have been a cleric. In early 1772, at around the time Olive was born, publication of the 'Letters' abruptly ceased. The two dates may not be coincidental. King George III wrote in his private journal; 'We know who Junius is … and he shall write no more'. [7] Later in her life, Olive would champion the cause of Dr James Wilmot as the

true 'Junius' and this might just be another case where she was telling the truth and her subsequent detractors were wrong.

The second, even more tantalising, mystery about Dr. James Wilmot implied that he was in the unique confidence of King George III, because of a personal favour rendered to him when he had been a youthful Prince of Wales. This involved, it was rumoured, an illicit affair that linked young George with a beautiful young Quaker girl called Hannah Lightfoot. And, as we shall also see in a later chapter, the evidence about this affair, with its alarming implications for the Hanoverian succession to the British throne, would one day be inherited by none other than Olive herself.

Olive's father, Robert Wilmot, was an artist, and a few years after she was born he was commissioned by the Earl of Warwick to paint some murals in Warwick Castle. While taking a break from this work one day, he was sitting in the grounds making some sketches when he was introduced to the famous artist Dominic de Serres. Not only was this gentleman a founder member of the Royal Academy, but he was 'by appointment' the official Marine Artist to King George III, and he was also working on a commission for the Earl, to do external studies of Warwick Castle. [8] This was during the period when the Earl was spending money – that he did not have – on lavish enhancements to his art collection, including purchasing antiquities, such as the 'Warwick Vase', from his uncle Sir William Hamilton in Naples. The Earl himself was still in a state of inconsolable shock after the death of his beloved young Countess during childbirth, in the very same month that Olive had been born in 1772. The coincidence of these two events would be one of the many bonds that would later tie Olive to the Earl in a long and complicated friendship – misinterpreted by some, misunderstood by many – that will have dramatic consequences later in her life. Dominic de Serres was rather impressed by the sketches he saw Robert Wilmot commit to paper and he suggested that they should keep in touch.

Suddenly, when she was eight years old, Olive's cosy and genteel upbringing was shattered. Her father, Robert Wilmot, had inherited his father's prestigious position as Warwick County Treasurer, [9] a role which involved collecting the Parish Rates. [10] In 1780, Robert was accused of embezzling and mishandling these substantial sums of money and he was sacked from his office. This misdemeanour would sully the local reputation of the Wilmots for ever, with Robert being damned with the sobriquet of 'Black Bob' and his father, the once prestigious 'Beau Wilmot', coming down through history as having merely been an 'innkeeper'. The Wilmot's landlord, Col. Money, who had put up £1,000 surety for Robert's stewardship, promptly evicted them from St John's. The family, now including three young sisters for Olive – Sarah, Sophia and Anna-Maria – were forced to take much humbler lodgings within the parish for the next five years and slid even further down the social scale when they moved into the neighbouring parish of St Mary's on April 16, 1785. [11]

At this moment, it seems likely that Robert approached his brother James with the threat that if something was not done for his family, he might be forced to reveal

certain secrets surrounding Olive's true origins. There had been local surprise at the time of Olive's baptism, because at first it been believed that Anna-Maria Wilmot had been delivered of a still-born child. [12] Dr. James Wilmot realised that a crisis had been reached. He responded to this blackmail by arranging for the disgraced Robert to move with most of his family to the London area, where he set his brother up in business as a painter/decorator in Paddington. But he insisted that Olive should now live with him. To the outsider, this might have seemed a strange situation, a teenage girl leaving her parents and going to live with a bachelor clergyman. Unless, of course, it was deemed necessary by 'higher authorities' that the truth of her birth was in safer hands if they were entrusted to a man who was already the guardian of State Secrets.[13]

So this is why we next hear of Olive living with her uncle, his house-keeper and her grandmother in the hamlet of Barton-on-the-Heath, at the southernmost extremity of Warwickshire. This small feudal village, dominated by its great Elizabethan Manor House, appears to be very isolated on a map but was in fact less than two miles from the turnpike road that linked London and Oxford with Stratford-upon-Avon and the routes to Warwick and the North. In 1781, James Wilmot had been appointed as the Rector, the living being in the gift of his college, Trinity, Oxford.

He moved his extensive collection of books into the library of the imposing Rectory and it was from these that Olive, a bright, highly intelligent girl, gained most of her education. **(Plate 2)** 'There she perfected herself in divinity, philosophy, poetry, painting and history, and also received much useful knowledge of the constitutional laws and civil jurisprudence of her country.' [14] She must have shown early talent as an artist because Edward Knight, a Worcestershire connoisseur, gave her 3 guineas for a miniature she painted when only 13. [15] Her uncle was a conscientious but demanding tutor, giving her a dissertation every morning on which she had to write an essay in the afternoon. He taught her to play chess as an exercise in logic and anticipation. [16] On the other hand, he was frequently away on business, at Warwick, Oxford and up in London, and she would have ample time to develop youthful fantasies of what happened in the world beyond her rural isolation. She would also have the time, and the opportunity, to delve into some of his more secret papers. But, equally, she would become one of the best educated women of her age.

Life in the Rectory for a young, high spirited girl must have been stultifying. With no friends of her own age, her only escape from loneliness was by immersing herself in the plays of Shakespeare, history and poetry, and her over-imaginative mind fed on the dramas she read about. One of her uncle's visitors would have been his distant cousin, George Greville, the Earl of Warwick. It is not too fanciful to imagine that, to the lonely Olive, he would seem the ideal focus for romantic hero-worship. She would have known the tragic story of the early death of his beloved young wife and how his grief was so overwhelming that he almost lost his reason. With his passion

for poetry and the arts, he may well have talked to the impressionable girl about the books she studied, and perhaps the seeds of their life-long friendship, which was to cause such scandal in the future, were sown in those early days.

Olive first hit the headlines when she appeared at Warwick Assizes as a witness in the trial of a 'desperate gang of ruffians', who had broken into the Rectory at Barton on the night of January 14, 1790 – one of the nights when Dr. James Wilmot was not at home. The 17 year old Olive, so she claimed, had been nailed up in her bedroom while the robbers tied up the servants and ransacked the place before availing themselves of the Doctor's port and brandy. At 6 o'clock the following morning, she had escaped from her bedroom window, jumped off the roof and run across the fields in her nightgown to raise the alarm. Olive put up a dramatic performance in the witness box, but many people had doubts about her veracity, particularly when another witness claimed that she had, for some unaccountable reason, fired a gun from the back door at 9 pm the previous evening. Could this have been a signal that the coast was clear? Was she actually in cahoots with the robbers?

Tongues were wagging as two of the brigands were sent to the gallows and Dr. James Wilmot decided it was high time she went to live in London and develop her artistic education. Taking up the connection made some years earlier, Olive may even have become a lodger with the Serres family in St. George's Row. Dominic Serres (also known as Count Jean Dominic de Serres, born in Gascony 1722), had first come to England as a prisoner of war, but had then decided to stay on and soon reached the pinnacle of the British artistic community. So when the beautiful, teenage Olive arrived in London in 1790, it was arranged that Dominic Serres's son, John Thomas Serres, would give her painting lessons.

John Thomas was then aged 31 and a very talented artist in his own right. He had been the drawing master at the Maritime School in Chelsea, an academy for training midshipmen for the Royal Navy, and he would inherit his father's Royal appointment in 1793. [17] Olive proved to be a most responsive pupil in more ways than one. It is clear that her own latent talent blossomed under his instruction, and John Thomas reciprocated by falling head over heels in love with the girl described by a contemporary as one who 'to the effects of great beauty, added a fascination of no ordinary power … [with] an unusual acuteness'. [18] Her unique style also caught the eye of Sir Joshua Reynolds, who drew a pencil sketch of her wearing a large straw hat. **(Plate 5.)** The couple got engaged but were soon parted. John Thomas had to go abroad on an official assignment to Italy and Olive, always one to try and get her own way, wrote an impassioned letter to her fiancé in Naples imploring him to return quickly. Such was the spell that she had cast on him that he, rather unprofessionally, abandoned his assignment and scuttled back to England. They were married at Barton-on-the-Heath on September 17, 1791, with Dr. James Wilmot presiding, but also warning his son-in-law to 'keep her employed, or she will be plotting mischief'. [19]

There seems to be little doubt that Olive was initially welcomed into the Serres family and there is affectionate correspondence that supports this. [20] But her marriage to John Thomas was to become a tempestuous affair. Olive towered above her husband in stature and probably nagged him incessantly about being away from home for long periods on assignments for the Royal family and private patrons. She was extravagant, flirtatious and wilful, believing that she was as good an artist as her husband. Certainly some other people agreed with her and she was one of the first women to be 'hung' in the annual exhibitions of the Royal Academy in 1793. From then until 1808, she exhibited 14 paintings, while another 19 examples of her work were shown at the British Institute. [21] Assessments of her skill as an artist have been generally favourable. 'She could not only paint, but paint well. … firmly and rapidly handled, with pleasing purity of paint and onceness (sic) of brushing … she could paint almost as well as the best of her contemporaries.' [22] Her style was clearly influenced by Richard Wilson RA. 'Olive was a painter of some talent in the Romantic Landscape Tradition, and a voluminous writer of Romantic drivel'. [23] A less flattering opinion emanated from Windsor Castle in 1970. 'The two paintings by Olive Serres [*in the Royal Collection*] are classical landscapes with figures and are almost unbelievably bad.' [24] It is surely of some interest that any of her work should now be in the Royal Collection, which they are, **(Plate 6)** [25] and that the author of this comment seems unreasonably biased against her.

Fifteen months after their wedding, Olive gave birth to a son, born on November 23, 1792, and baptised with the names of John Dominic South Serres on December 22. [26] The christening might have been delayed so that all the Serres family could be present to celebrate the arrival of the great painter's first grandson. John Thomas had a younger brother, Dominique Michael, already married four years earlier to Maria Lucretia Madden, though this union was as yet childless. [27] But twin tragedies were just around the corner. Four weeks later, Olive's baby son was dead and the following month would witness the death of her father-in-law as well.

It seems that Olive had a number of unsuccessful pregnancies before her first daughter to survive infancy was born in 1797. [28] She and John Thomas were then living in the west end of Liverpool, near the docks, in Birkett St. The child was christened in the church of St Nicholas on August 31 with the names of Lavinia Janetta Houghton Serres. [29] The last name might appear to be highly significant in the light of later events in Olive's life. It was certainly not a family name on either side of her own family, yet it sounds precisely like 'Horton', which is how Lavinia spelt it in later life. One could be tempted to think that Olive guessed, from something let slip by her uncle, Dr. James Wilmot, that her parentage was more complicated than she had been brought up to assume. Perhaps he had even called her 'my princess' and entertained her childish fantasies with stories based on his contacts at Court, elaborated with tales of the glamorous characters he had met from foreign royalty. Including, and this is crucial as we shall see later, one from the Kingdom of Poland.

But the true origin of the enigmatic 'Houghton' is, in reality, probably more mundane. In the years when the Serres marriage was still romantic and affectionate, John Thomas would write loving letters to Olive when his business demanded that he should be away from home and she was staying with his brother Dominique and his wife in London. His letters began 'Mia Cara' and he signed himself 'Giovanni'. 'I send you by this evening's coach', he wrote from Edinburgh on Christmas Eve 1794, 'a turkey, two fowls, part of a leg of pork and three pigs' feet, and hope their coming from ME will render the presents the more acceptable and palatable to you all. Next week a friend of mine will convey a packet to you all – his name is Houghton.' [30] Perhaps the friend would be invited to be Lavinia's godfather, the honour being acknowledged in one of her Christian names.

Olive gave birth to a son in 1799, an event that might have saved the marriage, but this baby only survived for a few weeks. [31] The Serres's next child was born on December 2, 1802 and baptised with the name of Britannia Serres on January 20 the following year. Records of the old Marylebone church give her parents' address then as No 2, Berners St, London, next door to the gallery set up by John Thomas, the 'British School', as a showcase and saleroom of broader appeal than the elitist Royal Academy. But by now their relationship was becoming untenable; she accused him of neglecting his 'marital duties' while John Thomas accused her of infidelity and had become exasperated by Olive's extravagance and her indifference to the welfare of their children, particularly her new-born baby. Later, when he discovered that Britannia had been farmed out on another family, he snatched her away and brought her up himself; Britannia would never again have close contact with her mother – until her funeral.

No 2 Berners St had also become home to a bizarre 'ménage a trois'. John Thomas had taken a partner into his British School by the name of George Field – who also became the Serres's lodger and Olive's most attentive and intimate companion. John Thomas now sought to distance himself from Olive and all the problems she was causing him and his career by declaring a formal separation on March 18, 1803. [32] The document, three large sheets of vellum, is extraordinary, and shows that John Thomas either had a very generous, trusting nature or that he was quite unbelievably naïve. First of all he appoints George Field as Trustee, adding; 'It being fully understood that the only reason for the separation of the parties is the difference in their tempers and dispositions and not from any conjugal infidelity on the part of the said Olive ...' He then agrees to give Olive an allowance of £200 per annum if she never bothers him again, [33] to be paid out of a Trust fund of £3,000 he intended to set up, though because the British School quickly folded he only ever contributed £16.13.4. If he thought that this agreement would solve his problems and allow him to concentrate on his painting he was sadly mistaken.

When Olive gave birth to another child in early 1804, John Thomas knew conclusively that he was not the father. What happened to this child is yet another

intriguing riddle; if it survived, it was certainly sent away for adoption somewhere, and there is some evidence that the baby girl might have grown up to marry and become a Mrs Binkes. [34] And when John Thomas tried to escape to Edinburgh, she pursued him for her allowance, while on another occasion she stole some paintings he had set up for an exhibition. She issued promissory notes in his name, notes on which John Thomas would later claim that Olive had forged his signature while he was abroad.

Olive needed money to fund her increasingly flamboyant life-style in London, where, in March 1805, she was introduced by the Marchioness of Downshire, a cousin of the Wilmots, to a very important person who had caught her eye, none other than George Augustus, the Prince of Wales...

ENDNOTES

1 This property was rented from Colonel James Money of Pitsford in Northamptonshire. Col Money had married an heiress of the Stoughton family, to whom Henry VIII had given St John's on the dissolution of the monasteries in the 16th century. It is now (2011) a museum.

2 Willis-Bund p1

3 The Heraldry of Worcester, 1873 p628. Herald's Visitation of Worcestershire 1682. Genealogy of the family of Wilmot, Earls of Rochester – The Ancestor, October 1904. The arms in question were – Argent, on a fesse gules between three eagle's heads rased sable, two escallops or.

4 Post Captain, July 1780. *Bateson's Political Index*, ii, 51. Born in Virginia, he was master of the 'Priscilla'; its loss led to the financial ruin of his family. (Virginia Historical Society archives.)

5 Records at Trinity College, Oxford, give the year of his birth as 1726, though a tablet at the church in Barton-on-the-Heath states 1724.

6 Pendered & Mallett, p70

7 Aspinall.

8 Russett 2001. The first painting Dominic Serres did at Warwick Castle was a large canvas measuring over 4 ft high by 6 ft wide. It was exhibited at the Royal Academy in 1761, but failed to win a 'Landscape Premium' Prize. Like Canaletto and Sandby, Dominic Serres is recorded as being a 'frequent visitor' at the Castle.

9 In fact it did not pass directly. Thomas Wilmot was Treasurer from 1732 – 1761. A Robert Taylor held the position from then until Robert's appointment in 1776.

10 The Treasurer was supposed to spend the Rates from the County Parishes on items such as keeping road bridges in repair, staffing the county jail, feeding the prisoners and burying them when they died, as well as shifting vagrants beyond the county boundaries. (Hughes.)

11 WRO DR 712 and 714. Certificate dated April 16, 1785.

12 Olive's baptism record has a strange, indecipherable word written some time afterwards in the left hand margin. Later still, it seems that someone has tried to scratch this out with a sharp implement, making holes in the paper. (WRO)

13 Olive claimed in her 'Statement to the English Nation', 1822, that Dr Chapman – the President of Trinity College, Oxford – and his wife had offered to adopt her at this moment.

14 Olive 1822, p29

15 Russett 2001 p69

16 Olive 1813.

17 There are several examples of the work of both father and son in the National Maritime Museum at Greenwich. Russett 2011.

18 Pendered & Mallett p85

19 ANON 'Memoir'

20 WRO CR1886 Box677, quoted in Russett 2010 p62.

21 *The Royal Academy Exhibitors*, edited by A. Graves. Over the same period, her husband exhibited 23 paintings.

22 Grant, pp 442-443

23 Henning.

24 Price family papers. Private correspondence from the Lord Chamberlain's office, 1970. The catalogue numbers are 1082/3, though Miller quotes numbers as 'Windsor Castle 1179/1180'.

25 Royal Collection WC 1179 405168. See plate 6. The other landscape is WC 1180 405167.

26 Records of St Mary's, St Marylebone Road, London.

27 They did have a son in 1796, christened John Edmund Dominick Serres, who grew up to become the vicar of Easebourne in West Sussex. He married his cousin Elizabeth Madden by whom he had no less than ten children.

28 Olive had given birth to a daughter, christened Mary Esther Olivia, on December 13, 1793, at St Mary's, Marylebone Road. She either died in infancy or was sent out for adoption.

29 Liverpool Record Office 283 NIC 1/7. Another interesting feature of this record is that it appears to have been added to at a later date, with the words, alongside those of Olive; 'Painter to his Highness the Prince of Wales'. The record also implies that Lavinia was the 4th child of the Serres marriage.

30 WRO CR 1886 Box 677. The letter describes Houghton as 'un famoso Pittore de qui.'

31 Gentleman's Magazine, March 1826.

32 WRO CR 1886 Box 677

33 Farington, Volume 2, p29, entry for 20/6/1804. Joseph Farington was secretary to the Royal Academy Council.

34 Notes & Queries, 5th Series, Volume V, p44. [January 1876]

Chapter 2

An affair with the Prince of Wales – and echoes of an earlier one

GEORGE AUGUSTUS, Prince of Wales, was the eldest son of King George III and Queen Charlotte, born in 1762, a year after his parents' marriage. His mother spoilt him and his father disliked him, much preferring the second son, Frederick Duke of York, who was born the following year. The young Prince had led a disreputable and profligate youth, and had incurred his father's fury by secretly going through a form of marriage to a rich widow, Maria Fitzherbert, in 1785. Worse still, Maria was a Roman Catholic. This event had been aided and abetted by one of King George's own brothers, Henry, the then Duke of Cumberland, and his Duchess the former English commoner Anne Horton. Their marriage in 1771 had also been a clandestine affair, and when George III had heard about it he flew into one of his famous rages and insisted that Parliament should approve the Royal Marriages Act in the spring of 1772. In a later chapter, we will see how Olive herself had played an unwitting but crucial role in this notorious piece of constitutional legislation.

At 35, the Prince of Wales had been forced – in order to pay off his debts – to make an official, 'arranged' marriage to his cousin Princess Caroline of Brunswick in 1795. It was a disaster. He loathed Caroline from the moment he first set eyes on her and he returned to Maria Fitzherbert within a year of the wedding, having performed one night of conjugal duty. A daughter, Princess Charlotte, would be born nine months later. The Prince's lifestyle became increasingly dissipated, his debts started to escalate again and he was not even faithful to Maria. Over the next nine years he had a long succession of mistresses, love affairs and one-night stands, [35] so his meeting with Olive in the spring of 1805 and their mutual attraction caused little comment in Society at the time.

Olive's daughter, Lavinia, would later recount how she and her mother had both been invited down to stay in Brighton by the Prince and how her mother attended all the fashionable balls during the summer of 1805 in his company. [36] Their dalliance may have only been a brief fling, but Olive would soon be rewarded by her (unofficial) appointment as 'Landscape Painter to His Royal Highness the Prince of Wales';

which explains those two paintings in the Royal Collection. [37] Olive claimed that he continued to visit her at her London address, a house in St James's on the corner of Stafford Street, where she was struggling to make an independent career for herself by her painting and the writing of romantic fiction. [38] She had just published a collection of poems, 'Flights of Fancy', and a three act opera entitled the 'Castle of Avola', which she dedicated in flowery prose, not to her Royal lover, but to the Earl of Warwick. [39] She was perpetually hounded by creditors. One anecdote tells how a tradesman turned up demanding payment of his account just before the Prince of Wales was due to arrive. To buy the fellow off, Olive tore down 'the rich window curtains' from one room and told him to pawn them as settlement. [40]

One person that the Prince of Wales introduced Olive to was his younger brother, Edward Duke of Kent. Olive's affair with the Prince was a flame that burned brightly for a moment and was soon extinguished, but her friendship with Edward would prove to be far more enduring and have even greater consequences ten years later.

What had not been planned was that Olive should give birth to the Prince of Wales's child in December 1805. Under normal circumstances, another illegitimate child of a Royal Prince would not have raised many eyebrows, but because of secrets known only to the Royal family, this one might cause particular problems. So 'Special Agents' were summoned to take the baby girl away for immediate adoption and it was made very clear to Olive that she must never, ever try to find out what happened to her. Unbeknownst to Olive, this baby, Caroline, would be brought up by another branch of the Wilmot family, and her story and that of her adoptive parents will be recounted in a later chapter. Olive's life was beginning to get more complicated, and it will be impossible to understand the full ramifications of the next few years unless we backtrack at this point to delve into the haunting mystery of a previous affair by a youthful Prince of Wales.

* * * * *

George III had been a mere 22 years old when he ascended the throne of Great Britain in 1760, much sooner than he might have expected because his father Prince Frederick, the eldest son of George II, had died at the age of only 44 from a burst abscess in a lung, possibly caused by an earlier sporting accident. Frederick had been disliked by both his parents, his father having once described him as 'the greatest ass and the greatest liar … in the whole world, and I most heartily wish he was out of it,' [41] while his mother, Princess Augusta, spent her life plotting to have him disinherited and removed from the succession in favour of his younger brother William. (William would be made Duke of Cumberland, the first of three Royal brothers who would bear this important title throughout our story, earning the sobriquet of 'Butcher' for his determined actions in the Jacobite Rebellion of 1745.)

Prince Frederick had run up massive debts and successfully carried on the old Hanoverian tradition that the reigning monarch would have a bitter, tempestuous

relationship with his eldest son, a relationship that was to be repeated in many subsequent generations. Frederick did not help this relationship by forging alliances with his father's political opponents. In his youth, Frederick had been lured into a romance by the dowager Duchess of Marlborough, who held out the tempting prize of a dowry of £100,000 if he married her grand-daughter Lady Diana Spencer. (The Spencers would have to wait over 200 years to achieve their ambition.) Plans for a clandestine marriage in Windsor Park were frustrated by the First Minister, Robert Walpole, who had fallen out with the Duchess, even though she had been responsible for his earliest appointments on the ladder to high office. After a number of mistresses including Lady Archibald Hamilton, [42] whose grand-daughter will have an important role in Olive's later life, Frederick was persuaded to marry the more 'suitable' 16 year old Princess Augusta of Saxe-Coburg in 1736. They had five sons over the following 13 years, the eldest of whom was George, Prince of Wales and later King George III. (See Appendix B).

George III married his cousin Princess Charlotte of Mecklenburg-Strelitz in September 1761 a fortnight before his coronation. This was another arranged, dynastic marriage, imposed on the King by his widowed mother and her powerful 'friend' Lord Bute. George had been a shy, slow witted young man who lost his father when he was 13, thereafter adopting Bute 'in loco parentis' with an admiration and respect that bordered on hero worship. George had received preliminary reports that Charlotte 'was without any beauty at all' though 'physically suited for childbearing', but he confided to his mentor that he knew where his duty lay, even though his bride to be was 'not in every particular as I could wish'. [43] Queen Charlotte had a strong personality and a keen intelligence and in many ways dominated her husband, though in the early years of their marriage he and his wife presented a picture of unpretentious familial harmony, living without ostentation in the modest Royal Palace at Kew on the banks of the river Thames. Not for them the extravagance of Hampton Court, so any resentment over the expense of the monarchy was directed more against the rest of his family than at the King himself.

Charlotte had not been George III's first choice. In 1760, the year that he became King, he had fallen in love with a beautiful young girl who, although only 15, had been brought to the Court by his grandfather, George II, just before he died. Lady Sarah Lennox was the youngest daughter of the Duke of Richmond, and therefore a direct descendant of Charles II. Her brother-in-law, Lord Holland, wrote later that 'she had the finest complexion, most beautiful hair … with a sprightly and fine air, a pretty mouth and remarkably fine teeth'. [44] At his birthday ball on June 4th, 1760, 'the King had no eyes but for her and hardly talked to anyone else'. He even went so far as to confide to Lady Susan Fox-Strangways that Sarah would make his coronation 'a much finer thing'.[45] No wonder the Court had been on tenterhooks. The precocious Sarah, more at ease flirting with the wits and poets at Court, had initially found his gauche, awkward attention flattering but uncomfortable, though

quite soon she could write that she was 'absolutely in love with the young King'.[46] For his part, George suffered a heartfelt struggle between 'the boiling youth of twenty one years and prudence'. [47] He confessed his turmoil to Bute, who persuaded him that prudence must win the day. But he did not forget Sarah and insisted that she should be the chief bridesmaid at his wedding the following year, 'never taking his eyes off her throughout the ceremony'. [48]

If this had caused Queen Charlotte embarrassment, it was nothing compared to the rumours that soon reached her that her husband, the man who had stood beside her at the altar at the Chapel Royal, Windsor while their vows were solemnised, had previously been *legally married* to someone else. That person was the 'fair Quaker' Hannah Lightfoot. Much later, Olive would be accused of inventing this story, of adding it to her other scandalous revelations, but there is considerable evidence that there was tittle-tattle about this youthful escapade going around before Olive was even born. [49] Hannah Lightfoot was certainly a genuine historical character, having been born on October 12, 1730, the daughter of a Quaker couple living in Wapping, East London. Her father, Matthew Lightfoot, died two years later and Mary Lightfoot took Hannah to live with her brother Henry Wheeler and his family. [50] Wheeler had a flourishing drapery business in a shop in St James's Market, which was sited close to the present junction of Jermyn Street and Lower Regent Street. Contemporary descriptions of Hannah are rare, but they all agree that she was a considerable beauty, particularly because her skin had not suffered the ravages of smallpox.

The Quakers, or Society of Friends, lived by high moral standards; they denied the authority of the established Church, they were pacifists and they refused to swear any oath of allegiance to a temporal monarchy. They treated all people as equals, men and women, peer and peasant, showing no deference to rank or title. By the 1750s they had earned a reputation, particularly in trade, for honesty, integrity and an unselfish will to do good by their fellow citizens. The Society's own rules were stringent. To the younger generation they were often irksome, with marriages to 'outsiders' leading to automatic expulsion from the Society and the family fold. And for pretty girls there was the frustration of having to dress in the sombre, dowdy uniform of plain black.

Prince George was only 15 when he first set eyes on the beautiful Hannah in 1753, while he was being carried in a sedan chair from his mother's home in Leicester House to an opera in the Haymarket. The trips became more frequent and soon secret rendezvous were set up with the connivance of one of his mother's Maids of Honour, the worldly and experienced Elizabeth Chudleigh. [51] But this flirtation could not be kept secret for long, and on December 11, 1753, a marriage took place between Hannah and an innocent young man called Isaac Axford, who was a shop assistant to a grocer by the name of Barton.

Arranged by whom? Certainly not by her parents, because Axford was not a Quaker, having been baptised into the Church of England in 1747. The couple were

acquainted, but only to the extent that young Isaac cast adoring glances at Hannah when she came to buy provisions from his father's shop. So, when told that he was actually going to be married to her, he probably could not believe his luck, particularly as it was suggested that he would also receive a substantial dowry. The most likely candidates as match-makers are George's mother, the dowager Princess Augusta, and Lord Bute, with Elizabeth Chudleigh acting as the go-between. This notorious, swashbuckling lady, herself secretly married, kept a privileged position at Court because she could hold the threat of blackmail over her employers, knowing the true extent of the relationship between them. Once Hannah was married, however, George's mother must have assumed that the chance of a royal scandal involving her eldest son might be avoided.

There was no question of the Isaac Axford and Hannah Lightfoot wedding being performed in a Quaker Friends' Meeting House. Instead – and this is authentically documented [52] – it took place in a rather shady marriage mill called Keith's Wedding Chapel on Curzon Street, presided over by the equally shady Rev. Dr. Alexander Keith. Keith had been ordained a legitimate priest of the Church of England, having taken both an MA and a Doctorate in Divinity at Oxford. He had spent some time in the Fleet prison for debt, where he found there was a ready market for 'quickie' marriages at a guinea a time with no questions asked. (With the Law incapable of intervening, the Church took matters into their own hand and defrocked Keith in 1744.)

Keith's lucrative business in Mayfair was in its last days anyway, because the Act 'For the better preventing of Clandestine Marriages' had just been passed by Parliament in October 1753, and so there could be justifiable concerns later as to whether the Axford/Lightfoot marriage was in fact legitimate – on two counts. Keith pocketed his fee with a sigh of relief, but he could not have anticipated what happened next. A closed carriage with blacked-out windows came clattering up to the front of the chapel, the door was flung open and Hannah pushed her husband out of the way and leapt in. A chase now ensued, with the despairing Isaac grabbing the nearest conveyance he could find. However, at the first Toll Gate the driver of the leading carriage shouted out 'Royal Family', the Turnpike barrier was hastily opened and Hannah had made her get away. This is perhaps the most colourful version of the end of the marriage, but all commentators agree that it was very brief, lasting no more than a few weeks at most. Axford would never see Hannah again.

Hannah then disappears into a fog of myth. There is some suggestion that she lived in a succession of secret addresses in Tottenham, Knightsbridge, Peckham, Isleworth and Hampstead, kept by her royal admirer. [53] The Knightsbridge address is particularly interesting because that was also the location (in those days utterly rural) of a farm that supplied milk to the Royal household. The steward was a man by the name of Perryn, or possibly Pearne, and, as we shall reveal later, the Pearne family certainly had a close connection with Hannah. She is reputed to have been

painted at least twice by Sir Joshua Reynolds around 1757/8. One portrait is at Knole, the seat of the Sackville family in Kent, and is entitled 'Hannah Axford'. Another, clearly the same sitter, is (2011) in the possession of the John Brandler Galleries, Brentwood, Essex. **(Plate 7)** In the original pocketbook in which Sir Joshua Reynolds recorded his sitters, there is an entry against Tuesday, July 19 1757; 'Prince of Wales, Bill £50'. Furthermore, and this is both intriguing and possibly rather sinister, the pages for October 24 to November 6 are missing and appear to have been sliced out. [54]

Hannah never got in touch with her parents. Axford sought her high and low, and, suspecting what might really have happened, presented a petition to the King asking for his wife to be returned to him. [55] The Quakers, after spending three years searching for her, threw her out of the Society of Friends on the pretext of her marrying an 'outsider' and this well documented ruling re-confirms the facts of her wedding and her disappearance. Although the marriage was never consummated, Isaac Axford did not file for divorce, but he married again in December 1759, this time to his cousin Mary Bartlett, describing himself as a widower. Perhaps he believed the rumours that Hannah had died on May 27 that year, and that she had been secretly buried, during the hours of darkness, at Islington churchyard by the Rev. Zachary Brooke, chaplain to King George II, even though the tombstone was engraved with the name of Rebecca Powell, a 'chaste maiden of 23'. [56] Rev. Brooke did have a niece by this name, but why should she be interred with no mourners and under a cloak of such secrecy? And why, on his retirement, should this cleric be rewarded with the livings at no less than three parishes? A possible explanation seems to be that Brooke was being paid hush-money for keeping an embarrassing Royal secret. Perhaps it was not Hannah's body that was being buried, but documentary proof that her life had, very recently, taken on a much more important and potentially threatening role.

The rumour that alarmed Queen Charlotte so much was that in the spring of 1759, Prince George, having now reached his majority, had actually *married* the subject of his infatuation. Just before he died in 1834, the eccentric but influential and well informed William Beckford was interviewed by Cyrus Redding, the editor of the *New Monthly Magazine*.

> The Prince fell in love with a beautiful Quakeress named Hannah Lightfoot ... and as he could not obtain her affections in the way he desired, he persuaded Dr Wilmot to marry them; which he did at Kew in 1759, William Pitt and Anne Tayler being witnesses, and for aught I know that document is still in existence.

Now the 'Dr Wilmot' had been none other than Olive's uncle, Dr James Wilmot, a man who Beckford went on to claim 'enjoyed the *exclusive confidence* of George

III'. Furthermore, what Beckford did not know was that 'that document' had been, since 1815, in the possession of Olive herself! How she came by it, how it was opened in the presence of a Royal Duke and why she subsequently kept it secret will be revealed in a later chapter, because the implications would once again rock the monarchy and raise alarming questions about the legitimacy of the Hanoverian succession. Particularly when gossip began circulating that Hannah had given birth to a child.

As Beckford recalled, the first witness to the marriage, William Pitt, was the great parliamentarian and so-called 'great commoner', later made Earl of Chatham in July 1766 when he was appointed as First Minister, though in 1759 he was in temporary retirement, due partly to ill-health and partly to the antagonism of political opponents. Pitt had already left his indelible stamp on history as the Minister who had master-minded Britain's global victories against the French during the Seven Years War, in North America, the West Indies and India, but had railed against the peace terms that he believed to be too conciliatory. Even out of office in 1759, he retained huge political ambitions and, ever the opportunist, sought to curry favour at Leicester House. Here lay the power base of the dowager Princess Augusta and the young Prince George, who would inevitably succeed his aged grandfather before long. And what greater influence might he enjoy than to be an accessory in a secret indiscretion?

But was Beckford a reliable informer? In spite of his other eccentricities, the answer is probably yes, because his own father, also called William Beckford MP, had been not only Lord Mayor of London but also a close friend of William Pitt, with whom he 'came to enjoy a remarkable intimacy.' [57]

Anne Tayler is more enigmatic, but she was probably a former maid-servant to Hannah's uncle, Henry Wheeler. Some authors claim that her discretion had been bought by appointment into service with the Royal family, being the bell-ringer at St James's Palace. [58] And George III certainly admired and respected the Quakers, 'a body of Christians for whom I have a high regard.' [59] Even more revealing, perhaps, was his comment to the artist Benjamin West. 'Had I been left to my own choice, I should have been a Quaker myself.' [60]

So, was Queen Charlotte involved in a bigamous marriage? Were her first two children illegitimate? It has been suggested that these matters preyed on her mind to such an extent that when she got hold of yet another whisper that Hannah had really died in early 1765, she persuaded George III that they should go through a re-marriage ceremony as soon as possible. [61] This apparently took place at Kew Palace in the summer of 1765, with Dr. John Moore, the Bishop of Bangor, officiating and the King's brother, Edward Duke of York, acting as witness. [62] (The Hannah saga will be taken up again in later chapters.)

* * * * *

Back to 1805. The Prince of Wales was not Olive's only conquest in that year. According to the memoirs of Katherine Byerley, [63] Olive enjoyed 'the bounty of a half-witted gentleman ... who worshipped her beauty', referring to George Greville, the Earl of Warwick, in the final year of his extravagance. The writer, as a child, had enjoyed meeting her and 'hearing that queen-like looking creature talk naturally and sanely.' She went on to describe her. 'She was very handsome – at least I thought so; rouged, tall, fat, audacious. There was a mystery made by the family at whose house we met touching her birth.'

The earliest correspondence between Olive and the Earl of Warwick that has survived dates back to 1804, by which time they had already established a mutual admiration, complimenting each other on their painting and poetry. In a poem he wrote to her was the following verse; [64]

> And may no future storms arise
> But sailing under cloudless skies,
> Our vessel steer; and friendship guide
> Where's known no sad tempestuous tide.

Their relationship is open to many interpretations and the surviving correspondence is completely one-sided. [65] She seems to have kept every letter she ever had from him (all 134 of them) while her replies can only be guessed at by interpolation. What will become apparent is that he was privy to the secrets of her birth, while at the same time under strictures of Royal confidentiality to keep them from her as long as possible. And when some years later he realised that he was about to die, what he finally divulged would appear to be only half the truth.

'A letter from your venerable uncle', the Earl wrote to Olive in April 1804, 'requested me my patronage for your painting ...nothing will give me more satisfaction than your welfare, *which I have promised sacredly*'. (Author's italics.) On receiving a copy of her poems *'Flights of Fancy'* in 1805, he had replied effusively; 'You really astonish me! Thou second Shakespeare! Thou Warwickshire Maid! Thou Witch of Wonder!' On another occasion, some years after he had remarried, he wrote in more guarded terms;

> Pray write by return of post – your letters are a great solace at all seasons. Lady Warwick shall at some time know the excellence of your heart; at present it will be best not to interrupt our usual channel of correspondence – your friendship for me should not be misconceived.

And misconceived it was in some quarters. Thomas Creevey would refer to her as 'Warwick's Pop-Lolly', [66] a phrase of lewd innuendo, though Olive herself would have us believe that there was no other reciprocity in their friendship, quoting the

Earl's opinion on women generally; 'the weakness of their nature and the un-guardedness of their hearts rendered them the easy prey of libertines … but I thank my God that I have never seduced a female nor departed from the fidelity which a married life should command.' [67] In another revealing letter to Olive he wrote; [68]

> … most gracious reception from the Prince Regent. *He reminded me so greatly of yourself; his eyes are very like your own; he smiles as you do.* I suppose the world, with its busy folly, has exaggerated our friendship, for I fancy the Prince looked at me significantly, but in the best humour imaginable. (Author's italics.)

Like a dripping tap, a succession of hints and innuendos were reaching Olive's ears, hints which suggested that her own origins might be more ambiguous than she been brought up to believe. In later years, her physical resemblance to members of the Royal Family would be a subject of much comment. (**see Plate 14**) What did the Earl of Warwick really know about her? Were there ulterior motives in his sponsorship? By 1806, one reason he needed her friendship was, amazingly, that he needed to borrow money off her, so it is important to understand how and why the owner of Warwick Castle and other vast estates became a pauper.

ENDNOTES

35 Camp. This monumental work analyses the evidence for 27 candidates over the period.

36 Evidence given at court case Ryves vs. The Attorney General,1866.

37 The appointment was 'unofficial' to the extent that there is no record of it in the Royal Archives.

38 Farington.

39 *'Flights of Fancy'*, by Mrs J. T. Serres. J. Ridgeway, 170 Piccadilly, London, 1805.

40 Olive, 1813. p18n

41 Longford, E. p306. An interesting, and generally more sympathetic, analysis of Prince Frederick was written by Sir George Young, *'Poor Fred'*, OUP 1940, drawing parallels with Edward, Prince of Wales, later Edward VIII.

42 Camp pp38-47

43 Tillyard, p51

44 Fox

45 Ibid.

46 Tillyard, 1994.

47 Ibid.

48 Compton Mackenzie, p250

49 Pendered & Mallett, p156. Quoting from Public Advertiser 1770. Subsequent pages give other sources.

50 This explains the later confusion when Hannah Lightfoot was sometimes referred to as Hannah Wheeler. Doubters, like William Thoms, would later claim, erroneously, that they were two different people.

51 She was at one time engaged to the future Duke of Hamilton, then secretly married to the heir to the Earldom of Bristol. But since she had destroyed all the evidence of this event, she could claim it had never happened, her husband concurred, and in 1769 she married the Duke of Kingston.

52 Records of Keith Chapel, Guildhall Record Office, London.

53 Kreps, p20

54 Royal Academy Library, Burlington House, London. There are three anonymous sittings – 'A lady/ a stranger' – in 1758; April 7, July 12 and Aug 31. It has been hinted that there is a third painting of Hannah in the Royal Collection.

55 Pendered & Mallett, p155

56 Kreps, p21

57 ODNB. M Peters.

58 Pendered & Mallett, p187

59 Conversation with Bishop Hurd, quoted by Gattey, p ix.

60 Ibid.

61 *'An Historical Fragment relative to her late Majesty, Queen Caroline'* 1824. Anonymous. Various authors have been suggested for this work, including Alderman Wood and J. H. Adolphus. Although William Thoms, librarian at the House of Lords in the 1860s, attributed it to Olive, this

cannot be the case because of internal inconsistencies and the deprecating references to Olive herself.

62 National Archives TS 18/112. Letter – number 55 – from Henry Bell to the Under Secretary of State at the Home Office, Feb 21, 1821. Dr Moore was later appointed as Archbishop of Canterbury. Apart from the unreliable '*Secret History*' attributed to Lady Anne Hamilton (q.v. Chapter 15), this is quoted as a fact by Charles Bradlaugh in his more reliable '*Impeachment of the House of Brunswick*', 1874. The Attorney General would refer to the evidence for this event during the Ryves court-case of 1866, though without actually providing it. See also Pendred p195.

63 Byerley, (later Mrs Thompson), quoted in Pendered & Mallett, p140.

64 Olive 1819, p164

65 Olive, 1819.

66 Maxwell. Jan 29,1821.

67 Olive, 1819.

68 Olive 1819 p182

Chapter 3

The impoverished Earl of Warwick and the last years of Dr James Wilmot

THE GREVILLES could trace their nobility back to Sir Fulke Greville, who was 'a distinguished courtier in the reigns of Elizabeth and James I' and who obtained a grant of Warwick Castle' in 1621.[69] George Greville's great-grandfather, Francis Greville, had married Lady Anne Wilmot, daughter of the 2nd Earl of Rochester – hence the belief that Olive's family were cousins.

When George Greville succeeded to the Earldom of Warwick in 1773, he probably did not fully understand the extent to which his father had mortgaged the estates, as well as running up other debts. **(Plate 8)** He didn't want to know anyway, and after the death of his beloved young wife in childbirth in 1772,[70] he had sought solace in spending vast sums of money on the fabric of Warwick Castle and a new bridge over the River Avon. As a young man, he had indulged his passion for hunting and painting, and Olive herself has left us an insight into his character in his early years; scholarly, outgoing, a sensitive poet and an accomplished draughtsman, whose drawings she compared favourably to those of Claude Lorraine.[71] He and his father were welcome visitors at Court and he had been madly in love with his young bride.

Now, however, he became progressively more introspective and in his own words was 'the most solitary and wretched of human beings'.[72] Another commentator described him as 'passing across the pages of history like some forlorn ghost trying to make its presence felt in the contemporary world'.[73] His colleagues found his company increasingly dull. In 1775, with the idea of cheering him up, some of his friends had taken him to Newmarket and introduced him to the excitement of horseracing. He very quickly became a confirmed gambler; he acquired a string of fine thoroughbreds and the following year he enjoyed considerable success as an owner. Encouraged by his apparent skill and judgment in this risky sport, he somehow entered into a wager with Richard Vernon MP (a founder member of the Jockey Club and known as the 'Father of the English turf') for the phenomenal sum

of £50,000 – or approximately £1.5million in early 21st century money. He lost. Now it so happened that Richard Vernon had three extremely pretty daughters, and it wasn't long before an engagement was announced between the Earl and Henrietta Vernon. She was only 16 when they married in July 1776 and she came to the marriage with what one can only describe as a negative dowry, an understanding that her father would not press for settlement of the wager. [74]

The new Countess of Warwick bore her husband a son, Henry Richard Greville, in March 1779, and later a second son, Charles, followed by another son and no less than six daughters. If the Earl really thought that his luck had changed, he was to suffer another terrible blow in 1786, when his son and heir by his first wife died at the age of only 14. Suddenly the Vernon's grandson, Henry Richard, was now Lord Brooke and the heir to the Earldom, and the ambitious Vernons became much more interested in ensuring that he had something positive to inherit before his father squandered everything away. All the Estates were put into trust for the new heir, with the Earl of Upper Ossory and the Earl of Galloway (both half-brothers of the Countess) appointed as trustees. [75] This was the first step in the stranglehold that would soon strain the Earl of Warwick's relationship with his Countess and drive him into penury – and into a very close association with Olive.

In the meantime, the Earl refused to recognize any financial restraints imposed on him and, among other things, entered an undertaking in 1800 to buy the 2,500 acre Tachbrook Estate from the executors of Lord Bagot. He was not going to be put off merely by the price, which was something of the order of £100,000. The trustees were horrified and drew up a new set of draconian Trust Deeds, casually signed by the Earl, who continued to ignore any of the supposed implications. At the same time, the trustees appointed two land-agents in an attempt to bring some order into the escalating chaos. The first, responsible for the Home Estates, was John Casper Vancouver, [76] while the second, put in charge of the less valuable 'Outer Estates' was a local lawyer called William James. [77]

William James reported to the trustees that there were no proper estate plans, no up to date records of tenancy agreements and no real idea of the Earl's indebtedness. Soon the trustees put him in sole charge of all the Estates, sacked Vancouver and authorised him to produce a plan to rescue the family – and themselves – from the embarrassments of having to put everything into the hands of the Court of Chancery. When in 1806 James came up with the staggering figure of just how much was owed in total, the trustees realised there was nothing for it but to banish the Earl from his own Castle, sack most of the staff and reduce it to a basis of care and maintenance only. Allowances would be paid to the Countess for her and the children – now living at one of the Vernon country properties – but absolutely nothing by way of an income for the Earl until all the debts were paid off.

But he was still in favour at the court of George III and on good terms with several of the Royal Dukes. King George II had been his godfather. [78] There is a nice story

of how he had exploited this privileged position a few years earlier. The Earl's role as Recorder of the town of Warwick was an entitlement of his peerage, but not the role of Lord-Lieutenant of the County, a position held by Lord Hertford up to his death in 1794. The then Prime-Minister, William Pitt (the younger), and other ministers were anxious to have Lord Hertford's son appointed to succeed him and a secret meeting was held in Birmingham to arrange this. However, in a bravura performance, they were pre-empted by the Earl, who got to hear of this plot and rode post-haste to London, where he requested an audience with King George III to plead his case for the appointment. The King acceded, and the first thing his opponents knew about it was confirmation in the *London Gazette* the following day.

* * * * *

In the years following 1806, the Earl was forced to live in very straitened circumstances, having to beg off his wife and borrow his day to day expenses from his friends. Olive would be extraordinarily generous to him, even though she herself was not at all well off. She lent him £500 in 1808 and a further £240 the following year, while he promised to repay her 'ten-fold … when his affairs were settled'. [79] More riskily, she accepted Bills of Exchange from him – an early form of cheque – and when one of these bounced, she was arrested for the debt and detained in the lock-up of a firm of London lawyers. He replied to her frantic cries for help in November 1809;

> I am almost distracted by the contents of your letter. What is to be done in this dreadful affair! I know not – a most cruel disappointment has prevented my paying the acceptance. I will execute any instrument that will procure your emancipation from this cruel and distressing confinement, so unsuitable to your sex and situation in life! What do I not owe to your friendship? To have plunged you into such misery is more than I can support.

Somehow or other that matter was resolved and Olive would continue to believe his repeated promises that one day he would break the constraints of his Trust and provide an annuity for herself and Lavinia. Meanwhile, Olive and her estranged husband, John Thomas Serres, were still involved in a mutual slanging match; she trying to extract maintenance money off him while he spread it around that she was a lousy and neglectful mother of easy virtue. The British Institution set up by John Thomas and his father had proved to be a great success; it had been given official Royal patronage by George III in 1805 and had attracted many life members at 50 guineas each. Olive was determined to get her hands on some of the 10,930 guineas that had been subscribed. She hounded John Thomas across the country and ran up debts in his name, until in desperation he opted to allow himself to be declared bankrupt in 1810. In November the previous year she had placed an advertisement in the *Morning Post*;

> Ten guineas reward – Mrs Olive Wilmot Serres, No 12 Cleveland Row, St James's, having discovered that some party or persons are concerned in the most dreadful conspiracy against her happiness, evinced in anonymous letters, false and unfounded misrepresentations to her trades-people, depriving her of servants etc. offers a reward of Ten Guineas to any person who will give information of such offenders.

But the gossip-mongers might have been correct in suggesting that Olive was hardly living a life of celibacy. Sometime around 1807/8 she gave birth to a son and the facts would not emerge until an old man wrote his memoirs in South Africa in 1867. [80] He was called Charles Wilmot Serres, though he was probably never baptised with that name, and within a few days of his birth he was spirited away, to be brought up we know not where, nor by whom. He will not recur again in his mother's lifetime, though his tale will be told later when we review the lives of all Olive's children when they grew up.

It may have been in an effort to counteract the tongue-waggers that Olive, signing herself as 'Landscape Painter to HRH The Prince of Wales', published her '*Letter of advice to her daughter*' (Lavinia) in 1808. This is a high-minded document, full of moral precepts and extolling the virtues of honour and parental devotion. Perhaps understandably, John Thomas Serres was staggered by its hypocrisy, adding as a footnote to his own copy an alternative title – 'The Devil rebuking Sin.' [81]

<p style="text-align:center">* * * * *</p>

1807 had witnessed the death of Olive's uncle, the mercurial Dr. James Wilmot DD. [82] After he had married Olive off to John Thomas Serres in 1791, we know rather little of his life at Barton-on-the-Heath over the next decade. He seems to have become increasingly cantankerous and he refused to have any contact or correspondence with his brother Robert, who had brought such disgrace on the family. Perhaps he brooded on the fact that he had never been made a bishop. Perhaps he regretted that he had turned down the Presidency of Trinity College when offered to him, instead recommending Dr Chapman, 'a good-natured man, of an even temper, and therefore likely to be considerate of the errors of youth'. Perhaps he recalled how he had been offered the very lucrative living as vicar of Solihull by his cousin Lord Archer, and his refusal on the grounds that there were too many political strings attached. Or perhaps he harked back to his youthful disappointment in love, when the sister of Sir James Wright of Warwick announced her betrothal to a young noble. [83] He developed a passionate dislike for the fashionable actor David Garrick, whom he regarded as a poseur.

We do know that he devoted much time to trying to trace local sources for Shakespeare's plays and sonnets, concluding, when he failed, that they must have been written by someone else of greater erudition and better education, someone

like Sir Francis Bacon. The 'Francis Bacon Society' today acknowledges Dr. James Wilmot as their founder and inspiration.

Among his local friends, there was, however, one most significant connection and that was with the Rector of the nearby parish of Cherington, the Rev. Charles Willes, the son of Lord Chief Justice Sir John Willes, [84] who had been the main beneficiary of a Will in 1757. The testator was a certain Captain Robert Pearne of Isleworth, a parish just across the River Thames from the Royal Palace at Kew. Captain Pearne was a bachelor who had made a small fortune in Antigua, and among the other bequests in the Will was an annuity of £40 to 'Mrs Hannah Axford, formerly Miss Hannah Lightfoot'. She is correctly described in the Will as 'the niece of Mr John Jefferyes', who had married Hannah's aunt Rebecca Lightfoot. [85] Most intriguing is a clause in the will which insists that this annuity 'shall be for her sole use and behoof' and not the subject of any 'debts, forfeitures or engagements of her present or any after-taken husband'. This might seem to imply that Pearne knew a lot of the background to Hannah's original marriage and may have had hints that she might take another husband.

There are other interesting features as well. Why does he link Hannah with an uncle by marriage rather than some closer, blood relation? Both her mother and her uncle Henry Wheeler had lost touch and did not know where she was living (they posted advertisements in their efforts to find her), but perhaps John Jefferyes did. Furthermore, he was not a Quaker. And why did Robert Pearne make this bequest to Hannah? Had he been her guardian during her affair with the young Prince George? If so, and this information had been passed on to the Rev. Willes, one can surmise that he and Dr James Wilmot might have had much to chat about. In Olive's biography of her uncle that she published in 1813 she wrote that Willes had once entrusted him with 'many political concerns of consequence'. At that time, she did not know exactly what they were, but as we will see shortly, a remarkable chain of events would deliver some of them into her hands.

Examples of James Wilmot's correspondence are virtually unknown but my research has unearthed a couple of letters that he wrote in 1784 and 1785 to his nephew-in-law Joseph Ball Downman, who had married the daughter of his sister Olive Payne. They are of critical importance, not because of the content (financial problems after Olive Payne was widowed when her husband was lost at sea) but because they provide authentic examples of his handwriting and signature. (See fig.1.)

James Wilmot's eyesight certainly deteriorated and by 1796 he was completely blind. Lady Sarah de Crespigny, daughter of the Earl of Plymouth and then living at Barton Manor, came across to the Rectory and read to him every morning. [86] In 1805, suspecting that he may not have long to live, James Wilmot summoned the schoolmaster from the neighbouring village of Long Compton and ordered him to take 'all the bags and boxes of writings you can discover in my bedroom' and burn

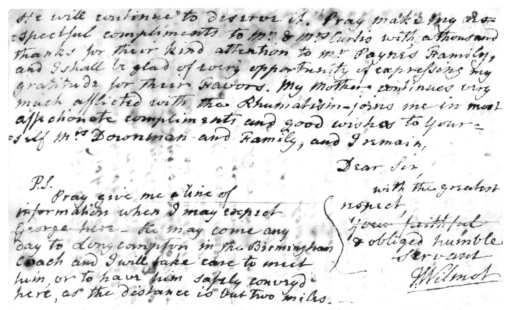

Fig. 1. Letter from Dr. James Wilmot, 1784. (Virginia Historical Soc. Mss1 D7598a 35.)

them on the terrace outside the Rectory. [87] For future historians, this was a tragedy; for Olive it would turn out worse than that, because they contained the proof of Olive's true pedigree. The destruction of James Wilmot's archives might appear to have been the act of a man with sensitive secrets that he felt were better kept as such, particularly if he had got wind of Olive's amorous liaison that year with the Prince of Wales.

But was his action one of freewill, or was he obeying orders that emanated from 'high places' in London? Olive certainly had her suspicions as she wrote later; '*Agents were sent down to Warwick to threaten the Doctor.*' [88] As we will learn shortly, in 1777 he had been instrumental in one last piece of manoeuvring for a member of the Royal family who had produced an inconvenient child, a role in which he already had some previous experience. For the moment, his involvement in Olive's saga is over, though his ghost will haunt the story for another 60 years. In his Will he left property to the value of about £3,000; after a few small bequests, the bulk was to be equally divided between his nephew Thomas Wilmot and his niece Olive. [89] He may have found her behaviour increasingly scandalous, but he did not disinherit her.

* * * * *

In contemporary detective fiction, the hero, whether he is Inspector Morse or even Commander Adam Dalgliesh, sometimes has his case suddenly snatched from him by a mysterious group of people who assert that they are from the 'Special Branch'. They claim over-riding powers from a 'higher authority'. Informers about to produce crucial evidence are whisked away; witnesses with possibly embarrassing secrets to

reveal are made to vanish and the body-count often rises sharply. Chief Inspector Andy Dalziel referred to such people as the 'Funnies', while in other fictional dramas they are called the 'Spooks'. In the 21st century, their higher authority comes either from the Home Office or MI5. When one tries to unravel the true story behind Olive and her family, one perpetually comes up against situations where it appears that a similar, shadowy group of individuals to the 'Special Branch' are at work, though in the period we are involved with they are direct agents of the Royal household. We seem to have encountered them in the Hannah Lightfoot mystery; they seem to have been involved in the secret adoption of Olive's child by the Prince of Wales in 1805 and now it looks as if they had acted to see that an old man would take his secrets to the grave. And it won't be the last time that they emerge again to substitute one piece of mayhem for another.

ENDNOTES

69 Burkes Peerage. The original title was passed down through a succession of families, but finally became extinct on the death of Edward Rich in 1759. It was revived – the second foundation – and granted to George Greville's father, Baron Brooke, in November that year.

70 Georgiana Peachey, daughter of Lord Selsey.

71 Olive, 1819. WRO C920

72 Olive, 1819. WRO C920

73 Pendered & Mallett. p93

74 Her father did give her a personal dowry, for her use only, of £6,000.

75 Richard Vernon had married the widow of John Fitzpatrick, first Earl of Upper Ossory, in 1759.

76 The elder brother of George Vancouver, the famous explorer and circumnavigator after whom the city of Vancouver is named.

77 William James would go on to be a very important railway pioneer, advocating the use of steam locomotives on railways many years before his better remembered contemporaries, but his early successes as a land-agent were based on an astute appreciation of three things; accurate records, the importance of mineral resources beneath his clients' land and the harsh realities of escalating inflation and new taxes resulting from the onset of the Napoleonic Wars. (Macnair 2007)

78 Annual Biography & Obituary vol. 1, 1816.

79 Olive 1819.

80 'The Travels, Adventures and Hair-breadth Escapes of Mr Charles Wilmot de Serres', published in The Friend, Bloemfontein, Aug 6, 1867.

81 ANON, attributed to Jos. Parkins, Memoir of J T Serres, p37

82 January 15, 1807; buried January 20.

83 Olive, 1813. p28. On page 83, she wrongly claims that James Wilmot had officiated at the marriage of the Duke of Cumberland to Anne Horton, and that the Royal displeasure resulting from this act had cost him the chance of a bishopric.

84 Lord Chief Justice from 1735-61.

85 Oliver. The Pearnes and the Lightfoots had linked interests in the island as well as being linked by marriage to the family of Sir Thomas Warner, the first Governor. (died 1695). See also Pendered 1910.

86 Olive ,1822, p29

87 Pendered & Mallett, p75

88 Olive 1822, Introduction.

89 Pendered & Mallett, p76

Chapter 4

Edward Duke of Kent and 'The Grand Old Duke of York'

OLIVE'S BRIEF affair with the Prince of Wales was over, though she could never forget it. She continued to write to him intermittently over the next twenty years, often recalling their moments of intimacy and hoping to reignite the original spark of intense sexual attraction. One of her letters that has survived from 1809 is of crucial importance, because it shows that she was beginning to be intimately involved in personal machinations within the Royal family. But to understand its significance we have to go back to the earlier life of George III's fourth son, Edward Duke of Kent, later to be the father of Queen Victoria.

Edward, a younger brother of the Prince of Wales, was perhaps the nicest of the Royal Dukes, the one with the most amiable disposition, 'a cheerful, convivial man about town.' [90] **(Plate 9)** At least in later life. In his early military career, he was noted as a cruel disciplinarian. He had been born in 1767 and had a harsh upbringing in Teutonic military discipline as a cadet at Luneberg. When he went absent without leave from the bullying he received there, his father was stringently unsympathetic. Nor did he get any sympathy from his elder brother Frederick, Duke of York, when he pleaded for a military command in England. Instead, he was packed off as a regimental officer for a year in Gibraltar and then the following year (1791) to Canada. But it was while he was briefly in Gibraltar that he met Alphonsine Therese Bernadine Julie de Montgenet de St Laurent, who, to the relief of biographers, has come down to us with the abbreviated title of Madame St Laurent. Edward had a life-long love of music and she was the rather aristocratic 'chanteuse' in an orchestra he had hired. With a warm and giving nature, she and Edward formed a loving partnership for twenty seven years, though it seems unlikely that they ever had any children. (He had previously fathered an illegitimate daughter by a French actress, Adelaide Dubus in 1789.) [91] His father, the King, never seems to have liked him nor given him any allowance from the civil list.

Edward and his mistress returned from Canada in 1799, when he was created Duke of Kent and Strathern, granted an income of £12,000 a year from a grateful

Parliament in recognition of what he had achieved and gazetted to a full General, only to be shunted by his brother back to Gibraltar, where he assumed the role of Governor in 1802. His brief was to restore discipline and morale to the garrison, though he went about it with such a heavy hand that a mutiny ensued. This was crushed by the Duke with what was judged back in London to have been over zealous harshness and he was recalled a year later. Although he was promoted, in title, to Field Marshal in 1805, his active military career was effectively over and he slipped into retirement at Castle Hill Lodge, Ealing, with the nominal role of Keeper of Hampton Court. **(Plate 3)**

Here Edward and his mistress lived a frugal life away from the public gaze, his one luxury being to keep a personal orchestra. Privately he blamed his brother Frederick Duke of York (and Commander in Chief of the Army) for his military eclipse. The Duke of York certainly disliked him, and though Edward 'was too discreet a man to dislike anyone', [92] there was an officer on Edward's staff who was highly ambitious for himself and who started looking out for a chance to discredit his boss's brother. This was Major Dodd, Edward's military secretary, and his chance would come in 1808.

Edward's relationships with his family appear to have been complicated, mainly because of his misguided endeavours to intercede in rows between his siblings and their parents, and his involvement in a number of cases which triggered his sense of fair play and his instinct to rectify injustices. One of these concerned his sister-in-law Caroline, the discarded Princess of Wales. Caroline was living with her daughter, Princess Charlotte, at Blackheath in south London and she was becoming the focus of attention for two rival segments of public opinion and political pressure groups. To one group, the Reformists, she was the innocent victim of abuse by the louche, drunken, dissipated Prince of Wales, who was increasingly seen as the symbol of all that was wrong with a hereditary monarchy. To the loyalists, however, she was the one who was undermining the status of a revered institution by her own bawdy behaviour and loose living. There were rumours that she was taking unsuitable lovers and had even mothered an illegitimate son, called William Austin. [93] And a daughter, christened Edwardina after her uncle who had stood as her godfather. Into this maelstrom stepped Edward, who had somehow got hold of a bundle of incriminating letters written by Caroline which he passed on to Queen Charlotte. This attempt at a 'cover-up' infuriated the Prince of Wales, who was desperately looking for an excuse to divorce his wife.

The first consequence was enhanced antagonism between the Prince of Wales and his brother Edward. The second was the setting up of a 'delicate investigation' by Lords Erskine, Spencer, Grenville and Ellenborough, though the outcome was not the one the Prince of Wales had hoped for. Commissioners appointed by King George III cleared the Princess of the allegations of adultery, but concluded that 'her extraordinary behaviour was indiscreet to the point of recklessness'. [94] The third

consequence was the writing of a document by Spencer Perceval (later the Chancellor of the Exchequer and then Prime Minister, until he was assassinated in 1812) called simply '*The Book*', which exposed all the gory details of the accusations against Caroline, largely based on the evidence of Lady Douglas, one of her Ladies in Waiting. Although it was not supposed to be officially published at the time, leaked copies quickly spread into the gossip market. It was suppressed when printed in 1807 and then became a 'Number 1 bestseller' when it was finally published in 1813. It was probably this event that decided Princess Caroline to go abroad, spending a year touring Europe and the Middle East before settling at the Villa D'Este on Lake Como in Italy.

It was another example of Edward's attempts to throw oil onto the troubled waters of his own family's turbulent relationships that would involve Olive, who he had first met in 1805 and clearly not only liked but trusted. Olive's daughter Lavinia would later claim that Edward was a frequent visitor to her mother's house from then onwards, right up to the time of his death. What Lavinia may not have known at the time was the true extent of their relationship which grew, over the years, into something far greater than mere friendship, a deep mutual dependence based on shared secrets and burgeoning affection. This emerges from the intimate letters, starting in 1809, from the Duke to Olive, letters that still survive though never published before. [95] They will illuminate much of what follows. Furthermore, and possibly highly significant, the Duke of Kent was a senior officer in the Order of Freemasons, just like his uncle Henry Duke of Cumberland had been.

In 1809, the Royal family had been rocked by a very public scandal involving Edward's elder brother, Frederick Duke of York, King George III's second son and his clear favourite. The King had appointed him as Commander in Chief of the Army at Horse Guards, a role in which he proved to be far more successful than as a Field Commander against the French both in 1793 and 1799, when he had marched his 10,000 men backwards and forwards across the Low Countries to a series of ignominious defeats. He founded two officer training academies, at Woolwich and Sandhurst, and initiated improvements to the command structure, sacking incompetent officers and encouraging the concept of promotion on the basis of merit. These actions enhanced his personal popularity with the soldiers, who would later contribute generously to the erection of the memorial column to the 'Grand Old Duke of York' on Pall Mall. They might not have been so generous if they had been aware of his – very expensive – addiction to gambling.

His own married life, to the rather dull Princess Frederica of Prussia, was on the whole blameless, though childless and fairly brief. He had been introduced to Olive but seems to have dismissed her as no better than a harlot. The scandal of 1809 that threatened to sink his reputation for good centred on a committee of enquiry set up under Colonel Wardle, MP for Okehampton, to investigate claims that, during an affair with the wily Mrs Mary Anne Clarke in 1806, she had persuaded him to give

military promotions to her own particular friends. Pressure from both sides of the political divide resulted in the matter being debated on the floor of the House of Commons, with Mrs Clarke putting on a dramatic performance as the star witness. [96] The cartoonists had a field day. **(Plate 10)** On a division, what was in effect a motion of no confidence in the Duke of York was defeated, but only by a small majority, and the Duke felt it was his duty to resign. The case against the Duke had failed partly because it appeared that he himself had not personally benefited from any deals consummated between the sheets, but also from lack of witnesses, who seemed to withdraw their evidence at the last minute.

* * * * *

Amazingly, it seems that one person who did have important evidence was Olive, as the following letter from her to the Prince of Wales seems to imply. It is dated December 5, 1809, and is quoted in full because it shows her own rather subtle form of blackmail. [97]

Sir, I most anxiously hope all my late letters have safely reached the hand of your Royal Highness.

Allow me to inform your Royal Highness that, thank God, I have got over a fiery ordeal! I cannot give a more expressive term or name to a temptation offered one in the hour of adversity that promised affluence could be obtained by a little deviation from principle.

Allow me to inform your Royal Highness that a large sum of money has been offered me for my details of the *Gibraltar and Wardle* business as agreed between their Royal Highnesses the Dukes of York and Kent – with the memorandums, dates, names etc of these transactions!

But thank the good master in Heaven, I have conquered over such a temptation and have been generous, altho' his Royal Highness the Duke of York has so unhandsomely treated me. But to preserve me from ever expressing such a temptation again, I entreat your Royal Highness (*for I have a child and in the wish to serve her would alone be found my vulnerable part*) graciously to authorise some honourable and faithful nobleman to await upon me that I may commit the nasty and dreadful papers to his hand. They have never met an eye and have been sealed ever since the month of May.

I am but human nature, your Royal Highness, and I will acknowledge the littleness of mind that at times gives origin to resentment for any injury done me – but I love nobleness best, so I endeavour to be generous to my enemies.

Come what will, my constant prayer will be for the dignity and welfare of the House of Brunswick. God bless your Royal Highness with health and happiness is the sincere hope of, Sir, your Royal Highness's most grateful and devoted, Olive.

Credence is given to the whole business, and its successful conclusion, by a surviving memorandum dated March 30, 1810, in which a Mr Richard Sheperd gives Olive a receipt for communicating 'circumstances and facts relating to parts of the Royal family, under the full impression and confidence of secrecy and honour'. [98] There is no mention of any possible 'reward'.

How on earth had Olive obtained the documents? She was certainly not in league with Mary-Anne Clarke, against whom she had even gone to the lengths of publishing a 37 page tirade earlier in the year, entitled 'Observations and Strictures on the Conduct of Mrs Clarke' and addressed 'to lovers of truth and encouragers of justice'. [99] Rather tellingly, in the light of later accusations of her forgery, she asked the compositor to be particularly careful because she 'wrote a bad hand'. The book contained the following example of Olive's rather flowery poetry.

> So shall thy malice and revenge, poor Clarke,
> Entomb thine honour: and if one small spark
> Of deep regret thy bosom should explore,
> Repent! Atone! and, frail, oh! err no more.
> For life must vanish, and the vicious joys
> Will end in sorrow – as all nature does!

There is, however, a small clue to solving this mystery, a coach party which was seen touring around Brighton in 1808. [100] Obviously enjoying each other's company and possibly swapping confidences, the three occupants of the coach were Col. Wardle, Major Dodd – and Mrs Clarke. So perhaps the enigmatic 'Gibraltar' mentioned in Olive's letter was the scheming Major Dodd, who had served with the Duke of Kent in that rocky outpost. And letters to Olive from the Duke suggest that he had been prepared to take her completely into his confidence about everything he knew, not only of this business, but also about an even more explosive affair involving Queen Charlotte herself. 'The Queen of England,' he confided to Olive in March 1809, 'has been taking advantage of foreign news to obtain gold at her subject's expense.' [101]

The key to unlocking that episode may lie in a document penned by Olive herself, undated but written sometime in the late 1820s when she was less inclined to be discreet. It suggests that she apparently played a vital role as a go-between, not only in this episode but also in an audacious cover-up for an extraordinary piece of Royal insider-dealing. [102]

> About the stormy season of the political world, when Mary Anne Clarke became the scourge of Royalty, and truth made an effort to triumph over corrupt power and to stem the torrent of iniquity that flowed too successfully

… a new sensation was created of unprecedented importance to the English nation.

Evidence of the most decided and unquestionable papers of convincing facts were being prepared for the British senate, and the impeachment of a High Female was deemed requisite to terminate actions that degraded the Honor (sic) and dignity of the Crown too seriously to escape reprehension. The business was laid before me by a Gentleman who wished to preserve the peace of the Royal family and if it was possible to save the Queen from ignominy and disgrace.

After I had become mistress of the charges … I was so terrified by the exposure that was likely to take place that I asked Mr King if he would permit me to make the affair known to the Duke of Kent. Mr King said that the persons who were in possession of such appalling facts had determined not only to lay the matter before the House of Lords, but to get the history published in France!

When he had given me this information, I requested him to ask the 'parties' what sum would be deemed an equivalent for the papers? He replied not less than Ten Thousand pounds down, and Ten Thousand in six months afterwards. I offered to apply to the Duke of Kent privately, in order that I might give his Royal Highness opportunity to inform the Queen upon the subject.

Mr King at first hesitated, but in three days he brought me a copy of the charges. The first part was that her Majesty, in concert with her Fund broker, had been in the habit of taking advantage of any good news that arrived from abroad, by purchasing into the Funds immense sums, before a Gazette came out to usher the News for the Country. And then as soon as the Funds rose, to sell out immediately …upwards of Four Hundred Thousand pounds!!

The second charge was against the Queen, Dr R and a Lady of the Queen's establishment for having received nearly Seventy Thousand pounds for the sale of Cadetships and other places. … The Duke of Kent on seeing these started out of his chair and exclaimed that 'the covetousness of his mother and her German propensities would be the downfall of his family'. He expressed his gratitude to me in an almost incoherent manner for my devotion to the Royal family's interests, and entreated my influence with Mr King, that he might be permitted to take the MS to Windsor.

I went to Mr King that day and Lady L invited me to stay to dinner. After the Ladies had retired, Mr King took me into the library, where I so successfully pleaded the cause of the Queen that he consented to name my proposition to the parties, in order that His Royal Highness, Duke of Kent might negotiate to save his Royal Parent from the most humiliating exposure.

Mr King, whose identity is wrapped in mystery, had then gone to Kensington Palace the following evening in Olive's carriage, returning 'in great spirits to my

residence in St James's Street.' Two days later, Mr King called to say that 'he fancied the matter would be hushed up, and if so the Royal family were indebted to me more than ever could be repaid.' After a further three days, the Duke of Kent called at eleven in the evening;

> He entered my drawing room with a look of pleasure and, seizing my hand, he pressed it, and informed me that he was a courier from her Majesty the Queen, as every part of the unpleasant affair that I had so loyally interested myself in was settled, and the character of her Majesty thereby preserved. He presented me with Two Thousand pounds in Bank Notes, and said in return for my services, the Queen wished me to purchase jewels or plate in commemoration of her Royal Esteem. [103]

While the Duke of Kent had handled the documents that related to the Queen's alleged insider dealing, perhaps Olive had been left to return the cadetship papers via the Prince of Wales. And in answer to sceptics who might say that all the revelations above were Olive's invention, we have the following letter of confirmation from the Duke of Kent himself. [104]

> The letter you wrote yesterday does infinite credit to your heart, and merits, my dear Madam, my very grateful thanks when I recall the many kindnesses which the loyalty of your disposition has induced you to render the Royal Family. I am at a loss (for) words to express my gratitude, but when such family degradations will terminate heaven alone can tell! The elder brother has through life suffered by the unnatural behaviour of the Commander in Chief, thus no affection can exist in that quarter ever.
>
> My poor father, God bless him, is in the hands of a surgeon and ministers, who are completely deceiving him, for the most unconstitutional purposes! Well may Old England lament the sways of such interested characters! I have to repeat my sense of your attachment to the Prince of Wales and my welfare, and assure you of my sincere and grateful esteem. Much is due to you, very much; but for your endeavour the whole of the Royal Stock Jobbery would have been in public print, and a fine exposure it would have been. You have saved my Mother's peace and honour. I am your obliged friend, Edward.

Olive continued to bombard the Prince of Wales with a succession of letters, some pleading for money, some, amazingly, offering to lend money to him. Writing from 56 St James's Street on March 12, 1810, she offers to sell him a painting by Titian, adding that she was suffering from a 'terrible illness' in her eyes. [105] In September, she could write to acknowledge that she was 'exceedingly sensible of your Royal Highness's polite kindness in having so immediately condescended to notice my last

letter',[106] though from the date that the Prince of Wales was appointed as the Prince Regent in 1810, it appears that he never replied to any more of Olive's letters. In one that survives from October 2, she bemoans his change of attitude; 'Nothing so grieves me as being deprived of the ear of your Royal Highness', adding the prescient question *'Why, Sir, was I so humbly born?'*.

One reason why the Prince Regent ceased to reply to any of Olive's letters was, perhaps, because he never received them. Apparently Col. John McMahon, the Prince's private secretary, had called on her one day, pulled her into his arms and made lewd suggestions about what he wanted to do with her. Olive slipped from his grasp and pulled the bell to summon her footman. 'Open the door for this gentleman, and whenever he calls again, say that I am not at home!' As he left, Olive claimed she heard him swear 'By God, I will prevent the Prince's patronage for the future, Madam, for no letter of yours shall ever reach his hand'.[107]

Olive had, most unwisely, made a sworn enemy of a man who wielded extraordinary power within the Prince Regent's household, and the 'black mark' against Olive's name would inevitably be passed down to McMahon's successors after 1817, first Sir Benjamin Bloomfield and then Sir William Knighton. On the other hand, Olive now had a Royal Duke as well as the Earl of Warwick in debt to her, and it would not be long before they both repaid her, in kind, by revealing the truth about her birth.

ENDNOTES

90 Tillyard. Caption to plate following p130

91 Gillen.

92 Fulford.

93 He was in fact merely adopted. In her will, Caroline left him the residue of her estate.

94 DNB George IV.

95 Bodleian Library, Oxford. Shelfmark MS. Eng. Hist c722, f10-57. See Appendix C.

96 Mary Clarke published a book entitled 'The Rival Princes', suggesting that the Duke of Kent, via Colonel Dodd, had tried to discredit his brother so that he could take over as commander-in-chief of the army.

97 WRO CR1886 Box 676

98 National Archives TS18/112 Box 2, large folder.

99 As published by T.J. Hookham, 112 New Bond Street, London, the author merely given as 'A Lady'. A letter from Olive to the printers, in the possession of the Price family, asks for a run of 500 copies to be sold at 2 shillings or 2 shillings and 6 pence. In it, she claims that the text 'has been read by a solicitor who says it contains not any libel'.

100 Fulford, p76

101 Bodleian Library, Oxford. Shelfmark MS. Eng. Hist c722, f40/41.

102 WRO CR1886 Box 677. 'Her late Majesty Queen Charlotte and the East India cadetships and the Statement as to the Funds.' Given that Queen Charlotte died in 1818, this must have been written later.

103 The truth of this account is backed up by letters to Olive from the Duke of Kent in 1816. Bodleian Library, Oxford. Shelfmark MS. Eng. Hist c722, f52

104 Bodleian Library, Oxford. Shelfmark MS. Eng. Hist c722, f40/41

105 WRO CR1886 Box 676

106 National Archives TS18/112, letter no. 12

107 Olive, 1822.

Chapter 5

Books and a half told secret

AS WELL as trying to earn a living from her paintbrush and acting as an art dealer, Olive was busy writing; 1812 saw the publication of three books which appeared under her name. In this role she was a rare phenomenon, and while she was no Jane Austen ('Emma' was published the same year), she was a feminist pioneer in the field of romantic fiction. She had to fight a lone battle against male prejudice without either her own financial resources or a rich patron; it is a sad irony that the one man who had sworn his 'sacred patronage' was now more of a liability than an asset.

Olive's first novel was a historical romance entitled 'Procrastinated Memoirs' [108] and consists of the fictional correspondence of the 'Countess Messalina', a thinly disguised pseudonym for the Prince of Wales's latest mistress, Lady Jersey, to 'Mary-Anne'. The main topic in the letters is a plot to discredit 'Lady Haroline, the daughter of the Duke of Branzer' on her marriage to 'the Marquis'. (It is not difficult to break the 'code' – Caroline, the Princess of Wales, her father the Duke of Brunswick and the Prince of Wales himself.) This satirical work was subtitled 'The Book!!!', clearly hoping to cash in on the suppressed publication of the same name by Spencer Perceval that was selling at a premium in the underworld book trade. Olive followed this up with the letters of Mary-Anne Lais, the Courtezan', [109] the replies to the letters of the 'Countess Messalina' and dwelling on the Duke of York's affair with Mary Anne Clarke. In the light of Olive's later attempts to produce documents to prove her Royal credentials, cynics have latched onto two quotations from these books;

> You know, my dear Mary-Anne, there are two ways of telling the truth; the most *Impressive* way was mine.

> Recipe to make a very valuable publication; take of invention the utmost degree of falsehood, and the extreme of calumny, well blend these two desirable compounds in the oil of audaciousness.

This extract, implying that if one is going to tell a fib it might as well be a big one, would come back to haunt her. Next came 'Memoirs of a Princess; or First Love', [110]

recounting, over 165 pages, an early love affair of Princess Caroline during her time in Brunswick before she was dragooned into coming to England. When the relationship between Olive and the Prince of Wales – now the Prince Regent – went sour, or was soured for her, she became an ardent supporter of the discarded Caroline.

In June 1813, a year after the death of Robert Wilmot, the man Olive had been brought up to believe was her father, Olive published a biography of her uncle under the title, 'The Life of the Author of the Letters of Junius, the Rev. James Wilmot D.D.'. It consisted of two parts, the first of which expounded on all her uncle's friends and acquaintances from his student days onwards. It reads like pages from 'Who's Who', including mention of his meeting a Polish Princess. Olive analyses his character; his breadth of learning, his patriotism and his popularity, though she does not hide the fact that he had a short temper and could bear a grudge for a long time, including many years of non-speaking with his brother Robert right up to the date of his death. She claims that his retirement from the world of politics and academia after 1773, to a succession of rural rectories, was brought about solely by financial stringency. He had lived well up to then and had been a liberal and generous host, but had simply run out of money.

In the second part of her book, Olive makes the case that James Wilmot had been the writer behind the Letters of Junius. Having established that he was on very close terms with all the people who were suspected of being the author – Lords Sackville and Shelburne, Sir Philip Francis, even William Pitt (Earl of Chatham) – she claims to have 'seen documents' which proved it, documents that had been burnt in James Wilmot's possibly compulsory bonfire of 1805. An article from the journal 'Panorama' for November 1813 asserted that the publisher of the Letters, Mr Woodfall, 'recognised the initials J.W. as the author of Junius, and that he also received a gratuity from Lord Warwick in order to meet the expenses of printing'. [111] This may be a more compelling argument than anything Olive had to say on the matter. And there were others who agreed with her, such as Sir Richard Phillips and William Beckford. Beckford, famous among other things for writing the pioneering Gothic novel 'Vathek' and, in imitation of its leading character, building the vast Gothic folly of Fonthill Abbey, confided to the editor of the New Monthly Magazine shortly before he died; [112]

> Dr Wilmot was the author. No man had better opportunities; for he was a good scholar, a sincere Whig and a most intimate friend of Lord Chatham's. He had opportunities of being fully acquainted with everything, from his enjoying such an exclusive confidence of George III. (Author's italics.)

As mentioned in chapter 2, it was in this interview that Beckford had confirmed his knowledge of the marriage of the young Prince George to Hannah Lightfoot –

conducted by Dr. James Wilmot. Finally there is the only portrait of 'Junius', shown in an allegorical engraving by Bonner, sitting between Lord George Sackville and William Pitt. And 'Junius' is depicted as a clergyman. [113] Was the close friendship between Lord Sackville and James Wilmot the reason why there is a portrait of Hannah Axford/Lightfoot in the Sackville family home at Knole? This portrait has always been attributed to Sir Joshua Reynolds and an artist of his standing was accustomed to keep precise notes about his sitters and the patron who commissioned any work. It is highly significant that some records from around the period this painting might have been executed are missing, also referred to in chapter 1. Nor should we overlook the fact that Reynolds once made a pencil sketch of the teenage Olive in the last year of his life. **(Plate 5)**

Of major relevance to our story is what Olive writes about the relatively few women in James Wilmot's life. She mentions his youthful disappointment over the engagement of Miss Wright. She says he was a friend and admirer of Lady Archer, and that the Marchioness of Tavistock 'honoured him with her confidence', but she is *absolutely adamant* that her uncle never married. So how about the mysterious Polish Princess who will shortly figure so prominently in Olive's attempts to construct her family tree? The only mention is in a brief footnote; 'When the Princess of Poland visited England, Dr Wilmot attended her to the University. She valued him exceedingly during her residence in England and invited him to the Court of Poland; she frequently corresponded with him, after her departure from this kingdom.' [114] (A Princess Poniatowski, sister-in-law of the King of Poland and wife of Count Poniatowski did visit Oxford briefly in July 1767, when James Wilmot would have been 41.) [115]

Six years after Olive's book appeared, a letter from a Mr Campbell threw an interesting new light on the 'Junius' debate. [116]

> With an elegance of person, the Doctor possessed the easy politeness of a courtier, and with the assistance of his intriguing friend Henry Beauclerk … turned appearance and manner to advantage.

Henry Beauclerk had apparently introduced Dr. James Wilmot to the famous actress Mrs Abington, the leading lady in several plays written by Lady Craven. In her memoirs, Lady Craven implied that Henry Duke of Cumberland, a younger brother of George III, had once been her lover. 'The king's brother was very partial to me and his partiality turned to love.' Olive claimed that this lady, a friend of both Princess Czartoriska [117] and Georgiana Peachey, the Earl of Warwick's first, tragic wife, was one of her uncle's correspondents. And Lady Craven also claimed that 'The Princess Czartoriska had, some years before, passed a winter in London'. So perhaps she had been James Wilmot's 'Polish Princess'? But most intriguing was the fact that Mrs Abington had been the mistress of Lord Shelburne, and it was through this

connection that Campbell claimed James Wilmot had 'acquired a knowledge of the private views and transactions of Lord Shelburne, that was useful to him before the public as Junius'. Campbell's letter ended;

> You may place the foremost affiance in what I have written from the proofs before me that Dr Wilmot and no other man on earth wrote the Letters of Junius.

Sometime after 1820 Olive clearly intended to publish an updated version of her biography of James Wilmot and her own personal copy, with hand-written amendments, now lies in the National Archives. [118] One amendment, on page liii, is intriguing, since it refers to Princess Amelia, George III's maiden aunt, who died in 1786. 'He [Doctor Wilmot] served her Royal Highness in several instances, but in *one delicate affair*.' (Author's italics.) Apart from her 'heavy gambling at Bath'[119], this Princess Amelia led a relatively scandal free life, though her name was amorously linked over the years with Admiral Rodney, the Duke of Newcastle and the notorious philanderer Augustus Fitzroy, Duke of Grafton – 'Junius's' bête-noir. [120] Olive may in this instance be confusing her with quite a different Princess Amelia, George III's youngest and favourite daughter. As we will see later (Appendix E), this Princess Amelia, born in 1783, was rumoured to have been involved in a 'delicate affair' with another Fitzroy, Colonel Charles, a liaison that may have been explosive enough to lead to 'Agents' arranging the robbery of the Parish records from Kew chapel in 1845, an incident we will return to in chapter 18.

* * * * *

1813 also witnessed another attempt by the Earl of Warwick to restore his fortunes and get his hands on some cash, not only to improve his own living standards but to repay the money he owed to several friends, including Olive. In an autobiography he intended to publish in his lifetime, he described the depths to which he had sunk. [121]

> Not having any other fund, I have been for years the poorest and most miserably distressed person alive. I have pawned my watch to relieve persons in distress, and my gold sleeve buttons, which I have worn for thirty years. I could not get my tailor to make me a coat, a shoemaker a shoe, tho' they worked for my servants.

In a final gamble he brought a case against his Trustees in the Court of Chancery and Olive would later write that it was she who had somehow borrowed the £1,200 that it cost to bring the action. [122] The Earl claimed that the income from the estates should have been sufficient to pay all the taxes, debt repayments and maintenance bills and still leave sufficient surpluses to provide generous allowances to the

Countess, his children and, most importantly, himself. He demanded that William James should be removed from his role of Land Agent (with Power of Attorney), that all the accounts for the last five years should be re-audited and that the standing timber should be felled and sold for his benefit. The Earl of Upper Ossory, the Countess's half-brother, mounted a staunch defence of the status quo on behalf of the Trustees, and the court, in a surprisingly prompt verdict, agreed with him. The Earl of Warwick came away with nothing except more debts incurred in legal fees. He had promised Olive that he would repay the large sums of money he owed her 'when he could put his affairs in order' and now this last chance had gone. They both ended up as substantial losers.

* * * * *

By early 1815 the Earl of Warwick's health was deteriorating and he realised that he might not have long to live. He had not been able to repay Olive financially but he knew that he did owe her another obligation, to unburden himself of the secrets he had been guarding for the last 43 years about the true nature of her birth. But the documentary evidence was locked up in Warwick Castle. Somehow he made a clandestine trip to Warwickshire, slipped into the Castle by a back door and rescued a few papers from his desk.

Back in London, the Earl, accompanied by Edward Duke of Kent, called on Olive one day in April and handed her a collection of documents, some of which he stressed should not be opened until after the death of King George III. These were sealed in two separate packets. There were more papers, but he had not had time to locate them. For the moment, all he could tell her was that she was of Royal birth, that her real father had been Henry Duke of Cumberland, one of George III's younger brothers, and that she must promise, in the presence of the Duke of Kent, that she would do nothing about this revelation until the King, now certified as completely mad, should die. What the Earl omitted to confirm to her at this stage was who her mother had been, and Olive, doubtless in a state of some shock from the revelation about her birth, failed to press the point. This omission would lead to the most monumental misunderstandings and, indirectly, be the most important factor that undermined Lavinia's case fifty years later. Olive's own account of this meeting, written in 1822, is as melodramatic as any incident in one of her romantic novels. [123]

> With much care and prudent caution, the Duke gave [me] to understand that Lord Warwick had a matter of the most sacred importance to communicate as to my origin, requesting that I should bind myself to the most solemn secrecy for the time, until they could regulate my rights for my advantage.
>
> On my knees, I took my sacred oath on the Bible, and was then informed by Lord Warwick of the particulars of my birth. … 'Would I was more worthy of the high rank it has pleased Divine Providence to call me to', I exclaimed, when

the Duke of Kent, taking me in his arms, pressed me to his full heart, saying 'You will do credit, my dear cousin, to the Royal family.'

So, how many documents were there, and what did they contain? The only other witness was Lavinia – she lived with her mother until 1819 – and her rather more sober account of the meeting came out in her evidence to the trial in 1866.

> There were three sets of papers, and the Earl said he had obtained one set from Dr Wilmot and another set from Lord Chatham, and the third set had always been in his possession. One packet was marked 'not to be opened until after the King's death', and it was not opened on that occasion.
>
> The others were opened and read aloud in the presence of the Duke of Kent, the Earl of Warwick, my mother and myself. His Royal Highness took each of the papers in his hand and examined it, and he expressed himself perfectly satisfied that the signatures of George III were in his father's writing. He acknowledged my mother as his cousin. He said that she was Princess Olive of Cumberland, the only legitimate issue of the Duke's marriage, and that for the future, Lord Warwick, being in such a state of health that he might die at any moment, he would take on himself the sole protection and guardianship of my mother and me.

We now launch into the great detective exercise of trying to work out what the 'three sets of documents' were, because from this traumatic moment Olive's life was transformed. Our sources must be the raft of documents – and there were more than 70 of them – that Olive quoted later in her life and Lavinia produced as evidence at the court case of 1866. [124] With hindsight, we can deduce that some of these must have been forgeries, fabricated after 1820, and in a later chapter these will be identified, along with those that were in the category of 'not to be opened until the King's death'. If Lavinia was correct, then some of the papers opened at the time contained the signature of King George III, and Lavinia, unlike her mother, was not a fantasist, so it seems reasonable to conclude that this part of her evidence was true.

The documents that emanated from Dr. James Wilmot might have included the following, the first of which described certain physical marks on the baby Olive, to protect her against any possible future claimants to her identity. [125]

> Princess Olive bears on her right side a large brown mole and a mark of fruit upon her back near the neck.
> March 7, 1773
> Signed J Wilmot J Dunning Robert Wilmot

Perhaps of even greater import was one that did contain an oblique reference to other secrets. [126] It would be referred to in a subsequent letter to Olive from the Duke of Kent.

> Olive; provided the Royal family acknowledge you, keep secret all the papers which are connected with the King's first marriage, but should the family's desertion be manifested (should you outlive the King) then, and only then, make known all the State Secrets which I have left in the Earl of Warwick's keeping for your knowledge. Such papers I bequeath to you for your sole, and uncontrolled, property to use and act upon as you deem fit, according to the expediency of things. Receive this as the sacred Will of James Wilmot.
>
> June 1st, 1789. Witness Warwick

The one most likely to have come from William Pitt, because it was endorsed with the written comment 'to Lord Chatham', reads as follows; [127]

> Whereas it is our Royal will that Olive our niece be baptised Olive Wilmot, to operate during our Royal pleasure.
>
> April 4, 1772 George R

If this document and its date were genuine, then it proves that King George III was fully aware of the 'cover-up' from day one. Another might have been this.

> This is to declare that Lord Chatham binds himself to pay to Olive, the Duke of Cumberland's infant daughter, the yearly sum of Five Hundred pounds during the said Olive's life until a more suitable provision is made for her; acting by the command of His Majesty. In witness and confirmation of the same his Lordship places his signature.
>
> May 1, 1773 Chatham & J Wilmot, witnessed by George R. and R Wilmot.

And if this money had been paid to James Wilmot rather than Robert, it might explain why the two brothers had subsequently fallen out. The Earl had said that there were more documents in Warwick Castle that he had not been able to extract during his raid, so the exercise had to be repeated, Olive claiming later that she provided the money to enable the Earl to make a second trip to Warwick. [128] She would have been encouraged when she received the following letter; [129]

> Madam – all goes well. I have got safe your papers. My poor old house-keeper wept with joy at seeing me. [130] What the nefarious Trust will say as to my being here I am at a loss to conceive. I write to relieve your mind, so bear up. In exceeding haste, ever yours sincerely, Warwick. Love to L(avinia).

On July 17, three months after their first visit, the Earl and the Duke of Kent called on Olive again, the Duke providing a signed 'delivery note' for the additional documents.[131]

> This is to declare that the Earl of Warwick has delivered in my presence the papers that confirm the birth of Olive, Princess of Cumberland.
> Signed Edward
> Witnessed Warwick

The Earl apologised that one of them had the corners cut off, following an accident with a candle, which seems to suggest that the crucial document he now gave to Olive, missing its corners, was the following; **(Plate 16)** [132]

> **By his Majesty's command, we solemnly certify that Olive Wilmot, the supposed daughter of my brother Robert, is Princess Olive of Cumberland, the only child of Henry Frederick, Duke of Cumberland and Olive his wife, born April 3, 1772 at my mother's, Warwick.**
> Signed J Wilmot Brooke
> Witnessed by J Dunning Robt. Wilmot

When the Earl and the Duke left her, Olive must have sat down and read this revelation over and over. Here was the proof of her Royal birth, but there was one outstanding problem. It seemed that her mother had also been called 'Olive'. Who on earth was this woman? If Olive had been sent out for adoption to the Wilmot family, perhaps her mother had been some Wilmot relative, but the only relation she knew about with this name was her *aunt* Olive Payne, Robert and James Wilmot's married sister, who would have been aged 44 at the time of her own birth. Was it possible that her aunt could have been the mistress of the 27 year old Duke of Cumberland only weeks before he had been known to have married Anne Horton? There seemed to be a serious generation gap as well as one of plausibility. And how could she square this with being the *legitimate* daughter of the Duke of Cumberland? The only possible explanation must be that the Duke had undergone a legal marriage to another, quite different woman called 'Olive' and that his second marriage to Anne Horton was therefore bigamous. The implications were staggering. This was all stranger and even more mystifying than the plot of Olive's opera, and over the next few years her fertile imagination would weave a provenance for her mother that was more romantic, more tragic, than any work of fiction she had ever devised. For the moment she could do nothing more about all this, because she had sworn a solemn oath to the Duke of Kent not to do anything herself until her two protectors did some diplomatic work on her behalf behind the scenes.

But almost immediately Olive had to come to terms with a sensational turn of events. Now that Edward Duke of Kent had been able to confirm that she was in fact his cousin of the Royal blood, his affection for her could be elevated to a higher plane – he wrote her a letter suggesting that he would like to marry her! They had been seeing more of each other in private, snatching a few hours of intimacy at Olive's house, clandestine meetings that were clearly provoking jealous suspicions in his long-standing mistress, Madame St Laurent. 'The happiest moments of my life are in your society' Edward wrote, adding;[133]

> Madame has contrived to occupy more of my time than has been usual. Few females have Olive's liberal mind. She is a good woman, but in this too much the Mistress; if she knew your Royal birth, she would be frenetic and penetrate the secret that I cherish in my heart, that I adore Olive and fondly and with hourly impatience anticipate the moment of happiness which will unite me *in marriage forever* to the best and most amiable of her sex. Oh! God! my heart is full of anxiety indeed! Heaven bless Olive! (Author's italics)

Earlier in the same letter, he implored Olive 'not to breathe a single mention as to the certificates left by the worthy Dr Wilmot *as to the Quaker* or your own legitimacy'. (Authors' initials.) Soon afterwards, when he went to broach his intentions to the Queen, the Duke of Kent reported on 'an unpleasant visit to Windsor … both brothers flew at me at dinner like bulldogs'.[134] He also mentions 'the Duke of York's gambling etc. though his spirits rise whenever his elder brother is ill'. The letter ends on a tender note. 'Excepting my dear (sister) Sophia, you Olive are the most affectionate relative I have.'

ENDNOTES

108 Published by Sherwood, Neely & Jones, Paternoster Row, London.

109 Published by Rodwell, London.

110 Published by John Maynard, 9 Panton Street, London.

111 Letter from H. Colby, *Daily Telegraph* August 6, 1864. Comparison of James Wilmot's handwriting from Parish Records with that on a letter to Woodfall accompanying a draft letter of Junius seems to provide further evidence.

112 Lindsey, p107. The article was published by Cyrus Reading in 1844.

113 Phillips, Also reproduced in Pendered & Mallett, p112

114 Olive, 1813. p116

115 Pendered & Mallett, p71(n)

116 WRO. The letter is dated 9/3/1819 and is slipped inside the cover of the copy of *'The Life of the Rev. James Wilmot'* that was once in Warwick Castle. On it is written, in William Thoms's handwriting the word 'interesting', but since it did not suit his case against Olive's claims, he had attempted to hide it.

117 The Princess Czartoriska's husband was at one time a candidate for election to the monarchy of Poland, an honour that he declined.

118 National Archives TS 18/112

119 Tillyard, 2007 p31

120 Camp pp49-51.

121 WRO C920. It would eventually be published by his solicitor.

122 Olive 1819.

123 Olive, 1822. By the time Olive wrote this, she was referring to herself as 'the Princess'. In this quotation, the personal pronoun has been substituted.

124 National Archives J77/44. The documents, numbered 26-113, were released into the public domain in 1966. When first examined by Richard Price, they were loose but were subsequently pasted and bound into a book.

125 National Archives J77/44. Doc. 63

126 National Archives J77/44. Doc. 71

127 National Archives J77/44. Doc. 61

128 Olive, 1822.

129 National Archives J77/44. Docs. 82/3

130 Mrs Hume. Since 1806, she had been running a profitable sideline by allowing paying 'tourists' to visit the empty Castle. William James had been appalled by this breach of security.

131 National Archives J77/44. Docs. 85/86

132 Private papers in possession of Richard Price. We assume that this is the original version and the basis of all the fabricated documents that refer to the mystical 'Olive', our Olive's supposed mother; viz. National Archives J77/44 Docs. 30, 44-57, 60, 64, 67, 70, 89/90

133 Bodleian Library, Oxford. Shelfmark MS. Eng. Hist c722, f28

134 Bodleian Library, Oxford. Shelfmark MS. Eng. Hist c722, f30

Chapter 6

The love life of Henry, Duke of Cumberland

HOW CREDIBLE was it for Henry Duke of Cumberland, younger brother of King George III, to have been Olive's father? To answer this question, we need to indulge in another flashback, to the youthful, sexual adventures of a Hanoverian Prince with the high testosterone levels that typified his family.

Henry had been born at Leicester House in 1745. He was a good looking man, though rather short, and never blessed with a great intellect. But he was jovial, easy-going, an excellent dancer and he much preferred informality to the stuffy rituals of the Court. On the death of his uncle, William Augustus, the 'Butcher' Duke of Cumberland of Culloden infamy, Henry was awarded the title in 1766. He had been destined for an uncontroversial career in the Navy, where he would doubtless, because of his parentage, achieve high rank on minimal talent. The Duke paid lip service to his naval duties but was much more interested in chasing the ladies. His first mistress, according to the *Town and Country Magazine*, was the voluptuous Venetian opera singer named Signorina Anne Zamperini, whom he shared with Lord Marsh in 1766.

By the following year, the Duke had taken up with a Miss Anne Elliott. Lady Mary Coke, who had been rather left in the lurch by the sudden death of her lover, Henry's elder brother Edward, the then Duke of York, strongly disapproved of this liaison. [135] She had never seen 'such want of breeding' and was particularly offended that Anne Elliott had been seen driving around St James's Park in a Royal carriage. Probably she was secretly jealous that this hussy had managed to persuade her lover to mortgage his house for £6,000 and promise the money to her. When George III heard about this, he flew into an apoplexy of rage – the first of many such tirades that anticipated his even deeper and longer periods of madness. Anne Elliot died in June 1769 and Henry seems to have shown genuine distress; it is reported that he failed to attend a masquerade on June 4 because 'he was greatly affected with the death of Miss Elliot'. [136]

Henry's 'warm passions and weak character' [137] soon transported him into the arms – and bed – of Polly Jones, the daughter of a couple of street pedlars. She

apparently kept her lover amused by somersaulting on the grass and exposing her undergarments. [138] Polly was supplanted, briefly, by a Mrs Archer, who in turn lost out to the charms of Lady Camilla Bennet – by then the widowed Countess D'Onhoff. [139] In the light of subsequent events in Olive's life, she is the most important of all the Duke's mistresses.

Lady Camilla Bennet had finished her education in Paris, where she met the glamorous young King of Poland, Stanislaus Poniatowski, who had been one of Catherine the Great's many lovers. They returned to Warsaw, where she 'remained for nearly two years, being created Countess of Dunhoff, living in the utmost splendour … as the mistress of a great and youthful monarch.' [140] At the end of the two years, they had a titanic row and Camilla found herself banished back to London. Here she elaborated on her time in Warsaw, claiming to be the widow, not of the Count, but of the King of Poland's brother. She was 'courted and adulated by the first of the nobility – the men offered their hearts and the ladies tended their purses; and she so condescending as not to want much pressing in the acceptance of both.' [141] It became well known in society that one of the men offering their hearts was the impecunious Henry, Duke of Cumberland, and the *Town and Country Magazine,* using the coy, but rather obvious, anonym of 'Nauticus' was soon telling its readers about the Duke's latest infatuation.

The Duke's affair with Countess D'Onhoff/Dunhoff would be as nothing compared with his next fling – with Lady Grosvenor. Her husband, Baron Grosvenor of Eaton in Cheshire, was himself a notorious rake, using the above mentioned Mrs Archer as a procuress. Henrietta, Lady Grosvenor, was the daughter of Lady Harriet Vernon, who was Lady of the Bedchamber to George III's sad spinster sister, Princess Amelia, once the fiancée of Frederick the Great. Henrietta's younger sister, Caroline Vernon, also held a position at Court as a Maid of Honour. Henry Duke of Cumberland took every opportunity to be in the company of Henrietta – at the theatre, operas, Ranelagh Gardens etc. – but tongues really started wagging in February 1769 at a grand Masquerade held at Mrs Corneley's, when the Duke and Henrietta danced the whole night together. Over the next eight months the lovers became more indiscreet. When Henrietta thought her husband was spending a few days at Newmarket, the Duke would ride up to Cheshire and slip in through the back door of Eaton Hall. The Duke and his gentleman porter, Giddings, stayed at various inns on the way, using a succession of hopelessly amateurish disguises to travel incognito. When meetings became impossible because of the Duke's rather notional naval duties, they wrote passionate letters to each other, some of which fell into the hands of Lord Grosvenor. [142]

The lovers' final, farcical meeting took place in the White Hart at St Albans on the night of December 22, 1769. They would not be alone. The couple were 'surprised' by Lord Grosvenor's agents bursting into her bedroom, and in the mayhem that followed, she tripped and fell over, while the Duke of Cumberland stood in

confusion, buttoning on his clothes, but did somehow manage to escape down the back stairs and head home to London. George III was to throw another of his fits, but there was worse to come.

On July 5, 1770, Lord Mansfield sat in judgement in the Court of the King's Bench when Lord Grosvenor sued the Duke of Cumberland for 'criminal conversation' with his wife, demanding £100,000 in damages. The Duke was defended by Dr. James Wilmot's friend John Dunning, MP for Calne and, until recently, the Solicitor-General. (He would later become Baron Ashburton.) Scores of witnesses were called, the Duke's illiterate letters were read out in court, while allegations and counter allegations were flung backwards and forwards to the great amusement of the public – and, one suspects, Lord Mansfield, who was renowned for his sense of humour. Finally the judgement was handed down. The Duke was ordered to pay only £13,000 damages and costs, partly because of Dunning's oratory but partly because Lord Mansfield suspected that any sum would have to be paid out of the public purse anyway. The Duke certainly could not pay, following his generosity to Anne Elliott, so he had to go cap in hand to his brother the King. This brought on another fit, worse than the last. And it soon came out that Countess Dunhoff had been in league with Lord Grosvenor all along, receiving half the damages for secret information about the Duke! This revelation sealed her fate in London society and she found herself exiled once more.

It was on July 25, 1771, when the 26 year-old Duke was being installed as a Knight of the Garter at Windsor, that he caught sight of an attractive young widow, who had the most seductive eyes. By all accounts, and there were many, Anne Horton – born Anne Lutterell – was a very lively and provocative lady. 'There was something so bewitching in her languishing eyes, which she could animate to enchantment, if she pleased, and her coquetry was so active, so varied, and yet so habitual, that it was difficult not to see through it and yet as difficult to resist it'. [143] **(Plates 11 & 12)** It seems that her eyes were certainly her most striking feature, 'the most glamorous eyes in the world … with eyelashes a yard long'. Elsewhere she has been described as being 'artful as Cleopatra, and completely mistress of all her passions and projects.' Later she would be painted by Gainsborough, Romney and Reynolds – among others – always giving the impression of 'a tall, slender beauty with a lovely neck and thick, golden hair.' She was 28 when the Duke of Cumberland started their relationship and she had been a widow for two years since the death of her husband, Christopher Horton of Catton Hall in Derbyshire. She had mothered a child by him, thereby proving her fertility, but the baby, christened George Henry Horton, had died in infancy. [144]

Anne's family, the Lutterells, were among many English families 'planted' in Ireland by King James 1. Their subsequent history was littered with stories of murder, assassination and trysts with the devil. In 1744, Simon Lutterell married well, the heiress to wealthy sugar plantations in Jamaica, and was rewarded with the title of

Lord Irnam, Earl of Carhampton, for dubious 'services rendered' to Augustus Fitzroy, the Duke of Grafton, in 1768. Horace Walpole admired his wit and boldness, but 'Junius', in his pungent letters condemning George III's ministers from 1768 to 1772 , particularly Grafton, thought he was a 'hoary lecher'. Lord Irnam had four sons and three daughters; one of the sons, Temple Simon Lutterell, was an absentee landlord with sugar plantations in Jamaica, while the eldest, Henry Laws Lutterell, had a dashing and distinguished career in the Army. He was a deadly shot and no one dared to challenge him to a duel. In 1769 he took on a serious political challenge, standing as the Tory candidate in the Middlesex election against the local hero, the radical anti-monarchist politician John Wilkes. This election would go down in the history of the House of Commons as a *cause celebre* – because ministers ruled that Lutterell, although polling by far the fewer votes, should be declared the winner. Wilkes had managed to avoid a charge of sedition following an outburst in his satirical journal the '*North Briton*', but was considered too dangerous to be allowed a voice in Parliament again. And Col. Lutterell was a close friend of Henry Duke of Cumberland, writing pamphlets in his support during the Grosvenor case in 1770.

* * * * *

Of most significance to our story, the *Public Advertiser,* the organ that not only published these but also the '*Letters of Junius*' , informed its readers that they would shortly be able to read '*The Letters of an Elder Brother to a Fair Quaker*'. This is the earliest printed reference to the Hannah Lightfoot affair and clearly implied that the Lutterells, and/or 'Junius', held the key to dark secrets.

What else do we know about Anne Lutterell/Horton? She was the most beautiful of three sisters and an amusing, vivacious talker, though it was said that she enjoyed using coarse language and telling risqué stories. This did not endear her to many society ladies; Lady Louisa Stuart wrote that she was 'vulgar, indelicate and intrepid', and Lady Mary Fordyce is quoted as saying that after listening to her for half an hour, 'she felt she ought to go home and wash out her ears'.[145] But her conversation captivated the racier gentlemen. Henry Duke of Cumberland fell deeply in love with her, becoming a daily visitor to her house in Windsor. Three months after their first meeting, she told him that she was carrying his child.

History is littered with Royal mistresses having illegitimate children but this affair would take a different twist, because on October 2, 1771, Henry Duke of Cumberland and Anne Horton were married. **(Plate 15)** The ceremony took place in her house in Hertford Street at 6 pm, the Reverend W. Stevens officiating 'according to rites of the church of England', though her sister Elizabeth was the only witness. [146] John Jesse, who inspected the document in 1773, recorded that 'the signature of the Duke is traced in singularly tremulous characters, while nothing can be neater or steadier than that of the Duchess.' [147] The Lutterells were politically highly ambitious, and if the Duke's signature was an indication of any reluctance on

his part, the simple truth was that Col. Lutterell had probably made it very plain that if his sister was not made an honest woman, he would challenge the Duke to a duel – likely to be fatal.

It is important for our story to have confirmation that Anne Horton really was pregnant at the time of her marriage, and not merely trying, with the connivance of her family, to blackmail the Duke into taking a step he knew would throw up horrendous complications in his family. Horace Walpole recorded in November that she was *enceinte*, a polite way of saying that she was 'with child', while Lady Greenwich wrote on November 24 to Lady Mary Coke; ' Mrs Horton being two months gone with child before he married her … I'm anxious to know how His Majesty will act'. [148]

How indeed! The Duke had summoned up enough courage by November 1 to visit his brother at Richmond Lodge, but, unable to tell him the fact of his marriage to his face, had slipped him a piece of paper for him to read. The King was very, very cross. As he saw it, an 'upstart widow of a commoner was now, after the Queen, the second lady in the land', and, perhaps more importantly, he had lost a potentially useful diplomatic tool by being denied the opportunity for another arranged marriage with a European princess. Nor could he avoid hearing of an item in the *Public Advertiser*, from the sarcastic pen of 'Junius'; 'It is now, happily for this country, within the limits of possibility, that a Lutterell may be King of Great Britain.'

When the King learnt a little later that another of his brothers, William Duke of Gloucester, had secretly married the Dowager Countess Waldegrave (the gossipy Horace Walpole's niece) without telling him, he became ruthlessly determined to bring in an Act of Parliament that would forbid any descendant of King George II from marrying anyone before the age of 25 or indeed anyone who did not have the Monarch's specific approval – and that meant, in effect, only a protestant Prince or Princess, preferably German. The notorious 'Royal Marriages Act' would be forced through Parliament over the next four months, finally gaining the Royal Assent on April 1, 1772. Like many Bills put before Parliament, both then and now, it had been drafted in haste. Crucially, what it was supposed to enforce and what it actually proclaimed were not quite the same – as we will see later.

Eight days earlier, on March 24, the *Gentleman's Magazine* carried a small paragraph stating; 'We are assured that her Royal Highness, the Duchess of Cumberland, is in a state of pregnancy'. Then silence. However, on March 28, the same journal (and the *General Evening Post*) reported that 'Lord North, the Prime Minister, waited on the Duke of Cumberland with whom he had a long conference.' One can only speculate as to what was discussed, but Lord North was probably bringing the King's terms from St James's Palace. The Cumberlands would not be received at court and Anne Horton would not be allowed the title of 'Her Royal Highness'. They must go and live abroad. The Duke would get no income from the civil list, though he could retain his title and remuneration as the Earl of Dublin –

and as a Vice-Admiral. Most importantly, it was probably suggested they must renounce the rights of any children to the line of Hanoverian succession. (Did Stanley Baldwin hear echoes of all this in 1936, in his discussions with the Duke of Windsor?)

The most satisfactory solution all round would be if the child about to be born could disappear – be sent out for adoption. To this end, Lord North had a suggestion to make, with the promise of assistance from the Royal Surgeon [149] and Anne's brother Temple Simon Lutterell, together with Dr. James Wilmot, who offered a route to adoption through his own brother and sister-in-law. Anna-Maria Wilmot's latest pregnancy had coincided almost precisely with that of the Duchess and she had just endured the tragedy of giving birth to a still-born child. The last piece in the jigsaw of Olive's true pedigree had been slipped into place.

We do have one vital clue to Lord North's mission and it lies in a letter written to Olive by the Earl of Warwick in July 1815. [150]

> I consider it just to state that his Majesty was compelled to act as he did in regard to *your father's* conduct to prevent other family troubles. For the late Duke of Cumberland had *betrayed the secret of the King's first marriage* to Mrs Horton, or justice would have been faithfully done you, my dearest Princess. But the ungenerous and unforeseen conduct of Lord North operated to your loss, as all the parties acquainted with your birth were sworn to secrecy. (Author's italics.)

Here we must note two other facts. First, the young King George III was feeling particularly vulnerable because he was still in mourning for his mother, who had died the previous month. Secondly, Lord North's tutor at Oxford had been none other than Dr. James Wilmot. The Earl's letter continued;

> The King almost lost his mind with distracted fear, but the noble forbearance of Doctor Wilmot saved the family from infamy, all of which I have faithfully stated to the Duke of Kent, as he will declare to you. … his royal protection will be certain, until Divine Providence is pleased to restore you your Royal birth-right.

In fact, Olive would not be the Cumberland's only issue, and the story of their second child, very contentiously a son, will become so intricately mixed up with Olive and the Wilmot family that we need to retrace our steps for a moment to find out how it all began.

Anne Horton turned out to be an extraordinarily good wife to her husband and he remained faithful to her for the rest of his life. Not only did she restrain his wayward follies and flirtations, but she educated him in cultural pursuits, encouraging him to read widely and take an interest in music, law and geography.

The *Craftsman* journal reported that they spent contented evenings together poring over maps and atlases. [151] (It also confirmed that she had been pregnant in early 1772.) She arranged for him to have learned men as tutors. Later, when they travelled extensively in Europe, he took pains to try and learn a little of the local languages, which made the pair popular guests. She encouraged him to play the cello, at which he became proficient, and to build up a music library. He in return took a pride in his married status and when the Royal Marriages Bill had been debated in the House of Lords, he stood by to speak in her defence in case they tried to make the legislation retrospective. They did not. The Act was finally passed, by a small majority, on March 24, 1772, though it cost the King dear. Not only in money terms – £25,000 in cash and promises of several lottery tickets – but also in political support from many nobles. The only winner, apart from the King, was Lord North, who was made a Knight of the Order of the Garter.

The Cumberlands, feeling happier that their marriage was indeed legal, proposed to retire to Ireland, to live close to her family roots, but this request was denied by the King, fearful that his brother would set up a rival court and form the focal point for dissention. Instead, they moved into the Duke of Gloucester's stolid mansion on Pall Mall, which was renamed Cumberland House. [152] Here, in the first year of their marriage, they augmented their meagre income by running a high-class gambling establishment based on the popular card game of Faro. The Cumberlands ran the bank, Anne's feisty sister Elizabeth Lutterell was the croupier, while the aristocratic gamblers bet against the next card that would be turned up out of the 'shoe'. In spite of the odds being heavily in favour of the 'house', it proved to be immensely popular and Anne gained the reputation as a beautiful, entertaining hostess.

In the autumn of 1773, the Cumberlands, referred to by Horace Walpole as the 'wandering court', started on a long tour of European cities, including Strasbourg and Basle and ending up in Rome, where the Duke and his retinue received the Papal blessing. This not only upset the King when he heard about it, but infuriated the young pretender, 'Bonnie' Prince Charles Stuart, who was living there in exile at the time and said he would never attend the Vatican again. *The Times* reported on Christmas day 1775; 'The Duke and Duchess of Cumberland are still in Avignon, known there as the Compte and Comptesse of Dublin. For four evenings a week they visit the playhouse and give private parties and suppers often. They are very popular and highly regarded. No English travellers ever did more honour to their country then this illustrious company'.

Over the next few years, there were occasional rumours of a possible reconciliation between the Duke and the King, but it did not happen, partly because of his continued antipathy towards Anne, but mainly because the Duke was increasingly tying his colours to the mast of the Whig opposition in Parliament and speaking out in defence of the American colonists. Another cause of friction was the developing friendship between the Cumberlands and the Prince of Wales, with young

Prince George spending more and more time in the company of his favourite aunt and uncle. As the war in America went from bad to worse and the French got more involved, the Duke kept pressing his brother for an active Naval command, but this was consistently denied and the Duke had to content himself with organising yacht races on the Thames. These became an important part of the social calendar, betting on the outcome was lively and the participants became known as the 'Cumberland Fleet', later the Royal Thames Yacht Club.

The Cumberlands seem to have spent 1776 in that part of the Netherlands that would later become Belgium, at Spa and Brussels, and the British press could not find any gossip about them to report – until 1777. In February that year, the Duke was back in England on his own and tongues began to wag that he and Anne were not getting on. Why was she not with him? Then an incident at the Drury Lane theatre really gave them something to get their teeth into. Mary Robinson, 'an attractive and amoral actress with sad eyes and shapely limbs' [153] was starring in Sheridan's new play 'A Trip to Scarborough'. But when the audience realised that it was merely a rewritten – and considerably sanitised – version of an earlier production by Vanbrugh, they booed and hissed and threatened to storm the stage. The Duke of Cumberland, attending the first night, gallantly stepped down and restored order. He assured the actress that the crowd were only expressing resentment about the play and that her performance was magnificent, a compliment to which Mary Robinson responded with a gesture that brought the house down to thunderous applause – and not a few nods and winks. When the Duke later took his nephew to meet the actress in her dressing room, the 15 year old Prince of Wales was enraptured and she became his first mistress. The King used this introduction to deepen his resolve never to be reconciled with the Cumberlands, but it must have stirred uncomfortable recollections of his own youthful infatuation with Hannah Lightfoot.

What the press did not pick up was the reason why Anne had stayed abroad that winter in private seclusion. She was pregnant again. As in 1772, a child was not going to be helpful in any reconciliation with the King. When the child turned out to be a baby boy, alarm bells rang out loudly in Windsor. A legitimate niece of King George III – Olive – was one thing; a legitimate nephew might have more serious implications. So the services of the loyal and discreet Dr. James Wilmot were called upon once more. This time another branch of his family would be persuaded to act as adoptive parents, Eleanor Wilmot and her husband Thomas Dearn – and Eleanor was the granddaughter of Dr. James Wilmot's father by his first wife. (See Appendix A).

It is not clear what inducements were offered to Eleanor Dearn by her 'half-uncle' Dr. James Wilmot and Agents from the Royal household to adopt a seven week old baby boy from abroad, but on June 9, 1777, at the church of St Clement Dane in the Strand, the child was christened Thomas Downes Wilmot Dearn. His story will be told in a later chapter. For now we only need to note that the young Thomas D W

Dearn, Olive's blood brother, grew up and married, and in 1805 he and his wife were themselves persuaded, by the next generation of shadowy characters from Windsor, to adopt Olive's baby girl, Caroline, the outcome of her 'summer of love' with the Prince of Wales. These machinations would keep three uncomfortable secrets within one family orbit. But if William Beckford had been correct, another secret, the one about Hannah Lightfoot and perhaps the greatest of them all since it affected the Royal succession, remained locked in the memory of William Pitt, Earl of Chatham. On April 7, 1778, Pitt staggered to the House of Lords to make what would prove to be his last speech, during which he collapsed in a delirious fit. This event was soon made the subject of a dramatic painting by John Singleton Copley which now hangs in the National Portrait Gallery. The person closest at Pitt's side is Henry Duke of Cumberland, perhaps anxious to know if he might blurt out some sort of deathbed confession. **(Plate 17)**

ENDNOTES

135 Coke

136 Camp, p128

137 Jesse

138 Gattey, p17

139 Also spelt Dunhoff. She had married the Count on Sept 5, 1764 and was a widow within three weeks.

140 *Town and Country Magazine*, quoted in Gattey p18

141 *Town and Country Magazine*, quoted in Gattey p19. Camp p130 points out that many sources have confused the lives of two quite distinct Countess Dunhoffs, one born 1744, the other 1768.

142 This whole, often farcical, affair is told in great detail in Gattey.

143 Walpole.

144 Camp p131. He draws attention to the fact that this Registry entry had been 'struck through' at some stage – perhaps by someone wishing to deny Anne Horton's fertility.

145 Gattey, p90

146 Jesse. Some more recent writers, including Donovan, have stated erroneously that the ceremony was performed by Dr. James Wilmot.

147 Jesse

148 Coke

149 Donovan, p12

150 National Archives J77/44 doc. 89. This document is torn and certain words are missing. It is not insignificant that the transcript made in 1866 has probably misinterpreted some of the gaps.

151 Gattey, p101

152 Later still, it would become the site for the Royal Automobile Club.

153 Gattey, p137

Chapter 7

One Wedding and Four Funerals

IN 1815 Edward Duke of Kent had declared his devotion to Olive, who he now acknowledged to be his cousin. His avowed intentions to help her establish her credentials and be accepted by his family were absolutely genuine, though his first approach had been tactless under the circumstances. It had antagonised both his two elder brothers, one of whom was now in a much greater position of ultimate power and responsibility. When it was clear to the Government that King George III's mental condition rendered him incapable of ruling the country any more, the Prince of Wales had been declared as the Regent in 1811. He might very soon inherit the throne and he had to pay rather more attention to the future line of succession, and even protecting the very survival of the Monarchy itself.

He had kept his daughter, Princess Charlotte, out of the public eye, restricting any contact she might have with her mother after the 'delicate investigation' and exercising strict control over the household he had established for her at Warwick House. Although this was adjacent to his own residence at Carlton House on Pall Mall, he saw very little of her, any communication being via a series of critical, unaffectionate letters. She was very much a tomboy, while also being highly intelligent. At the age of 14 she developed a teenage crush on a dashing, roguish young cavalry officer, Lt. Charles Hesse, believed to be an illegitimate son of her uncle, Frederick Duke of York, who her father used as his postman. [154] Charlotte and Charles Hesse started writing passionate love-letters to each other and so he was promptly posted abroad on active service.

Later, when she was allowed to attend a few balls, her eye fell on the handsome Prince August of Prussia, a nephew of Frederick the Great. Edward Duke of Kent referred to him as the only 'black sheep' in the Prussian royal family and he was known to be the lover of the beautiful Madame Recamier. On both counts, he would be a most unsuitable match for a future Queen of England. Charlotte also took a slight fancy to Prince Leopold of Saxe-Coburg-Saalfeld, though he was originally very second best. Whatever Charlotte's personal thoughts were, her father was determined that she should be used as a diplomatic pawn and be married off to the hereditary heir to the House of Orange. Napoleon Bonepart had over-run the Netherlands during his rampage through Europe, putting his brother Louis on the

throne of Holland, but by 1814 the Allies had taken charge and the restoration of the House of Orange was in prospect. To the Prince Regent, a strong buffer state, ruled by a Prince bound in marriage to England, would be a diplomatic coup. The problem was that Charlotte found the weedy Prince, whom she referred to as 'Slender Billy', loathsomely unattractive.

She herself has been described as 'difficult, talkative and rather coarse', [155] but she was also extremely determined, and she was prepared to stand up to her father on this issue at all costs. On the other hand, marriage was the only practical way that she could escape from the semi house-arrest that she was forced to endure. So when Prince August very politely dropped her, returning her letters and the gifts she had given him, she suffered the natural anguish of rejection – but only briefly. Prince Leopold had remained a quiet, undemanding suitor. When she next met him, she thought he was really rather attractive after all, as well as being in great favour with her grandmother and her aunts and uncles. She had soundly beaten her father over his first choice and now she was prepared to acquiesce to the next best diplomatic compromise. Once 'Leo' had been made a British citizen, and a General in the British Army, the engagement was announced. (Few people would have known that he had applied to Napoleon for an appointment as an officer on his personal staff in 1807.)

There might have been a hiccup at the last minute. Before the engagement, Charlotte was staying at the Royal residence of Gloucester Lodge in Weymouth, 'for her health'. Glancing out of the window one evening, who should she see walking down the street with his arm in a sling but her first love, Captain Charles Hesse? He was convalescing, having been severely wounded at Waterloo. Hesse had no idea Charlotte was in Weymouth – he was merely staying overnight, on his way to visit friends in Cornwall. At noon the following day, he caught the mail-coach to Exeter and passed out of Charlotte's life forever. [156] Later he returned to Italy as an equerry to Charlotte's mother at the Villa d'Este, had an affair with the Queen of Naples and was killed in a duel with another bastard – Napoleon's son Count Leon.

By coincidence, the Earl of Warwick and his family were also in Weymouth, as he recounted in a letter to Olive. [157]

We are very gay here at present and much of my time is spent with the Princess we so truly love. As she was talking to me last evening, it struck me there is at times a great similarity of mind to yourself; she is genuine, open and sincere; and possesses an integrity beyond the usuality of things. …I fear she studies too much, for although she is *en-bon-point* her health is not, I fear, exactly as it could be wished; but when one loves, one is ever apprehensive – her excessive paleness alarms me – she told me she was not well, but Lady _ _ observed that it was from being out of humour!!

Edward Duke of Kent had informed Olive about Charlotte's engagement in a highly confidential letter in which he raised concerns that there might be a question mark, not over Charlotte's right to be considered as the heir presumptive, but who would be next in the line of succession – if anything should happen to her. [158] Did she, in fact, have a younger sister with claims to legitimacy? 'I often recall that her mother has another daughter born within the pale.' He had already told Olive about this child in an earlier letter. [159] 'The Princess of Wales, my sister-in-law, had a daughter born at Blackheath in 1801 – baptised Edwardina, now wife of Major Norton of Halifax, New Brunswick.' [160] The Prince and Princess of Wales were still officially married; how could it be proved that he was not the father? (Princess Charlotte herself seems to have believed that Edwardina was her mother's child by Sir Sydney Smith.) [161]

With further reference to the whole question of the succession, Edward had ended his letter with a warning to Olive – and a note of his admiration. 'Be circumspect. *You are too near the throne not to have enemies.* Well may Lord Warwick declare that you would make the best Queen in the universe!'

The marriage of Charlotte to Prince Leopold was scheduled to take place in early April 1816. But on the 18th, the *Warwick Advertiser* informed its readers;

> The Royal marriage is again postponed. The Princess Charlotte, it is said, has a cold, but the chief reason probably is that preparations at Camelford House are not likely to be completed till the 25th. Saturday May 4 is now expected to be the day for the Union.
>
> Rumour says that the Princess of Wales is on her return to England; a house is taken for her Royal Highness and she may be expected here to participate in the general joy. We merely state the report which is current.

And it was this rumour, combined with the Prince Regent's gout, that was probably the real cause for the postponement. The Royal Agents were given the task of making certain that the mother of the bride would not be in the country.

The *Warwick Advertiser* for May 5 devoted half a page to the wedding;

> The nuptials of the Princess Charlotte and Prince Leopold of Saxe-Coburg were celebrated yesterday. The streets in the vicinity of the royal residences were crowded at an early hour with people anxious to obtain a view of the Royal Bride and Bridegroom. The fineness of the day, corresponding with the interest of the occasion, contributed to increase the multitude.

At Clarence House, where Prince Leopold was staying, 'the crowd was so great that the footman, in letting him out of the carriage, had nearly been pushed under it. A number of women and children were forced into Clarence House against their will

by the extreme pressure.' Ten column inches were devoted to a description of the bride's wedding dress, plus the thirteen other dresses specially ordered for her trousseau. A further two inches were given over to the splendid uniform of a British General worn by the groom, his chest bedecked with jewels, medals and Orders from seven countries 'for his military service.' How the British public love a Royal wedding!

On the same page of the *Warwick Advertiser* that described the wedding, there was a small announcement that the Earl of Warwick had died two days earlier at his house in Green Street, London, while having breakfast. A week later the paper devoted half a page to his obituary, highlighting his philanthropy and benevolence which was 'dispensed with a large and lavish hand to all his dependents, the poor of his neighbourhood and all of those whose distress he was properly informed of.' The writer devoted most of his piece to the Earl's artistic investments in and around Warwick Castle; 'improvement and embellishment of that stately and noble mansion were, through his whole life, the great object of his unceasing care and his proud delight … executed with equal spirit and ardour'. The costs, however, 'extended beyond the strict limits of prudence, since they probably contributed to those embarrassments that threw a shadow over the closing years of his life.' On the evening of May 11, the Earl's body lay in state in Southam, and the following day it was taken in solemn procession for burial in St Mary's Warwick alongside his ancestors. The streets were lined with a 'huge crowd' according to the *Warwick Advertiser*, which left the final epitaph to a weeping estate worker. 'He was indeed the poor man's friend.'

Olive had received a letter from the Earl on her birthday, April 3. [162] It had been accompanied by a bunch of violets and a sprig of myrtle, tied together with a white silk bow. The letter had ended;

> Around thy brow the Myrtle bind,
> Emblem of thy spacious mind;
> Take violets too – how sweet! how rare!
> Fostered by thy native air.

His last two letters of all were dated April 23 and 29. [163] They are mainly concerned with the historic legacy of Dr. James Wilmot and his knowledge of George III's first marriage. His discretion had 'saved the Royal Family of England from a revolution inevitably' and if this news was now made public, the Earl feared lest the 'country be engaged in a civil war at least! … Doctor Wilmot sacrificed himself *and yourself* to preserving the welfare of the country and subsequently have we all been treated – for our Loyalty!'

Despite a consoling letter from Edward Duke of Kent – 'I am, Olive, all sense of your kind and generous endeavours to serve the Royal Family, who are infinitely

indebted to you! Keep up your spirits all you can as to the Earl's death' – [164] Olive must have heard the news of the Earl's demise with some despair. She had been wildly generous to him, she had believed his promises that he would one day be able to repay her and now she was herself deep in debt as a result of her efforts to relieve his 'embarrassments'. But she believed she held the trump card – his Will, which he had written in the weeks before he died, witnessed in Olive's presence by the Duke of Kent. [165]

> From the injuries that I have received at my eldest son's hands, and my present state of health, I am reduced to make this my last will and testament and I bequeath to Olive, Princess of Cumberland, all my real and personal estate, upon certain conditions which I am satisfied she will faithfully observe.
> Signed Brooke and Warwick April 2, 1816
> Witnessed Edward, Duke of Kent.
> Provided my debts are not paid nine years after my death, I solemnly command that the above may be fully acted on.
>
> Having received £2,000 from the late Duke of Cumberland in the year 1784 in trust for the benefit of Olive, Princess of Cumberland, his daughter, called at this time Olive Serres, I bind myself, heirs, executors and administrators to pay the said £2,000 so received, which I am indebted, with the whole of the interest up to this period.
> Signed Warwick April 17, 1816
> Witnessed Edward, Duke of Kent

Unknown to Olive, there were other creditors of the late Earl who were poised to take immediate action and they had employed the Earl's personal solicitor, Mr Wilmot Parker of Gray's Inn Square. On the day after the Earl's death, Messrs Forster, Cooke & Frere, acting for the Trustees, wrote to Parker asking if he had any knowledge of the late Earl having made a Will. Parker, who was not acting for Olive at that stage, replied on May 5 that he had no precise knowledge of such a Will, but that he had a 'nuncupative Will to fulfil, namely to vindicate his Lordship's honour to the Public by the Publication of his most lamentable and distressing case, from his manuscript, in case all his just and honourable debts are not satisfied.' [166] Five days later, the Trustees' solicitors wrote to 'acquaint Mr Parker that the late Earl of Warwick *has* left a Will, which will probably prevent any further exposure of the late Earl's affairs by his indiscreet friends.' [167]

This was not the Will in Olive's possession, but another document that had been prepared long in advance, like the obituaries of elderly, famous people that lie in the desk of the editor of *The Times* in case of a sudden death. In no way was it the sort of document that the Earl himself would have written or willingly signed. Dated as long

ago as June 27, 1812, it bears the signatures of the Rev. Froward, J. Merrifield and Jas. Parker as witnesses to that of the Earl, with Lord Cathcart and John Dickenson appointed as executors.[168] It is long and complicated, a lawyer's delight, and in effect it claimed that all the Earl's assets were already held in Trust and therefore the Trustees could not be responsible for any personal debts or liabilities that the Earl may have entered into. (Not surprisingly perhaps, it contains no mention of any legacy to Olive.) Any subsequent Will, properly witnessed, could put the legality of an earlier one in jeopardy.

The correspondence between the lawyers then became increasingly testy;

> Parker, May 11. Acknowledges information about the Will, but 'feels himself called upon by the rude remark in Messrs. FC&F's note to justify to the world his own conduct on the part of the late much injured Earl.'
>
> FC&F, May 14. 'Before you attempt to justify what you term the Earl's Rights, you will doubtless take care to inform yourself what these rights really were … you do not appear to us to have any conception of them …'
>
> Parker, May 15. 'If you had been cooperative, we could have sorted it all out by now to everyone's benefit etc etc.' Asks for name of Executor and when the Will would be proved.

By now it appears that Olive had been in touch with Mr Parker, joined his list of claimants and told him about the Will in her possession.

> FC&F, May 17. 'You must excuse us for saying that you appear to us to have such a total misconception of what you term the just rights of the late Earl … *any (other) Will of the Earl is mere waste paper* …We must request you will relieve us from any further correspondence whatever.' [Author's italics.]
>
> Parker, May 27. 'As some of the creditors of the late Earl have applied to me respecting their claims, I request to be informed if there is any intention of paying such debts as appear to be just and honourable. …It will be vain to suppose that the Trust and receiver's accounts, or even your own, can remain un-investigated on the part of the creditors … I will not hesitate to vindicate the character and honour of the late Earl.'

Later that year, '*A Narrative of the Peculiar case of the late Earl of Warwick, from his Lordship's own manuscript*' was published anonymously, but presumably by Parker. [169] It is a sad, self-justifying autobiography, in which the Earl blames everyone else except himself for his financial ruin. It merely highlights his complete ignorance of business management. Where he quotes examples of the huge incomes that should have been generated from coal-mines on his land in Somerset, as suggested by William James, he completely ignores the need for massive initial capital investment.

Olive had now thrown her version of the Earl's Will into the ring. But it is surely significant that neither the executors nor the Trustees took any steps to prosecute her for forgery, especially as that crime was considered so serious that it was on the statute books as a capital offence. And to understand why, we must make a small diversion into the business practices of the time.

When war had been declared against France in 1793, the Prime Minister William Pitt (the younger) soon took two key steps to protect the economy. One was the introduction of income-tax in 1797 which, combined with a sharp reduction in the import of low cost corn and wheat, sparked a rapid rise in inflation. Commodity prices soared and one of the effects was that coinage virtually disappeared, because the price of silver (the principal coinage metal) rose higher than the face values, so coins were melted down to be sold for their metal content. Pitt's other draconian move was to suspend 'convertibility' of official paper money into bullion; no new bank notes would be issued by the Bank of England and those in circulation could no longer be swapped for gold. An early attempt to run the economy by control of the money-supply. In this new climate, virtually the only means of transacting any business was by way of Bills of Exchange – IOUs – written out by hand and passed from one party to another. The system only worked if people kept their word or if they could rely on the genuineness of such promissory notes. If these were forged, the whole pack of cards collapsed and this is why forgery was seen as a very serious crime indeed, punishable by the courts with the ultimate deterrent.

Olive had accepted many Bills of Exchange issued by the late Earl of Warwick, and if she could not get satisfaction from his executors and Trustees she would have to try and persuade his son, the new Earl, to redeem them. Four weeks after the funeral, she took the bull by the horns. In a letter dated June 8, 1816, she enclosed the bills, pleading for settlement and implying that the bailiffs were knocking on her door and that she was under threat of the debtors' prison. Her letter is partly sycophantic, partly cajoling, and in part even subtly threatening. [170]

> It gives me pain to send the enclosed. … I hope your Lordship will see Mr Moss to keep the matter from public exposure, in order to save your father's character. … The promissory note for £80 of your father. …Mr George advanced £20 for your father's use …there is a promissory note of £350, many months overdue, for which your father pressed interest in my favour. … I shall be all obligation if your Lordship will take it up, or I shall be lost. If your Lordship will do it, it will be no loss as your Lordship can receive it from the executors. It will, my Lord, preserve me from prison, which I have not deserved, by doing so much for your late noble father. It is a duty I owe my dear daughter that I protect her rights, and your father said you would fulfil his wishes.

It fell on deaf ears. If a personal plea did not get a response, Olive next tried an approach through her lawyer, a Mr Barfoot, whom she peppered with frantic instructions on an almost daily basis throughout July. [171] Barfoot submitted a courteous resume of his client's claims to which the Earl replied as follows; [172]

> Warwick Castle, August 7, 1817
>
> Sir, I am sincere in thanking you for your good intentions towards me, but the truth is there is nothing respecting Mrs Serres that I feel as you do. My Father, I know, had his faults, which I would do everything to keep to myself. I know they sprang from an over zealous endeavour to accomplish generous actions.
>
> I know Mrs Serres obtained his entire confidence, but I never can believe she ever had any property to give him of her family and if she had, she states to me it was expended in endeavouring to break through the Trust deeds of the family, by which means I and my family would have been ruined. Mrs Serres would have obtained her annuities and everything she could have persuaded my father to grant her, to the prejudice of us all. And for this I am now to recompense her? I certainly had to defend no end of Bills filed against me and the Trust, which fell to the ground one after another. As for buying people's statements off, after the infamous pamphlet that made its appearance last year, there can be no use in thinking of it. Everything has been and will be said again by me and by Sir L Parsons, as my father placed his dependence on him, and therefore they must say and do their worst.
>
> I have paid a good deal and I will have a good deal more to pay, but I am answerable to my Father's solicitor and shall place all the money raised into Court for his use, and all will go through his hands. As for the present personage, we are not likely to think the same if he credits Mrs Serres. But his believing what I do not will not make me the more credulous about my own experience and knowledge of facts; nor in any way influence my conduct, which must be regulated according to my own feelings – which I do not think I am bound to state. I have formed my opinions on what I know and what I have seen.
>
> Letters to my Father are in existence as well as those from my Father to her. Excuse my not saying more than that.

Seven years later, Olive would still be trying to achieve repayment.[173]

* * * * *

Just around the time of the Earl of Warwick's death in May 1816, dramatic events were brewing in the household of Princess Charlotte. It all started with one of her footmen, a man called Neale, who had been placed in her establishment by Edward Duke of Kent. And to understand why and to appreciate the significance of this seemingly minor matter, one that would throw Olive and Edward into an even greater

pact of confidentiality, we need to go back once more, to another event that had taken place six years earlier. It was one of the darkest incidents in the history of the House of Hanover and it involved Edward's younger brother Ernest, on whom the title of Duke of Cumberland had been conferred in 1797.

During the night of May 30, 1810, Ernest's valet, Joseph Sellis, had been killed. The so-called facts which emerged at the inquest into Sellis's death were that someone had attacked the Duke with his own sword at around 2am. His cries for help had summoned one of his footmen, Neale, who had an adjoining room, and Sellis had later been found in his own bedroom just down the corridor, with his throat slit. [174] The gossip of the time hinted that Sellis had surprised the Duke in bed with either Mrs Sellis or Neale. There had then been a fight. Certainly the Duke had sustained some wounds to the head. At the inquest, he showed the court a slash to his skull that had 'exposed part of his brain', though Sir Henry Halford recorded in his diary that the injuries had only been superficial. [175] The jury found that Sellis had tried to kill the Duke in his bed, either because he suspected him of having seduced Mrs Sellis or because, being a staunch Catholic, he could no longer take the Duke's coarse jokes about the Pope. They concluded the Duke had been an innocent victim of Sellis's brutal attack and that he, Sellis, had then returned to his own room and committed suicide in a fit of remorse.

But this may not have been the truth at all and in early 1815 the footman, Neale, was apparently about to reveal that he accused Ernest Duke of Cumberland of having murdered Sellis because he had indeed found him in bed with someone else – his own sister, Princess Sophia. To keep him quiet, he had been bribed by Edward with cash and a promotion to serve Prince Leopold and Princess Charlotte. However, a year later Neale was getting restless and now there was talk in the shady publishing world that he was planning to go into print about what had really happened on that night in 1810.

The Royal family were in despair; who could they possibly turn to for help? Edward wrote a series of letters to his 'literary cousin' Olive imploring her to use her contacts in the publishing world to 'get the proof for my perusal …hush the printer …I will purchase the work … it will oblige the Queen and myself much … Neale merits hanging at best … that Sellis did not commit suicide I am well aware … the wretched valet was destroyed to prevent a dreadful exposure … murder will out … D of C had better not reside in England … his unnatural incest is criminal … the affair of Sophia and the incest make me shudder … alas, blood calls for blood … the Queen is in great mental agony … Sophia very unwell – her last accouchement has ruined her health.' [176]

This very personal revelation confirmed Court gossip that the child Princess Sophia had given birth to in 1800 was a result of her incestuous, and conniving, relationship with her brother, a relationship that was still continuing in 1810. [177] (Given the oppressive seclusion to which the sibling Princesses had been subjected

by their parents, this may have been the only way that Sophia's frustration could have found vent. In 1811 she transferred her passionate affections to the Royal doctor, Sir Henry Halford [178] – who had also supervised the last days of the Earl of Warwick).

Olive appears to have succeeded in her negotiation to acquire the draft of Neale's exposé, leading Edward to report that 'the Queen is satisfied, the money has been paid and the Manuscript is ours! ... gold and power may conceal crime!' [179] He ends the letter;

> What an unhappy family ours is, my dearest cousin. I tremble when I recall to my remembrance matters within your and my own knowledge! Our obligations to yourself, my beloved Olive, can never I fear be repaid as your kindness merits, but I will be with you at nine tomorrow evening. I am interrupted – in haste, adieu.

Eighteen months after her marriage to Prince Leopold, Princess Charlotte, the heir to the throne, was in the final stages of pregnancy. Her confinement in the autumn of 1817 was taking place at Claremont, the elegant Palladian house near Esher that had been purchased for her and Leopold. It had been built originally by Robert Clive of India, but he had committed suicide before completion. Jane Austen wrote that it was 'a house that seems never to have prospered'. [180] Moreover, the wife of the family who owned it immediately before Leopold and Charlotte had died in childbirth. [181]

Charlotte had generally been a healthy girl and her attendants had no cause to think that the birth of a baby would produce particular complications, though it was later said that she was not eating well in the final weeks. [182] She had, however, put on a massive amount of weight; Lady Holland confided that she showed 'strange, abnormal symptoms' and her grandmother, Queen Charlotte, a very experienced mother herself, expressed concern over her 'immense' figure. [183] Leo, her devoted husband, was at her bedside, but the rest of her family were far away. Her mother was cavorting in Italy, her grandmother was taking the waters in Bath, while her father was spending ten days enjoying the comforts and hospitality of the Countess of Hertford.

The Princess was under the overall, somewhat remote, care of the King's Physician Extraordinary, Dr Baillie, who appointed his brother-in-law as the 'accoucheur', the well-connected but somewhat amateur Sir Richard Croft. A Mrs Griffiths, a very experienced midwife, was taken on as the nurse. The expected delivery date of October 19 came and went. Finally, on Wednesday November 5, 1817, with the Lord Chancellor, the Lord Chamberlain and the Prime Minister attending in an ante-room, two bulletins were published and signed by a Dr Sims, a botanist and physician who had 'expertise in the use of instruments'. The second, issued at 8 pm. confirmed that all was going well. One hour later, the Princess was

delivered of a still-born baby boy. Charlotte rallied somewhat over the next 24 hours and seemed to be more concerned with comforting her husband than grieving for her own loss. The dignitaries departed for Windsor. In the early hours of the following morning, Charlotte suffered a fatal haemorrhage and by 5am she was dead.

The immediate public reaction was one of stunned grief. The country had lost a young Princess untainted by vice and corruption, who had offered a beacon of hope for a new era of enlightened monarchy, one that would replace the debauchery of her father and his court. Lord Brougham recorded in his Memoirs; 'It really was as though every household throughout Great Britain had lost a favourite child.' 'One met in the street people of every class in tears', wrote the wife of the Russian Ambassador, 'the churches full at all hours ... everyone, from the highest to the lowest, in a state of despair which is impossible to describe.' [184] Edward Duke of Kent was all too aware of the potential implications for himself, as he confided to General Wetherall. 'I recollect no event in my life that has so completely overwhelmed me as the catastrophe at Claremont.' [185]

It would be one hundred and ninety years before the death of another Princess touched the hearts of the nation to such an extent. Very quickly this grief turned to anger and fury over the callous way that the Princess had been neglected, and the main target of popular resentment was the Royal family. Why had her father given higher priority to his own selfish indulgence? Why had her mother not been recalled from Italy? Ignorant of the new life she had made for herself at the Villa d'Este, the public believed her mother, Princess Caroline, to be the persecuted, exiled victim of the Prince Regent's scornful indifference. In many quarters, Caroline was elevated to an almost saint-like status and her followers, like the Jacobites of 1745 waiting for Bonny Prince Charlie, could only pray for the time that she might return to England and reclaim her regal rights.

The popularity of the monarchy sank to new lows, adding to a rising tide of republicanism fuelled by the dire economic situation in the country following the end of the Napoleonic Wars. The Battle of Waterloo may have been a famous military victory, promising peace on the international stage, but on the home front serious civil unrest was brewing. There was a general economic slump across the whole country; there was a chronic shortage of horses to do work on the land, nearly all those commandeered for military service having been left abroad. Manufacturing industries collapsed when the need for armaments ceased. But the single most important factor was the introduction of the notorious Corn Laws.

During the war years, it had been virtually impossible to import corn from overseas. The Royal Navy may have been able to keep the main French battle fleet from recovering after the Battle of Trafalgar in 1805, but the sea lanes had been under perpetual threat from French privateers. Landowners, meanwhile, had been encouraged to bring unproductive land under cultivation, and now the Government

was determined that the country would never again be held to ransom by depending on imports of food. Marginal land could only be retained in production by keeping the domestic price of corn at an artificially high level, which meant setting a minimum price at which corn could be imported.

There were furious debates in Parliament. On the one side were the Government ministers supported by the farmers and landowners; on the other were the 'philanthropists' and the industrialists, who wanted to see the price of corn as low as possible, partly for subsistence reasons and partly to suppress demands for higher wages. Eventually the Corn Laws were passed in 1815 and the minimum price at which corn could be imported was set at £80 per qtr. This was bad enough, but within the Corn Laws was an even more damaging clause: the selling price of bread, previously set by law and monitored by magistrates, would now be 'deregulated'. This was a fine excuse for profiteering by millers and bakers. Riots broke out across the country and County Yeomanry Regiments had to be called-out to deal with them, often severely. The whole fabric of law and order was under threat, to such an extent that the right of 'Habeas Corpus' was suspended and people could be arrested and locked up in prison without charge. And, to the mass of the people, the one person to be blamed for all this, even the foul, sunless summer of 1816 and its disastrous harvest, was the Prince Regent. He was lucky to survive a number of assassination attempts.

One man took the death of Princess Charlotte very personally indeed and it weighed heavily on the conscience of Sir Richard Croft. Three months after her burial, he put a pistol into his mouth and blew his brains out.

ENDNOTES

154 Camp p222. Also gives alternative origins for Charles Hesse.

155 DNB. Lewis, J. S.

156 Chambers, p152

157 Olive 1819, p134

158 Bodleian Library, Oxford. Shelfmark MS. Eng. Hist c722, f21

159 Bodleian Library, Oxford. Shelfmark MS. Eng. Hist c722, f54/55. Also f23. Edward had been her godfather – hence the name. Richardson suggests an alternative reason for her name; the curate who baptised her on September 21, 1800 (Lewisham Parish registers) was called Edward and she was born in the county of Kent.

160 Edward was in fact mistaken about several matters here. Edwardina had been born early in 1798 and married a Captain Normann, ADC to the Duke of Brunswick in 1814. Camp p209.

161 Aspinall, 1938. This was impossible, since Sir Sydney Smith did not return from abroad until 1801, though he might well have then become Caroline's lover. Camp p215.

162 Olive, 1819. Bodleian Library, Oxford. Shelfmark MS. Eng. Hist c722, f59-64

163 Bodleian Library, Oxford. Shelfmark MS. Eng. Hist c722, f61/62 and 63/64

164 Bodleian Library, Oxford. Shelfmark MS. Eng. Hist c722, f24

165 National Archives J77/44 document 33 and 98

166 'nuncupative'; verbal – in anticipation of confirmation in writing.

167 WRO CR1886 Box 452

168 Olive 1819. A transcript of the Will forms an Appendix.

169 WRO C 920 GRE.

170 WRO CR1886 BB828 Box 452

171 WRO CR1886 Box 675

172 WRO CR1886/Box 420/BB 810

173 WRO CR 1886 Box 452. Another letter, threatening 'legal restitution'.

174 Wardroper, chapter 5. Also Fulford, p210-13

175 Wardroper.

176 Bodleian Library, Oxford. Shelfmark MS. Eng. Hist c722, folios 36, 50/51, 14, 15, 24 & 38.

177 The child, Tom Garth, had been brought up by a courtier, General Garth, though few people had ever believed he was the father.

178 Wardroper p86

179 Bodleian Library, Oxford. Shelfmark MS. Eng. Hist c722, f12.

180 Chambers p41

181 Chambers, p164. The house remained in the possession of Leopold's family until it was seized by the Board of Trade in 1922 under the 'Trading with the Enemy Amendment Act' of 1916.

182 Later historians have suggested that she showed early signs of the 'Royal Malady', porphyria. Richardson, p54

183 Chambers, p187, quoting Harcourt.

184 Quoted in Chambers, p3

185 Gillen, p218

Chapter 8

Crisis in the Royal Succession

FROM THE point of view of the Royal family, however, the critical dilemma following the death of Princess Charlotte lay in the succession. Who would now succeed to the throne after the Prince Regent? He would certainly have no more children by Princess Caroline, and unless he could obtain a divorce from her he was in no position to seek a new wife. But this option had to be considered, and the Royal Agents, this time in the form of three commissioners, were ordered to Milan to collect more evidence of Caroline's infidelity and the names of potential co-respondents and compliant witnesses. [186]

As it was, the next person in the line of succession was the 54 year old Frederick, Duke of York, still legally married to his barren wife. But what if the rumours that the young Prince George had legally married Hannah Lightfoot, and that she was still alive in 1763, were true? Both the Prince Regent and the Duke of York would then be illegitimate.

As we saw earlier, Queen Charlotte is believed to have insisted on a form of re-marriage to King George in 1765, when they were informed that Hannah Lightfoot had possibly died, thereby making any subsequent children legitimate. (Appendix B). First of the sons to whom this applied would be William Duke of Clarence (now aged 52), followed by Edward, Duke of Kent (age 50), Ernest, Duke of Cumberland (age 46), Augustus, Duke of Sussex (age 44) and finally Adolphus, Duke of Cambridge (a sprightly 43). But in 1817 *not one of these sons of George III had any legitimate children of their own*, and so the edict went out from Windsor that they must get down to doing something about it. Mistresses would have to be discarded and German Princesses wooed and wed.

Lurking in the background, like a ghostly spectre, was the unthinkable possibility that no child would emerge from this marriage charade, in which case the line of succession would revert to George III's married brothers and their offspring. First of these would have been William, 'Silly Billy', Duke of Gloucester, born in 1776, [187] followed by any legitimate child of Henry, the former Duke of Cumberland, and his wife Anne Horton, though here there might be complications involving the precise terms of the Royal Marriages Act. Anyone who fell into this latter category would have to be kept under special surveillance; as would anyone who might have testimonial evidence of the Hannah Lightfoot affair.

Olive matched both these criteria and it would perhaps have been prudent for her to keep her secrets to herself. But this was not her style at all. She was determined to make her mark, to be accepted by the highest echelons of society and to obtain the rank and recognition to which she now believed, with justification, that she was entitled. She had been slighted by the Duke of York; both she, and her daughter Caroline, had been discarded by the Prince Regent. She was in no mood to pull her punches. Moreover, she empathised more and more with the plight of Princess Caroline, while at the same time there were an increasing number of people who were rallying to Caroline's cause and who would find it convenient to use Olive as a mouthpiece for their discontent. While Olive set out on her own crusade, there were others who would try to manipulate her for their own ends.

* * * * *

Back to the Royal Marriage Stakes. In this breeding race, there was one 'non-runner' who, under one interpretation of the rules, could not even come under starter's orders. Augustus, Duke of Sussex, the tall, burly sixth son of George III, had been married and was not divorced. It was while he had been visiting Rome to try and cure his asthma at the age of 20 that Augustus had fallen in love with Augusta, his darling 'Goosy', the much older daughter of Lady Murray. On April 4, 1793, they were secretly married in the Duke's hotel room by the Rev. William Gunn, the rector of Sloyle in Norfolk, who happened to be in Italy, also on account of his health. Back in England in December, the heavily pregnant Augusta underwent a more conventional marriage to her husband (his banns being read merely in the name of Mr Augustus Frederick) at St George's, Hanover Square, and on January 13, 1794, a son was born, christened with the same names as his father. King George III went into one of his famous rages and, backed by the whole of the Privy Council, demanded that the marriage should be annulled on the grounds of non-compliance with the Royal Marriages Act, an edict that was pronounced by the Dean of the Arches that summer.

Undaunted, Augustus and Augusta lived together for the next seven years, their mutual devotion being rewarded with the birth of a daughter, Augusta Emma, in August 1801. But then it all went wrong and the inseparable couple separated. Had she been unfaithful to him? Had the ten year difference in their ages started to open up cracks? Of the many theories put forward by the gossips of the time, the most likely is that he was simply bribed to leave her, by the promise of a Parliamentary grant of £12,000 a year and the titles of Duke of Sussex, Earl of Inverness and Baron Arklow. He did at least give Augusta £4,000 a year and custody of the children – initially – but in 1809 he brought a court action against her and claimed his son and daughter back to his administration, a role in which he proved to be a kind and affectionate father. Later, in 1830, the son known as Captain Augustus d'Este would start making waves by claiming his own Royal entitlements, and though his story

would have many fascinating parallels with Olive's struggles for recognition, we must leave the Sussex succession and return to the Marriage Stakes of 1817.

The objectionable Ernest, the current Duke of Cumberland, had already left the stalls and was up and running. He had married the widowed Princess Frederika of Solms, the daughter of the Duke of Mecklenburg-Strelitz, in May 1815, an event that had caused utter mayhem at Windsor. On the face of it, the marriage was incontestable – he was over 26, she was a Protestant German Princess in her own right and he had even tried to get his parents' consent in advance. But there were deeper seated, more complicated objections. Ernest was quite different from his brothers. While they were all rather cosily rotund, he was lean and taut. While they all espoused the Whig cause in politics, admittedly more to annoy their father than because of more principled convictions, he was an arch Tory and an 'ultra' proponent of the Protestant ascendancy, who thought the Duke of Wellington was positively liberal. And what was seen as being equally dangerous was that he was extremely clever. Princess Frederika had been proposed to in 1813, not by Ernest but by his younger brother Adolphus, and she had turned him down in favour of the insignificant Prince of Solms. This was seen as an intolerable slight on the British Monarchy, an unforgivable affront and a shocking lack of respect. So when the Prince of Solms died and Ernest announced his intention to marry the widow, without even observing the statutory period of mourning, there was panic at Windsor. Queen Charlotte wrote to her son advising him not to think of returning to England and vowing that his Duchess would never, ever be received at Court. The Cumberlands opted to remain abroad, staying with the Prussian Royal family in Berlin, which merely added to suspicions back in England.

When it became known that the Duchess was pregnant in 1817, alarm bells rang even louder. The Duke was 'feared for his talents, his unscrupulousness and his utter contempt for the decencies of political warfare. The people felt that he would stoop to any crime ... in order to block the path of progressive opinions in England.' [188] (Much later, the Duchess of Kent would be terrified by suggestions that Ernest might abduct her own daughter and have her poisoned.) [189] Although the murder of his valet and his incestuous affair with his sister Sophia had been hushed up, rumours abounded. Any son of the Duke would doubtless be a tyrant, so many sighs of relief were heaved when the Duchess's baby proved to be a girl, and there were few tears shed in Windsor when she died a few days later. But in the late autumn of 1818 the Duchess of Cumberland was once again in an 'interesting condition'.

William, Duke of Clarence, was undoubtedly potent, having produced ten illegitimate children by his mistress, the renowned comedy actress Dora Jordan, who had 'coarse manners and several children by several fathers' when they started their relationship in 1791. William had opted for a career in the Navy, a profession in which he showed some enterprise, combining an endearing informality to his

sailors with modernising innovations at the Admiralty. He became a close friend of Horatio Nelson, who genuinely admired him. When not on duty, he and Mrs Jordan lived a rather homely life at his house at Bushy, near Richmond, where he had been appointed to the honorary title of Park Ranger. [190] Their lifestyle was not extravagant, largely because he was deep in debt, and it was once again the lure of a marriage settlement that had led to him unkindly discarding his mistress in 1811, along with accepting the title and income that went with being appointed Duke of Clarence.

Three subsequent proposals of marriage by him were rejected; first by the heiress Miss Tilney Long, then by the daughter of Lord Elphinstone, who had been Princess Charlotte's confidante, and thirdly by Lady Berkeley. William had no better luck when he turned his attention abroad, being spurned in love by Princess Anne of Denmark and then by the sister of the Tsar of Russia, so the failed swain retired to Bushy and the company of his children. But the death of Princess Charlotte and an introduction by his mother to the plain but amiable, twenty-six year old Princess Adelaide of Saxe-Meiningen reactivated his interest, though he told Lord Castlereagh that the engagement would be off unless Parliament voted him a substantial dowry. The couple were married at Kew Palace in July 1818 and the new Duchess of Clarence was soon reported to be pregnant. Suddenly a rather unlikely outsider was running strongly in the Royal Succession Handicap race.

The other rank outsider was Edward Duke of Kent, the companion of Madame St Laurent. When told it was his duty to discard her and find a suitable wife of childbearing age, he suffered genuine pangs of remorse as he confided to Thomas Creevey – with a sly dig at his brother the Duke of Clarence.

> God only knows the sacrifice it will be to make. It is now twenty seven years that Madame St Laurent and I have lived together; we are of the same age, and have been in all climates and in all difficulties together; and you may well imagine, Mr Creevey, the pang it will occasion me to part with her … She is of a good family and has never been an actress.

But the Duke was penniless, his properties were mortgaged and he was unable to resist the 'starting money' offered to enter the Succession Handicap. (All the Royal Dukes were notoriously extravagant, but the Duke of Kent had suffered a peculiar accident in Canada, when his train, carrying his silver plate and all his regalia, had been lost while crossing a frozen lake. Shades of King John and the Wash 600 years earlier.) Nor could he consider consummating his fantasy of marrying Olive; she was now 45 and still technically married anyway.

So 'Madame' was shipped off to Paris and the consolation of her relatives [191] and the Duke of Kent soon announced his engagement to the 32 year old Princess Victoire, the sister of Prince Leopold and the widow of the Prince of Leiningen, once

described as being 'short, stout, with brown eyes and hair and rosy cheeks, cheerful and voluble'. 'This marriage to ensure heirs to the English throne', the Duke wrote to Olive, 'does not admit of much conjugal hope, but it is in obedience to my mother's wishes'. [192] He added that his intended spouse was poor and had her own family to provide for. He would also have 'to provide apparel, jewels and matters necessary for the nuptuals.' Olive, amazingly, was so touched by this cri de coeur that she lent him £2,000, for which Edward wrote a receipt. [193]

> The Princess Olive of Cumberland, my cousin, having received £2,000 from my mother the Queen, lends the same to myself to assist me in preparing for my marriage. I solemnly promise to repay the same when she commands me so to do so.

Princess Victoire came to their Lutheran wedding on May 29, 1818, with two children by her previous marriage. She was in her own right the Regent to her young son, the future ruler of the minute state of Leiningen, and it was to the modest castle at Amorbach that the newlyweds headed to start their married life on the continent. [194] No more clandestine meetings with Olive and no more opportunities to promote her interests to his eldest brother. Amorbach Castle was no building for a Prince of England, so Edward pawned himself into further debt to the tune of £10,000 and insisted that English craftsmen should be brought over to transform it into a miniature Windsor Castle. Within five months of the wedding, surrounded by scaffolding and fresh plasterwork, Victoire could gleefully tell her husband that they could expect a 'happy event' the following spring.

Before we leave the Duke of Kent and his bride of necessity, it should be noted that, at the time of his wedding, he had appointed a new equerry – the tall, handsome Captain John Conroy. Conroy was married to the niece of the Bishop of Salisbury, who had been Edward's tutor, and he came to his appointment with a simmering resentment against his employer. Rightly or wrongly, Conroy believed that his wife was not the daughter of Major-General Benjamin Fisher but an illegitimate child of the Duke of Kent. [195] Conroy immediately started to plot a form of revenge.

The final runner in the Succession Handicap was Adolphus, Duke of Cambridge, who managed to keep on good terms with all the members of his family. The Prince of Wales even forgave him for sending him exaggerated reports on the attractions of Princess Caroline, his future bride, before he met her. Adolphus adored his sisters and they worshipped him. He spent most of his life in Hanover, rising to high rank in the Hanoverian Army. Created Duke of Cambridge, Earl of Tipperary and Baron Culloden in 1801, a lady once described him as 'extremely handsome, tall and finely formed, with fair complexion and regular features, charming manners and a flow of amusing conversation'. He was in command of the Hanoverian army when Napoleon threatened them with invasion on 1803, but though he was bursting for a fight, he

found it difficult to rally resistance; the peace-loving citizens, having first declared neutrality, then just gave in and allowed themselves to be absorbed into the French Empire.

By 1813 however, when it was clear that Napoleon was in retreat, they welcomed Adolphus back as Governor-General and he set about introducing a new Constitution along British lines. He had seemed content to lead a bachelor life, unblemished by personal scandal, but all this changed with the death of Princess Charlotte, and within a fortnight he had proposed to his cousin Princess Augusta of Hesse-Cassel, a beautiful twenty year old great grand-daughter of George II. The couple were married in Cassel in May 1818 and re-married at Buckingham Palace in front of Queen Charlotte on June 1, during a brief visit to England. Wherever they went in London they were cheered by large crowds and there is no doubt that this popularity included all members of the Royal family as well. (The only blemish was when the Duchess of Cambridge fell into conversation with the hugely unpopular Duchess of Cumberland after they met by accident in Kew Gardens. When Queen Charlotte heard of this encounter she had a minor stroke and there were brief fears for her life.) When news came from Hanover the following March that the Duchess of Cambridge was expecting a child, there was a very clear, popular favourite in the Succession Handicap Stakes.

<p align="center">* * * * *</p>

We have now reached the final furlong, the run-in to the finish. All four contenders were racing neck and neck. First past the post was the Duke of Cambridge, with a son born in March 1819. He was – tactfully – baptised with the name of George, after his grandfather the King. A short head behind was the Duke of Kent, his daughter Alexandrina Victoria arriving on May 24, almost in a photo-finish with the Duke of Cumberland's child, also christened George, born on the 27th.

But the prizes of life do not always go to the fastest, the first to break the tape. Under the handicapping rules, it was the seniority of the fathers that determined the outcome and any child of the Duke of Clarence would therefore be the automatic winner by right. Indeed, such a child had been born that March, but the baby Charlotte only survived for a few hours. However, should the Duchess of Clarence produce another child at any time in the future, that child would be next in line to the succession. The stewards had to announce that the race result was still 'pending'.

For a few months, Olive had lurked on the fringes of the parade ring as a possible contender to the succession. This was now less likely, though from the viewpoint of the Establishment there was still a lingering threat that she could appear as a 'late entry'.

Olive herself had no ambitions in this direction, though she believed, with justification, that the revelations about her true origins should soon transform her life, and that of her daughter, into one of prosperity, recognition and distinction. She

had once captivated the man who was now the Prince Regent and soon to be the King. She had enthralled one of his brothers, who still held her in the highest esteem and deepest affection, while George III might die at any moment, allowing her to open the final batch of conclusive documents.

Olive had promised her mentors that she would be patient. While she waited, she set about laying down some journalistic groundwork for the proclamation of her Royal birthright.

ENDNOTES

186 John Powell (solicitor), William Cooke KC and Major James Browne (military attaché.). Fraser, p 304.

187 His ranking in the succession dissolved on his death in 1834.

188 Fulford, p221

189 Hudson, p62

190 Here he did take up a belated interest in architecture, perpetually rebuilding the house and its outbuildings.

191 Gillen. She became known as the Comtesse de Montgenet, supported financially by Louis-Philippe, the Duke of Orleans, among others. She died aged 69 in 1830, the day after Louis-Philippe was declared King of France. She did not, as some historians have written, disappear into a convent.

192 Bodleian Library, Oxford. Shelfmark MS. Eng. Hist c722, f26/27

193 Bodleian Library, Oxford. Shelfmark MS. Eng. Hist c722, f52

194 Now known as Ansbach, about 50 kms. south-west of Nurnberg.

195 ODNB. Elizabeth Longford. Also Hudson.

Chapter 9

Journalism, Reform and Theatricals

THE MAIN road that ran west from St Paul's Cathedral down Ludgate Hill and along Fleet Street, passed through Temple Bar and then into the Strand, before reaching Charing Cross and Pall Mall. Fleet Street and the Strand were the haunt of the printers and the booksellers, with pavements lined by shop-windows displaying the latest poetry, pamphlets and cartoons. Passers-by swarmed into the little shops, eager for copies of the latest weekly journals and reviews, accounts of the most sensational trials and executions, the social tittle-tattle and an anti-establishment slant on what was going on in Parliament. The major daily newspapers, the 'Times' and the 'Courier' trumpeted the Tory Government line, while applauding everything done by the Prince Regent and other members of the Royal family. But in the years following the end of the Napoleonic wars and the subsequent economic slump, the popular mood was becoming increasing restive, demands for political reform were getting louder and respect for law and order was breaking down. The courts were often viewed as dispensers, not of justice, but of tyranny, while the system of political elections was seen as an outdated mechanism for self-perpetuating an Establishment through nepotism and corruption.

One of the most radical of this new breed of journalists and bookseller-publishers was William Hone, who had been a torch-bearer for the Reform movement since the early years of the 19th century. His earliest vehicle for rousing public opinion to this cause, the London Corresponding Society, had been suppressed in 1805, when the popular mood was focused on military patriotism and saw the defeat of a continental despot as more important than affairs on the home front. Once the war was over, however, the mood changed dramatically.

The French Revolution had had its horrors, its reign of terror and its own injustices, but the underlying causes and its fundamental assertions of human liberty struck a more sympathetic chord in an England that may have been a winner on the battlefield but a loser in the economic aftermath. Thomas Paine's 'The Rights of Man', a book that had sympathised so vehemently with the initiators of the

French Revolution at the end of the previous century, was reprinted several times and widely read.

There had been one significant breakthrough in the cause of reform when the Westminster constituency had elected two independent MPs in 1807, one of whom was Sir Francis Burdett and the other the wartime hero Lord Charles Cochrane, later Earl of Dundonald. Westminster had over 12,000 registered electors, in contrast with most constituencies where the number of electors was measured in tens or hundreds at the most (or in the case of Old Sarum, only one). But such examples of democratic enlightenment were rare. The whole question of the freedom of the press was coming under threat in 1817, as the Government tried to hold back a tide of rising social unrest and resurgent republicanism. Hone and his colleagues, like William Hazlitt, were seen by the Establishment not as amusing satirists but purveyors of sedition, through their increasingly popular weeklies such as the *Critical Review*, the *Reformist's Register* and Wooler's *Black Dwarf*.

* * * * *

This may seem rather a long introduction to a new chapter about Olive, but the relevance will now be revealed. Writing and publishing were now her life and she was swept along on the tide of the emerging populist politics. She was an enthusiastic customer of William Hone, first at his 'Old & Curious' bookshop on the Strand and then later at 33 Fleet Street. There she doubtless met Lady Augusta Murray, the discarded wife of Augustus Duke of Sussex, who was another client of William Hone and now living in some poverty on a meagre royal pension. Olive appreciated that there was money to be made by the right sort of popular journalism and surely her own papers, the secrets of her own birth and her intimate relationship with the Prince Regent, could be the basis of a bestseller. She needed a partner, though if she thought that Lady Augusta Murray would fit the bill she would be disappointed, because one of the conditions of Lady Augusta's pension was that she should not go into print, particularly with the love letters of her ex-husband.

But how about William Hone himself? This would be a supreme catch, someone prepared to publish and be damned in the cause of fighting on behalf of victims of injustice and in support of the freedom of speech. So Olive invited him round to her lodgings off St James's Street and laid out all her documents for his inspection on a round table. She had tempted him with the chance of getting a sensational scoop, but he was quite unprepared for what happened next.

> Hone joined her and, to his growing discomfort, she insisted that they read the documents together. As they pored over the papers, she edged her chair closer to his and Hone began to realise that he was being seduced. He moved his chair away, she got closer. According to Hone, there followed 'another edging of the chair – another retreat – and so on until we had fairly circled the table. With the

prospect of other rounds in view, I started up, seized my hat and escaped, never more to examine the proofs of the Princess Olive's title to Royalty.' [196]

Olive had wrecked the best chance of allying herself with a celebrity journalist; she had used a weapon that had often worked on previous occasions when she wanted to get her own way, but Hone, a married man who set great store by his vows of fidelity, was the wrong target. He was used to conversing with Cochrane, Byron, Keats, Leigh Hunt and Charles Lamb but not to being compromised by a feisty lady with overt sexual intentions. Now she was on her own, and it would be some time before she found another partner with whom she could empathise. And when she did find such a partner – as we will see later – it was another woman, Lady Anne Hamilton.

The following year, Hone was arrested and put on trial for 'blasphemous libel'. He had published three political satires entitled '*The Political Catechism*' based on the format of the Ten Commandments, the Litany and the Book of Common Payer, his targets being corrupt Government ministers and their toadies among the ranks of Members of Parliament. Hone conducted his own defence, pleading over the course of many hours that he was merely following in the footsteps of other satirists from Juvenal, through John Milton and John Reeves, to James Gillray and even the rising Tory star, George Canning. Eloquent, witty and penetrating, Hone put on a performance that enraptured the hundreds of his supporters that had crowded into the Guildhall, and the verdict of 'Not Guilty' was greeted with cheers from the crowds outside. David could still slay Goliath, setting a precedent that would not be lost on Olive – and Lavinia fifty years later.

After he had recovered from his ordeal, Hone returned to his crusading journalism with renewed vigour and enhanced popularity. Two subjects particularly exercised his scorning satire (assisted by the drawings of George Cruikshank). The first was the infamous massacre of innocent men, women and children, who had been scythed down by soldiers of the Yeomanry on St Peter's Field near Manchester in 1819. A crowd of several thousand hungry and disillusioned people had assembled to protest against the impoverishing effects of the Corn Laws and listen to a speech by the radical reformer, Henry Hunt. The magistrates had panicked, read the Riot Act and sent in the soldiery. It was the perfect opportunity for Hone to sharpen his pencil and lambaste the 'ministry and all their works'.

The second cause that Hone railed against was the indiscriminate way that the laws against forgery were enforced. The somewhat crude, small denomination banknotes of the period, issued by private banks, were easy targets for forgers, who would then offer them to sad down-and-outs on the Gin Alleys of the cities to buy alcohol – provided they gave the 'change' back to the forgers. It was an early and pernicious form of money-laundering. The victims were easily caught, tried and hanged, while the perpetrators got away scot-free. It was the injustice of the way the

law operated that Hone campaigned against, while not in any way condoning the crime itself. Hone's crusade would induce magistrates to be rather more sympathetic in the way they dispensed justice in minor forgery cases, but any suggestions of serious forgery were still prosecuted ruthlessly – as Olive would have been well aware.

<p style="text-align:center">✻ ✻ ✻ ✻ ✻</p>

If Fleet Street and the Strand had become the arterial highways of printing and publishing, other avenues of popular entertainment were opening up south of the Thames, on the land recently reclaimed from the Lambeth Marsh. Incidentally, this was another undertaking of the enterprising William James, who supervised the project over a number of years on behalf of the main landlord, the Archbishop of Canterbury. [197] A little further south, the Vauxhall Pleasure Gardens had flourished for the past 150 years, along with their smaller imitators, the Belvedere and the Royal Cumberland Tea Gardens. At Astley's Amphitheatre, circuses and equestrian shows were popular diversions, and in 1816 a new theatre began construction on the Waterloo Road.

The foundation stone was due to be laid by Prince Leopold and the luckless Princess Charlotte of Wales on September 14, though in the event, wary of the reaction of the locals to a public appearance by a relation of the unpopular Prince Regent, the Royal couple stayed at home and the ceremony was performed by a City Alderman. [198] But of most interest to our story was that one of the principal backers was none other than Olive's estranged husband, John Thomas Serres. He acquired a one eighth share in the venture for £1,500. [199] It was through his own Court appointment as the official marine artist that he had obtained the Royal patronage, allowing the theatre to be called the Royal Coburg.

> Camelford House, 16 August 1816.
> Sir Robert Gardiner is commanded by Prince Leopold and the Princess Charlotte to communicate to Mr Serres their Royal and Serene Highnesses gracious permission of giving the name of Coburg to the theatre building under his management. [200]

John Thomas Serres devoted a whole year of his life to painting the lavish murals that decorated the public spaces, half his wages being deducted to fund his investment. [201]

> On one side of the saloon was Neptune – with his due allowance of sea-horses, water gods and dolphins; and on the other a representation of the most recent triumph of the British Navy – the bombardment of the pirate stronghold of Algiers by the fleet under Admiral Lord Exmouth.

Like many construction projects both then and now, costs escalated way over budget, the backers' money ran out, it was taken over by new owners and the theatre was not opened until 1818. As a 'minor' theatre, it was prevented by the monopoly of West End theatre managements from performing straight plays, and so the early performances were restricted to anthologies of circus acts, singers, short ballets and single scenes from Shakespeare – the prelude to the Victorian Music Hall. John Thomas Serres was once more in financial difficulties, but the theatre survived through a number of incarnations, including the 'Royal Victorian', before becoming the much loved 'Old Vic'.

ENDNOTES

196 Wilson (2005), p62

197 Macnair, chapters 6 and 13. Two other important clients of William James, Lords Holland and Thurlow, were also landowners in the vicinity. James envisaged that the area would become the site of a through station on his ambitious railway scheme of 1823, one that would link London with the great naval dockyards of Chatham and Portsmouth – and the Midlands.

198 Chambers, p181

199 WRO CR1886 Box 674

200 WRO CR1886 Box 677

201 Pendered & Mallett, p89. Receipts for this work can be found in WRO CR1886 Box 674. Also Russett 2011.

Chapter 10

Another Royal Cousin and finding a Benefactor

AFTER THE death of the Earl of Warwick, Olive was in something of a quandary. As far as claiming her Royal entitlements, she had agreed with the Duke of Kent that he would do the work behind the scenes on her behalf. She probably believed, perhaps naively, that this would not be a problem; she had been on the most intimate terms with the Prince Regent and now she had his brother as her champion. But he was out of the country and preoccupied with his new marriage. She had the packet of papers 'not to be opened until the death of King George III', who was by now blind and completely mad, so it might not be long before their content could be revealed. But there was this conundrum about the true identity of her mother. She had been told quite clearly that her father had been the Duke of Cumberland, with indications that she was indeed legitimate, though the only documentary proof she had was the paper given to her by the Earl of Warwick, which seemed to state categorically that her mother had been called 'Olive'. **(Plate 16)**

Edward Duke of Kent had seen the document and made no comment, so she had to believe it was the truth. Furthermore, the Earl had been a trusted, lifelong friend who had died knowing that he had obligations to her which he had been unable to repay in cash terms. And it was surely impossible that he would have given her false information. This one document seemed to put paid to the simplest solution of all, namely to assert that her mother had been Henry Duke of Cumberland's Duchess, Anne Horton. Anyway, to Olive's understanding in 1817, this solution might be self defeating, because she seems to have been under a misapprehension about the implications of the Royal Marriages Act.

Olive's close friendship with Edward Duke of Kent had led to an introduction to his chaplain, a man of high respectability, the Reverend William Groves, former curate at St Margaret's, Westminster, and Rector of Kingsnorth. In those days of sinecures and patronage, curates did not become chaplains to members of the Royal Family unless there was a hidden agenda and in this case it was possibly another Royal baby adopted at birth.

* * * * *

Although William Groves's notional father was in the employ of George III as a builder, he had been educated at Eton and Oriel College, Oxford, before taking Holy Orders. The King was known to have taken a particular interest in the boy's education. He had been born at Haverford West on March 15, 1768, and there were suggestions that his real father had been the King's brother Edward Augustus, the then Duke of York, who was living in Monte Carlo with his last mistress. [202] Edward Augustus had died in September, 1767, and his pregnant mistress had been brought back to friends in Wales, only for her to die giving birth to a son. [203] Olive would forge a very close friendship with the man sometimes referred to as the 'Prince of Monaco'; a friendship that was not appreciated by Mrs Groves.

Illegitimate children of Royal Dukes and Princes were traditionally well rewarded, the sons with titles, pensions and senior appointments in the Army or the church. Daughters did not fare quite so well, but were often given places at Court, a springboard for making 'good marriages'. Olive herself had written to the Prince Regent in 1816 asking both for a pension, in recognition of her former status as his Landscape Painter, and some position in the Royal Household. [204] One of the Rev. Groves's first acts on her behalf, and probably without her knowledge, was to write to the Prince Regent on June 23, 1817, explaining that he believed Olive was indeed the daughter – illegitimate – of Henry, Duke of Cumberland, her mother being Olive Payne, the sister of Dr. James Wilmot and the wife of Captain Payne. [205] He doubtless believed that he was helping her, but in fact it probably had exactly the opposite effect, when Olive herself put forward quite different versions of her pedigree in later years. For the time being though, Olive went along with this line, writing a letter directly to the Prince Regent, not only reminding him of happier times together in each other's company but also of their mutual ties by blood. [206]

> Believe, Sir, that my heart has never ceased to recollect gratefully the favours I have received of your Royal Self … since I was made known to your Royal Highness at Brighton … The papers that I hold are decisive in regard to my being the daughter of the late Duke of Cumberland … Forgive me, Sir, but even in so illegitimate a way yet the same blood flowing in my veins encourages me to love, and more than venerate, your Royal self, independently of the dignified charms of your Royal person , which have left so lasting an impression on my memory.

She did not receive a reply. Twelve months later, Olive's friendship with Rev. William Groves became the subject of slanderous gossip, and she felt compelled to defend herself in a letter to the Home Secretary – the first of many. [207] She denied that they had run off to Paris together. She was as bemused as everyone else by his

two month absence, during which time she had been exclusively in the 'society of my daughter and ladies of the highest respectability'. She believed that Rev. Groves had removed himself to escape domestic violence and counterattacked by claiming that his wife had started the rumours because 'her brother was an intimate friend of the present Earl of Warwick'.

* * * * *

In 1818, Olive and Lavinia were renting a house, rather appropriately, at 1 Cumberland Street, but there was the perpetual problem of tradesmen knocking on the door and demanding money. Furthermore, Olive was soon in arrears of rent to her landlord, a Mr Lewis. [208] While the Duke of Kent had promised his support in establishing her legitimate claims, he himself was in no position to help her financially. But he had a philanthropic friend who now came to her rescue.

Robert Owen is one of the most genuine characters that impinged on Olive's life, firstly because his own life story was largely one of doing good and secondly because there is no reason to question the authenticity of any of his well documented transactions with the Duke of Kent on Olive's behalf. If William Hone was the mouthpiece of the Reform movement, pleading the defence of free-speech, Robert Owen was the practical embodiment of the new social order they envisaged. Born in South Wales in 1771, Robert Owen grew up to become a successful mill-owner at New Lanark on the banks of the River Clyde in Scotland. He ran his cotton mills under a regime that combined efficient capitalism with a benign, humanitarian concern for the general welfare of his large workforce. He appreciated that contented employees worked more effectively; he built them 'model' accommodation around his mills, with their own school and hospital, an environment that was in stark contrast to the industrial slums of towns like Manchester. These principles would later earn him the title of the 'father of socialism'.

Since 1815, Edward Duke of Kent had taken a keen interest in Owen's social experiments, which combined a responsible approach to labour with sound financial management. And it was the latter that he needed most. Deeply in debt, the Duke decided to delegate the responsibility of managing his income to a Trust, appointing Robert Owen's partner William Allen as one of the trustees. Edward's house at Castle Hill, Ealing, was also put into the trust and it was here that he had lived in modest, semi-retirement while he devoted himself to sponsoring charitable organisations.

On June 26, 1818, a fortnight before celebrating his marriage to Princess Victoire of Leiningen at Kew, the Duke wrote to Robert Owen asking him to call the next day to see if they could agree upon some arrangements for the relief of their 'unfortunate literary friend in Cumberland Street.' [209] 'His Royal Highness the Duke of Kent,' Robert Owen later wrote in his autobiography, 'introduced Mrs Serres to me as his cousin, and as legally entitled to the rank of Princess Olive of Cumberland. He was

deeply interested in her cause and in that of her only daughter and child, Lavinia.' [210]
Over the next two months, Robert Owen advanced several tranches of money to
Olive to pay off her most pressing creditors and leave her enough to live on in
reasonable comfort while she pursued her literary ambitions. It seems that the total
amount over three years came to £1,200 [211] and Edward wrote a document stating
that 'HRH will guarantee its repayment to Mr Owen as soon as he returns to the free
enjoyment of his income'. [212] This debt could not be discharged on Edward's death
and it remained unredeemed on the death of Robert Owen in 1858. It was, however,
later repaid in full to Robert Owen's son on March 8, 1859 on an appeal to Queen
Victoria, accompanied by a letter from her private secretary.

> It would be very disagreeable to her majesty to think any gentleman should
> suffer in pecuniary affairs … because of the character of your father; she
> considers it would not be advantageous to enter into examination of the details
> of the different sums.

Olive, now temporarily relieved of financial worries, returned to her writing. She
had already published an addendum to her biography of James Wilmot in 1817, in the
form of a 'letter addressed to the English nation' under the title of '*Junius: Sir Philip
Francis denied!*' The only new revelation was Olive's claim that 'Dr Wilmot was
distinguished by the friendship of two of his Majesty's brothers – and with him rested
confidence connected with *transactions little conceived by this world*; but which may,
at no very distant epoch, claim public attention and belief.' Next she turned her
attention to writing a memoir of the Earl of Warwick entitled '*Letters of the late Right
Hon. Earl of Brooke and Warwick*', which she published herself and sold through the
booksellers Messrs. Birkett and Sons in 1819. The foreword claimed that her
purpose was to raise money to 'pay off his several sums of which I stand indebted'.
The first half of the book is her personal recollections of the Earl. She makes a fine
apologist for him, and excuses his wilful neglect of financial responsibility by
claiming that 'most of his Lordship's errors were the offspring of too great a
sensibility of disposition; all his adversities were brought on him by the humanity
and liberality of his nature'. But she gives examples of his reckless, irresponsible
spending, how he never recorded any of his spur of the moment purchases in his
pocket book, and if, for example, he wanted another carriage horse, he would not
settle for one unless it matched the others precisely and exactly, whatever it cost.
Having praised the personal characteristics of the second Countess, Olive then goes
into a tirade about the machinations of her relations, the trustees and the stewards,
resulting in 'the control, even of his domestic affairs, being immediately delegated
to the Countess of Warwick's direction.'
 She claims that the Earl was 'supported as far as they were able by his noble
brothers, Fulk and Charles Greville, and his charitable sister Lady Francis Harper,'

but 'his purse was emptied continually by persons of the most interested description, who were wallowing on the spoil of his Lordship's possessions.' When Olive had renewed their acquaintance in London in 1805, he had immediately borrowed £50 off her, and over the next few years she supported him with gifts of money, jewellery and paintings, including 'a Salvestor and a Rembrandt valued at £500 pounds each.' At one stage, as recounted earlier, she even ended up in a bailiff's lock-up, having unwittingly guaranteed a promissory note for £70 written by the Earl.

When Olive did get her hands on some money, she failed to keep it a secret, as the following incident shows, described in a testy letter she received from one of her legal advisors Thos. Drury at his chambers in Clement's Inn. [213]

> How could the Princess be so incautious as to allow the boy, who brought my letter to you yesterday, see her count over 2 boxes of sovereigns! This has been told to Mr G and he insists that the entire debt and cost be levied immediately.
>
> What am I to do? I have hitherto stood between you and danger as long as I possibly could … I have got together every shilling I can possibly raise and I am ready to advance it till you can repay me, but when you calculate that the interest alone on the Bills is £20 and upwards, you must be aware that the arrears and costs are beyond my present ability to pay. Send me therefore £20 and I will settle the rest from my own pocket, for believe me I do not wish to see you put to an additional trouble.
>
> PS. The Princess (by her incautious conduct) has brought upon her what I have struggled to avert. For God's sake, let me hear from you directly!

Careless behaviour like this was stretching the patience of her legal advisors to the limit.

* * * * *

After his marriage, Edward Duke of Kent had taken his Duchess to live abroad and his promise to advance Olive's cause slipped off his list of priorities. The cost of living in Amorbach was substantially less than in England, but having spent most of his marriage allowance – and more – on rebuilding Amorbach Castle, he was again financially embarrassed. So when he decided that his child, due in the spring of 1819, must be born on English soil, the Ducal party would have to travel as cheaply as possible. With himself at the reins, Edward loaded his seven-month pregnant wife into his carriage and set off on the long, bumpy journey home. Also in the carriage was his step-daughter, Princess Theodora, a pair of Russian lap-dogs and the Duchess's song-birds, together with her lady-in-waiting and a nurse. Two coaches of luggage followed behind.

The English public took the whole episode of this weird caravan to their hearts, seeing it as a gesture of patriotic devotion rather than a potentially mortal threat to

the birth of a future monarch. But even this frugal journey required cash, and Olive would claim that it was she who organized a subscription to raise £400 for the purpose, with Lord Darnley being a major contributor. [214] Such a sum was indeed sent over in a money-draft from William Allen, the Duke's trustee and Robert Owen's partner, with Olive playing a crucial role as a go-between. Edward confirmed this himself in a letter to Olive from Kensington Palace after his child had been born. 'It will give you much joy to learn that the infant is well and is thriving hourly … but for your exertions, she would not have had an English birth'. [215]

ENDNOTES

202 Some authors have suggested that his mother might have been Lucy Propert, herself the illegitimate daughter of 'Bonnie' Prince Charles Stuart.

203 Rev. William Groves died in Bexley, Kent in 1851. Among the papers he left was this account of his background, which he had gleaned from Lady Anne Hamilton, later published by Alfred John Dunkin in '*Archaeological Mine*', Vol. 3, pp 3-18.

204 National Archives TS/18 112

205 National Archives TS/18/112

206 National Archives TS 18/112. Letter dated July 15, 1818.

207 National Archives TS/18/112. Letter 39, 26/10/1818. Camp p100 implies that he had been 'intimate with Olive Serres since at least 1817 and their relationship may have precipitated the desertion of his wife.'

208 WRO CR1886 Box 674. A letter threatening prosecution for the sum of £18 17 6p.

209 National Archives TS 18/11, quoted Shepard, p31

210 Gattey, p186. He remained ignorant of the existence of Britannia – and Olive's numerous other offspring.

211 Owen. The original letter to the solicitors, White, Broughton & White, is in National Archives TS 18/11, listing the dates of the individual payments.

212 National Archives TS 18/11, quoted Shepard, p31. Also '*Appeal to the House of Lords*' 1867, Pendered & Mallett, p208f

213 WRO CR1886 Box 676 The letter is undated.

214 Pendered & Mallett, p130. Other donations to the Duke of Kent at this time came from Lords Dundas and Fitzwilliam. Gillen p243

215 Bodleian, Oxford. Shelfmark MS. Eng. Hist c722, f16

Chapter 11

Great Expectations and Crucial Documents

THE NEXT two years would prove to be exciting times for Olive, with good news and bad news in equal measure. She would find herself on a rollercoaster of elation and despair, of encouragement and disappointment, while as many people would espouse her cause as would stand against her. If this was fiction, the events of these two years would stretch credibility.

When Edward Duke of Kent had celebrated the baptism of his daughter, Princess Alexandrina Victoria, in May 1819, he instructed his personal servant, Anthony Hillman, to deliver to Olive a piece of the christening cake, together with a small flask of wine. [216] **(Plate 22)** 'I have sent to you, my dear cousin, some of Alexandrina's christening cake and a vial of the wine used at the said baptism, as you wish to preserve it. When my daughter receives it from your or worthy Lavinia's hand, I hope, should I be no more, that Alexandrina will gratefully repay all that I am indebted for the great and exceeding services I have received at your hands.' [217] This event was later recorded in an affidavit sworn by Hillman at the Mansion House on November 27, 1843. [218]

I, Anthony Hillman of 5 Pelham Terrace, Brompton, in the County of Middlesex, do solemnly and sincerely declare that shortly after I had been hall porter, in or about the year 1807, I came to know the late Mrs Olive Serres, who used to visit His Royal Highness. I have often seen His Royal Highness and Mrs Serres together, when His Royal Highness always behaved to her with the greatest respect and regard.

I was frequently employed by His Royal Highness to carry packets and letters from him to Mrs Serres, when he often said 'Hillman, take this to my cousin Serres.' I have frequently attended His Royal Highness on visiting Mrs Serres. When her present Majesty was born, I received from the Duke's steward, by order of the Duke, a packet containing a phial of some of the christening wine and some of the cake, to take to Mrs Serres.

In the autumn of 1819, the Duke of Kent's baby daughter was healthy but his personal finances were not, so he decided that he must economise still further by taking his family a long way from his creditors in London and into temporary retreat on the south coast of Devon. He stayed for three days in Exeter on a preliminary investigation, visiting Torquay, Teignmouth, Dawlish and Exmouth, before settling on Sidmouth, where he agreed to rent Woolbrook Cottage from the mother of his friend General Baynes. Not that the term 'Cottage' was really appropriate, because by then it had over 15 rooms and the name was soon changed to 'The Glen'. [219] A lease was arranged that would allow the Duke and his entourage to take possession in time for Christmas. He paid his last private visit to Olive on November 19, to explain that he had felt himself unable to press her case to his brother while the latter was so tied up with his own marital problems. He had tried once, but his timing had been unfortunate. He might not be able to see Olive, or his brother, for some time, and since King George III was clearly on his death-bed, perhaps there was no harm in now opening those secret documents in Olive's keeping since 1815, 'not to be opened until the death of the King'.

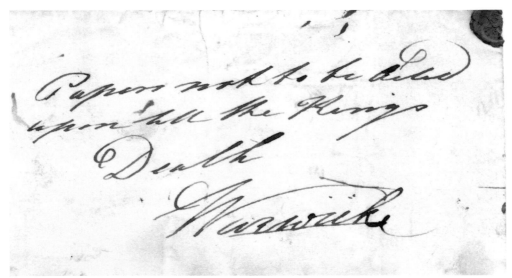

Fig. 2. First of the covers opened by Olive and Edward Duke of Kent in 1819. (Price family papers.)

Together they opened the packets and went through the untidy scraps of paper inside. It was a momentous occasion for both of them. There must have been at least one that pertained to George's secret marriage to Hannah Lightfoot in 1759, and although it was irrelevant to Olive's claims and did not impinge on the Duke of Kent's legitimacy, nor that of his daughter, Edward realised that it was a shattering revelation, one that struck to the heart of the monarchy itself. It had to be kept secret at all costs and he was prepared to give Olive a financial inducement to keep it secret. [220]

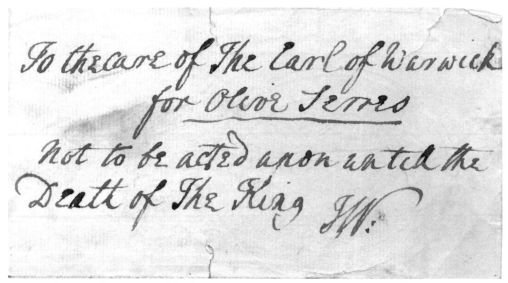

Fig. 3. The second cover, possibly the one containing the first 'marriage certificate' of Hannah Lightfoot and Prince George. (Price family papers.)

> I solemnly bind myself to pay to my Cousin Olive, Princess of Cumberland, £10,000 on condition that she keeps secret *the certificate of the King's first marriage* during his life, and the better to secure to my said cousin Olive the sum of £400 yearly [221] during Princess Olive's life on an observance of the above conditions, I solemnly bind myself, my heirs, executors and assignees to a strict observance of this sacred obligation. November 19th, 1819.

In total, eleven documents relating to Hannah Lightfoot and her involvement with George III when he was Prince of Wales would be produced in the years to come. Some can easily be proved to be forgeries. All are intriguing and make a fascinating story in their own right but they will not be analysed in detail at this stage because they did not affect Olive's claims to her birthright. It is sufficient to mention just two of them.

The first is the crucial marriage certificate already referred to in Chapter **2** in relation to Beckford's testament. It states that George and Hannah had been married at Kew by Dr. James Wilmot on April 14, 1759, witnessed by William Pitt and Anne Tayler – Dr. Wilmot's 'confidential service', precisely as Beckford had recalled. [222] (See fig. 4.)

The second is another marriage certificate apparently showing that a further ceremony, with an identical cast, had been performed at Peckham on May 27. [223] Why? On the first occasion, Hannah's surname had been omitted; an error that someone, probably much later, believed should be corrected by the addition of 'Lightfoot' on the second occasion. And, ludicrously, the surname of Guelph to that

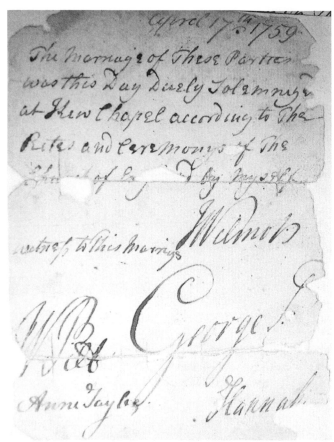

Fig. 4. The marriage certificate of George Prince of Wales and Hannah Lightfoot. Kew April 17, 1759. (NA J77/44 Doc. 74.)

of George, a form of signature never used by the Prince. But why did the presumed forger choose this particular date? (A speculative answer will be discussed in a later chapter.) Of much greater relevance to Olive were papers that seemed to be letters of wishes from the King himself. Four of the latter read as follows, and while there is no absolute proof that they are genuine, they appear to have the highest credibility factor and do not relate to nor mention the mysterious 'Olive', our Olive's supposed mother, who would soon haunt her ambitions.

> Kew Palace, May 2nd, 1773.
> Whereas it is our Royal command that the birth of Olive, the Duke of Cumberland's daughter, is never made known to the nation during our reign; but from a sense of religious duty, we will that she be acknowledged by the Royal family after our death, should she survive ourselves, in return for confidential service rendered ourselves by Dr. Wilmot in the year 1759.
> Signed George R. Witnesses Chatham and Warwick [224]

(Beneath this text was written; 'Indorsed (sic) London, June 1815. Delivered to Mrs O. Serres by Warwick, witness Edward.')

St James's Palace, May 17th, 1773.

We hereby are pleased to create Olive of Cumberland Duchess of Lancaster, and to grant our Royal authority for Olive, our said niece, to bear and use the title and arms of Lancaster, should she be in existence at the period of our Royal demise.

Signed George R. Witnesses Chatham and Dunning. [225]

January 7th, 1780

We are pleased to recommend Olive our niece to our faithful Lords and Commons for protection and support, should she be in existence at the time of our Royal demise; such being Olive Wilmot, the supposed daughter of Robert Wilmot of Warwick.

Signed George R. Witnesses J Dunning and Robt. Wilmot. [226]

The fourth document was nothing less than a Will. [227] (See also Appendix D).

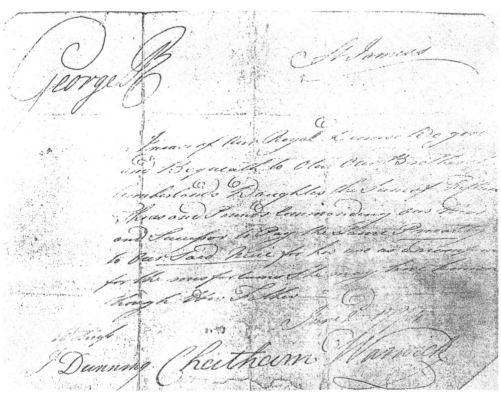

Fig. 5. The Will of King George III, leaving Olive £15,000. (See Appendix D)

St James's Palace, June 2nd, 1774

In the case of our Royal demise, we give and bequeath to Olive, our brother of Cumberland's daughter, the sum of £15,000, commanding our heir and successor to pay the same privately to our said niece, for her use, as a recompense for the misfortune she may have known through her father.

Signed George R. Witnesses; Dunning, Chatham and Warwick.

As he had in 1815, Edward apparently authenticated his father's signatures. Olive was suddenly looking at the key to unlocking her future – and enormous riches. The Will alone would have been worth approximately £500,000 in early 21st century terms.

The document which expressed the King's apparent wish to appoint Olive as Duchess of Lancaster would later become one of the most contentious items in her battle for recognition. Was it likely, even possible, that the King could grant such an entitlement?

When he ascended the throne in 1760, he surrendered all his hereditary estates in exchange for an annual payment from the Government for managing his household – the Civil List. Except for the Duchies of Cornwall and Lancaster. The latter dated back to the time of John of Gaunt and consisted of a vast amount of land and property scattered across the whole country. Much was sold off to fund the Royalist cause in the Civil War, the remains then being sequestered by Parliament and only partially recovered at the Restoration in 1660. Inept management in the early 18th century meant that by 1760 the Duchy was virtually bankrupt, yielding absolutely no income to the Monarch whatsoever. So, to George III in 1773, the intention of possibly creating one of his relations as Duchess of Lancaster 'par parole' can be seen as little more than a gesture, a conscience-solving gift that would not cost him anything. At the time. Nothing further was ever done to implement Olive's elevation, which would have required a Royal Proclamation and the approval of the Privy Council. And this never happened. However, no one else was awarded the title, so Olive can perhaps be excused for pressing her own claim, particularly as the fortunes of the Duchy estates had been transformed by 1819, making them a very valuable asset indeed. [228]

* * * * *

Already heavily in debt, Edward had now pledged himself to pay Olive £10,000 (on top of the repayment of the loan of £2,000 for his wife's trousseau) and the only way he could see to raise some cash was to sell his estate at Castle Hill, Ealing. This idea now became a practical proposition when Olive introduced him to her latest conquest, a man called Joseph Parkins, who held the prestigious post of Sheriff of the City of London – a direct route to the ear of the monarch. The post of Sheriff – originally 'Shire-Reeve' – had been devised by King William I (the Conqueror)

towards the end of the 11th century. Sheriffs were directly appointed by the Monarch as his personal representative in the counties, responsible for maintaining the law and collecting taxes. But the arrangement for London was slightly different. Because William I had never actually conquered the City of London, he came to an accommodation with its administrators, giving them a degree of autonomy, which survives to this day, in exchange for their allegiance. London had two sheriffs, who were *elected* by fellow members of the Livery rather than being imposed by the Monarch, though their role was the same as those in the Shires. [229] The position was often a stepping-stone to becoming Lord Mayor.

Parkins was a slippery character, always on the look-out for a self-advancing deal, who will later play a 'Judas' role in our story, but when Olive had first met him a little earlier in 1819 she thought that she could manipulate him to her advantage, using the most potent weapon in her armoury – seduction. Early in their acquaintance, she had written to him with typical panache, and exaggeration. [230]

> It is in vain, Sheriff, that I endeavour to surmount the affections I bear you; thus I throw myself on your honour and feelings as a Gentleman and a man of honour, convinced such a heart as yours will always hold sacred the confidence of a lady. Virtue has hitherto been my chief observance, but love triumphs …meet me at the Grosvenor Gate, Park Lane at exactly 3 o'clock. *Be mine, Sheriff!*

Olive wrote to Parkins on December 6, 1819, telling him that the Duke of Kent wished for his advice and arranging for the three of them to visit Castle Hill the following Friday. [231] Three days later Edward replied to Olive saying he would 'highly appreciate any assistance and advice that Mr Parkins may be disposed to give', hoping that a minimum of £40,000 might be raised, even though this would 'barely cover one third of the sum laid out on it'. [232] This letter also included a memorandum; 'I solemnly bind myself by my executors and administrators to pay to my dearest cousin Olive Serres the sum of £10,000 the moment Castle Hill Estate, my property, is sold, in return for her exceeding services she has rendered myself.'

Edward had originally come up with a scheme to sell the property by way of a Lottery, hoping to procure buyers for 500 tickets at 100 guineas each. Trustees had been appointed in the names of Generals Wetherall and Desseax, John Conroy, Sir William de Crespigny and Messrs. Barings, but this idea had been stifled by Parliament on the grounds that it was 'undignified'. [233] Parkins now came up with the idea of a 'Tontine', a sort of raffle with the ultimate prize going to the ticket-holder who survived the longest. The deal was confirmed in a letter to Olive from Kensington Palace on December 9, 1819, in which Edward refers to himself by their pet codename as 'the Colonel'. [234]

> The cousin may depend that in his next communication with the Sheriff, the
> Col. will allude to the *consanguinity* in the most delicate manner, so as to satisfy
> him fully on that point, and he is already appraised that he leaves all to the
> general management of the Sheriff, the cousin and the General. (Wetherall.)

Parkins believed that he was on to a very good thing indeed. He had acquired further Royal patronage, he could look forward to a handsome sales commission and he was receiving the flattering favours of a woman who was still very attractive and, seemingly, about to become a member of the Royal family in her own right.

'I cannot delay going to Sidmouth and relays are waiting', Edward wrote to Olive a few days later, 'the Duchess is a good soul but we must defer a little longer the fullness of our confidence or Leopold (*his brother-in-law*) may learn more than he ought to.' [235] He was not only deeply attached to Olive; he was, apparently, prepared to put his trust in her to a remarkable degree. On December 17, he forwarded a document to her in which he appointed 'Olive, Princess of Cumberland, Earl Grey and Alderman Wood to be joint guardians of Alexandrina after her sixth year'. [236] It would seem clear from this that he was already harbouring suspicions about the potential influence of John Conroy on his household.

The Duke's last letter to Olive from Kensington Palace was dated December 19. [237] In the opening paragraph he confides that he has ceased all correspondence with his sister-in-law, Princess Caroline, because of 'her conduct during her residence abroad; such deviations from virtue are lamentable and at the present moment may be fatal in its future consequences', adding that he had 'never reconciled Edwardina's birth to his satisfaction'. He continued;

> The excellent cousin will at no very distant period experience that reward her
> generous and praiseworthy forbearance so richly merits ... Providence will yet
> restore all the rights of the dear cousin's birth ... The Royal family are indebted
> more than it can repay, but the Colonel hopes to be found grateful too.
>
> The cousin may rest assured it will be the future endeavour of his life to
> convince her of his unbounded gratitude, independently of the consanguinity
> which ties their affection to each other, knowing as he does her claims of birth,
> which, *but for the honour of his aged parent*, should not have remained a secret
> since poor Lord Warwick made the disclosure. ... Far and near, the Colonel will
> ever remain the dearest cousin's most grateful, most affectionate and
> unalterable friend, not forgetting his love and blessing to the dear L(avinia).

This letter is very important. It reconfirms that Edward had definitely seen some document or papers relating to his father's affair with Hannah Lightfoot among those that he and Olive had opened together. It unequivocally gives the lie to later accusations that *all* Olive's 'Hannah' documents were subsequent forgeries. Some

of Olive's journalist friends, particularly the Baylis family, tried to persuade her to publish the Hannah marriage certificate in their Sunday newspaper, the '*British Luminary*', [238] but Olive had made a solemn promise to the Duke of Kent. And she was astute enough to believe that the mere threat of its existence gave her a more powerful bargaining weapon. It would stay in the rumour-mill until after her death – apart from one unfortunate leak, involving a gentleman of the cloth, as we will see shortly.

On their way south to Devon, the Duke of Kent's party called in at Windsor, where his adoring sisters Sophia and Elizabeth expressed their delight with the 'beautiful fat baby and the excellent good little wife who made Edward so happy'. [239] Edward and his family had reached Salisbury by December 22, where they stayed at the Bishop's Palace, and had arrived safely at Woolbrook Cottage on Christmas Eve. Early January found the Duke embracing the warmer climate and the sea breezes. He took to walking and exploring the countryside, believing that the healthy environment would ensure that he 'outlived all his brothers'. [240] But one day he got soaked to the skin, leading to a chest infection. His own doctor, along with Doctor Stockmar, physician to Prince Leopold, was summoned to cup him and bleed him but all to no avail. His last two letters to Olive were written in a shaking hand. [241]

> If this paper meets my dear Alexandrina's eye, my dear cousin Olive will present it, whom my daughter will, for my sake, I hope, love and serve, should I depart this life.
>
> I sign this only to say that I am very ill, but should I not get better, confide in the Duchess my wife, who will, for my sake, assist you until you obtain your Royal rights. God almighty bless you, my beloved cousin, prays Edward.

Edward Duke of Kent died on January 22nd 1820. Robert Huish relates; [242]

> Almost the last act of the Duke of Kent was the perusal of a letter from the Prince Regent, to whom the Duke had given some offence for the credit which he gave to the claims of a certain lady, the soi-disant Princess Olive of Cumberland, to be admitted as one of the legitimates into the Royal family.
> The Prince Regent took alarm at this introduction of a new member of the Royal family and he castigated his Royal brother very severely for giving even the semblance of his sanction to so spurious a claim. The death of the Duke following almost immediately put an end to the dispute and also to the introduction of Mrs Serres to the distinguished honour of being admitted a member of the Royal family.

Having died a pauper, the Duke's funeral expenses were paid for by the man who was both his nephew-in-law and his brother-in-law, Prince Leopold, and not,

significantly, by his brother. And to save further expense, the Duke's funeral was arranged to coincide with that of King George III, who had finally passed away a week later. As in the case of the Earl of Warwick, the 'official' Will of the Duke of Kent – dated the day he died and witnessed by General J Mason, Doctor Matten and Doctor Wilson – would be quickly proved. [243] It left everything to the Duchess and required his 'beloved wife to be the sole guardian to our dear child Princess Alexandrina Victoria to all intents and for all purposes whatever', with John Conroy as the administrator. Not surprisingly perhaps, this document made no mention of Olive, while the disposal of the Castle Hill estate, to the chagrin of Joseph Parkins, was left to the administration of Edward's executors. [244]

* * * * *

There are few cases in the history of the British Monarchy when the death of the Sovereign caused less disturbance to the general order of things. It made no difference to the way the country was governed, the Prince Regent merely assuming the title of King George IV, and, to the disappointment of the Whigs, retaining the Tory administration under the leadership of Lord Liverpool. In many quarters, the old King, 'Farmer George', was mourned as a symbol of a happier, socially more cohesive era, one of sympathetic patriotism and a domestic harmony that was starkly at odds with the flamboyant, immoral extravagance of his eldest son.

The Duchess of Kent and her baby daughter moved back into Kensington Palace, with John Conroy appointed as Comptroller of the Household, a position from which he would exercise a suffocating hold over the young Princess, and her mother, for the next seventeen years. [245] This regime became known as the 'Kensington System' and it would have a most damaging influence on the character of Princess Alexandrina Victoria. How very different her early life would have been if her father's real wishes had been granted and Olive had been given a hand in her upbringing.

To assist him in his plot, Conroy recruited (seduced?) the connivance of a perhaps unlikely assistant and spy within Kensington Palace – none other than the sad, invalid, lovelorn Princess Sophia. She had a huge personal income from the civil list of £13,000 a year with nothing to spend it on, and over the next thirty years she showered Conroy with gifts of money and property that have been estimated to total over £150,000 – several million in today's terms. [246] It was also she who persuaded her brother George IV to grant Conroy a knighthood in 1827, though he was never granted the Earldom he craved. (The Duke of Wellington saw to this. He despised Conroy for never putting himself forward for active service.) [247]

Before George IV could plan his coronation, an awkward, haunting reminder of his past would have to faced – or exorcised. His wife, formerly Princess and now Queen Caroline, had been living a reportedly louche life in Italy since 1814, first at the Villa D'Este on Lake Como and later at Pesaro, and he was determined, somehow or other, to expunge her from any future considerations. She, on the other hand, was

equally determined to return to England and reclaim her entitlement to be his Queen. As Prince Regent, he had instigated some preliminary groundwork for his scheming in 1819, with the setting up of another 'Delicate Investigation' to establish grounds for a divorce. This enquiry had lasted six months and reported its findings on July 10. It recommended to the Privy Council that a divorce would be politically disastrous and that a permanent separation, with Queen Caroline renouncing her right to be crowned, would be a more satisfactory solution. In return for an income of £50,000 per annum, Caroline would have to agree never to take up residence in any part of the United Kingdom, nor even to pay a visit. This compromise was supposed to be delivered to her by Lord Hutchinson and Henry Brougham at St Omer in France on June 3, 1820, as Caroline charged north towards the English Channel, determined to return to England and rectify the slights she felt she had been subjected to. She had decided to leave her comfortable, and entertaining, life in Italy because the authorities there had refused to acknowledge her as a Queen. But what really ignited her fury was her husband's ruling that she should be written out of the liturgy of the Church of England. Her 'subjects' were forbidden to pray for her. With impetuous ingenuity she evaded Hutchinson and Brougham, made her way to Calais and took the scheduled packet boat across the Channel. Diplomacy had failed – or, rather, been bungled – and the Queen of England would now have to answer accusations of adultery in a trial before the House of Lords. George IV's coronation was postponed.

Caroline was escorted back to England by the radical Alderman Matthew Wood and her former maid-of-honour Lady Anne Hamilton. Her landing at Dover on June 5 was the start of a triumphal progress, accompanied by a boisterous crowd of her supporters. Arriving in London, the mob pulled her carriage past Carlton House, smashing the windows of any house that did not display lights in support for the Queen – including that of the Home Secretary. Parliament was ordered to debate a 'Bill of Pains and Penalties' which, if passed, would open the way for a divorce. The proceedings became the sensation of the moment, the first time that a Queen of England had been effectively put on trial since Anne Boleyn. Some people even speculated whether the King, like his predecessor Henry VIII, would try and change the charges from one of adultery to the capital crime of treason. The main plank of the prosecution lay in Caroline's outrageous household in Italy, ruled by a poseur named Bartolomeo Pergami, with his entire family in positions at an unofficial court. Caroline had appointed her alleged lover, Pergami, as her Chamberlain; also Knight of Malta, Baron della Francina and Grand Master of an order of chivalry she invented herself, the Order of St. Caroline.

Leading her defence, the ambitious Henry Brougham managed to demolish the testament of so-called witnesses who had been primed to testify against her and who were clearly reading from a script that had been prepared for them by other hands. He admitted that his client's behaviour had been foolish and ill-advised, that it was

open to scandalous interpretation, but it had been nothing more than a pantomime, a charade concocted by a neglected and ill-treated woman, who had constructed a fantasy world to relieve her boredom and resentment. He could quote a letter from her husband, the Prince of Wales, written in 1796, in which he had given his wife 'entire liberty of action' and promising 'never again to seek the resumption of marital relations'. After weeks in which the public chortled at the obscene allegations – including an affair with the King of Naples, the brother-in-law of Napoleon – and cheered every point scored by the defence, the prosecution collapsed. The popularity of Queen Caroline soared to new heights; even the soldiers, who had lined the streets to keep order, clapped her on her way and 'skirmished in their barracks.' [248]

Elsewhere in the House of Lords, a Divorce Bill had been debated at the King's insistence. It passed its second reading by a narrow majority and its third, on November 10, by an even smaller margin. Lord Liverpool was forced to tell his Majesty that there was no point in sending the 'Bill of Pains and Penalties' to the House of Commons. The cartoonists and pamphleteers had another field day, with William Hone publishing his most successful book to date, 'The Queen's Matrimonial Ladder – a National Toy'. Illustrated with George Cruikshank's barbed drawings, it was in such demand that it had to be reprinted twelve times in the first week. [249] There were three days of popular jubilation on the streets of London and Lord Grey, leader of the Whig opposition, feared that the country was on the brink of 'a Revolution more bloody than that of France.'

The King went into a deep, morose sulk. His coronation had to be postponed again.

* * * * *

In spite of having lost her two most important protagonists, Olive was not going to be diverted from her crusade and the following two years would see her at her outrageous and flamboyant best. Her next move was to get her documents, including those left to her by George III, authenticated as genuine by a Commissioner of Oaths, for which she went to Judge Abbott's chambers at Sergeant's Inn, one of the Inns of Court. Some were attested there; for others, she appeared 'at Master Simeon's office at the Court of Chancery, before Sir Robert Baker and Barker Beaumont.' It would be crucial to Olive's case that none of these legal gentlemen disputed the genuineness of the documents and their signatures. Furthermore, she was able to provide a number of confirmatory affidavits. [250] These had been signed by people whose motives for supporting her ranged from a genuine belief in her cause to others who believed they would benefit financially from joining her bandwagon.

In the first category were General Sir Frederick Wetherall, former equerry to the Duke of Kent; Sir Gerard Noel MP; Rev. William Groves and George Clark Pickering. This latter affidavit claimed that the writer had been well acquainted with the Earl of Warwick, 'who one day, speaking of Olive Serres, seemed greatly affected

and clasping his hands together addressed me; 'My dear Pickering, the world will one day know who she is." In the second group was John Vancouver, the unfortunate former agent to the late Earl of Warwick, who had once been advised by the Earl to keep in with Olive; 'it was impossible to express what importance it might be to his future success in life to be acquainted with Mrs Serres.' [251] John Dickenson, executor to the late Earl, probably had his feet in both camps.

Following this, Olive wrote to Lord Sidmouth, the Home Secretary, requesting an audience with the King, a request that was ignored. Next she tried to get to the King via the Prime Minister, Lord Liverpool, who very politely referred her to the Vice-Chancellor, Sir John Leach. [252] He received her, but said he was unable to do anything, and that she must apply to the Lord Chancellor, Lord Eldon. He in turn advised Olive's solicitor that he would indeed be able to give a ruling on the matters mentioned in her documents, but only on a referral to him by the Home Secretary, Lord Sidmouth! [253] This buck-passing spiral brought Olive precisely back to square one, with no progress whatsoever.

On August 1, 1820, she wrote directly to the new King, stating that she 'had been doubted and refused attention by Lord Sidmouth' and pleading that he would invite one of his brothers to inspect her documents. [254] Seven letters from Olive to the King over the years 1820 to 1824 survive in the National Archives, but this is the only one that seems to have induced any response. Two of the Royal Dukes did come forward asking to inspect the documents for themselves. First was William Duke of Clarence, accompanied by Olive's solicitor and Mr Charles Broughton of the Foreign office, who 'called on that lady, and, after examining the different autographs, expressed his conviction that the signatures of his father, King George III, and of his brother, the Duke of Kent, were genuine.' [255] Next the Duke of Sussex, together with John Dickenson, inspected the papers and confirmed that 'he was perfectly satisfied as to the authenticity of the royal signatures.' [256] What is equally important is that Dickenson would have been extremely familiar with the Earl of Warwick's handwriting and his signature. On another occasion, Olive and Lavinia had met the Duke of Sussex at the home of Alderman Matthew Wood (now Sir Matthew), together with the Duke of Hamilton and another gentleman, who will be crucial to the next chapter in Olive's story – the Duke of Sussex's chaplain, the Rev. J. Brett. [257] Once again the signatures had been authenticated.

With this introduction to the Rev. J. Brett, it is important to point out that he was also chaplain to Frederick Duke of York, George IV's eldest brother and next in the line of succession. Brett was a snake in the grass. He immediately went sneaking to his second patron to tell him that Olive had documentary evidence (about Hannah Lightfoot) that was potentially highly dangerous to the Duke's personal interests. The Duke of York had once had cause to be grateful to Olive over her handling of the Mary-Anna Clarke letters; as we saw in chapter 4, 'the Princess had in 1809 served his Royal Highness with her literary interest , exceedingly, and received the

thanks of his Royal Highness in person at York House. Also several letters from the late Duchess of a most friendly nature.' [258] Since then, he had always despised and disliked Olive. Now he realised that she could be a serious threat to his future.

On the other hand, Olive seems to have enjoyed a warm and light-hearted relationship with Augustus Duke of Sussex, as Thomas Creevey revealed in his diary. [259]

> Then Sussex entertained us with stories of his cousin Olive of Cumberland, with whom, for fun's sake, as he says, he had various interviews, during which she has always pressed upon him, in support of her claims, her remarkable likeness to the Royal Family. Upon one occasion, being rather off her guard from temper or liquor, she smacked off her wig all at once and said; 'Why, did you ever in your life see such a likeness to yourself?'

Edward, however, had not approved of his brother's flirting; 'I wish that the Duke of Sussex was more sincere and less of the Italian! We must not place any confidence in his sincerity'. [260]

Having exhausted a direct route to the King via his Ministers, Olive next tried another approach that was ingrained in the constitution. Since Saxon times it had been an inalienable right of all citizens to petition the monarch on matters of personal grievance and the redressing of injustices, this right being enshrined both in Magna Carta and the 1688 Bill of Rights. Petitions used to be read prior to debates in Parliament, but by the 1820s they were taking up too much time and so a sub-committee had been established to filter out the frivolous and those deemed to be irrelevant. Olive's petition suffered this fate; the Chancellor of the Exchequer, Nicholas Vansittart, claiming that it was 'the plea of a mad woman'. It probably failed because it did not have sufficiently powerful backing, being put forward by an MP called Peter Moore who was 'unknown to her and with whom she had no correspondence'. [261]

In spite of this setback, things suddenly looked much brighter for Olive because she had attracted the support of a very clever lawyer and genealogist, Henry Nugent Bell, who worked at the Home Office. Bell claimed that he believed fervently in her cause and she appointed him 'comptroller of her household'. [262] Olive's new petition, drawn up by Bell, was submitted directly to the Crown's legal advisors on December 31, 1820, [263] It was supported by the twelve affidavits mentioned above. Although not named on the petition itself, Olive had also recruited the active support of her lover Sheriff Joseph Parkins, his significance being that petitions endorsed by the Lord Mayor's office were given fast-track treatment. The reply from the under-secretary of state at the Home Office to Olive's petition was communicated to Henry Bell on January 23, 1821, and it appeared to be very positive indeed. [264]

Mr Hobhouse presents his compliments to Mr Bell and has the honour to acquaint him that the petition of his client will be taken into consideration tomorrow.

Bell called on Olive and, in the presence of Sir Gerard Noel MP and John Dickenson among others, announced that King George IV 'had been graciously pleased to acknowledge her Highness in the Privy Council that day as Princess of Cumberland.' [265] One can imagine the champagne being brought out and the room echoing to cries of congratulation. Doubtless a few tears of joy were shed as well. While the corks popped, Bell wrote the draft of a press release, 'for Newspapers as to the acknowledgement of Her Royal Highness Princess Olive.' [266]

We have authority to state that the claims of her Highness, Olive Princess of Cumberland, having been proved to the satisfaction of His Majesty, and that his Majesty has in consequence given direction that the same may be made known through the usual channels. Our present limits will not allow us to say more than that we understand a suitable provision, with all the usual privileges are to be accorded her Highness without the least delay.

However, Bell was somewhat anticipating the outcome and this statement was never printed, though the news leaked out. Olive suddenly found herself surrounded by people prepared to lend her money. Tradesmen who had recently pressed for payment now offered her unlimited credit. She started signing her letters 'Princess Olive of Cumberland' or 'Duchess of Lancaster'. She hired a carriage, complete with liveried coachman and footman, and had her own Royal coat of arms painted on the doors. And she and her new secretary moved into a lavish establishment at 48 Ludgate Hill while she awaited final confirmation of her triumph from the Home Secretary. Bell inferred that this was a mere formality, 'as there are only a few trifling forms to be complied with … created by the dull forms of office'. [267]

ENDNOTES

216 These artefacts were preserved in the possession of one of Olive's descendants and a photograph of them was printed in Pendered & Mallett p209.

217 Bodleian Library, Oxford. Shelfmark MS. Eng. Hist c722, f22

218 Price family papers. This affidavit was not allowed to be admitted as evidence in the Ryves trial of 1866. It also includes confirmation that Olive had raised money to help the Duke and Duchess of Kent return to England in 1819.

219 Gillen p245. The property is now called the Royal Glen Hotel.

220 Bodleian Library, Oxford. Shelfmark MS. Eng. Hist c722, f30

221 The annuity from Robert Owen.

222 National Archives J77/44, doc. 74

223 National Archives J77/44, doc. 75

224 The first was published in Ryves, 1858. If it was produced at the Ryves trial of 1866, the original appears to have been relocated.

225 National Archives J77/44. Doc 69

226 National Archives J77/44. Doc 65

227 The original was in National Archives PROB 31/1184 no. 661A, previously catalogued as PCC exli1822 661A, but can no longer be traced. See Appendix D. National Archives HO 44/1 folio 178 includes two endorsed copies. The image is from a poor photocopy sent to Richard Price from the PRO in July 1968.

228 At the time of Queen Victoria's accession, the Duchy properties consisted of 38,301 acres, spread across sixteen counties.

229 Gilbert.

230 Memoir of the late J T Serres, p37.

231 National Archives TS18/112 Large folder

232 National Archives TS18/112 Large folder

233 *The Times*, July 3, 1819.

234 National Archives TS18/112 Large folder

235 Bodleian Library, Oxford. Shelfmark MS. Eng. Hist c722, f18/19

236 National Archives TS18/112 Large folder. Olive gives a slightly different version of this letter in her '*Statement to the English Nation*' implying that she should be the sole guardian.

237 National Archives TS/112 Big folder.

238 Shepard p36

239 Quoted in Fulford p202

240 Fulford p203

241 National Archives J77/44, docs 111 & 112

242 Huish, p272

243 National Archives HO 44/1 folio 136

244 It was first auctioned as one lot on May 29, 1827, but failed to find a buyer. On a court order initiated by a Mr Fournier against the Duchess of Kent, a four day demolition auction took place

during the last week of May, when General Wetherall acquired two plots of land and 29 lots of architectural salvage. One of the houses later erected on the site was used in the eponymous TV series as the home of Inspector Morse. (Ealing Central Library; the Wetherall Papers.)

245 Hudson.

246 Wardroper chapter 22. Also Hudson.

247 Hudson.

248 Royal Archives Coutts MS Y 56/57

249 Wilson p320.

250 National Archives J77/44/R31. Also copies in WRO.

251 Vancouver.

252 Unpublished correspondence of Lord Liverpool, Dept. of Manuscripts, British Library.

253 WRO CR1886 Box 677.

254 National Archives TS 18/112 Letter no. 49

255 Ryves.

256 Ryves.

257 Shepard p35

258 Olive, 1822.

259 Creevey. Diary entry for January 29, 1821.

260 Bodleian Library, Oxford. Shelfmark MS. Eng. Hist c722, f17

261 Olive, 1822 p75-7

262 National Archives TS 18/112. Big folder. Original document of appointment, witnessed by Lavinia and Joseph Brett, Clk. MA. under Olive's 'Royal Seal'.

263 Gattey p188-9

264 Pendered & Mallett p182

265 Pendered & Mallett p182

266 Pendered & Mallett p277.

267 Letter from Bell to Lavinia, Jan 25. Quoted in Olive 1822. p67

Chapter 12

Triumph and Tribulation

'O put not your trust in princes …'
Psalm 146, the Book of Common Prayer.

OLIVE HAD already scored one triumph. In November 1820, she made a considerable hit at the Lord Mayor's banquet, as Thomas Creevey confided to his diary. [268] 'My attention,' he wrote, 'was directed to a splendid object – the Princess Olive of Cumberland. No one can have any doubts of the royalty of *her* image. She is the very image of our Royal Family. Her person is upon the model of the Princess Elizabeth, only at least three times her size. [269] She wore the most brilliant rose-coloured satin gown you ever saw, with fancy shawls (more than one) flung in different forms over her shoulder, after the manner of the late Lady Emma Hamilton. Then she had diamonds in profusion hung from every part of her head … the whole was covered with feathers that would have done credit to any hearse.' **(Plate 14 & cover)**

He noted, rather peevishly, that his own entry to the Mansion House had been held up for several minutes. Apparently Olive had made a scene, demanding that, as a 'Princess of the Blood' she should be placed beside the Lord Mayor. It took some time before she was persuaded to sit at another table. But when the principal guests later retired to the drawing-room, 'her train was borne by the ladies of eight aldermen … and refreshments were handed to her by the Lady Mayoress herself.' Quite a coup. On another occasion, when she attended a performance at Drury Lane Theatre on the arm of Sir Gerard Noel, the manager 'laid out the red carpet' and welcomed her personally with full honours.

The Home Secretary, Lord Sidmouth, was no minor minister; he was, on the contrary, a political giant. As Henry Addington, he had been the Prime Minister for three years from 1801, before falling out with William Pitt the Younger over his too conciliatory conduct of the war against Napoleon. A succession of high public offices had followed, including Speaker of the House of Commons and Lord Privy Seal, until he was appointed as Home Secretary in 1812. A determined anti-reformist, he was responsible for the suspension of Habeas Corpus in 1817 and the repressive

'Six Acts' that restricted the rights of public assembly and the freedom of the press. He had had to deal with the repercussions in the aftermath of the 'Peterloo Massacre' of 1819 and the deportation of the 'Tollpuddle Martyrs'.

In some ways, Sidmouth had good reasons to fear what Olive might do. The London mob had adopted the cause of the rejected Queen Caroline, at one time stoning the windows of Sidmouth's house in their fury. Those disaffected with George IV – and there were many – were looking for a new figurehead, and Olive, presenting herself as another slighted Princess, might easily slip into the role. If she was converted by her followers and supporters from an eccentric self-publicist into a folk hero, public law and order would be put in serious jeopardy. She was highly intelligent; she was charismatic and popular, and therefore increasingly dangerous.

She was also edgy and impatient. Bell had anticipated the outcome of the Privy Council meeting at the end of January, since when there had been no confirmation of Olive's rights and entitlements. So she ordered Bell to go back to the Home Office and find out what the stumbling block really was, and it became immediately clear that it was the 'missing' marriage certificate to show precisely when and where her father was supposed to have married her mother – 'Olive'. And this was a document she could not produce. However, she had recently taken on a dashing young secretary, William Fitzclarence, who proved to have a remarkably useful talent. He was not only handsome and plausible, but he had very neat handwriting.

Fig. 6. Letter in the handwriting of Olive's secretary, William Fitzclarence ('Fitz') [NA HO 44/1 f138]

Given Olive's tempestuous character and the uncertainties about her true origins, it is completely appropriate that she should become intimately embroiled with a young man as intriguing and mysterious as herself. Although she would not have known it at the time, believing him to be another illegitimate Royal cousin, his most likely identity is someone called William Strang Petrie who was born in Kirkwall, the son of a tailor, around 1800 – making him at least 25 years younger than Olive. [270]

From fragments of correspondence in 'Notes and Queries' during the 1860s, it is possible to reconstruct something of his career, starting as an auditing clerk in the Court of Session in Edinburgh before turning his attention to genealogy and becoming a freelance investigator 'into matters of heredity and the tracing of pedigrees'. [271] When he turned up in London (having had to flee from Edinburgh after stealing some documents from Holyrood Palace) he called himself William Henry Augustus Fitzclarence and claimed to be an illegitimate son of William, Duke of Clarence. Later it would be acknowledged that the Duke had fathered ten children by his mistress, the renowned comedy actress Mrs Dora Jordan, though none of these had that name. However, the Duke had been involved in several previous affairs, including a 'handsome young woman known as Polly Finch, who usually plied her trade in London.' [272] And around 1789, one such affair produced a son, coincidentally called William, who was adopted by his father. [273] For the time being, Petrie's alias was not questioned.

What does seem to have been accepted was that Petrie/Fitzclarence was a skilled calligrapher – with the implication that he might also have been a subtle forger. Not only did he become Olive's lover; he would also become closely involved with Lady Anne Hamilton, Queen Caroline's lady in waiting. This would, before long, prove to be an important link in a chain of events that sealed Olive's notoriety.

For the immediate future, however, Olive had to flesh out some details about her supposed mother, 'Olive', and, to prove her own legitimacy, how this lady had come to marry Henry Duke of Cumberland some time before he married Anne Horton. The scenario that Olive came up with was audacious and ingenious, but it introduced as many enigmas as solutions to the key problem.

The plot for her pedigree would now run as follows. Her 'uncle', Dr. James Wilmot, was in fact her *grandfather*, and his brief summer meeting at Oxford with a Polish Princess, as mentioned in her biography of James Wilmot, had taken place when he was a *student*. It had turned into a full-blown romance. Now the object of James Wilmot's desire became a sister of Stanislaus Poniatowski. King of Poland, and the couple had *married* and had a daughter, called 'Olive', born on June 17, 1750, who in turn married Henry, Duke of Cumberland. The ceremony had been performed by Dr. James Wilmot in the London house of his friend and patron, Lord Archer, on March 4, 1767. Perhaps surprisingly, the only issue from this supposed marriage was the baby girl – Olive herself – born five years later and who must have been conceived at almost exactly the same time that Anne Horton became pregnant.

When Henry Duke of Cumberland had ditched his semi-regal, half-Polish, wife and had gone through a bigamous wedding ceremony with the English commoner, 'Olive' had been heartbroken. Rejected and destitute, she had had to leave her baby to be adopted by her father's family, while she fled to obscurity somewhere in France, only to die in 1774, 'in the prime of her life, of a broken heart'. [274]

Into the blender of her imagination, Olive had tossed the stories she had heard from Dr. James Wilmot about the people he had met, together with the popular gossip about the early love-life of Henry, Duke of Cumberland and his affair with the Countess Dunhoff. Olive had not taken the trouble to find out that the King of Poland's two sisters had well documented marriages. [275] Nor did she seem concerned that there was not a single shred of evidence that 'Olive' had ever existed. Nor that Olive herself had been adamant in her published facts about James Wilmot's life that he had never married. The only thing that did fit into place was why James Wilmot, via the mouthpiece of 'Junius', had loathed the Lutterell family with such detestation. Later, Olive would elaborate on certain details of her imaginary mother's life, including the wild and romantically silly idea that young George Greville, later the Earl of Warwick, had also fallen in love with her, but had, with great chivalry, stepped aside and left the prize to the Royal Duke! [276]

Olive had now concocted her new, preposterous pedigree and the only problem, as far as she saw it, was that she had no documentary evidence to support it – apart from that single piece of paper about her own birth. **(Plate 16)** Crucially, she had to find her parents' marriage certificate. Surely the Earl of Warwick had meant to leave this to her, but perhaps he hadn't had time to get it from his desk during his last, clandestine visit to Warwick Castle? Olive claimed later that this omission must have weighed heavily on his conscience, disturbing his unquiet spirit 'on the other side'.

The proof she needed would now – apparently – arrive from a surprising, indeed supernatural, source; for which she had impeccable witnesses. [277] Late one evening, Olive and her daughter Lavinia had been at home drinking tea with two guests. One was Mr George Charles Pickering of East Soham, Suffolk, and the other was Olive's cousin, the Rev. William Groves. There had been a knock on the drawing-room door but no one was there. Ten minutes later, there was an even louder knock, which Olive again went to investigate and now her companions, who could only see a view of her back, saw her stand rigid for several moments in the doorway. Turning back into the room, her complexion ashen, she told the astonished company that the visitor had been none other than the ghost of the Earl of Warwick, who had thrust a packet of papers into her hand. She had then fainted. In reality, we must suspect that the 'ghost' had been Fitzclarence and the documents had been 'devised' in the office of her new secretary.

* * * * *

In the course of Olive's campaign for Royal recognition, and then in Lavinia's various court cases after her death, a number of papers would be produced that referred to

and apparently proved the supposed marriage of Henry Duke of Cumberland, to 'Olive'. All of them had signatures of real people, many famous. Some are undated; others bear dates that range from 1767 to 1791.[278] It is the present author's case that 'Olive' never existed, leading to the conclusion that they were all forgeries, fabricated by the man Olive referred to as her 'Fitz'. (Olive may have had artistic flair with a paintbrush, but her handwriting was excruciatingly imprecise.)

Since Olive had driven herself into a position of self-delusion about her parentage, had committed herself to denying that Anne Horton had been her mother, it is of interest – and some amusement – to look at some of these documents on which her future would so crucially depend.[279] And the outcome of Lavinia's court case in 1866.

The earliest is dated November 3, 1767, apparently signed by James Wilmot and witnessed by 'Chatham' and 'Archer'.

> Lords Chatham and Archer solemnly protest that the marriage of Henry Frederick, Duke of Cumberland and Olive my daughter, the said Duke's present Duchess, was solemnised legally, at the latter nobleman's residence, Grosvenor Square, London, by myself, March 4th, 1767.

Virtually identical, but undated, is another record of the 'marriage'.

> The marriage of the underwritten parties was duly solemnised, according to the rites and ceremonies of the Church of England, at Thomas Lord Archer's house, London, March 4th, 1767, by myself.

This document bears the signatures of Dr. James Wilmot, Henry Frederick (Duke of Cumberland) and 'Olive' Wilmot herself, the signatures being 'attested' in the presence of J. Dunning and Chatham. There are two witnesses, the first being Brooke (the title of George Greville before he became Earl of Warwick in 1773). It is the second witness who is most intriguing, a completely new character in our story by the name of J. Addiz. There was indeed a servant to the Duke of Gloucester by this name, but why should the presumed forger choose such an unlikely person in the role of witness? Was it thought that the choice would somehow add authenticity to the document? If that was the case, as we will see later, it spectacularly misfired. Perhaps most interesting of all is the fact that one of these documents was written on the back of an earlier one, one that certified the marriage of the young Prince George to Hannah Lightfoot! If, for a moment, we try and second-guess the mind of a forger, surely the best way of recreating an old document would be to put it on the back of a genuine one of approximately the same date?

* * * * *

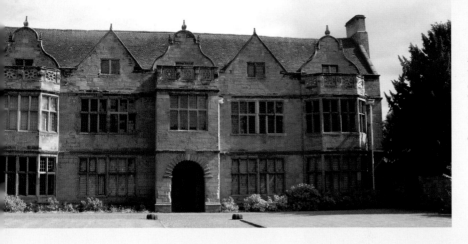

Plate 1
St John's, Warwick, where Olive spent her early childhood.

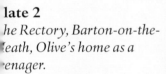

Plate 2
The Rectory, Barton-on-the-Heath, Olive's home as a teenager.

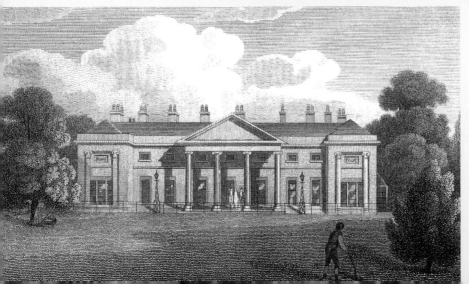

Plate 3
Castle Hill Lodge, Ealing, the home of Edward Duke of Kent and his mistress, Madame St. Laurent.

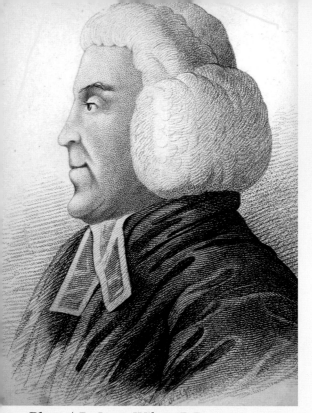

Plate 4 *Dr James Wilmot D.D.*

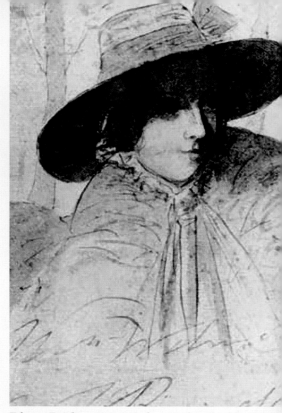

Plate 5 *Olive, 'Miss Wilmot', sketched by Sir Joshua Reynolds in 1790.*

Plate 6 *Classical landscape painted by Olive circa 1805.*

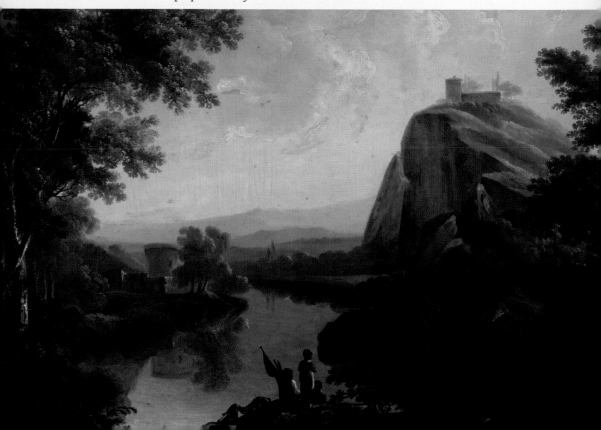

Plate 7 *Hannah Lightfoot, the second of possibly three portraits by Sir Joshua Reynolds circa 1758.*

Plate 8 *George Greville, 2nd Earl of Warwick. This bronze bust in Warwick Castle is the only known image of the adult Earl.*

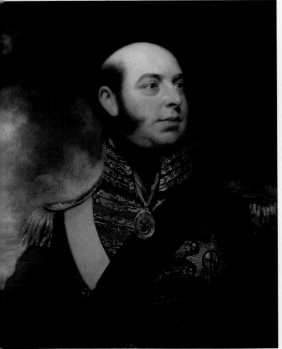

Plate 9 *Edward Duke of Kent, George III's fourth son, Olive's champion within the Royal family and the father of Queen Victoria.*

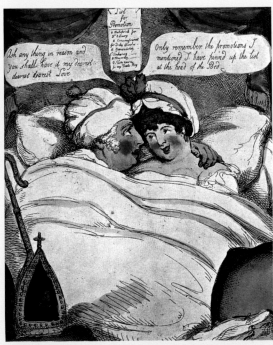

Plate 10 *Frederick Duke of York, the hereditary Bishop of Osnabruck and Commander-in-Chief of the Army, with Mrs Clarke.*

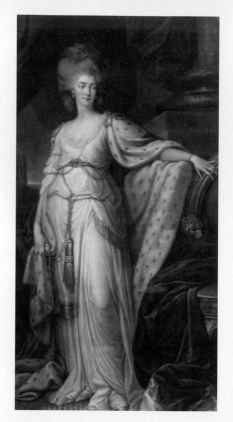

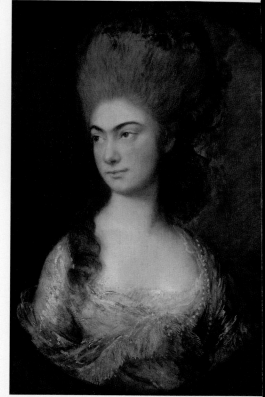

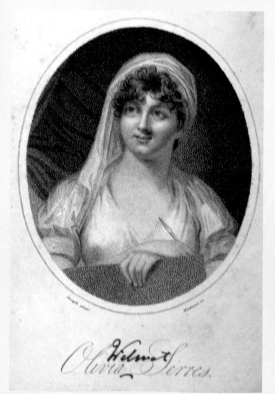

Plate 13 *Olive's visiting card, as sent to
Lady Anne Hamilton.*

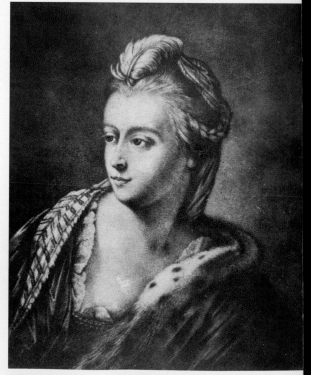

Plate 14 *Olive, painted around 1820, when she
adopted the title of Duchess of Lancaster. Note
ermine collar.*

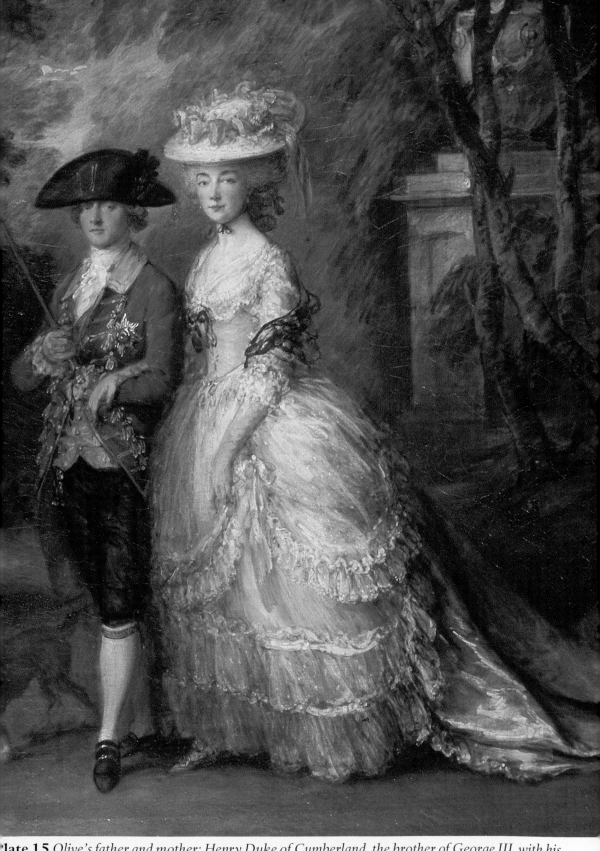

Plate 15 *Olive's father and mother; Henry Duke of Cumberland, the brother of George III, with his Duchess, Anne (Lutterell) Horton. Portrait by Thomas Gainsborough, circa 1785. (Detail)*

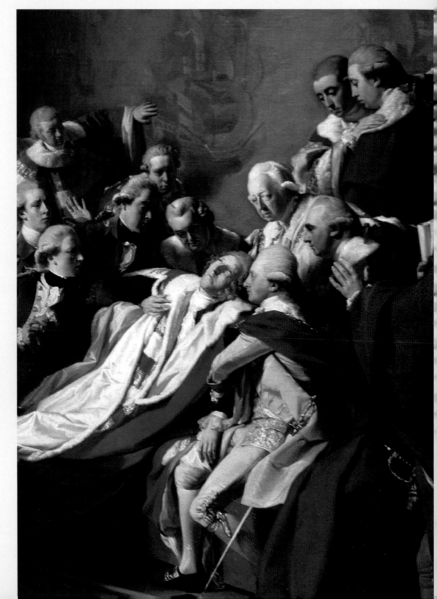

May 30th 1773 Solemnly
By His Majestys Command we certify that Olive Wilmot
the supposed daughter of my Brother Robert is Princess
Olive of Cumberland the only Child of Henry Frederick Duke
of Cumberland and Olive His Wife Born April 3d 1772 at My
mothers Warwick.

J Dunning J Wilmot

Robt. Wilmot Brooke

Plate 16 *Olive's 'birth certificate', the controversial document that appeared to show that her mother had also been called 'Olive'.*

Plate 17 *Collapse of Earl of Chatham in the House of Lords. Henry Duke of Cumberland is holding his left arm, April 7, 1778. (Detail.)*

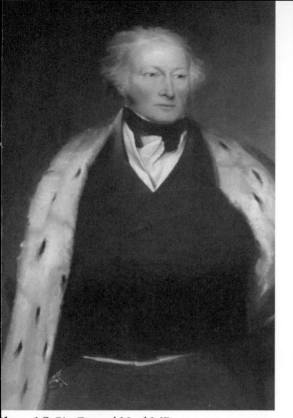

Plate 18 *Sir Gerard Noel MP.*

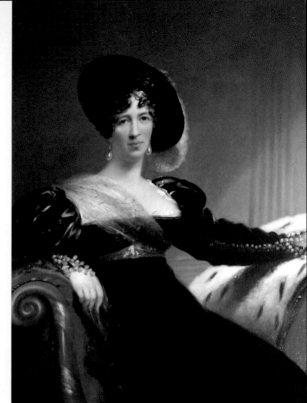

Plate 19 *Lady Anne Hamilton.*

Plate 20 *Cartoon of the return of Queen Caroline, 1821. Signor Pergami on her right and Alderman Wood on her left.*

Plate 21 *Thomas D W Dearn, Olive's brother, the son of Henry Duke of Cumberland and Anne Horton. (Painting by David Wilson, from a miniature, circa 1810.)*

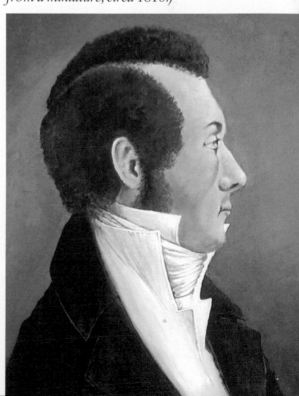

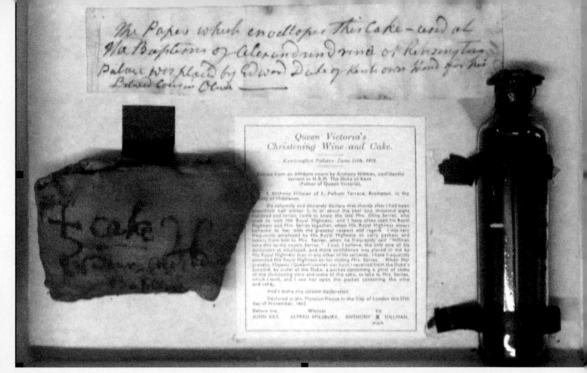

Plate 22 *Wine and cake sent to Olive by Edward Duke of Kent from the christening of Princess Victoria.*

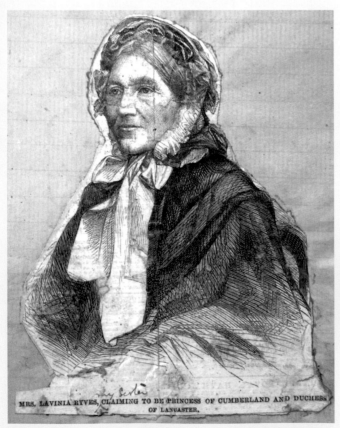

MRS. LAVINIA RYVES, CLAIMING TO BE PRINCESS OF CUMBERLAND AND DUCHESS OF LANCASTER,

Plate 23 *Lavinia Ryves, 1866, with note by Britannia.*

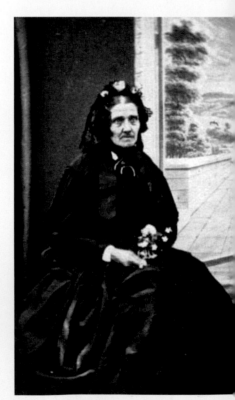

Plate 24 *Caroline Price (Dearn), Olive's daughter by the Prince of Wale. in old age.*

Armed with this new ammunition, Bell had been back to the Home Office, as he wrote to Olive on January 29, 1821. [280]

> In compliance with your Highness's commands, I went to the office of Lord Sidmouth and signified to his Lordship that your Highness was ready to produce a certificate of the marriage of your late Royal father, Henry, Duke of Cumberland, stating the place where the said wedding was celebrated, if his Lordship would declare in writing that his Majesty, or his Privy Council, deemed the same to be either expedient or necessary.
>
> To this statement, Mr Hobhouse, having communicated with his Lordship, verbally replied that it would be inconsistent for his Majesty, or his ministers, to dictate to any applicant or counsel involved what course they should pursue, but that his Majesty's ministers were disposed to evince such legal evidence as you might think proper to adduce in support of your claims, and Mr Hobhouse also stated, as much as I can charge my memory, *that the place where the marriage of the late Duke of Cumberland with Olive Wilmot was celebrated, should be expressly stated* in order to enable his Majesty's ministers to report to his Majesty what they conceive might be properly done with respect to the prayer of your Highness's Petition to his Majesty.

Sidmouth must have realised that this was the 'moment critique'. Would the address she produced be Anne Horton's house in Hertford Street where she had married Henry Duke of Cumberland on October 2, 1771? If so, the crown's last defence against Olive's campaign would be broached. He had to stall for time.

So when Bell later confided to Hobhouse that the crucial address that Olive believed to be location of her parents' marriage had been the house of Lord Archer, and the date had been 1767, Sidmouth must have heaved a huge sigh of relief. He knew perfectly well who Olive's real mother had been and she, by staking her claim on the basis of the fictitious daughter of Dr. Wilmot, had dug herself into a deep mire and he could safely let her drown in it.

But he was not prepared for the next revelation. On February 21, Bell wrote to Hobhouse with his latest intelligence, including the following: [281]

> I waited on my client the Princess yesterday after I had the honour of seeing you and found her perfectly tranquil & alone. She gave me some additional information about her claims, *and the marriage of his late Majesty.*
>
> It appears that old Wheeler, the cousin of Queen Hannah, is living in the neighbourhood of Charing Cross with an aged sister of his, who can give much information and who can also swear positively to the handwriting of that unfortunate lady.

Another old man of the name of Lightfoot, aged 83, can prove the hand writing of Anne Tayler and will also prove that it was the reputation and belief of his family and that of Queen Hannah that *she* was murdered in a French convent. There is a legacy left to Anne Tayler by a person whose Will is now with Doctors Commons, which hints at these facts and states it is the wish of the testator that, if the report of her untimely death should prove unfounded, she, the said Anne, is to have a sum of money therein specified (many thousands I believe) if she appear personally to claim the same.

Dr Moore, Bishop of Bangor I think but afterwards Archbishop of Canterbury, remarried his late majesty to Queen Charlotte on the 1st July 1765 and the Princess has various documents to prove this fact, some of which I have read. It may be prudent to state that it is my opinion and firm belief that the same are genuine. There is a parcel directed to the Society of Quakers, the seals of which the Princess assures me she has not broken; it is in the form like the others and directed in the handwriting of Dr J Wilmot.

This letter also confirmed that William Duke of Clarence had personally inspected Olive's documents. Bell ended with the suggestion that it might be advisable to make at least some show of progress. Perhaps a further letter stating that a second application had been made to the Privy Council? Hobhouse received another letter the following day from Olive herself, in which she protested in the strongest terms that her estranged husband had been spreading slander; 'he has dared to repeat that I had been intimate with His Majesty, poor Lord Warwick and others!' [282]

Meanwhile, Olive had continued building up her team of professional advisers, employing a Mr Primrose as her solicitor and Charles Knight, formerly the private secretary to Queen Caroline and recommended by General Wetherall, as her 'true and lawful attorney'. [283] She assigned him the task of recovering the '£2,000 owed to her by the Earl of Warwick for monies lent and advanced and paid out and expended by her to or for the Earl, and also for certain books, pictures and a marble statue owned by her and by him sold or converted to his own use and allowed by one of the Masters of the High Court in a case brought by Thomas Hunt on behalf of himself and all the creditors of the late Earl; also a further sum of £2,000 (plus interest) for monies received by the Earl from the late Duke of Cumberland for her use in 1884, plus the £2,000 that she was owed by the Warwick Trustees'. [284] She offered him a share in the bounty, money that she needed urgently. In return for this inducement, Charles Knight settled a number of her bills and wrote letters supporting her claims, but woe-betide him if he failed to deliver.

* * * * *

For several weeks Olive had been driven around London in her splendid equipage emblazoned with her Royal coat of arms as Duchess of Lancaster. No one stopped

her. The test would come in March 1821; would she be allowed out through the gate of St James's Park at the top of Constitution Hill? This well guarded gateway was for the exclusive use of members of the Royal family only. The sentries barred her way and refused to open the gates. She ordered her coachman to hold his ground, and so began a stand-off that would last for two hours, while the crowd of curious onlookers grew and grew and she chatted amiably with Lord Darnley. After twenty minutes, she scribbled an imperious note to the Home Secretary requesting his personal intervention in the matter. Her footman, in his spanking new livery, scurried across the Park to deliver it to Whitehall, and eventually a messenger came from the Home Office and the gates were opened. Waving to the enthralled crowd, Princess Olive drove through in triumph. She had scored a very public recognition of her status. [285]

While she waited for final confirmation of her Royal entitlements from the Privy Council, she rather tactlessly instructed Primrose to write to the Home Secretary virtually accusing him of being responsible for her embarrassment at the gateway out of St James's Park. Lord Sidmouth's answer had been blunt, causing Primrose to reply in feigned indignation. [286] It was not his client's intention 'to issue process against your Lordship' now that she understood the facts. However;

> I am directed to express her astonishment that she should in any way be alluded to as Mrs Serres, which name she utterly disclaims and the more particularly after the documents and affidavits which were submitted to your Lordship's consideration, on presenting her petition to the King and which her Highness apprehends must be quite satisfactory to your Lordship's mind, that she is what she assumes, Princess of Cumberland, as the legitimate child of the late Duke.

This, combined with the disturbing content of Bell's letter of Feb 21, was the last straw for Sidmouth. He summoned Henry Bell to the Home Office on the afternoon of March 20, 1821, for a confidential meeting – with himself and the Duke of York, Olive's nemesis. The Duke was next in line to the throne after George IV and he was relishing the prospect, but Olive's papers about his father's marriage to Hannah Lightfoot, casting doubts on his own legitimacy, might stand in his way. His chaplain, Brett, had seen the papers himself; Bell had now confirmed his own belief that they were genuine. Furthermore, the Duke had received a letter from Sir Henry Taylor, the private secretary of the Duke of Clarence, after his master had inspected them. [287] Sir Henry put his own rather dramatic, speculative and erroneous interpretation on their content. 'Her object is to hold out in terrorism the proofs she can produce of the illegitimacy of the King and of your Royal Highness … She had much communication with the late Duke of Kent … We must presume that his own illegitimacy would have been equally to be shown if the Duke of Kent had lived.'

Somehow or other Olive's campaign had to be stifled and the simplest way was to bribe Bell to withdraw his evidence from her case. And handsomely bribed he was.

Olive would never see him again and, even more important, he now had several of Olive's original documents. On April 3, Hobhouse wrote to Bell informing him that the Privy Council had rejected any further consideration of Olive's claims. Bell posted this news to Olive, explaining to Hobhouse that he 'thought it more prudent to send her a copy of your letter than to have any personal communication with her on this subject'. [288] Prudence or cowardice? 'If she shows this letter to those she calls friends' he continued, 'it will bring a host of clamorous creditors round her immediately'.

Two days later, Olive's solicitor penned a long letter to Lord Sidmouth politely requesting, on a point of justice, to know the reason for the rejection. Was the validity of any of her documents being questioned? [289] Lord Sidmouth's reply was a classic example of the 'Catch 22' syndrome. Since she had put her petition forward in the name of the Princess of Cumberland, a title for which she was seeking endorsement, he deemed it 'unnecessary for him to enter further into the question'. [290]

Shortly afterwards, Bell quit his rather humble lodgings at John Street in the Adelphi and moved into 19 Whitehall Place, a noble mansion owned by the Crown. He even had the audacity to apply (unsuccessfully) for a baronetcy. In October 1822, he committed suicide. Many years later, his widow, by then a Mrs Johnson, made a deathbed confession in a letter to Lavinia confirming her first husband's duplicity and returning to her the documents that Bell had accumulated.[291]

When reviewed in hindsight, it seems as if Lord Sidmouth pursued an almost personal vendetta against Olive, and the roots of this suspicion and antipathy might go back to his own father, Dr Anthony Addington. Dr Addington had been Lord Chatham's 'physician *and confidant*' [292] and so may have been privy to his patient's involvement with Hannah Lightfoot. And if this intelligence had been passed on to his son, Lord Sidmouth would have known, or at least suspected, that most of Olive's documents were not only explosive, but genuine.

* * * * *

Sheriff Joseph Parkins was still basically on Olive's side, though he was beginning to have doubts because he felt himself being squeezed out of her life and the financial deals that would make him rich. First, she told him that if he did manage to challenge the Duke of Kent's official Will and sell Castle Hill behind the executors' back, she had the Duke's other Will that gave her a prior claim for £10,000. Then, when he called on Olive at her house, he found that the youthful 'Fitz' was clearly in residence as her lover and he, Parkins, had lost out on access to her bed.

'Fitz' meanwhile decided that he had made a mistake about his own parentage, prompted no doubt by people in the know who pointed out that the real William Fitzclarence had been drowned in 1807. [293] So 'Fitz' now claimed that his father had not been William Duke of Clarence but Edward Duke of Kent! He explained this aberration in a letter to the Rev. Groves by saying that his mother had been

'surprised' in the dark by both Royal Dukes on the same night. [294] Accordingly, he made it known that his surname should be Fitzstrathern, a title of the Duke of Kent, and, coincidentally, one held previously by Olive's father, Henry Duke of Cumberland. He claimed in the same letter that his father had given him a generous allowance until he died and had left him a £5,000 bond against the Castle Hill estate. Parkins felt doubly insulted when Olive sent him a written instruction; 'You will feel pleasure to announce to the City that Mr. Fitzstrathern is the only son of his late Royal Highness!' [295] (And, by implication, the elder half-brother of Princess Alexandrina Victoria.)

Snubbed and patronised, Parkins now began to waver in his support for Olive and he started doing some of his own research into Olive's claims. He first went to visit Robert Wilmot's son, Thomas Wilmot, in Warwickshire. (Robert himself had died in 1812.) Thomas held a prestigious position as Official Receiver for Coventry and he told Parkins in no uncertain terms that he found Olive a gross embarrassment to his family name. In a statement he said that Olive was 'such a firebrand (that) he would not for the world allow her to come within the door of his house.' [296] He went on to declare that 'he would be glad if she could prove her relationship to *anyone* else, as he wished to cut all connection with her', though he personally believed that she was, and always had been, his sister. Interestingly enough, his genuine sister, Anna Maria Wilmot, who had married a John Kennet, believed in Olive's cause and subsequently signed affidavits on her behalf. [297]

When Parkins visited the 3rd Earl of Warwick, he was subjected to a tirade about Olive's persistent claims on his father's estate. With rude arrogance he gave Parkins £5 to pass on to Olive in a gesture to shut her up. [298]

* * * * *

King George IV's coronation could no longer be delayed and a date was set for July 19, 1821. He had obviously studied his ancient history, recalling that Roman Emperors had bought the favour of the populous by giving them triumphant spectacles and bloodthirsty 'games' in the Coliseum. He persuaded Parliament to vote the vast sum of £243,000 for the ceremony alone. [299] It was going to be the most splendid, extravagant coronation ever seen. (The Duke of York was heard to say that when his turn came, it would be just as good if not better.) [300] If Olive could get an invitation via the Lord Chamberlain, it would be a significant recognition of her status. She therefore wrote to him from Alfred Place on June 12 – copying the letter to several of her friends; [301]

> I take the liberty of addressing your Lordship to entreat the gracious permission
> of his Majesty to be allowed, as the legitimate daughter of his late Majesty's
> brother, Henry Frederick, Duke of Cumberland, to attend the coronation. And
> at the same time, I inform your Lordship that I am possessed of his late

Majesty's royal confirmation of my legitimacy, as Princess of Cumberland, in
addition to the laws of these realms, there being no marriage Act at the period
of my Royal parents' marriage to operate against its legitimacy, but I have no
wish to intrude upon his Majesty's presence, without it being his Royal pleasure.

The Lord Chamberlain was not going to be wrong-footed by this request and no
invitation arrived.

But there was someone else who did not have an invitation and was prepared to
try and gatecrash the event. Queen Caroline, hell bent on having an equal share in the
Coronation ceremonials as her husband, tried to gain access to Westminster Abbey
by a side door, only to have it slammed in her face. And some in the crowd even jeered
her.

By now she was a caricature of herself; short, very fat, over-rouged and with a
dyed black wig, dressing herself in skimpy muslin slips decorated with flowers.
(Plate 20) Three weeks later, exhausted and unable to gain strength from her
lingering but declining popularity, she died on August 9. Olive immediately wrote a
black-edged letter of condolence to her Lady in Waiting, Lady Anne Hamilton. [302]
Caroline's funeral brought thousands of her supporters back onto the streets again
and there was rioting along the route of her cortege, as it slowly threaded its way
from Hammersmith to the Pool of London, where her coffin was loaded onto a ship
for its final journey back to Brunswick. She may have lost her cause in her lifetime,
but numerous writers, including Olive, would later make her story the basis for a
whole library of literature that kept her memory alive.

While the King was enjoying his own new-found popularity, Olive's creditors
grew alarmed that there was no further word from Henry Bell and that there was
still no official recognition of her Royal status and the wealth that would
accompany it. Some of them started filing actions against her for unsettled loans
and debts, so it could not be long before she would be hauled before the King's
Bench to answer these charges. [303] But before this degrading experience, she carried
out a typically flamboyant act. If the secular authorities would not recognise her,
perhaps the Church would, particularly if she could catch the Bishop of London
off his guard. She had written to him on the day Queen Caroline had died, asking
to be confirmed. [304]

As Princess of Cumberland, I wish to be confirmed and shall be obliged if you
will perform that sacred ceremony. Educated by Doctor Wilmot in the true
principles of the Christian faith. … [she asks for an early appointment] … when
I will show your Lordship the authority and confirmation of his late Majesty
for my present request. Dr Wilmot, bound by certain secrets, by that sacrament
in 1772, could not explain until the late King's demise, why he delayed my
confirmation, which the documents of my royal birth fully explain.

The Bishop's staff procrastinated, and when the reply did eventually arrive in early September the Bishop politely declined, using the 'technicality' that confirmations in London were only conducted in May and June, adding the rider that 'it would be highly improper of him to enter into any discussion on a question which he had not authority to connive or decide.' [305]

Throughout the summer, Charles Knight seems to have done his best to advance Olive's interests. On July 16, he had written to the Lord Chancellor, Lord Eldon, and to the Duke of York, 'on behalf of a lady, the daughter of the late Duke of Cumberland, in the conviction that your Royal Highness cannot have been acquainted with all the circumstances attending her claim, for if you had, I feel assured that the sense of justice and humanity (for which your Royal Highness is so eminently distinguished) would long ere this have interposed on her behalf and have rescued her from the accumulated evils to which she has, for a considerable time, been exposed.' [306] In return for his efforts, Charles Knight merely got a flea in his ear. The Duke's secretary replied from Horse Guards the following day '… to acquaint you that his Royal Highness has repeatedly declined all communication, directly or indirectly, with Mrs Serres on the subject to which you refer and your application to be admitted to a private audience about it.'

Olive, having failed to get the church to recognise her status by way of confirmation, now tried another ruse. On September 6, 1821, she drove up in her carriage to the church of St Mary's, Islington. 'The curiosity of the neighbouring inhabitants', wrote the editor of a local newspaper, 'was much excited on seeing a portly, well-dressed dame, apparently about fifty, handed from the coach by a dashing young fellow of no more than half her age, to whom it was concluded that she was about to bestow her fair hand at the altar.' [307]

In fact – and this may have been rather an anticlimax to the eager onlookers – Olive had taken her young lover, now calling himself 'Captain' Fitzstrathern, not to a wedding ceremony but to witness her baptism. Later in the same article, the editor quoted a letter from 'the Princess of Cumberland herself', which he claimed as an exclusive scoop. Olive explained to the readers that she had been only 'half-baptised at three hours old, as the infant of the Duke and Duchess of Cumberland', without mentioning that she had been properly christened at St. Nicholas, Warwick, as the daughter of Robert Wilmot and his wife. [308]

Her letter continued that she now wished to be fully received into the Church; 'Her Highness, wishing to approach her God and satisfy the English nation as to her legitimacy, adopted the called-for measure – bound by every principle of conscientious honour to respect the ceremonies of that religion which has so eminently distinguished Great Britain, and preserved its internal repose amidst the turmoil of surrounding States!!!' It was all part of her performance to prove that she was not only a worthy Princess of the Royal blood, but a staunchly Christian and patriotic one as well. (It is interesting to note that the entry in the Islington Parish

records states that Olive's parents had been Henry Duke of Cumberland and 'his first Duchess' – unnamed.)

This bold assertion and recognition of her title finally tipped Joseph Parkins over the edge. Like a cuckolded husband, he vented his jealousy of young Fitz in a grovelling, obsequious letter to King George IV. [309] He was, anyway, desperate to get back into Royal favour, having been de-selected as a sheriff of the City of London after a damning enquiry into his official expenses in July 1821. [310]

> Sire, In presuming to congratulate your Majesty's safe return after a tempestuous sea voyage to the Metropolis of your British Empire, allow me with the most profound Deference and Respect, to subjoin a plain statement of some extraordinary circumstances, which came to my knowledge during my Shrievalty, materially affecting your Majesty's Royal family, more particularly your Majesty's gracious self, even to that of refuting *your Majesty's right and title to the throne of this realm*, arising out of, I believe, the most base and false reports, and what I consider the most wicked Treason on the part of a woman, who scarcely deserves the name of a human being, one Mrs Serres, for whom, on account of the late Duke of Kent, I have hitherto taken great consideration, and until within these few days, I have in a degree, believed that a number of documents which she has in her possession and often shown to me, and others, were true and authentic vouchers, conceiving that it was morally impossible for her or any person, to fabricate or counterfeit the various signatures to.
>
> But I have lately discovered, in my own belief, that the woman, Mrs Serres, styling herself Princess of Cumberland, and the legitimate daughter of your Majesty's uncle, the late Duke of Cumberland, and a Miss O. Wilmot, daughter of the late Dr. Wilmot, is a wicked impostor, and dangerous to the state, notwithstanding she produces a Certificate, written and signed by the said Rev. Dr. Wilmot, of the marriage between the said Duke and her mother, Miss Wilmot, as also a certificate of her own birth and christening, and another still more extraordinary document and certificate in the handwriting of the said Dr. Wilmot of a marriage said to have been celebrated between his late Majesty and the fair Quakeress named Hannah Wheeler, and which marriage I have heard this Mrs Serres repeatedly assert was consummated at Kew before your Royal Father's marriage to the Princess of Mecklenbough, and prior to the passing of the Marriage Act, and that there were by the first marriage two sons and one daughter; one of the former still living, a General in the Army; and that his late Majesty's first wife lived until the year 1765; and that immediately after her death, his late Majesty married your Royal mother, the Queen, a second time …

Then he came to the crunch point.

…and that the Duke of Clarence was the first born after that second marriage; and she, Mrs Serres, has repeatedly stated to me, and others, that, if her claim as one of the Princesses of the Blood Royal, was not recognised, and a provision made for her, she would publish these certificates to the whole world to show that *your Majesty was not the legitimate heir to the throne*, and she frequently made such declarations in the presence of sundry persons during the late unfortunate Queen's trial, threatening at the same time to join with the public in their clamour against your Majesty, for which I most severely rebuked her, and threatened to make her conduct known to the Government, in answer to which she put me in defiance.

At the same time, I must acknowledge that I, in a degree, gave credit to the documents until *lately*, when a violent quarrel took place between her and her daughter, when the latter opened her mind to me, expressing great uneasiness at her mother's conduct, and informed me the manner in which she had forged and fabricated the documents in question.

I further beg leave to inform your Majesty that I have ascertained, by informations from the Rev. Dr. Strachan, that this woman, to answer her vile purposes, has recently gone to Islington Church, and prevailed upon the curate to christen her as being the daughter of the late Duke of Cumberland, by which means she has established this point on record.

This woman's wicked declarations and evil intentions appear so evident to me that I consider it my imperative duty to make it known to my Sovereign, your Majesty, and to offer every assistance in my power to detect and frustrate them. Many meetings with individuals from both Houses of Parliament have been had by her.

With the most profound respect, I hold myself ready to receive your Majesty's commands, and remain, with sincere loyalty, your Majesty's most devoted, faithful subject, J. W. Parkins, ex Sheriff.

A case against Olive for debt was registered by the King's Bench as 'Margaret Grave vs. Olive Wilmot Serres' in October 1821. Pending the case, she was held under Mr Davis's security at 45 King Street, Soho, from where she wrote a pronouncement, which was plastered around the walls of key buildings in the City of London by her supporters.

Princess of Cumberland in Captivity.
Contrary to her Rights, Privileges and Rank.

The Princess of Cumberland informs the English nation that an execution has been served on her body for debt; and that the late King bequeathed her £15,000, which has been proved according to law * and application made to Lord Sidmouth for the payment of that sum, without effect. Therefore, not

having received one guinea from the Government, or any of the said large sum
...the Princess is under the painful necessity of soliciting the honourable and
generous protection of the English Nation.

- Olive was rather jumping the gun on this. Indeed she had had her documents
 attested as genuine at the Chancery Office, but as we will see shortly, it was
 not until the following June that an attempt was made to 'prove' the Will in
 open court.

She attached copies of her pronouncement to letters which she posted to
everyone of influence that she had met, including the Duke of Northumberland; 'My
Lord Duke, I apologise for this intrusion. I trust the annexed paper will induce your
Grace to honor (sic) me with your attention as to the injuries I am experiencing.' [311]

One person who responded positively to this appeal was Sir Gerard Noel MP,
who decided to add Olive to his list of eccentric 'lame ducks' whose causes he
espoused. **(Plate 18)** He even invited Parkins to join him for a weekend of hunting
and shooting with his aristocratic friends to discuss what they might do to help.
Parkins, flattered by the invitation, could not bring himself to refuse, though he told
Sir Gerard that he now harboured doubts about Olive's integrity and that he had
very personal reasons to mistrust her morals.

Olive was committed to the Fleet Prison, but when she appealed to the governor
on the grounds that members of the Royal Family could not be imprisoned for debt,
she was told by Mr Justice Bailey that she had answered the charge merely by signing
her name as 'Olive', without any titles. And, anyway, she hadn't appealed within the
statutory fourteen days. Not for the last time, Olive's cause would be obstructed by
a technicality.

Being confined to a debtor's prison in that era can perhaps best be described as
living under house-arrest in a very bad boarding house. (Charles Dickens has left us
an intimate portrait in *'Little Dorrit'*.) Inmates had to provide their own furniture
and pay for their food and accommodation, and the regime depended on the
corruptibility of the Governor. Prisoners might even bring their own servants –
visitors could come and go as they pleased. Short sojourns in these establishments
were not unusual for members of the gentry and some of Olive's fellow 'guests' would
certainly have been known to her. Creditors knew that their targets could not escape
overseas, while friends and relations tried to raise the funds to settle the defendant's
liability, but it was up to the Court and the person having the writ of 'habeas corpus'
to say when the prisoner could be released. Someone now appeared to pay Olive's
bail and she was released, only to be hauled before the King's Bench again to answer
another debt claim by a Mr Septimus Fitch. [312] This time the record showed that the
defendant was 'Olive, Princess of Cumberland.' Her confinement did not prevent
her writing stinging letters to Lord Sidmouth; [313]

> I venture to observe that your Lordship, and every one of his Majesty's
> Ministers, well know why Olive, Princess of Cumberland, has to lament the
> most uncalled for injuries! …You dare not, my Lord, see my original papers –
> YOU FEAR THE ETCETERA attached to them.

A little later, after she had slipped on an unlit staircase and dislocated her ankle,
she tried a different approach, hoping to arouse the Home Secretary's pity.

> View, my Lord, the sorrows of myself (the niece of your late sovereign, King
> George III) …behold me, faint in agony and anguish, extended upon a solitary
> bed, with but one friend (the late beloved Duke of Kent's son) to administer
> consolation, from whose hands my medicines are taken.

What happened next was described by Olive in a deposition she wrote around
1829. [314]

> In 1821 I had been given into the custody of the warden of the Fleet, by style and
> title of Princess of Cumberland. The habeas being from Mr Justice Pick, on June
> 28, I was removed under another Habeas on an action and judgement of Mr
> Septimus Fitch. I rendered to the magistrate Wm. Jones by my proper name and
> title, Olive, Princess of Cumberland.
> At my liberation from his custody, it was *no legal application of mine that
> caused my liberty*; I conceive that when Ministers found that I was determined
> to apply to the House of Lords that my liberation proceeded from that quarter;
> as I never applied on the Lord's Act, nor did I authorise any other person or
> solicitor to do so. I continue ignorant of every part of their proceedings,
> excepting being informed that Mr *Lushington* had sent to the Marshal a special
> writ for my discharge … and I paid NO FEE whatever upon the occasion.

This time, the technicality of the original Court Order being made out in a way
that appeared to acknowledge her Royal status seems to have worked in her favour.
Her release in November 1821 was ordered by the same Mr Justice Bailey who had
ruled against her before. For the rest of his life he believed in her Royal ancestry and
his daughter, Mrs Clissold, became a friend of Lavinia. [315]

Back at Ludgate Hill, Olive bombarded Lord Sidmouth with a succession of
imperious, but perfectly reasonable, letters. [316] 'If, my Lord, I had been an impostor,
it was the duty of the ministers to have inquiries into my claims and to have them
exposed if unjust or illegal.' She reminds him that 'all her documents and letters from
the Duke of Kent had been attested at Judge Abbott's chambers, Sergeants Inn, at
Master Simeon's office Court of Chancery, before Sir Robert Baker and Barker
Beaumont, together with twelve affidavits.' On the advice of Charles Knight, she had

been back to Simeon (now Sir John Simeon) in his role as a Trustee of the late King's estate. But he had said that 'it was not in his power to do anything.'

> It is evident that every avenue of justice is closed to me by Government. Why, my Lord, should every person that is the least connected with ministerial interface refuses to examine papers that the worst and basest calumnisters dare style fabrications?

Unlike 'other spongers on the state', she had successfully kept herself by her own efforts and talents. This was in itself a remarkable achievement for a woman of her time. 'By my pictures, I have made £1,500 and by my publications more; I have four times as much owing to me on the Earl of Warwick (£6,000) and the Duke of Kent (£12,000) as my debts, apart from Royal dues and the Will of King George III. Please advance some of the £500 per annum commanded by his late Majesty.' To one letter she adds a rather telling postscript. 'A lady's mind, my Lord, it is often said, may be understood best by the postscript to a letter. Then I beg leave to say, if I am considered an impostor, my lord, LET ME HAVE A TRIAL BY JURY! If not, give me, as Olive Princess of Cumberland, my due and lawful rights.'

Perhaps with a sense of some relief, the 64 year old Lord Sidmouth resigned as Home Secretary in December 1821. Olive could not resist putting the knife in and giving it a good twist. [317]

> It is reported in the papers of the day that your Lordship is about to leave your official situation, a measure that will prove satisfactory to at least two thirds of the English people, who, equally to myself, have to deplore that inefficiency and obstinacy should regulate matters connected equally with the throne and the subjects of these extensive realms. I am at a loss to account for the blind inconsistency of a Secretary of State's conduct as to the claims and dues of my Royal birth. I cannot avoid observing that I consider it high time your Lordship should be succeeded in your officiation.

If Olive could briefly celebrate the removal of the man who had been the major barrier to her crusade, she must have realised that it was only a Pyrrhic victory; she would have to start all over again with Sidmouth's successor, the Government's rising star, Robert Peel. She was ill, she was in physical pain and she was destitute. She felt there was nothing to lose by writing another direct petition to the King, her one-time lover and the father of one of her children. It was dated Dec 17, 1821.

To the King's Most Excellent Majesty.
The humble petition of Olive, Princess of Cumberland, showeth;

That your petitioner having a demand of £15,000 on his late Majesty's estate by a bequest dated 1774, referring to his heir and successor for payment of the same, your petitioner commanded her solicitor to address the Lord Chancellor on the subject some weeks back, when his Lordship referred him to the Secretary of State for the Home Dept.

That your petitioner will, therefore, be gratefully sensible of your majesty's condescension, if you will be pleased to allow her the knowledge of your royal pleasure on this important subject, as she is suffering from pecuniary disappointments; yet has but one desire, which is connected with your Majesty's good opinion, Royal favour and protection.

May it therefore please your Majesty to take your petitioner into consideration and to grant to her such relief as your majesty shall think proper.

If the King ever received it, he turned a deaf ear to her pleading.

* * * * *

Olive may have been at liberty again throughout the winter, but on March 12, 1822, she was summoned to the Insolvency Court, the first steps to a declaration of bankruptcy. On her way, she ordered her coachman to make a detour via the Home Office, where she delivered a most weird document for the attention of the new Home Secretary. [318] She was going to resort to shock tactics. It was, on the face of it, a damning indictment against her friend and attorney, Charles Knight.

> I, Olive, Princess of Cumberland, hereby arraign Charles Knight of High Treason against our Sovereign Lord King George IV, by the following disclosure of the treasonable expressions used in the presence of Sir William Anson, J Dickenson and the Rev. J. Brett and others that HM George IV caused his daughter Charlotte to be poisoned with arsenic poison … administered by Mrs Griffith in chicken broth…under the superintendence of the celebrated accoucheur Doctor Croft, and that the said Charles Knight further declared that he held in his possession proofs … particularly letters of the said Doctor Croft.

In a letter to Lady Anne Hamilton, Fitz claimed that he was deeply shocked by this betrayal of a mutual friend, but Olive had justified her dramatic action by saying that 'if Knight is guilty, he deserves detection. If innocent, the murderers will purchase him off, and grant me my honours – *which is my motive*.' [319] What should one make of this incident? Was Olive disillusioned with Charles Knight because he had made no progress in getting the money she claimed from the Trustees of the Earl of Warwick? Or was it a typical piece of inventive mischief-making by Fitz? But the documentary evidence has come down to us in a collection of papers assembled by Parkins a few

years later, when he was putting together anything that showed Olive in an unfavourable light. [320] Perhaps Charles Knight had indeed reiterated a rumour that had been circulating among the supporters of Queen Caroline. What is most intriguing is that this accusation, that Princess Charlotte had been murdered, would resurface in a notorious book published anonymously in 1832, which will be discussed in a later chapter.

* * * * *

At the end of May, 1822, Olive's lawyers went to the Prerogative Court of Canterbury to try and get the 1774 Will of George III, in which he had promised Olive £15,000, proved in open court. If successful, this should then lead to a grant of probate. This Prerogative Court was the most senior Church Court and was based in London, settling all issues arising from disputed Wills. [321] On the day the case was heard, there was standing-room only. Olive had engineered another performance in the public limelight, another moment of high drama.

> At ten o'clock, Sir John Nicoll took his seat, and, shortly after, Dr Dodson and Dr Lushington (*Olive's Counsel*), accompanied by General Desseux, soi-disant Capt. Fitz-Strathern and others ...A few minutes before one o'clock, Olive Princess of Cumberland entered the court and took her seat. [322]

Olive had already sworn an affidavit on oath as to the validity of the document before Dr Dodson and the Public Notary, while the King's Proctor had also been invited to inspect it. [323] This affidavit also recounted in sober, unemotional terms the way she had obtained her 'documents' from the Earl of Warwick and the Duke of Kent in April and June 1815 and November 1819. The Will was in exactly the condition that she had received it, except that she had pasted another paper 'at the back thereof', while she had also cut off the corners 'to prevent tearing'. She also mentions the 'wearing of the lower margin of the said paper by reason of the deponent's keeping the said paper constantly about her person to secure the same.' And here are two very important points. The first is that the document illustrated in Fig. 3 shows precisely these features. Secondly, in 1866, when preparing his defence to the claims brought by Lavinia, the Attorney General made handwritten notes against his own summary of Olive's affidavit. One note reads 'probably true'. [324] There were four other affidavits concerning the signatures sworn by John Dickenson, John Vancouver, Samuel Griffin (formerly the clerk to John Dunning) and Thomas Lloyd (Attorney-at-Law, Gray's Inn.).

The case in the Prerogative Court would never have been brought to open judgement if there were any serious doubts about the genuineness of the Will. Having allowed the matter to get this far, the Judge was in somewhat of a dilemma, and he opted-out of making any ruling one way or the other on the grounds that, because it

involved a member of the Royal family, his particular court had no jurisdiction over the matter! In his summing up, he stated; 'If this application were properly made under the forms prescribed by law and the constitution of the country before other tribunals, no doubt ought to be entertained that real justice would be done.' He went on to say that it was not his job to say which these tribunals might be, but implied that the correct course might be through a 'Petition of Right'. Had Olive's Counsel not done their legal homework, or was this a case of the Judge adjusting the rules to suit the circumstances, even yielding to external influences? Olive surely had every reason to be aggrieved that, yet again, she had been frustrated on what appeared to be a technicality.

In June 1822, she was once more committed to prison by the King's Bench on the charge of an unpaid creditor, the case being brought in the names of 'William Lewis versus Olive Wilmot Serres.' [325] No title, no intimation of Royalty, and therefore no prospect of an early release, but a letter from Lady Anne Hamilton to the Earl of Harrowby ensured that she was allowed to live in private lodgings under the less stringent 'King's Bench Rules', an area of 3 square miles within the Borough of Southwark. [326] And further help was about to emerge in the form of a solid proponent of her crusade, someone with a long, aristocratic pedigree, who had been in the House of Commons for many years and who would know precisely how to present a 'Petition of Right'.

Sir Gerard Noel MP was the nephew of the 6th Earl of Gainsborough and was now 63 years old. He had fervently espoused the cause of Queen Caroline on her return to England in 1820 and had been a leading light in the 'Queen's Cavalcade Committee' that had presented her with a loyal address on behalf of the City of London. It was probably through this activity that he first met Olive. His biographer emphasises that he 'was susceptible to female charms' [327] and, after Caroline's death, he relished the role of a knight in shining armour, riding to the rescue of another maltreated and misunderstood Princess.

ENDNOTES

268 Creevey, pp339-40

269 Princess Elizabeth (1770-1840), the seventh child of George III. She married Prince Frederick of Hesse-Homberg

270 National Archives of Scotland. MS622-32

271 Notes & Queries; 4th Series, Vol 2 pp 392/451/498; Vol 3 p60; 5th Series, Vol 6 p418. Among the notes prepared for the Attorney General in 1866, William Petrie was described as 'often in gaol and before the sheriff, Clr. Mr Wilson, for swindling.'

272 Tomalin, pp108 and 112

273 He was known as William Henry Courtney – not Fitzclarence. Camp p254

274 Olive,1822.

275 Stanislas Augustus Poniatowski (1732-1798) had two sisters (1) Ludwika Maria (1728-1781) who married Jan Jakub Zamoyski (died 1790) and (2) Isabella who married 1stly, Klemens Branicki and 2ndly Andrei Mokronoski [Wlodzimierz Dworzaczek, Genealogia (1959) Tables 135 and 160].

276 National Archives J77/44 doc. 52

277 *Gentleman's Magazine*, Vol. 92, pp34-40. Olive's own account of the incident published in 1822.

278 Most were impounded by the court after 1866 and were not made available to public examination for 100 years. National Archives J77/44/R31

279 National Archives J77/44/R31 docs. 48 and 49

280 National Archives TS 18/112 Big folder.

281 National Archives TS18/112 Letter no. 55. The 'second marriage' of George III and Queen Charlotte is also referred to in a letter from the Earl of Warwick to Olive dated April 23, 1816, ten days before he died. 'I have brought to my recollection that Lord Chatham told me that the certificate of his Majesty's marriage to Queen Charlotte in June 1765 was in Dr Moore's care'. Bodleian Library, Oxford. Shelfmark MS. Eng. Hist c722, f61/62

282 National Archives TS18/112 Letter no. 56

283 WRO CR1886 Box 677. This Charles Knight should not be confused with the philanthropic editor and journalist of the same name.

284 WRO CR1886 Box 674

285 'Bell's Life in London and Sporting Chronicle' June 29, 1823. This article, signed 'A Voice from the Tomb of Junius' claimed that 'three days later, her Highness passed the same way … without interruption.'

286 WRO CR1886 Box 676

287 National Archives TS 18/112 Letter no. 50

288 National Archives TS 18/112 Letter no. 58

289 WRO CR 1886 Box 676

290 WRO CR 1886 Box 676

291 Pendered & Mallett, p182

292 ODNB, Cookson.

293 Tomalin, p196

294 Shephard p41

295 National Archives TS/18 Large folder.

296 WRO CR1886 Box 676

297 Much of the private source material used by Pendered & Mallett came from the Kennet family.

298 Shepard, p37

299 DNB

300 Fulford, p92

301 Olive, p116.

302 WRO CR1886 Box 676

303 The King's Bench was the 'supreme court of Common Law'. One division, the Plea side, 'exercised a general jurisdiction over all actions between subject and subject.' Wharton's Law Lexicon, 1949, p557.

304 Olive p117

305 Olive p117

306 British Library Eldon papers.

307 Pendered & Mallett, p278

308 A copy of her 1821 baptism certificate, prepared on May 7, 1866, states that her parents had been Henry Duke of Cumberland and 'his first Dutchess (sic)'. National Archives TS 18/112

309 National Archives TS 18/112. Letter No. 60

310 Parkins correspondence. Guildhall Library, London.

311 Price family papers.

312 Septimus Fitch was probably a haberdasher of Aldgate in the City of London. (Essex RO, Mark Fitch papers.) His claim may have related to regalia for Olive and livery for her staff.

313 Olive, 1822

314 WRO CR1886 Box 677

315 Pendered & Mallett, p184 and Appendix K. By 1848, Sir John Bailey was Lord Chief Justice of the Queen's Bench.

316 Olive, 1822 p97-106

317 Olive, 1822 p106

318 National Archives HO 44/1 folio 143

319 WRO CR1886 Box 675

320 WRO CR1886 Box 676

321 In 1858, these courts ceased and jurisdiction for the granting of probate was passed to the new secular Court of Probate.

322 *The Gentleman's Magazine*, June 18, 1822. General Desseux was a life-long friend of the Duke of Kent. See also Gattey p193 and Pendered & Mallett, p185.

323 National Archives. Olive's original affidavit (dated 31/5/1822) is in PROB 31/1184 no 661a and a copy in TS 18 Big Folder item no. 17

324 National Archives T 18/112 Big folder, paper no. 17

325 This may have been the Mr Lewis who was her landlord at 1 Cumberland Street.

326 WRO CR 1886 Box 675

327 Noel, p123

Chapter 13

A flurry of Weddings
and another Petition

ON OCT 25, 1822, Olive scrawled a very cross letter to the editor of the '*Gentleman's Magazine*', which was printed by the same company that published the proceedings in Parliament. [328] She had been upset by someone writing that her 'father', Robert Wilmot, had only been a mere housepainter and she herself had been in that suspect profession of actress, having once appeared on the stage at Covent Garden in the role of Polly in the 'Beggar's Opera'. She demanded to know if the 'libel on her Highness had been contradicted'. In a footnote, she requests the printer to send her a copy of the Royal Marriages Act of 1772. Perhaps she needed to confirm that her birth date was before the Act came into force. Or perhaps she had heard that it was proposed to bring in a new, even more restrictive version of the Marriages Act.

Not only is the content of the letter intriguing but also the address from which it was sent – 15 Lambeth Road, which was the home of a Mrs Ryves. And Mrs Ryves was about to become Lavinia's mother-in-law. It must have been a rather weird household. Lavinia and Olive had temporarily parted company around 1821. The separation had been acrimonious, as noted by Parkins, and largely due to Lavinia's disapproval of young Fitz and his increasing influence on her mother; Lavinia knew he was a forger and feared that he would lead them both to the gallows. She had then met and fallen in love with a well connected but impoverished young portrait-painter called Anthony Ryves, whose family had once owned Ranston Hall in Dorset. The couple were married on November 22, 1822, at St George the Martyr, Southwark. (A clause in the up-coming Marriages Act precipitated another wedding, that of Caroline Dearn, Olive's 16 year old daughter by the Prince of Wales. The consequences of this will be followed in a later chapter.)

Anthony Ryves's mother was a widow, taking in lodgers at her house in Lambeth Road, an address that placed it within the 'King's Bench Rules'. Among these lodgers was one of the most remarkable men of his time, the eccentric satirist, journalist and literary imitator, William Combe. He had been born in 1742; his father had been a prosperous London iron-monger who had married the daughter of a Quaker

merchant whose fortune had been made in the West Indies. During 1776, William Combe's first wife, Maria Foster, had been the discarded mistress of both Viscount Beauchamp and, reputedly, Simon Lutterell, the father of Anne Horton. [329] William Combe had wasted his inheritance by 1780 and he struggled financially for the rest of his life, spending frequent spells in the King's Bench prison itself or having to live within the prison rules. One perpetual drain on his resources had been paying to keep his wife in an expensive private lunatic asylum – she did not die until 1814.

Combe had a long, but unprofitable, career as an author and journalist, including editor of *The Times* for a period, while a list he prepared in 1822 named 75 publications that he was either responsible for or contributed to. His most notorious publication was the fabricated '*Letters of Lord Lyttleton*', though his best remembered work was his last, the three volumes of poems, '*The Travels of Dr Syntax*'. These were illustrated by Rowlandson and published by Ackermann and caricatured the travels of William Gilpin, founder of the aesthetic school of the picturesque. Right at the end of his life, William Combe had produced a popular bestseller; '*Dr Sytax*' became a classic and enjoyed many reprints during the whole of the 19th century. After his second wife left him, William Combe had more or less adopted the young Anthony Ryves as his son and intended to leave him all his manuscripts and royalties. [330] This would have made Anthony quite a wealthy man.

We do not know precisely how Lavinia had met Anthony Ryves, though the artistic connection suggests it might have been through her father, John Thomas Serres, with whom she had had a brief reconciliation once she had stopped living with her mother at Ludgate Hill. Nor do we know whether William Combe had become acquainted with Olive when they were both in a debtor's prison on an earlier occasion, but we do know that he detested her and her pretensions to Royalty. When Anthony Ryves told his patron and mentor that he was going to marry Olive's daughter, William Combe immediately disowned him and cut him out of his Will. Perhaps he guessed he only had a few months to live and in an old man's fit of spite, he also decided to burn all his manuscripts.

That is what the historical records say, but there might be more to it, involving an intriguing sub-plot. Back in 1779, William Combe had written '*The Royal Register*', which contained the earliest published allusions to the Hannah Lightfoot story.

> Such a circumstance (*that George had a mistress who he married before his marriage to Queen Charlotte*) was reported by many, believed by some, disputed by others, but proved by none, and with such suitable precautions was the intrigue conducted that if the body of people called Quakers ... had not divulged the fact ... it would have remained a matter of doubt to this day.

Did his manuscripts contain more details that he had kept secret? Had he learnt more from his first wife about the Lutterells and Anne Horton's children? Was his

antipathy to Olive more deep-rooted because he might have held evidence that would actually support her case? It seems difficult not to draw parallels with the bonfire of Dr. James Wilmot's papers and even detect the hidden influences of the secret Agents from Windsor once again. When William Combe died on June 19, 1823, he owed Mrs Ryves £90 of back rent. His second wife wrote to R Ackermann from Ireland requesting him to settle the debt in exchange for the manuscripts, unaware that they had been incinerated. [331]

Lavinia's marriage was the last straw for her father, who had believed that he had at last rescued her from the influences of Olive. At the end of 1822 John Thomas Serres wrote his Will, disinheriting Lavinia 'for her undutiful conduct to me previous to her marriage by continuing to live with her mother, who was leading a most scandalous and depraved mode of living. ... I nevertheless grant her forgiveness and hope that she may be a more obedient wife than she has been a dutiful daughter to her father.' [332] He left everything to his 'dear, beloved daughter Britannia', though when he died two years later he was a destitute pauper.

* * * * *

When Olive received the copy of the Royal Marriages Act 1772 that she had requested from the printer, she read it very carefully. And close examination revealed, in the very first paragraph, an absolute bombshell, one that Lord Sidmouth and the Privy Council had probably been aware of all along. It started; 'To guard effectually the descendants of his late Majesty King George II ... from marrying without the approbation of his present Majesty etc. etc.' Inserted within this sentence was a specific exclusion in brackets – '*other than the issue of Princesses who have married, or may hereafter marry, into foreign families.*' (Author's initials.) Olive had married the son of Dominic de Serres, a Frenchman who had first come to England as a prisoner of war and so John Thomas was technically a member of a foreign family. This fact would not have affected Olive's own entitlements but Lavinia would be exempt from the terms of the Act. The implications of that first line in the Royal Marriages Act would, as we shall see, reverberate long after Olive's death.

At the end of 1822, Olive published her 125 page '*Princess of Cumberland's Statement to the English Nation*', a selective autobiography that detailed the basis of her claims and the correspondence she had had with ministers, secular and religious, and the letters she had sent directly to members of the nobility and the Royal family. [333] Typical of these letters was one she penned to the Duke of Norfolk, the Earl Marshal of England, on December 9, 1821, undaunted by embarking on the stormy waters of Catholic emancipation. [334]

> May I hope that your Grace will do me the honour to see me. I have some important matters connected with the late King to communicate, that may be of importance to the Crown and the Constitution.

In these more enlightened times, religion should be tolerated, especially that which gave origin to the religion that brought the House of Brunswick to the throne. My Lord Duke, I impress to you that I am his late Majesty's niece and other State facts that cannot be written about. Thus let me beg to see your Grace.

Olive ended her *Statement* with a simple plea for financial support from the public.

The Princess Olive of Cumberland will be grateful for a sufficient loan, by subscription, to enable her Highness to proceed in the recovery of her just RIGHTS, being at this period without funds for that purpose or daily support! Not having received one guinea on the account of her Royal Birth, either from Government or any branch of the Royal family.
The Princess has been now nearly 10 months a prisoner for debt and having experienced a severe illness, from a dislocated and broken leg in the last winter, her health is but indifferent, Her appeal is to the patriotic and humane subjects of her late Royal uncle, King George III; assured that, in this trying season, they will become her protectors and friends – which preserving kindness she will gratefully appreciate to the last moment of her existence.

In a separate four page publication, '*Documents to prove Mrs Olive Serres to be the legitimate daughter of Henry Frederick, the late Duke of Cumberland,*' her supporting documentary evidence was printed. [335] These also appeared in the *British Luminary*, with the Baylis family adding hints of darker secrets – about Hannah Lightfoot. [336]

We have known her family for upwards of half a century, and although '*we could a tale unfold*' … to let her tell the tale your hearts will throb and weep to hear her speak.

Olive's 'Petition of Right' to the House of Commons was entered by Sir Gerard Noel MP on March 3, 1823, and was debated on the floor of the House on June 18, when Sir Gerard moved that it should be referred to a Select Committee. [337] The motion was framed in such a way that it was an all or nothing risk; 'in order that the truth might be elicited and either the innocence of the petitioner proved or her guilt made manifest.'
Sir Gerard was well known for adopting rather obscure causes and this was one he obviously believed in with passion. Unfortunately, this passion was not matched by his oratory or his ability to present his case – he was a mind-numbingly boring speaker. As he droned on, various of Olive's documents about her supposed birth were shown, supported by the numerous affidavits mentioned earlier. And there was

a new affidavit, sworn and signed by Robert Wilmot's daughter and Olive's foster-sister, Anna-Maria Kennett. She was prepared to support Olive's claims even if her brother was not.

The Government's response was led by Robert Peel, the new Home Secretary, and his demolition of Sir Gerard's case was a travesty. He evaded any reference to the major issues and concentrated his attack on picking up minor details. While homing in on the document that attested the marriage of the Duke of Cumberland to 'Olive', conducted by Dr. James Wilmot – admittedly, the most suspect document – he did not try to prove, or even suggest, that 'Olive' had never existed, but merely questioned the validity of the witnesses – J. Addiz and William Pitt. According to 'his researches in Warwick', probably done by Parkins, Addiz never existed, and the signature must be a forgery because Peel read it out as 'Adder' and claimed it should have been 'Haddow' anyway, a well known Doctor in the town. (He even made a cheap jibe that people in Warwick often dropped their aitches.)

Of course this was completely irrelevant; the document originated in London, and Sir Gerard Noel's team should have pounced on this and proved that J. Addiz had been the Royal servant that he was. This would never have got past Dr Lushington, who had promised to second the motion, but unfortunately could not attend the Commons on that day. Peel then asserted that it was impossible that King George III would have invited the Earl of Chatham to witness his 'Will' leaving Olive a small fortune, given Pitt's stance against the King and his ministry in 1774. (Ignoring the possibility that if William Pitt had indeed been the witness to the King's marriage to Hannah Lightfoot, there was no better guardian of another secret.)

Peel then turned to the document of March 7, 1773, signed by James Wilmot, Robert Wilmot and John Dunning, describing certain birthmarks by which Olive could be identified.[338] Peel teased his listeners by suggesting that they were in very private places, whereupon the MPs jumped to their feet, waving their order papers and shouting 'Tell us where! Tell us where!' But the Home Secretary's piece-de-resistance was to quote from a bizarre document that Olive had published the year before, trying to exploit her belief that her 'grandmother', Dr James Wilmot's 'wife', had been a member of the Polish Royal family. Olive's '*Manifesto to the High Dignitaries, Principalities and Ecclesiastical Powers of the Kingdom of Poland and its Brave Peoples*' had begun as follows; [339]

> Whereas it has pleased Divine Providence to discover our high and illustrious descent from your last reigning Sovereign; being the immediate Heir and Representative of AUGUSTUS STANISLAUS, your King, as well as the only daughter and representative of HENRY FREDERICK, late Duke of Cumberland, by Olive, his Duchess, the legitimate daughter of the Princess of Poland … We, as afore mentioned, allied and descended, claim your affectionate consideration and regard …

Olive had then followed this up with a letter to Tzar Alexander, Emperor of All the Russias; [340]

> Alas, beloved nation of our ancestors, your Olive lives to anticipate the emancipation of Poland. Invite us, beloved people, to the Kingdom of our ancestors, and the generous humanity and wise policy of the Emperor Alexander will restore the domain of our ancient House.

This reduced the Members of Parliament to even greater paroxysms of mirth. One has to admit that this was one of Olive's weirdest pieces of journalism and one that played into the hands of those who thought she was completely mad, though as a later writer put it rather charmingly; 'supposing the charge of insanity is true, what then? In what way does it affect her Royal birth?' [341]

Peel concluded that Olive 'was herself practicing a most impudent imposture, or was the innocent dupe of others'. He was guilty of ignoring simple rules of evidence but he had exploited the weapon that William Hone and his fellow satirists had found so devastating – he had made the House of Commons laugh. The other radical MPs who might have spoken in favour of the motion, like Burdett, Hunt and Whitbread, were withered into silence. Sir Gerard himself threw in the sponge and in a humiliating withdrawal said that he 'would not be so impertinent as to trouble the House to divide.' The Petition had not been defeated; it had merely collapsed under the weight of ridicule.

From Olive's point of view, the result was a terminal disaster. For the Establishment and the Royal family, however, the outcome appeared to bury once and for all the claims of a dangerous loose cannon; because if Olive's claims had been recognised, it might have been impossible to ignore the potentially more destructive entitlements of her brother Thomas Dearn. A wild, possibly lunatic, female 'pretender' was one thing; an intelligent, educated male in the same role, to whom not a shred of scandal could be attached, might be a very different proposition.

Following the failure of his Petition, Parkins wrote to Sir Gerard Noel effectively saying 'I told you so', to which Sir Gerard replied on July 15; [342]

> You make me smile with your personal remarks. I heard with my own ears the Duke of Kent's ADC, who was with him at Sidmouth, speak of his Highness's known regard for the Princess Olive … I see more strong chain of proof in this case and the impossibility of the *whole* being a forgery than in any other case which ever came within my observation.
>
> I am much indebted to you for your caution to me and quite absolve you of all the harm I may incur by doing my duty fearlessly and honestly, however forbidding, as a Member of Parliament.

And not only as a Member of Parliament; he also agreed to be godfather to Olive's first grandchild, christened Olive Lavinia Noel Ryves.

One person at least went into print to highlight an irrefutable point that the Home Secretary had missed – or deliberately avoided. In an open letter published in June 1823, Dr Andrew G. C. Tucker leapt to Olive's defence. He wrote that he was 'animated by that spirit of justice which distinguishes him and which the people know how to appreciate', and that he had therefore 'undertaken to advocate the cause of the unfortunate and oppressed Princess of Cumberland'. [343]

> If she has forged any of the documents which she has proffered to substantiate her claim, why is she not prosecuted? If they are genuine, why is she not allowed the benefit of them?

Why not indeed? If the Establishment had serious doubts about the genuineness of Olive's documents and their signatures, a case against her for forgery would surely have been the easiest way of shutting her up for good. But nothing happened. To be fair to Sir Gerard Noel, he did try and muster some financial support for Olive, convening a meeting of her supporters and other interested parties at the Freemason's Tavern, London, in August 1823. This was widely reported in the press. [344] Among those present was Henry Hunt, the radical agitator; a solicitor called Mr Roubell, to whom Olive owed a lot of money, plus two shadowy foreigners who claimed to be Polish Counts. Also Dr Tucker, who was now referred to as her 'agent' [345] and, perhaps more surprisingly, Joseph Parkins.

Sir Gerard stated that the Government had already partly acknowledged her birthright by absolving her from paying certain taxes and even suggested that £50,000 had been approved for an offer to her in exchange for renouncing her claims. (Like Princess Caroline.) This seems to be the first time that an offer of trying to buy Olive off had come to light, and it may have been part of the negotiations carried on behind the scenes by Henry Bell. Probably Lord Sidmouth then decided that he could put the sum approved by the Privy Council to a better use; the bribe to Bell to drop his case.

Parkins made the snide observation that if she was acknowledged, it would just be another addition to the bloated Civil List and another cost burden on the taxpayers. When Sir Gerard invited subscriptions from those attending his meeting, he said that he had already paid off her back-rent and would add another £20, though he could ill afford it. Parkins offered the £5 he had been given by the 3rd Earl of Warwick, Hunt put in the same amount but others only contributed a total of £1. As Sir Gerard droned on about his own financial problems, the impetus of the meeting was lost and his audience slipped away into the night. In no way was the money that had been raised enough to pay off Olive's various debts and she would have to live for the next few years as an unredeemed debtor within the confines of the King's Bench Rules.

She still felt that her 'knight in shining armour', the loyal, honourable, bumbling Sir Gerard might be able to achieve something if he could have a private meeting with King George IV and so, on January 9, 1824, she wrote another pleading letter to her one-time lover. [346]

> The unceasing affection that I have contended for your Majesty's person and the duty that I owe you as a subject induces this most respectful prayer that your Majesty will be graciously pleased to grant a private audience to Sir Gerard Noel on my affairs, who will with pleasure and duty obey my commands which may be forwarded to him.
>
> May God preserve in power and health your Majesty, is the faithful prayer, Sire, of Olive.

This was forwarded to the Home Office with a sarcastic covering note from the King's secretary. 'Mr Watson presents his compliments to Mr Hobhouse and begs leave to transfer to him the enclosed letter from *the Fair Olive*'. (This sounds like an oblique reference to Hannah Lightfoot, often called the 'Fair Quaker'.)

Olive still had her pen and she was certainly not going to remain idle. She has left us, in her own handwriting, a *'List of works of Olive Serres'*, which shows her output – or intended output, since few examples survive – was prodigious. [347] Novels, written but unpublished, included the *'History of Don Pedro Tolenger of Valladolid'* [348] and *'Rosetta, or the mishaps of Louis the Thirteenth, King of France.'* [349] Among her more ambitious projects, listed under the category of 'ready to publish when revised', were three volumes of a *'History of England in Verse,'* two volumes of *'Memoirs of the Duke of Kent'* and an autobiography – to be published in weekly parts, aptly entitled *'The Royal Olive branch.'* She had printed a prospectus in 1822 for two volumes of her poetry, 'to be published by subscription – price £2.'

All these were honest attempts to earn her way out of bankruptcy, but since every single one of her efforts to obtain justice through legitimate routes had failed, she might now have to fight dirty. One can hardly blame her. She still had the Hannah Lightfoot papers and though they had been irrelevant to her own cause, there might be a profitable market for them in the gutter press; particularly if she could collaborate with someone who also had a stock of scandalous revelations about the Royal family.

ENDNOTES

328 Pendered & Mallett, p235

329 DNB and Pendered & Mallett, p282

330 *Mirror of Literature*, Jan 3, 1835

331 Pendered & Mallett, p282

332 WRO CR1886 Box 674

333 British Library Ref. 10826 d8

334 Private papers of the Price family.

335 British Library Ref 10826 d8. A. Sele, printer, 160 Tottenham Court Road.

336 Shepard, p40

337 Annual Register, 1823, Vol 65 pp141-44

338 National Archives J77/44 Vol 3 document 63

339 National Archives TS. 18/112 pt 1

340 Ibid.

341 Macauley, quoted in Pendered & Mallett p134

342 National Archives HO44/1 folio 142

343 WRO CR1886 Box 676. Pencil note on front, probably by W. Thoms; 'Bought at Burns sale'. Also old ink note; 'I have disposed of many papers of Olive Serres to Capt. Staunton of Longbridge House, near Warwick'.

344 Shepard, p45

345 Noel p124

346 National Archives TS 18/112 letter no. 67

347 WRO CR1886 Box 676

348 WRO CR1886 Box 676

349 Private papers of the Price family.

Chapter 14

A convoluted Quartet

LADY ANNE HAMILTON has already been mentioned at various stages in our story and she now assumes a major role as Olive's correspondent and literary collaborator – and, as we will see shortly, a rather unlikely partner in the invention of a device to assist marine navigation. As well as being a formidable character, Lady Anne was a remarkable looking woman, standing six feet tall and described by Thomas Creevey as 'bearing a striking resemblance to one of Lord Derby's great red deer'. **(Plate 19)**

She was the unmarried sister of the tenth Duke of Hamilton, born in 1766 and therefore six years older than Olive. Her grandmother, Lady Archibald Hamilton, had reputedly been a mistress to 'Fred', the unfortunate son of King George II, and had loathed both George III and Queen Charlotte. [350] Lady Anne had become lady-in-waiting to Caroline, Princess of Wales, in 1814, though, either by luck or a deliberate decision, she had not accompanied her to the continent later that year. This saved her the embarrassments of being associated with the raunchy goings-on in Caroline's 'Court' at the Villa d'Este. Along with Alderman Wood, Lady Anne was part of the welcoming party that escorted Queen Caroline back to England in 1820, resuming her previous role as Caroline's most personal courtier and inviting her to stay at her house on Portman Street. However, when Caroline died, her only bequest to Lady Anne in her Will had been a portrait of herself, a slight that Lady Anne took rather badly. But she remained a loyal supporter and an ardent advocate of her memory.

The relationship between Olive and Lady Anne would be made more complicated by the involvement and intervention of two other characters – namely Parkins and Fitz. Fitz had by now decided that in attaching himself to Olive he had been backing the wrong horse, and that he should ditch her completely. Then he could lay-off his bets by inveigling himself into the confidence of another older woman, one of proven aristocratic connections – Lady Anne Hamilton – and a scheming, unscrupulous man, who thought he still had the personal ear of the King – Parkins.

Fitz had written to Lady Anne from 48 Ludgate Hill saying that he was 'really ashamed by my Relation's unreasonable and suspicious nature'. [351] He reiterated his claim to be the son of the Duke of Kent – 'I am a chip off poor Edward' – followed up

by making the rather staggering claim that his mother had been another sister of the Duke of Hamilton, making Lady Anne his aunt! [352] This seems to be a ridiculously tactless assertion, since both sisters were still alive. Later in the same letter he claims he is unaware of any brothers he might have, but he did have a half-sister (Princess Alexandrina Victoria, acknowledged to be the eventual heir to the throne) who he hopes 'may live to be as persuasive a character as Lady Anne Hamilton.'

He then goes on to state that he has 'two volumes in manuscript on family affairs, court intrigues and secret politics which I am transcribing, and if the Government does not do something for me … I will be under the necessity of accepting the handsome offer for the publication of these precious relics of authentic enquiry, information and labour, which has hitherto been kept from mortal eye, from my natural affection and love to the Royal Family.' In a letter of March 26, 1824, [353] he told Lady Anne (who he now addresses by the pet name of Amelia, signing off as 'her affectionately obliged nephew') about a considerable success at Windsor.

> It will be gratifying to you to hear that the Royal Family are all inclined to be friendly to Fitz, for the causes with which you are so well acquainted. Love is out of the question. Politics are the order of the day.
>
> What do you think, Amelia? The Duke of Sussex modestly wanted to peruse the Duke of Kent's letters without any other security than that IF they touched on the SECRETS of the family, HE would lead me up to the King through the interest of the Duchess of Gloucester.

Fitz had sent him a copy of one of Olive's letters from Edward Duke of Kent via the Rev. J. Brett, hinting that sight of each subsequent letter would cost £1,000. Fitz then recorded the Duke of Sussex's reaction. 'Why, damn it parson, how the devil could this young fellow come by it? He must have many letters; Kent's been a fool to write so plain!' Fitz continued; 'If His Majesty will make me (*Baron*) Glenalvon or Wentworth, they would have *153 genuine papers* of the MOST IMPORTANT NATURE. If not, I shall not deal.' He added two rather fascinating postscripts;

> Mr Wm. Austen [*the supposed illegitimate son of the late Queen Caroline* [354]] has called twice in my absence. I am always glad to see him on my dear Amelia's account, because he is a moral character. …
>
> Brett called; he tells me he won't give the negociation (sic) up and is determined to annoy the Royal Family till they purchase him. He has got hold of a book that was sometime ago suppressed for £10,000, wherein the French Bonds etc. are detailed. [355] And he is now to publish it with illustrations and additions.

Of course I have no hand in this grand plan, but he says he will do me
much justice and honour in the work. *Parkins and he are as one.*

Rev. Brett had confirmed the details of his plot in a letter to Parkins dated April
29, justifying his blackmail on the grounds that he had to provide a nest egg for his
family. He is also kicking himself for once having been enthralled by Olive and
wanting to 'remunerate myself for the trouble, expense and cost … of the imposition
which has been practised upon me by the most designing woman ever known.' [356]

* * * * *

Details of precisely when Lady Anne Hamilton first met or started corresponding
with Olive are slightly blurred. Olive claimed that their friendship started in 1824;
Lady Anne claimed that she had at least known of Olive for very much longer, 'when
she was a very beautiful young woman'. [357] And she had seen Olive's 'documents', as
she confirmed in a letter she had written to Lord Harrowby, the Lord President of the
Council, during the case in the Prerogative Court in 1822. 'I have no hesitation in
giving my humble opinion, founded on long experience, that they are genuine
instruments'. She had ended the letter; 'I submit whether it would not be more
advisable to prevent, if possible, the necessity for the subject being more exposed …
by coming to such arrangement as may be prudent.' [358]

Olive wrote to Lady Anne on May 7, 1824, enclosing her 'visiting card', which
was an etching by Mackenzie derived from a portrait that had been made several
years earlier by the artist Joseph. Where her name was printed underneath, she had
inserted in ink the word 'Wilmot' between 'Olivia' and 'Serres'. [359] **(Plate 13)**. The
envelope was sealed with a wax impression of her signet ring, a capital **C** beneath a
ducal coronet. Olive presented her compliments and said she would be grateful if
Lady Anne could call on her, to which, Lady Anne replied on May 11, saying that she
would 'have the pleasure of waiting upon Her Highness the following day' but only
if Olive was alone. 'Lady Anne will consider herself much obliged at the Princess not
mentioning to her Highness's *attendant* that the Princess sees Lady Anne.' This is
undoubtedly a reference to Fitz, who Lady Anne was now recognising as a charming,
but indiscreet, rogue.

Fitz had also visited Parkins, offering on the one hand to give the Government
£100 'to save them the expense of hanging her (Olive)' [360] and with the other
offering to tell him precisely how he had forged some of Olive's documents.
According to Fitz, Olive had once upon a time been the mistress of a solicitor in the
Crown Office, from whom she had obtained examples of George III's signature.
Parkins jumped to the conclusion that Fitz was referring to the Hannah Lightfoot
papers, when in fact he was more likely to have meant those about the mysterious
'Olive', which must have been inventions. But Fitz's revelation appeared to be the
key information that Parkins had been looking for; he had always previously believed

that Olive herself could not have forged anything because her writing was so imprecise and illegible.

Parkins now exploited what he thought he knew about the Hannah documents by sneaking off to the Rev. J. Brett and telling him that his sponsor – the Duke of York – need not worry about his legitimacy after all, because he believed that they were all forgeries. Brett replied expressing his gratitude for 'exposing this gross imposture'. [361] In October 1824, Parkins extended his research into Olive's background by writing to Countess Poniatowski asking whether she could confirm that Olive's maternal grandmother had been the sister of King Stanislaus. He told his correspondent a few juicy details of Olive's life, including his belief that she had mothered eleven children. [362] The reply from Marchioness Polari was ambiguous, but implied that she would be prepared to swap intelligence if Parkins made it worth her while. A Mr Delagarde replied to Parkins that he did not think Poniatowski's sisters had ever married, but had also added the intriguing comment, not helpful to Parkins' case, that he had 'heard of George the Third being married to some woman who was sent to Philadelphia'. [363]

Parkins decided to go into print. In 1825, he wrote, though probably did not publish, his '*History of the 19th Century as concerns Royal Imposters and other frauds affecting the Reigning House of Great Britain; comprising details of the person assuming the title of Princess of Cumberland and Poniatowski of Poland etc. etc.*'[364] It attempted to draw parallels between Olive's claims and those of the much earlier pretender, Perkin Warbeck, and it did Olive no favours at all. He was smarting from the way he had allowed himself to be exploited.

> There is also much unique in her manner towards all whom she seduced; none ever before was so reckless of the character of those she approached.

At least in this instance he was prepared to put his name to the authorship. This was not the case with the '*Memoir of the late John Thomas Serres*', published anonymously around 1827, though with the stamp of Parkins discernable throughout. It is now generally believed to have been initiated and sponsored by the 3rd Earl of Warwick. It paints Olive in the worst possible light, while making out that her late spouse had been a man of huge artistic talent, a generous, forgiving husband and a devoted father to his two daughters. The book, consisting of 50 pages, subsequently became the standard reference work and primary source for writers interested in the life of Olive, including the first edition of the Oxford Dictionary of National Biography. It has often been said that history is written by the winners; to which might be added 'or those with an axe to grind and who can find a wealthy patron'.

On the other side of the coin, the loss of a patron could lead to ruin. John Thomas Serres died on December 28, 1825. The Prince Regent had refused to re-appoint

him as an official Court artist when he became George IV and John Thomas was declared bankrupt for the second time in 1822. His daughter Britannia stayed faithful to him until his death in the King's Bench prison. In his Will, he disinherited Lavinia, because she had stood by her mother, and left everything to Britannia. [365] But the main thrust of this bitter document was aimed at Olive herself. 'My wish is to prevent my wife, Olive Serres, for whose misconduct I was separated … having any claim as my widow to the least portion of whatever I am possessed …having repeatedly committed adultery with several persons, giving birth to illegitimate children and has unnaturally deserted them, to be supported by others.' Not that his Will was worth a single penny – his funeral expenses had to be paid for by a donation of £20 from the Society of Arts, while Britannia received nothing more than his blessing.

* * * * *

1825 also saw the publication of a wild, woolly but intriguing autobiography titled the '*Memoirs of Miss C. E. Cary, written by herself, who was retained in the service of the late Queen Caroline … next to Lady Anne Hamilton.*' [366] In the same style as many publications of the period, the names of important characters were disguised by the use of a dash or a single initial, though she feels no such inhibitions or gestures to discretion when referring to Lady Anne Hamilton or Olive, both of whom she obviously detested. She claimed she had proof that Olive's documents were forgeries, because she had been given this information by 'a clergyman of proved integrity'. This sounds uncommonly like the duplicitous Rev. J. Brett who seems to have been using Miss Cary as his spokesperson on behalf of the Duke of York.

A significant part of the book claims that Miss Cary was responsible for thwarting a plot to discredit the Royal family and enhance the reputation of the late Queen Caroline, naming the ringleaders as Olive, Charles Knight and Lady Anne Hamilton. She admits that she never met Olive, adding that Olive's 'intercourse with the Queen (Caroline) and Lady Hamilton was kept as secret as possible, lest her aid in the Queen's cause should induce the Royal family to refuse her claims.' Here we find the first published reference to the accusation that Sir Richard Croft had been bribed with £10,000 'if he would testify that Queen Charlotte had endeavoured to influence him to poison the Princess Charlotte'.

We must not forget that Olive had another string to her bow, the letters from Edward expressing his earnest wish that Olive should be closely involved with the upbringing of his daughter, Princess Victoria. As requested, Olive had tried over the years to have an audience with the Duchess of Kent but without success. On Aug 6, 1825, she wrote directly to the King begging for his intervention in this matter, and reminding him that 'once in past times, your Majesty favoured the candour of my disposition'.[367]

Olive submitted one last, pathetic petition to 'His Most Gracious and Excellent Majesty King George IV' on June 27, 1827.[368] She was 'without any income whatever

to support her Rank or to provide for the common necessaries of life'. She has 'experienced a long and dangerous illness produced by care and anxiety and the regrets occasioned by the gross libels and malignant slanders that have been propagated to deprive her of natural esteem by misrepresenting her character to the public'. (A rejoinder to Parkins's biography of her estranged husband published earlier in the year.) As 'Olive Guelph, Princess of Cumberland' she included a copy of the declaration by George III in May 1773 that created her Duchess of Lancaster[369] and ended by praying 'to be put in possession of the several rights and privileges that were intended by his most gracious Majesty of blessed memory'. Nothing happened.

But what did happen to 'Fitz'? He returned to Edinburgh, pursuing his genealogical detective work and digging up skeletons in aristocratic pedigrees – particularly the Innes family of Stow.[370] He wrote a pamphlet about a baronetcy claim in 1840, *The Leman Case*. He certainly never received any major recognition from the Royal Family for his 'services' to them, though he was apparently given an annuity of £50 per annum by somebody, on which he drank himself to death. A writer to *Notes and Queries* claimed that 'the last time I saw this scion of royalty, he was lying in a state of intoxication and squalor, on the floor of an apartment whose only furnishings were a heap of empty bottles.' [371] It is unclear precisely when he died, probably sometime after 1853, and he has no known monument, though perhaps he did leave ghostly fingerprints on a scurrilous, libellous book that would be published anonymously in 1832. Some authors have attributed it, at least in part, to Olive. It was titled '*The Authentic Records of the Court of England for the Last Seventy Years*' and it caused an unholy furore at the time.

ENDNOTES

350 Lindsey, p102. Camp, p32

351 WRO CR1886 Box 675. Olive had apparently intercepted a packet that he had sent to Lady Anne about some mysterious business he was doing for her brother and the War Office.

352 Lady Anne Hamilton had two younger sisters; Charlotte, who married the 11th Duke of Somerset and died in 1827, and Susan, who married the 5th Earl of Dunmore. She died in 1846. Both these sisters had children by their husbands.

353 WRO CR1886 Box 675 'Letters of William Fitzstrathern to Lady Anne Hamilton' p23-4. For some reason, this collection of letters covering June 1823 to July 1824 was printed. As the introductory note explains; 'Necessity obliges the insertion of these documents, as they form one link in the chain of events referred to in other statements herein submitted'.

354 Most probably adopted. He had spent most of his life with Caroline in Italy.

355 Presumably Spencer Perceval's 'The Book'.

356 National Archives HO 44/1 folio 151

357 WRO CR1886 Box 675

358 WRO CR1886 Box 675

359 WRO CR1886 Box 675. William Thoms, the editor of *Notes & Queries*, wrote in vol. 5 January 22, 1876, that at one time he had managed to get hold of some 200 letters of Olive to Lady Anne.

360 National Archives TS 18/112 letter no 66 from Parkins to Robert Peel.

361 National Archives HO 44/1 folio 149/151

362 National Archives HO 44/1 folios 152/3/6. The second letter is written in French.

363 A number of families in Pennsylvania with the Rex surname have claimed descent from Hannah, though DNA testing in 2002 found no connection to the Royal family. See also Pendered & Mallett Appendix E.

364 National Archives HO 44/1 folio 177

365 ANON, ca. 1827

366 Published in three volumes by T. Traveller, Park Street, Dorset Square. The preface was written from an apartment in the King's Bench Prison, July 16, 1825. Perhaps the most intriguing aspect of the book lies in the origins of the author herself. She had been adopted soon after birth by Lady Elizabeth Araminta Monck, the sister of the 3rd Earl of Arran, 'to prevent her father from knowing that she had been born alive'. The adoption had been accompanied by a large sum of money. But who was her father? Miss Cary implies it might have been the Duc de Berry, a younger son of the French regal line, though later on she writes that it was said 'by certain people that she was the daughter of the Duke of Devonshire.' The 5th Duke of Devonshire lived for a time in a strange ménage á trois, with his first wife Georgiana and his mistress (Georgiana's best friend) 'Bess' Foster, who he later married. Outside any marital bed, it is claimed that Georgiana had a daughter by Charles Grey, later Earl Grey, while the Duke had two children by Bess. Nor is it clear who Miss Cary's real mother had been. In her diaries, Lady Charlotte Bury hinted at some baby swapping that took place in a ducal family about the right time, adding that the only person who knew the truth had been Sir Richard Croft – and he had been executor to Lady Elizabeth Monck before he committed suicide.

367 National Archives TS/18/112 Letter 69

368 National Archives TS/18/112 Letter 68

369 See chapter 12 and National Archives J77/44 Doc. 69

370 National Archives of Scotland MS622-32. The Innes family were claimants to the Dukedom of Roxburgh.

371 'Notes and Queries' Vol 2, 1868, p498

Chapter 15

Astrology, Longitude and Libel

IN 1825 Olive renewed her interest in Astrology, a field of journalism that was beginning to capture the public's imagination. She had once added a Memorandum to a letter to the Prince Regent in 1816; 'According to the Rule of the Ancients in their Science – the oppositions of planets so posited (sic) in the heavens – the planet Saturn is opposed totally to Mars … the harvest will not be got in successfully and potatoes will not keep if there are seven frosts this winter.' [372] Now she started contributing articles to a new periodical called '*The Straggling Astrologer*'. Financed by the eccentric balloonist G. W. Graham, the editor was Robert Smith, who adopted the pen-name of the archangel 'Raphael'. [373] This was the same year that Smith joined a group of occultists, headed by Edward Bulwer-Lytton, who were interested in both astrology and alchemy. Bulwer-Lytton had, for a short time after the death of Lord Byron in 1824, been the lover of Lady Caroline Lamb. If Olive did ever meet Lady Caroline they would have found that they had much in common; their scandalous infidelity, their association with forged documents and a desire to be taken seriously as authors. Smith certainly believed in Olive's Royal claims and once wrote about 'Her Royal Highness who has, we are persuaded, been most unjustly persecuted'. [374]

One of Smith's innovations in his journal was a weekly Horoscope prediction of how the movement of the planets affected the lives of his readers – in their business, their travel and their chances of finding romance. Olive submitted her contributions under the pseudonym of 'Ptholomenies G. – The English Sybell', including a series of '*Planetary Predictions for the years 1826-1830*'.

A prediction that Olive failed to make was the death of her arch enemy, Frederick Duke of York, on January 7, 1827. While she rejoiced, the people, and particularly the army, mourned the passing of a Prince who was 'manly, gentle, un-intellectual – three qualities that were truly English.' [375] His pernicious and spectacularly unprofitable addiction to gambling had been successfully covered up and the public were unaware that he left debts on which the annual interest alone was over £40,000. Frederick would never have the coronation that he had longed for, while assertions about his possible illegitimacy never needed to be put to the test. Any documents referring to Hannah Lightfoot now became irrelevant to the Hanoverian succession, while

William Duke of Clarence, 'Sailor Bill', could look forward to ascending the throne in due course. With his eldest brother's obesity and life style, that day was not going to be far in the future.

August 1827 witnessed Olive's attempts to trace more details about her potentially most valuable inheritance as 'Duchess of Lancaster'. 'The Princess Olive presents her compliments to Mr Ellis and will be favoured if he allows Mr Phillip to see the volumes which contain the original grant to John of Gaunt, Duke of Lancaster.' [376]

Olive had been forced to live in one of the debtors' prisons or within the Rules of the King's Bench from 1823 until 1829. [377] From then until her death, correspondence shows that she lived at various addresses in the West End; first in Knightsbridge, then in Crawford Street, Marylebone (1830), followed by a number of addresses in St Pancras. So, how had her debts been settled and her creditors paid off? It seems that her pen had come to her rescue. In 1829 she published a two page appeal for funds, 'The Princess Olive of Cumberland to the English Nation'. [378] It starts;

> Having been the object, for so great a season, of much wilful misrepresentation, circulated for very obvious purposes, I take leave to recall to your remembrance that I am the legitimate daughter of the late Henry Frederick, Duke of Cumberland. [379]

After giving the familiar list of all the money she was still owed – the £15,000 from George III's will, the £12,000 from the Duke of Kent, the £6,000 plus from the Earl of Warwick – she concludes that she has been the victim of a wicked conspiracy, from 'some influence greater than the law, or the throne, (that) leaves me without protection or provision'. But she is not wasting her time in self-pity.

> I endeavour to render my solitary hours less painful by closely applying myself to literary and philosophical researches, still cherishing the hope that in due time the English nation will sympathise with a member of the Royal family, whose legitimate claims are authenticated, and whose independent and patriotic spirit has been, perhaps, her greatest offence.

Her final paragraph begs for some sort of loan so that she can continue her legal battle for recognition, a loan that 'she will honourably repay in happier circumstances.' It seems that her pleading must have raised enough money to purchase her release and she was now free to live where she liked.

* * * * *

The precise date when Olive turned her fertile brain to inventing a new form of marine compass is unclear, but in 1828 she had another leaflet printed and circulated. [380]

To the Naval & Maritime Officers of Great Britain.

Her Highness the PRINCESS OLIVE OF CUMBERLAND, anxious to promote the welfare of seafaring persons in her native land and other States of Europe, makes known to the British Public that she has been enabled, through her philosophic researches, to ascertain the cause of the Mariners' Compasses in modern use having so greatly vacillated in the Artic (sic) regions.

The PRINCESS Olive also has discovered that a distinct and separate Mariner's Compass is required in the NORTH WEST and SOUTH EAST passages of the Ocean. It affords the PRINCESS OLIVE the highest gratification to inform seafaring gentlemen, that she has perfected a NORTH and a SOUTH Compass, adapted for each side of the Equator; such being upon an entirely new principle, and different to any compasses hitherto made, and have been approved of by the highest scientific and naval characters.

She concluded by hoping that her inventions 'will be found so importantly useful to Mariners' that she would gain some sort of patronage. It wasn't all theory; she obviously had some prototypes made, because she was prepared to show them on 'Tuesdays and Fridays, between one and three o'clock', at the house where she was then living, No 2, Park Row, Mills Buildings, Knightsbridge. A tantalising clue to the main purpose of the compasses – and who had put up the money for the prototypes – lies in an undated letter from Olive to Lady Anne Hamilton. [381]

> If *Longitude* is apportioned by the compasses, to Olive of England and the noble and illustrious Caledonian Anne of Scotland mankind will be indebted for the safety of sailors and of fellow beings in every state; when I reflect, my esteemed friend, on the merits, we shall stand on a high ground, which will confer greater honour than our rank.

This question of how to determine Longitude had been exercising the Admiralty since the night of October 22, 1707, when 2,000 sailors and troops had been drowned in shipwrecks on the Scilly Islands. Under the Longitude Act of 1714, a Board was appointed that offered massive cash prizes to anyone who could solve the problem, the prizes varying in relation to the degree of precision achieved. The main prize had been won by the humble clockmaker John Harrison with his series of 'chronometers', but new improvements were still rewarded. [382] Here then was the clear motive behind Olive's invention, though it is unlikely that it would have qualified. Perhaps it was her pestering persistence that finally made the Board decide to retire in 1828, by which time it had paid out more than £100,000. [383]

Lady Anne's financial backing for the compasses project was not entirely prompted by charity. Olive had promised her a share – admittedly not a large one – of the money she was still hoping to extract from the Royal family. [384]

> Whenever I am paid His Late Majesty's legacy of £15,000, I solemnly promise to present my esteemed friend Lady Anne Hamilton as a testimony of my Royal regard the sum of £500.

But when Olive asked her to be an executor of her Will, a role that might be fraught with claims from creditors, Lady Anne found an excuse to refuse, finishing her letter as follows;

> Although Your Highness is becoming an Editor, you will in no way allude to the person (who gave you the information). If at any time I can serve Your Highness, it must be secretly.

The word 'Editor' is very significant. It seems highly likely that the production on which Olive was embarking in this role was 'The Authentic Records of the Court of England for the Last Seventy Years', which was published – anonymously – in 1832. It was 395 pages long and the preface is revealing.

> If critics should carp at the inelegance or incorrectness of the language in which these truths are conveyed, such persons are informed that the work has not been written by *professional book-makers*. The "plain unvarnished" recital of *facts* has been the aim of the present Editors, with which facts their long connection with the courts of Queen Charlotte and George IV have made them thoroughly acquainted.
>
> The whole history of England does not present two reigns of equal enormity to those of Queen Charlotte and her equally infamous son, George IV. Baseness of every kind was practised, and murder became an everyday occurrence. Deception and villainy were esteemed virtues, while incest and adultery proved passports to Court favour and promotion.

The chapters were arranged chronologically, starting in 1761 and ending in 1831. The general tone is Reformist, the pervading complaints being the repression of personal freedoms and high taxes on the general public, together with the arbitrary exercise of power by Government ministers. (Shades of 'Junius'.) The arch villain is Queen Charlotte, who the authors hold responsible for spoiling and indulging her eldest son while condoning his extravagance. She is also accused of having used her husband's increasing imbecility to enhance her own personal power base. And the root of all her character failings is ascribed to the fact that she was not British, but German! Another major villain emerges as William Pitt (the younger), for being a warmonger who imposed punitive taxes on honest citizens and allowed the National Debt to spiral out of control. All Tory Governments are lambasted severely.

There is no table of contents. Instead, to whet the reader's interest, the preface lists the most salacious subjects covered, including the following: George III's bigamous marriage to Hannah Lightfoot; the implied murder of George III's brother, Edward Duke of York; Queen Charlotte's insider dealings; the pernicious way that the Prince of Wales had raised loans from French nobles, loans that were never repaid; the escalation in the cost of the Civil List; the murder of Sellis by Ernest Duke of Cumberland and the accusation that Princess Charlotte and Queen Caroline had both been murdered. The public rushed to buy the book, but one chapter particularly (the implied charge of murder against the Duke of Cumberland and its homoerotic or incestuous undertones) was judged to be libellous. The publisher, J. Phillips, was brought to trial and condemned, but somehow managed to jump bail and escape to France.

* * * * *

So who was involved in writing this biased and libellous, but one has to say quite titillating and easily readable example of so-called history? It has many of Olive's hallmarks – the exaggerated prose, the many phrases highlighted in italics or capitals, the frequent use of exclamation marks. Unlike Miss Cary's book, there is none of the coy use of initials to try and hide people in anonymity. Lady Anne Hamilton was clearly the source of much of the material. Later in 1832 a re-edited version of this book, expanded over two volumes, was published under the title of the '*Secret History*

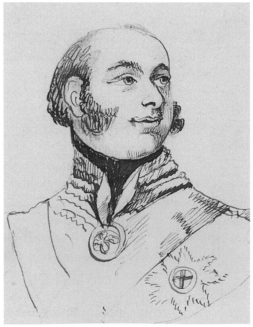

Fig. 7. Sketch of Edward Duke of Kent, drawn by Olive in the last year of her life. [Price family papers.]

of the Court of England from the Accession of George III to the Death of George IV'. [385] And now Lady Anne Hamilton was named as the author on the title page, accompanied by a portrait etching.

Up to her death in 1846, by which time she was living in poverty, Lady Anne never denied the authorship. This work repeated the accusations about Sellis and the Duke of Cumberland, in spite of the law suit, and initially it was sold clandestinely, 'by a woman in a dark cloak, at night, for one guinea a volume.' [386] Olive? Lady Anne herself? It enjoyed great popular success, being republished in several editions, including a weekly serialisation, with the last full printing in 1903.

There is a final thought – might not much of the material have emanated from 'Fitz'? Could the work have started as a collaboration between him and Lady Anne during the period of their partnership around 1825, with Olive being brought in after he absconded to Edinburgh? As we saw earlier, 'Fitz' claimed to have been working on something along these lines and the book, in part at least, may therefore be his last gift to posterity.

* * * * *

In 1833, Olive was staying with the actress and evangelist Miss Elizabeth Wright Macauley at 52 Clarendon Gardens, St Pancras. Miss Macauley's acting career seems to have come to an end when she had a terminal row with the actor manager Edmund Kean in 1818. After this, she became a fervent disciple of Olive's benefactor Robert Owen, touring the country giving lectures about his work at New Lanark and spreading his Socialist philosophy; it was through this mutual contact that they had probably first met. In her autobiography, Miss Macauley describes 1833 as 'the year in which I have strangely and imperceptibly become identified with the affairs of a certain Illustrious Personage! Whose cause, in spite of every difficulty and opposition, I have presumed to advocate.'

Her way of advocating Olive's interests was to publish a pamphlet with the rather long-winded title of *'An Appeal to the British Nation respecting the Wrongs, the Unparalleled Abuses, Injuries and Oppressions of Her Royal Highness Princess Olive of Cumberland'*. It was dedicated to the newly elected Reform Parliament, with the hopes that it would 'reform abuses and redress grievances', including those suffered by Olive, a 'truly legitimate daughter of the House of Brunswick', grievances 'which demand the attention of every noble and independent mind.' Later she asks the question; 'Wherefore do I presume to take up arms against the judgement and decree of the Royal Family, and publicly accuse them of the most culpable neglect?' to which her own answer is that 'she is a lover of Justice!' In a postscript to the second edition, Miss Macauley claims that the publication of the first edition had been delayed 'by various manoeuvres from some *secret agents* ... Have these agents an interest in retarding my proceedings in favour of Princess Olive?' The Secret Agents we have encountered so often before were still active, and still determined that all attempts to

legitimise Olive's claims should be frustrated. The body of the Appeal reiterates all Olive's claims, the names of those who had attested the authenticity of her documents, her attempts to bring her case to trial and the failure of her petitions to the King and his ministers. To us, it adds nothing new by way of evidence, though now the whole story is re-told with a voice of quiet, logical reason, rather than the shrill, exaggerated hyperbole of Olive herself.

In the spirit of the Great Reform Act, passed the year before, perhaps it would launch a bright new beginning to Olive's crusade. She was sustained by her collection of letters from Edward Duke of Kent, and kept his memory alive by doing a pen and ink sketch of her most illustrious proponent, based on the portrait by William Beechey. [387]

But she was now 61 years old and time was running out.

ENDNOTES

372 National Archives TS/18 letter no. 15

373 The journal was later renamed '*The Astrologer of the 19th Century*' when the original title became the object of some ridicule. This, in its turn, was succeeded by '*The Prophetic Messenger*', which ran until 1858.

374 Farnell, K. '*Seven Faces of Raphael*', Skyscript.

375 Fulford, p100

376 WRO CR 1886 Box 677

377 She was in the prison itself between June 14, 1827 and May 14, 1828. WRO CR 1886 Box 677

378 WRO CR1886 Box 676

379 She was still claiming that her mother had been Dr Wilmot's supposed daughter 'Olive'.

380 WRO CR1886 Box 676. She also put an advertisement in the Morning Herald, August 1, 1828.

381 WRO CR1886 Box 677

382 The story has been told in fascinating detail by Dava Sobel in her book '*Longitude*', one of the more surprising bestsellers of the 1990s.

383 There is a clue in the brief description quoted above as to how the compasses were meant to work in theory. All compasses point, not to the precise North Pole, but in a direction a few degrees off, known as the 'Magnetic Variation'. This variation has changed over the centuries – sometimes to the east of 'true north', sometimes to the west – and it also depends to a certain extent on the longitude of the compass's location. Over most of the surface of the earth, the extent to which the Magnetic Variation changes with longitude is so small that it would be impossible to detect, but near the poles themselves, in both the Arctic and Antarctic regions, it is a different matter. Here, and only here, if a series of compasses could somehow measure the *change* in Magnetic Variation as a ship moved, it might be possible to pinpoint the ship's longitude.

384 Shapard, p49

385 This time it was published by William Henry Stevenson of 118 Wellington Street, The Strand.

386 Pendered & Mallett, p247

387 Price family papers. The only other surviving example of her artistic work after 1805 would appear to have been a maritime painting, 'The celebration of the Emancipation of Greece 1829', sold by McLaughlin Christie in February 1927 and bought by Ackermann for 12 guineas. (Witt Library, Olive Serres folder.)

Chapter 16

A Regal Funeral

BY THE summer of 1834, Olive suspected that she was terminally ill and so, on July 5, she wrote and signed her last Will and Testament. [388] She appointed four executors; Lavinia, her doctor George Darling M.D., her barrister Richard Doane and her solicitor, John Primrose. The latter she describes as a man 'who acted with high honour and integrity towards me amidst all my misfortunes.' She wished Lavinia to have one third of any money she left, the balance to be shared by her executors, though she must have known that this would be a worthless bequest. (Her Will was eventually proved at 'less than £20.') There is no mention of Britannia, nor of any of her other children. In the event of the £15,000 owed to her from George III's Will ever being settled, her executors were charged with separate instructions – including the share promised to Lady Anne Hamilton.

Most important is how she wishes to dispose of her documents and papers, which she leaves to Lavinia and John Primrose with a number of caveats. She requests that 'the certificates of the marriage of George, Prince of Wales, to his first consort, the Princess Hannah, and also the Will of that injured and illustrious Lady' are to be shown to the Livery and Corporation of London, inviting them to purchase them, the documents 'being of the utmost value'. With regard to 'the other papers of my Royal Birth, my parents' marriage and my Legitimacy,' she wished them to be 'recorded in one of the Public Offices'. She could not resist a final dig at the Royal family.

> I bequeath to all my cousins of the Royal House of Guelph the sum of one shilling to each, to enable them to purchase a prayer for to teach them repentance for their past cruelties and injuries to myself, their legitimate and lawful cousin.

Olive died on November 21, 1834, at 48, Trinity Church Square, Southwark, in a house owned by a Mrs Huntley, an address that was outside the rules of the King's Bench. [389] But she was not buried in Southwark. Lady Anne Hamilton remained a true friend to the last, obtaining a licence from the Home Office for Olive's funeral to take place twelve days later, with some pomp and 'cautious marks

of distinction', [390] at the church of the Royal Academy, St James's in Piccadilly – almost opposite Burlington House, where Olive had once upon a time exploded onto the art scene as one of the few women to be 'hung' in their annual exhibitions.

> Several ladies and gentlemen, moving in the best society, attended the funeral; the coffin, composed of costly materials usually appropriated to Royalty, bore an inscription setting forth the title and honours to which the deceased had long made claim. [391]

The chief mourners, riding in the leading carriage, were, somewhat surprisingly, Olive's virtually estranged daughter Britannia and her husband Thomas Brock, accompanied by Mr Huntley and a Mrs Orby-Hunter. [392] This lady was a wealthy patron of the arts who had become a friend of Olive's when she had been honoured with the appointment of Landscape Painter to the Prince of Wales. [393]

* * * * *

But where was Lavinia? Britannia had never been close to her mother, not even figuring in her Will, whereas Lavinia had lived with her for most of her life until she married and had shared many of the most climactic moments of her association with the sons of George III. The truth is that the tyrannical Anthony Ryves had locked his wife up in a room at their house at Wargrave-on-Thames and had refused to let her go and see her mother on her death-bed or attend the funeral. Which leads us into a very sinister sub-plot.

Mrs Huntley had tried to contact Lavinia when her mother was dying but had lost her address, so she placed the following advertisement in *The Times* at the end of November.

> Should this catch the eye of Lavinia, daughter of the Princess Olive of Cumberland, who departed this life on the 21st inst. she may yet be in time to see the last remains at 48 Trinity Square, Borough.

While Lavinia did not respond, another group of people certainly did. On two separate occasions over the next couple of months, 'special agents' turned up at the address and departed with the only valuable items in Olive's estate – her papers. [394] They were operating on the orders of the Duke of Wellington, exercising his responsibility as executor to the late King George IV. He must have been acutely aware of the importance of Olive's documents, while it is unlikely that Mrs Huntley would have volunteered to hand them over except under threats of requisition. And it has been suggested that the same 'agents' had persuaded Anthony Ryves that they would make it worth his while to ensure that Lavinia was not in a position to answer Mrs Huntley's charitable advertisement.[395]

It is possible that another of Olive's children was among the mourners walking behind Olive's coffin, namely her illegitimate son, Charles Wilmot Serres, last mentioned in chapter **3**. Very little is known about him. There was a reference to him in the Register of the Marine Society for March 10, 1825, as being aged about 17, 'the destitute, illegitimate son of Mrs Serres, who was later employed as an errand boy by White's library, opposite the King's Bench, and finally discharged on April 3, with a middling character and a bible.' In 1828, he was working as an apprentice to a coin engraver. [396] (He himself would later claim that his father had been Anthony Askew, the son of a prominent London surgeon.) Around the time of the funeral, this young man, then aged about 26, turned up at a London police station claiming that he was Olive's only child. [397] His appearance on the scene was an embarrassment to those who thought that Olive's death might close the books on her claims to Royalty. Uncertainties about the precise date of his birth, or the identity of his father – given that Olive and her husband were never divorced – raised potentially uncomfortable questions about a male successor to adopt her crusade. Which probably explains why this destitute character was shortly shipped off to South Africa, to take up an appointment in the Cape Colony on a stipend of £50 per annum, hush-money funded by the Duke of Sussex. [398]

* * * * *

A brief and unsympathetic obituary notice about Olive was published in the *Gentleman's Magazine*, referring to Olive as 'this extraordinary and aspiring impostor.' Sadder, but far more intimate, the *Court Magazine* printed a poem that Olive herself had submitted in the last weeks of her life;

> E'en thus, while others calm repose,
> And locked in sleep their eyelids close,
> I count the lingering hours in vain,
> Oppressed with grief, inured to pain.
> Fast rain the teardrops from mine eyes,
> While Echo pale repeats my sighs;
> And, oh! less happy than that flower,
> No sunbeam cheers my waking hour.

Olive may have gained notoriety during her lifetime, but her funeral was a fitting demonstration to the world that she still had friends and supporters who treated her with the respect that her birthright deserved. It was by her pen that she had striven to make a career for herself; it was by her own words that she wished to be remembered.

* * * * *

Olive herself was now dead but this is by no means the end of her story. Her fight for recognition would be taken up by her daughter Lavinia, and her own battles against the Establishment, leading to the 'Trial of the Century' in 1866, will follow shortly. What happened to two of her other children can be summarised briefly because they only play minor roles in Olive's legacy to future generations. [399]

After Charles Wilmot Serres had been exiled to South Africa, his Royal appointment came to an end when the Duke of Sussex died in 1838. He then spent seven years in the Army, nineteen years in the Civil Service and five years as an itinerant schoolmaster, known locally as 'Old Wilmot', while records from Bloemfontein show that he was admitted to the Order of Freemasons – Rising Star Lodge, no. 1022. He is presumed to have died around 1869, 'lost and wandering on the veldt'. [400]

Olive's younger legitimate daughter Britannia had married Thomas Brock at St Matthews, Brixton, on December 20, 1830. They had five children over the years between 1831 and 1845. [401] Britannia seems to have adopted an ambivalent attitude to her mother's claims to Royal birth and she remains a shadowy figure for the rest of our story. [402] But the later life of Caroline, Olive's child by the Prince of Wales, is far more complex and in many ways as intriguing and compelling as her mother's. And to understand this, we have to go right back to 1777 and pick up the story of Olive's blood-brother, Thomas Downes Wilmot Dearn, who we last encountered at the end of chapter 6.

ENDNOTES

388 Tegg, W. '*Wills of their own; curious, eccentric and benevolent*', 1879.

389 Camp, p124

390 Pendered p146. This phrase appears to be a quotation from some contemporary newspaper, though the source is not given.

391 *Morning Post* Dec 3, 1834.

392 *Notes & Queries*. Letter to the editor from Britannia. Private papers of the Price family.

393 Her address was 28 Grosvenor Place.

394 National Archives TS 18/112*. Large folder of papers used by the Attorney General in preparing his defence in 1866. The two packets, dated December 10, 1834, and January 16, 1835, have covering notes in the Duke of Wellington's handwriting. The second reads; 'These papers delivered to the Duke of Wellington sealed up by Mrs Huntley and not to be opened excepting by the King himself.'

395 Pendered & Mallett, p143. This was asserted by Lavinia's grandson, G L West, the son of Lavinia's daughter who married an Edward West. It was this branch of the family that ended up with the cake and wine from the christening of Princess Victoria.

396 WRO CR1886 Box 676. Letter to W. Thoms from Edward Brimhault, 4/8/1875.

397 Shepard p50

398 *Times of Natal*, 1867. Also WRO CR1886 Box 676

399 Farington, Vol 7, 1813. John Thomas Serres told Farington that Olive had mothered '3 or 4 children by different men' since they had separated.

400 *Quarterly Paper of the Orange Free State*, April 1869. According to a quoted letter, he apparently left three sons.

401 Camp p127. Britannia born in Lambeth 1831/2, Louisa Sophia born in Lambeth 1833/4, Charlotte Georgina Serres, born in Dublin , March 5, 1836, Thomas Dominic Serres, born in Bishopsgate 1839 and Frances Eva born in Shoreditch 1844/5.

402 She died in 1867.

Chapter 17

Olive's mysterious brother, Thomas Downes Wilmot Dearn – and his adopted daughter

THOMAS 'BEAU' Wilmot, Dr James Wilmot's father, had married twice, on the first occasion to a certain Mary Downes. Thomas and Mary Wilmot had had three sons, the eldest of whom, also called Thomas (1719-1760), had two daughters and a son. This son, Thomas Downes Wilmot, stayed a bachelor all his life and made a considerable fortune in India, both as a merchant-venturer and a trader. The eldest daughter, Eleanor Wilmot, married a London pottery dealer called Thomas Dearn around 1760, and by 1777 they had two surviving children. [403] (See Appendix A).

As noted earlier in chapter 6, this was the year when Eleanor and Thomas Dearn had been induced to adopt the second child of the Duke and Duchess of Cumberland, and the record shows that the boy had been christened Thomas Downes Wilmot Dearn on June 9, 1777, with Eleanor and Thomas Dearn being named as the parents. Their neighbours probably expressed no surprise, because Eleanor had seemed to be in a permanent state of pregnancy since her marriage, having suffered multiple cases of miscarriages and still-born babies. The young Thomas Dearn was initially brought up at the house of his adoptive parents near Lincoln's Inn Fields. If they had been told the truth about his origin, which is highly unlikely, they were also under the gravest strictures to keep the secret to themselves.

But if the unexpected child had meant extra expenses in the family, it looked as if any financial worries would be relieved when Eleanor Dearn was informed in 1781 that she was the main beneficiary of her brother's Will when he died unexpectedly in Calcutta. The Will was relatively straightforward, but separate sets of executors had been nominated both in India and England; a blissful situation for all the lawyers involved, but a nightmare for the legatees. (One of the executors in Calcutta was a certain James Stevenson, whose niece later became young Thomas Dearn's wife.) Poor Eleanor never received a penny of her inheritance and inevitably the whole estate ended up under the tortuous supervision of the Court of Chancery. When

Charles Dickens later wrote the story of the Jarndyce family in his novel '*Bleak House*', he might well have had this case in mind.

Eleanor died in 1785 and matters grew worse in 1787 when her husband, Thomas Dearn Snr. was declared bankrupt and unable to support his two younger children. Elizabeth Dearn, the eldest child, had already married a Mr Charles Dodson, though she died the following year, and her husband then acquired her portion of the inheritance rights. He used the promise of the legacy to set himself up as a grocer in Kent – at the market-town of Cranbrook. Young Thomas Dearn and Anna-Maria, the other legatees and wards of the Court, were now fostered on a couple called John and Mary Hough, but four years later they were shunted on to the care of George and Mary Moss of Vauxhall, also in the pottery business, with the Court of Chancery providing a modest income for their upbringing and education.

At the age of 16, Thomas Dearn left school in 1793 and an apprenticeship was arranged (by whom?) to a well known and well respected architect named William Thomas. Young Thomas Dearn proved to be a good pupil, his tutor writing that he was 'expert at figures and has a talent for drawing'. **(Plate 21)** This report was used as a lever on the Court of Chancery to release more sums for his tutelage. Towards the end of his six year apprenticeship, Thomas Dearn had his first offering accepted for display at the Royal Academy, though as a water-colour it could at that time only be exhibited in the Architectural section. It is an interesting speculation as to whether he ever saw one of Olive's landscapes among the oil paintings, or indeed if they ever bumped into one another. Each was still oblivious of the other's existence, unaware that they were in fact brother and sister. Olive would never find out, but it would not be long before Thomas was let into the secret, and the strain of keeping it to himself would blight his career for the rest of his life.

It was Anne Horton's brother who told Thomas Dearn the real story of his birth. Temple Simon Lutterell was a member of the Prince of Wales's inner circle and had always been close to his sister, accompanying her and the Duke of Cumberland from Windsor when Olive had been born. [404] In 1774, he was elected as a Whig MP for Milborne Port in Dorset, though he lived at Eaglehurst, Fawley, on Southampton Water. Here, in the grounds of the house, he built a magnificent tower 'folly' with vast cellars and a tunnel down to the sea. Legend has it that it was used for storing the booty from smuggling, with the tower acting as a private lighthouse. [405]

Temple Simon Lutterell had been captured by the French at Boulogne in September 1793 during one of the daring 'Scarlet Pimpernel' rescue missions he organised. Afterwards he was taken to Paris and displayed to the mob as a prize hostage; his captors erroneously described him initially as the brother of the King of England. Given the mood of the time, it is amazing that he kept his head, though he would spend 18 months in the Luxembourg prison. [406] He was finally released on St Valentine's day, 1795, to return to England, where in early 1803 he was told that he had a fatal disease and could not expect to live much longer. [407]

One of his last acts was to seek out his nephew, Thomas Dearn, telling him about his birth, warning him against making any attempt to establish contact with his real mother and imploring him to keep the secret locked up forever. He urged him 'to act with discretion, to accept the generous start in life he had been given, to avoid politics, not to gamble away his inheritance and graciously to consent to any rewards or responsibilities that might come, directly or indirectly, from the Royal family, who were aware of his ancestry'. [408] His most urgent plea, however, was that he should never make contact with his sister, the wild, beautiful but unreliable Olive.

* * * * *

This news must have come as a thunderbolt to Thomas Dearn. Later, he would acknowledge the debt he owed his uncle, 'not from the fortuitous circumstances of birth', but also 'in the friendship of this gentleman, the author felt most highly honoured and gratified.' [409] At least he now began to understand why he had received the totally unexpected honour in 1802 of being appointed as official architect to William, Duke of Clarence, the third son of King George III and later to become King William IV. It had seemed a most improbable appointment at the time, since the Duke of Clarence was a professional sailor and, unlike his brother the Prince of Wales, was not known to have any interest in sponsoring the arts at all.

Not only that; the youthful Thomas Dearn had been arrogant and tactless. In one of his earliest publications, introducing himself to the public as a 'young professional, ambitious of making a reputation', he was highly critical of some established architects for taking the plaudits for work that had in fact been done by their young assistants. Worse still, he had been openly critical of the Prince of Wales's extravagant design for the Brighton Pavilion, ending his remarks with the conceited comment that 'the public voice, I will venture to affirm, has been in unison with my own.' Not the way to attract Royal patronage unless there was a hidden agenda. And another hint of Royal interest also now fell into place. Thomas Dearn might well have been surprised that two of the personal items auctioned after the death of his mentor, William Thomas, in 1801, had been a full length print of the Duchess of Cumberland by V. Green [410] and a set of maps from the estate of the late Duke of Cumberland.

The pattern of Thomas Dearn's life had to some extent been steered by unseen hands and it would now be a test of his character as to whether he could keep the promise he had made to his uncle just before the latter died. And the first test was whether he should keep the secret even from his wife. Thomas Dearn had married Elizabeth Stevenson on November 21, 1800, in her family's local church in the town of Cranbrook in Kent, about 12 miles from Tonbridge Wells to the west and 20 miles south of Maidstone. How he had first come to this location is not certain; it may have been at the invitation of his 'brother-in-law', the grocer James Dodson, or it may have been in connection with a survey he worked on for a new strategic canal proposal to link Maidstone with the south coast. This rural backwater of Cranbrook would be his

main home for the later years of his life as he sacrificed his career ambitions to keeping away from the temptations of London, with the chances of running into Olive and breaking the solemn promises he had made. Instead, he buried himself in a number of architectural projects for local dignitaries, producing several books which gave guidance to builders on bricklaying and other aspects of construction management.

At least he now had some independent means, having been given a large portion of his inheritance by the Court of Chancery when he reached his majority. He and his wife Elizabeth could live in reasonable style and they would have had the status of gentry. Elizabeth had given birth to their first child, baptised Anne Wilmot Dearn, the year following their marriage. Four years later in December 1805, while living at Rotherhithe in the Borough of Bermondsey, their domestic harmony would be seriously disturbed. As recounted in chapter 2, some shadowy figures appeared on their doorstep with a baby girl and it was intimated to Thomas Dearn that he and his wife should, indeed must, adopt it as their own. No questions to be asked; it was a Royal command and he was reminded of the duty he owed to his Royal patronage and his vows of discretion. The child, Olive's daughter by the Prince of Wales, was christened Caroline Dearn.

Thomas Dearn had spent most of the early years of his marriage working in London, returning for the occasional spell with his family in Cranbrook. By 1809, he decided that he would move there permanently, away from the pressures of the metropolis and the chance of somehow getting embroiled in Olive's affairs. (For a time, he and Olive had lived almost next door to one another in Charlotte St.) Before he made the move, he published a pocket-sized book of 112 pages, called the *'Bricklayer's Guide'*, which would become a standard in the building industry and which indirectly laid the foundations for the profession of Quantity Surveying.

Cranbrook was a medium-sized market town in the Weald of Kent, and it was one of the first to have a public library and reading room accessible to women. The total population was about 3,000. Thomas Dearn was awarded a number of architectural commissions from local gentry and published a *'History of the Weald of Kent'*, lavishly – and expensively – illustrated with his own sensitive lithographs. [411] He had already written his three volume work *'Designs in Architecture'*, including *'Designs for Public and Private Buildings'* and *'Designs for Lodges and Entrances to Parks'*, and some of these proposals led to other commissions to turn his ideas into stone, bricks and mortar. Thomas and Elizabeth Dearn lived in modest gentility, contributing to local charities and generally becoming pillars of the community. The income from his practice, combined with the money from his Trust, enabled the two girls, Anna and Caroline, to be given good educations at a governess school. Thomas Dearn was made Town Surveyor for Cranbrook in 1816, the salary for which more than compensated the termination of his Royal sinecure as architect to the Duke of Clarence in 1815. Now financially secure, Thomas and Elizabeth had two more

daughters; Julia born in 1818 and Sarah a couple of years later. But the implications of his Royal birth were suddenly forced upon him again in 1822.

* * * * *

Caroline Dearn, Thomas Dearn's adopted daughter and genuine niece, was only 16, but on June 3 she was married by special licence from the Archbishop of Canterbury to a local brewer called George Tomkin. Thomas Dearn arranged it with 'all the discretion, dignity and formality that the occasion demanded.' [412] But why the precipitate haste? There is no question of a 'shot-gun' marriage, with the Tomkin's first child being born at least nine months later. Thomas Dearn had heard that a new Marriages Act was about to be rushed through Parliament in July and one of its clauses was going to be highly relevant. This demanded that in any case of a marriage by licence, the vicar had to *enquire into and be informed of the precise parentage of the parties involved*. Thomas Dearn may have wished to hand over responsibility for the 'imposed' child, Caroline, to another man as quickly as possible and so the window of opportunity had to be taken while it still remained open.

The marriage would have been viewed as being quite suitable; the Dearns were minor gentry and George Tomkin was a prominent, respectable man in the community. He owned several properties in the town, including the George Hotel and a good-sized brewery. So, as Mr. & Mrs. George Tomkin set off on their honeymoon after the wedding breakfast, Thomas Dearn could heave a sigh of relief that he had kept his vow of secrecy and could now put one part of his burden of silence behind him. But not for very long.

Caroline gave birth to her first child, a daughter baptised Caroline Augusta, the following year. Then a rather strange thing happened. For no known reason, the Tomkins left Cranbrook and went to live in Ipswich. Local records in Cranbrook give no hint of any problems there and George Tomkin does not appear to have had any family reasons for moving away. Another child, William, was born at Ipswich in 1826, but twelve months later George Tomkin died and Caroline, now aged 22, found herself a widow, far from her own family. And the honourable, self-sacrificing Thomas Dearn found that once again he had to assume some responsibility for her future.

Caroline was a young widow with two small children when she returned from Ipswich to Kent, and though it seems that Thomas Dearn gave her some financial support by way of a regular allowance, she did not go to live with her adoptive father. [413] Instead, she stayed with her in-laws for a time before moving to Coxheath, near Maidstone, where she set up a school. She did, however, return to live in Cranbrook in the 1830s. Thomas Dearn had by now built six houses there, in the classical Georgian style, his own being decorated with two large carved pineapples above the porch, a symbol of 'Regeneration'. Caroline moved into the house that he and his wife had previously rented.

She married her second husband, William Henry Price, on October 3, 1840. William Price was a tenant farmer at Glassenbury Hill Farm, close to Cranbrook, so it is something of a mystery as to why they were actually married in Iden church, within the parish of Rye and over 12 miles from Cranbrook. (Perhaps the vicar was less concerned to know the true details about the bride's parents.) Neither Thomas Dearn nor his wife seems to have attended the ceremony; perhaps they disapproved of the fact that William was ten years younger than his wife; perhaps they felt that their adopted daughter had 'married beneath herself', since William was only a tenant, while her first husband had been a property owner in his own right.

Within a few years, William Price was persuaded to give up farming and try his hand as a grocer in the hamlet of Willesley Green, just to the north of Cranbrook and the home of Caroline's younger 'sister' Julia and her husband, who had married in 1839. By 1851, Caroline and William Price had five children [414] and had gone back into yeoman farming, though now at Le Rette Farm, Battle, near Hastings. Caroline's adoptive mother, Elizabeth, died in April 1851 aged 74. Her husband, the loyal, trustworthy Thomas Dearn lost the will to live and died the following January, in his 76th year. One of the artefacts he left behind was a six-foot long staff, headed by a carved acorn and inscribed with the single word, steeped in symbolism, SECRETA. [415]

His Will was complicated, with various properties set up in different trusts for the benefit of his children and grandchildren. It seems that Caroline inherited one third of the value of a short lease on 10 Charles Street in London, worth £91 6s 8p a year. But most crucial was a letter that Thomas Dearn left for Caroline, one which explained the facts of her birth and the need to continue the trust of secrecy. He had earlier written in one of his journals; 'My problems arose from an accident of birth'. [416] Caroline inherited these problems, but now compounded by the added complications of her own origins. She doubtless confided these secrets to her husband, and, in the way that secrets have a habit of doing, some garbled versions later leaked out and became the subject of local jibes and unkind gossip. Nor did Caroline have much luck or happiness with her own children by William Price. The two daughters, Inez Naomi and Mary, never married, both living spinster lives into their eighties. By a cruel quirk of fate, two of her sons were killed in their early twenties in accidents on railway lines; Jabez while building a tunnel at Caerphilly in South Wales in 1869, and Robert while working on a railway at Harrisberg, Pennsylvania, USA, two years later. [417]

But at least her surviving son, Thomas Wilmot Dearn Price, fared better, proudly carrying the family names and marrying Sarah Elizabeth Martin in 1872. This marriage proved to be a great success, producing ten children. Their fourth son, Alfred Ernest John Price, born at Hoo on October 3, 1879, became a distinguished citizen of Kent, first as a JP and later as Mayor of Rochester from 1921 to 1923. Among his other honours was his appointment as Constable of Rochester Castle

and Admiral of the Medway Oyster Fisheries. He was the grandfather of the author's collaborator, Richard Price.

Caroline Price died in a rented cottage at the age of 77 in 1882. **(Plate 24)** Her devoted husband continued to work on his brother's farm for a while, but suffered from increasing fits of depression. He wrote; [418]

> My dear wife is gone where she no longer has to heed the evil tongues of men. I am left to listen and condemn them. God gives life and He takes it away. He alone knows the true mysteries and I deliver myself unto him, as He is all forgiving. I care not for else.

William Price, who had unwittingly become involved in matters of state and complex secrets that were far beyond his comprehension, took his own life on October 20, 1884. Suicide was a mortal sin to the Victorians and his death would stain future generations of the Price family with a stigma that was difficult to talk about. For many in the family, Olive was to blame, and the only way to expunge a sense of guilt-by-proxy was by destroying any trace of the long shadow she had cast. Letters were burnt and memorabilia discarded. This was a disaster for future historians and it is why we have to rely heavily on oral traditions from within the Price family for much of the information about the most controversial of Olive's daughters.

That is not to say that Olive's eldest daughter was not controversial in her own way. Lavinia took a great pride in her mother and it is the threads of her story that we now pick up and weave into the tapestry that ends with the 'Trial of the Century' in 1866. Admittedly, she had a lot to gain from proving her mother's rights to her entitlements, and Lavinia would take up this challenge with quite remarkable tenacity and determination, on minimal resources.

ENDNOTES

403 Elizabeth Dearn born in 1766 and Anna-Maria Dearn nine years later.

404 Private papers of R Price.

405 Barton. The house was later considered as a residence for Queen Victoria, but she chose Osborne on the Isle of Wight instead. The architect for the Tower was Thomas Sanby, the next-door neighbour of Dominic Serres, Olive's father-in-law.

406 Alger. He shared a cell with Sir William Codrington and General G. O'Hara, who was later appointed Governor of Gibraltar in 1802.

407 He died, in Paris, on January 14.

408 Donovan, p25, based on Price family papers, and Dearn,1806.

409 Dearn.

410 This may have been the original from which was made the lithograph that now hangs in the Royal Masonic Trust.

411 Several are reproduced in Donovan.

412 Donovan, p105

413 Donovan pp129-33

414 Inez Naomi (b1842), Thomas Wilmot (b1844), Mary (b1846), Jabey (b1848) and Robert (1850).

415 Donovan, p154 and illustration p80

416 Donovan p172

417 Price family papers.

418 Donovan, p176

Chapter 18

Lavinia's story and the 'Trial of the Century'

LAVINIA HAD married the artist Anthony Ryves in 1822. They subsequently had seven children, four girls and three boys, [419] but Anthony proved to be a bully, and soon after the birth of their last child she left him. Three years after her mother's death, she obtained a divorce in 1837 on the grounds of physical cruelty. To try and support her children, she gave music lessons at a school in the West End of London. She never remarried and would devote her life to becoming the torch bearer of Olive's claims into the next generation.

Lavinia's first problem was to regain possession of her mother's documents that had been spirited away from the house of Mrs Huntley in the weeks after she died. This was eventually achieved, with great difficulty and only in part – it excluded the letters from Edward Duke of Kent – by Olive's loyal and industrious solicitor, Mr Primrose, who then entrusted them to Lavinia's solicitor, a Mr Bourdillon. [420] And some of these documents had related to Hannah Lightfoot.

In May 1844, a committee was formed to start activating her claims, particularly for payment of the £15,000 left to her mother by George III, leading to a Bill in Chancery being filed against the surviving executor of George IV – the Duke of Wellington. The Duke filed a demurrer, a delaying tactic, so it would be another two years before the Bill was revived, giving the Duke time to ensure that a few skeletons were kept locked in the cupboard. George IV had died in 1830; the coronation of William Duke of Clarence, as William IV, had led to a change of Government, now under the leadership of the Whig, Earl Grey. It seems that the Duke of Wellington in his role as executor to George IV, aided and abetted by Sir William Knighton his private secretary and 'fixer', had tried over the years to ensure that all the papers and correspondence of the late King were collected together in a secure place. It was he who had arranged for Olive's papers to be kidnapped. Other more compromising documents that related to George IV (and his father) might have to be destroyed.

It seems possible that Lavinia's action prompted one particular attempt to sweep a potential embarrassment under the carpet, an embarrassment that might lie in the

church at Kew. The *Times* of February 28, 1845 reported a theft. 'On the night of Saturday, February 23, 1845, a little before nine in the morning, the pew opener found the vestry door unlocked, went in and missed the iron chest from its accustomed stand … the iron chest contained all the Parish Records from 1717 to the present time.' [421] The robbery certainly took place – a reward of ten guineas was offered for information – while coincidentally some registers from the neighbouring church at Isleworth appear to have been burnt. [422]

Both locations had been intimately linked with the saga of Hannah Lightfoot. In 1975, Arthur Lloyd Taylor, while researching his family history in Kew, came up with information that one of his ancestors had been paid for dumping the 'iron chest' into the Thames. [423] Apart from any uncomfortable documents that there might have been about Hannah and Prince George's marriage, how about any children? Rumours abounded that there might have been two sons and a daughter, and over the years a number of candidates have been suggested with varying degrees of authenticity or implausibility, though it is important to stress that none of them, during their own lifetimes, made any such claims. [424] Robert Huish wrote in his book, *'Public & Private Life of his late most excellent Majesty, George the Third'*, 1821, that George had known 'the bliss of purest love when the object of his affections (Hannah) became a mother'. [425] The nearest we get to documentary evidence for the existence of any children appear to be three signed statements by Dr. James Wilmot, of uncertain provenance, that would emerge, almost by accident, at the Ryves trial of 1866. [426]

This is to solemnly certify that I married George Prince of Wales to Princess Hannah, his first consort, April 17, 1759, and that two princes and a princess were the issue of such marriage. London, April 2, 1760

This is to certify to all it may concern, that I lawfully married George, Prince of Wales to Hannah Lightfoot, April 17, 1759, and that two sons and a daughter are the issue of such marriage. Undated; witnessed by Chatham and Dunning.

I solemnly certify to the Parliament of England that I married George Prince of Wales to Princess Hannah, his first consort, April 17, 1759, and that three children were lawfully begotten on the said Princess Hannah's body. Barton January 1789.

Another document, Hannah's supposed Will, dated 7 July 1762, and signed 'Hannah Regina', implied that George had fathered two sons and one daughter by Hannah. [427] This must be a later fabrication, because in the second paragraph Hannah leaves her property (if she outlives all her children) to 'Olive Wilmot, daughter of my best friend Doctor Wilmot'- and this 'Olive' never existed. This document would

prove to be particularly damning to Lavinia's case in 1866; if one of the Hannah papers could be shown to be fraudulent, how very much easier would it be to cast aspersions on all the others? Theories about the possible children of George and Hannah have fuelled many books and a television programme, and a summary of these is given in an appendix to this book. (Appendix E). One speculation seems to the present author to be more credible than any of the others and this will be resurrected in the concluding chapter. For now, we return to Lavinia and her plan of campaign.

* * * * *

Lavinia did not remain idle while she waited for the Court of Chancery to consider the demurrer filed by the Duke of Wellington. On July 24, 1844, she wrote directly to the late Duke of Kent's younger brother, Adolphus, Duke of Cambridge, pleading for a personal audience, so that she could have 'the pleasing consciousness of having done my utmost on all occasions to prevent pain, and delay exposure of family affairs.' [428] She respectfully reminded the Duke that he had once been gracious enough to intervene in the petition brought by another abused woman. [429] Lavinia's audience was granted two days later. When she said who her mother had been, the Duke had replied; 'I know who you mean, the daughter of my late uncle, Henry Frederick, Duke of Cumberland, brother of my father.' The Duke had then quizzed her about the Earl of Warwick, the meetings with the late Duke of Kent, and about Dr. James Wilmot, who he acknowledged as being of 'a very old and highly connected family.' When he had asked how Dr. Wilmot had become so confidentially associated with his father, Lavinia took care not to mention anything controversial. She recounted how he had come to London and 'through the family connection with Sir Edward Wilmot, the physician to George II, his son and George III, was much respected and received into the Court circle … and became intimate with your Royal father and his brother and was made in every way a friend and confidant.' After two hours, the Duke of Cambridge had excused himself, requesting that Lavinia should ask her solicitor to discuss her papers with the Duke's own legal representatives. As he shook her hand in parting, he had said: 'You will soon hear from me'.

It seems that there was no follow-up to this interview but evidence that it did take place is confirmed in a letter from Charles Goodwin, who had been the chief cashier at Coutts Bank and who had personally handled the payments made by Robert Owen to Olive on behalf of Edward Duke of Kent. Goodwin wrote to His Serene Highness Prince Edward of Saxe-Weimar on January 28, 1861; [430]

> The late Duke of Cambridge once had some conversation with me concerning Mrs Ryves, which finished by his Highness saying that he believed in her statements.

Lavinia's case against the Duke of Wellington for payment of her mother's bequest from George III was eventually heard in the Chancery Court during June 1846, before Lord Langdale. Arguments from counsel on both sides were put forward over three days. At the heart of the case was an Act of 1800 referring to Royal documents, with one clause seeming, unequivocally, to make the legislation retrospective.

> Any instrument in writing made and executed by his Majesty before the passing of the said Act, as and for his last will and testament … should be as effectual to dispose of the property … intended to be disposed of thereby, as if the same had been made before the passing of the said Act.

The Will of George III, leaving Olive £15,000, had already been judged to be authentic by senior law officers. This was the case of Lavinia's counsel. But the defence claimed that the Will had never been *proved in an Ecclesiastical Court* (the case of June 1822) and on July 28, Lord Langdale handed down his judgement that his court had no jurisdiction to rule on the matter or to grant probate either! [431] Although the outcome was a disaster for Lavinia, the case is of some intrinsic interest to students of jurisprudence, because it seemed to establish a precedent that there could be a 'wrong' in English law for which there was no legal remedy – 'Damnum sine injuria'.

Lavinia's next step along the line of litigation was to establish that she was her mother's legitimate daughter under the terms of the Declaration of Legitimacy Act of 1848. This was achieved quite readily, but when she presented a further petition to the Court of Divorce and Matrimonial Causes to establish her descent from her grandfather, she hit a brick wall. This was going to be a battle – a very expensive one – and it took a long time for her to rally sufficient funds.

* * * * *

In 1858, a 92 page booklet was published under the title of '*An Appeal for Royalty: a letter to her Most Gracious Majesty Queen Victoria from Lavinia, Princess of Cumberland and Duchess of Lancaster.*'[432] The introduction began;

> After patient endurance of most cruel wrongs through a period of thirty eight years, during which I have been plunged from affluence and honour into a condition of continuous privation and almost utter destitution; from the experience of kindly regard and true friendship, on the part of your Majesty's late Royal father, to a state of entire neglect by all those persons to whom his Royal Highness expressed his solemn wishes – even on his deathbed – that I should be protected; I am at length compelled to make this public appeal to your Majesty's sense of justice and to the loyal and honourable feelings of the people of this great nation.

The '*Appeal*' then, tactlessly, mentioned that Lavinia has 'hitherto scrupulously guarded ... *the great state secret, which so deeply affects the honour of that House (of Hanover)*'. This reference to the Hannah Lightfoot affair, and its overtones of blackmail, undermined Lavinia's hopes of resolving her claims without having to go to further litigation and made the concluding presumption that 'your Majesty has now gone through the *Appeal to Royalty*' most unlikely. Indeed, in 1858 Edward White the Queen's Solicitor had been persuaded to present a copy to Queen Victoria in person; a few days later, he reported back to Lavinia's solicitor that 'Her Majesty had thrown the book on the floor, saying that "I will not do anything for her; let her go into the Courts of Law to get it." ' [433] Not that Queen Victoria had never shown any sympathy for Lavinia's situation. In March 1840, Lavinia's solicitor had received a letter from Marlborough House enclosing £5 'to aid your endeavours of making some fund from which you may be able to educate the children of Mrs Ryves – the payment ... comes as a donation from her Majesty Queen Victoria.' (But that had been before the death of Prince Albert.) Queen Adelaide, the widow of King William IV, had been even more generous, to the extent of a £10 donation. [434]

All along, Lavinia's case was two-fold; that her mother, Olive, had been the legitimate daughter of Henry, Duke of Cumberland and that she had therefore been entitled to the money and honours that were due to her as Princess of Cumberland and Duchess of Lancaster, from which it followed that her eldest daughter (Lavinia) should have inherited them. It was Lavinia's clearly stated declaration that, should she win, any financial rewards were solely for the benefit of her children, not herself. The accumulated value of the Duchy of Lancaster would have been enormous, but Lavinia let it be known that she was only concerned with the sum owed to her mother and would not be claiming any accrued interest or income. [435] And it was this seemingly un-greedy, selfless approach that gained her sufficient support to finally launch her case against the Attorney General in February 1866.

Like the Duke of Wellington back in 1844, the Attorney General immediately filed a demurrer on the basis that the Crown had not had sufficient time to prepare their defence. Lavinia's lawyer protested that this was ludicrous, since copies of all the documents had been produced for examination in 1848, and that any delay was unreasonable, particularly in view of his client's age. This was the first argument on which he would be overruled and the hearing was postponed until the following legal Term. The main reason the Attorney General needed time was to plan a strategy on how to deal with Olive's letters from Edward Duke of Kent.

After they had been abducted from the house of Mrs Huntley by those sinister 'agents' after Olive's death, they had been sealed up by the Duke of Wellington himself and given to Lord Melbourne for safe keeping. The Attorney General realised that they could seriously undermine his whole case and he asked John Greenwood QC, Solicitor to the Treasury, to write copious notes about each one. Greenwood

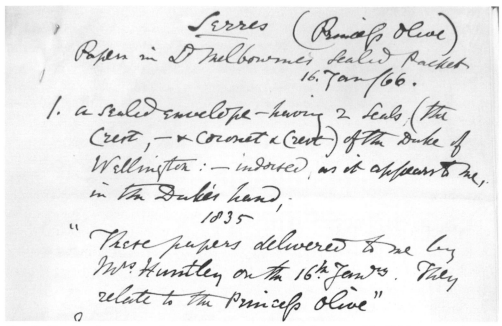

Fig. 8. Hand-written note for the Attorney General, January 16, 1866, concerning the provenance of Olive's letters from Edward Duke of Kent. (NA TS 18/112)

immediately raised this tricky, delicate matter with the Prime Minister, Earl Russell, in a letter dated January 29. [436]

> My Lord, I venture to submit that the letters need not be destroyed *yet*. Many others, from the same hand, are I think in possession of the claimants. It is *possible* – but extremely unlikely – that one or more of those in our hands might be serviceable upon the approaching enquiry. I leave this to your Lordship's discretion.

Nothing shows more clearly that the defence team was clearly rattled, with the Attorney General 'passing the buck' to the Prime Minister to decide whether vital evidence should even be destroyed. It is fortunate for posterity that he did not.

<p style="text-align:center">* * * * *</p>

It is impossible to gauge the impact of the 'Great Trial' of June 1866, Ryves v. Her Majesty's Attorney General, without appreciating the robust, indomitable character of the 'little old lady' who was prepared to take on the might of the Establishment virtually on her own. [437] **(Plate 23)** Lavinia was now 68 but quite amazingly fit, both physically and mentally, for a woman of her age. She was known to walk from Camden to visit relations in Stockwell, a round distance of about 12 miles. [438] She had inherited many of Olive's best traits; she believed passionately in her cause, she was

going to present herself in the way she believed Royalty should behave and she was certainly not going to be intimidated by some of the greatest legal brains of the time.

For many years, she had lived in the direst poverty, in wretched lodgings on Haverstock Hill, Camden Town, north London, [439] surviving on the charity of visitors intrigued by her story. One writer described her as being 'a chatty and agreeable old lady, full of anecdote and vigour.' [440] An American visitor wrote that her room 'showed the signs not only of poverty but want. Although it was a cold day in December, the grate was fireless, and she told me, with tears, that one of her daughters had actually died of exhaustion brought on by want of the necessary comforts of life'. [441]

Another American, Moncure D. Conway, asked his London host if he could arrange a meeting with Lavinia, who sent him an invitation 'with the royal seal of England upon it, that seal which it is a high offense for anyone but those of the royal blood to use.' [442] On first seeing Lavinia, he was deeply impressed. 'If ever a woman felt herself to be that which she claimed to be, it was the woman before me. Her manner was queenly, her eye clear and calm, and her voice deep and earnest.' 'I have never seen such pathos or such pride,' declared another visitor, 'yet it was not a proud pride; but rather a rectitude, an abstract assurance of her own integrity that, from that time, I never doubted.'

* * * * *

Lavinia's case before the Court of Divorce and Matrimonial Causes was presented by Dr J Walter Smith, assisted by Mr D M Thomas, neither of whom was of any note whatsoever. In fact, Dr Smith was not even a qualified barrister, having to gain special permission to plead at the bar of the court. At least there were no fragile reputations at stake; Dr Smith would prove that he was prepared to take considerable risks in advancing his client's case, however implausible some aspects of it certainly were. He would have to suffer brutal intimidation and insults from the defence. The chief defendant was the Attorney General, Sir Roundell Palmer, who would later become the Lord Chancellor under the title of Lord Selborne, and his support team consisted of the Solicitor General, Sir Robert Porrett Collier and Queen Victoria's personal advocate, Sir Robert Phillimore QC. And as if this team was not enough, they were assisted by two other eminent barristers, Mr Hannen and Mr Burke. A 'special jury' had been selected, and the defence must have prayed that they would not be as independent minded as their counterparts in the trial of William Hone back in 1818.

Raised above the main body of the courtroom, in a position that symbolised their supposed detachment and impartiality, sat the three judges; the Lord Chief Justice himself, the Lord Chief Baron and the Judge Ordinary. [443] But this was no ordinary assembly of persons to administer justice, one that proves that the Establishment were taking the case extremely seriously. Printed versions of all the main documents

that Lavinia and her team were likely to produce had already been exposed in previous cases and publications, so what were they frightened of? One can only assume that it was the fear that Dr. Walter Smith was going to produce another, startling rabbit out of the hat. He himself, however, must have known that the case immediately threw up a legal quandary. Lavinia had established her own legitimacy in a previous case in January 1861 on the basis that her parents, Olive and John Thomas Serres, had been legally married, but if her counsel was now about to try and prove that Olive was the legitimate daughter of Henry, Duke of Cumberland, that marriage could have been invalidated by the Royal Marriages Act. So before the trial could start, the judges had to wrestle with the intricacies of this dilemma, and after hours of deliberation it was conceded that earlier judges had been at fault in not appreciating the significance of the point brought out in an earlier chapter; Olive's children were exempt because she had married into a 'foreign family'. The trial could now proceed. In boxing terms, Lavinia's team had won round one on points.

Dr Smith, his confidence boosted, opened his case by explaining to the jury the intricacies of the Legitimacy Act. He told them that their task was perfectly simple and straightforward; all they had to decide was whether or not Lavinia's grandmother had been lawfully married to Henry, Duke of Cumberland. He then produced the piece of paper on which was written the declaration that Henry, Duke of Cumberland, had been married to 'Olive' Wilmot by Dr. James Wilmot at Lord Archer's house on March 4, 1767, witnessed with the signatures of Brooke and J. Addiz, and attested with those of J. Dunning and Chatham. To a hushed court, he then went on to tell the unbelievable fairytale of 'Olive' Wilmot's life; how her father, Dr James Wilmot had met and married the Polish Princess Poniatowski, her own birth in 1750 and her marriage to Henry, Duke of Cumberland; how, when she was pregnant in 1771, the Duke had then deserted her to marry Anne Horton and how their child, Lavinia's mother, Olive, had been born in April 1772 and fostered out on Dr James Wilmot's brother and sister-in-law; how she had then disappeared to France where she had died of a broken heart in December 1774.

Dr. Smith produced one document after another to justify each phase of Lavinia's mother's life, including those which showed that King George III had been aware of his niece's birth and how he had personally endorsed her christening as the child of Robert and Anna-Maria Wilmot, followed by his wish that she should grow up to be acknowledged as the Princess of Cumberland – and Duchess of Lancaster. Dr. Smith claimed that he would produce over seventy documents to support his client's case, including the Will of George III in 1774 where he promised to leave Olive £15,000 to compensate her for the un-chivalrous way that his brother had behaved. The judges immediately ruled that this piece of evidence was totally inadmissible.

Throughout his presentation, Dr. Smith had to endure a sequence of inter-ruptions from both the defence counsel and from their lordships on the bench. One judge asked if he was seriously implying that the Duke of Cumberland, by marrying

Anne Horton, had committed bigamy? Dr Smith replied that indeed he was. There were other questions about the wording of the declarations that read more like jotted memoranda than serious legal documents, completely lacking the longwinded jargon beloved of lawyers.

And why were they written on mere 'scraps of paper', rather than parchment? Dr Smith was not to be rattled. Patiently he explained that all of them had to be worded as simply and briefly as possible; they contained secrets known only to the participants and the witnesses, composed in haste on the writing materials available at the time. Another judge referred back to Olive's petition in the House of Commons in 1823 when the Home Secretary, Robert Peel, had declared that all these documents had been forgeries. Dr Smith had a neat rejoinder – Robert Peel had only been a politician, and his personal opinion had no weight in law. What was not picked-up on, however, was the complete lack of supporting evidence that 'Olive' had ever existed, something that Dr Smith must have known to be the weakest link in his whole case.

* * * * *

The Lord Chief Justice and the Attorney General may have been apprehensive that Dr Smith would produce some new bombshell and now, when it came, it took the form of a quite different certificate of a marriage that had absolutely nothing to do with Lavinia's case. But the explosion would prove to be the biggest single factor in undermining everything that she was trying to achieve. Dr. Smith had, unwittingly, opened Pandora's box. On the other side of a document declaring that Dr. Wilmot had married 'Olive' to the Duke of Cumberland in 1767 was another stating that, eight years earlier, Dr. Wilmot had performed a similar, secret ceremony, the one when he had married the young Prince George to Hannah Lightfoot.

The court erupted. The Lord Chief Baron was shocked. 'It is really a great *indecency* to inquire into matters like these affecting the Royal family!' Then the Lord Chief Justice exclaimed; 'You say that the King, as well as his brother, committed bigamy?' [444] Dr Smith was forced to agree. 'We are bound to take notice,' interjected the Lord Chief Baron, 'that George III was publicly married to Queen Charlotte … If there was a prior marriage and the first wife was living at the time of the second marriage, George IV may have had no right to the throne!'

Now the Attorney General waded in; 'Nor her present Majesty! I do not disguise from myself that this is nothing less than a claim to the throne.' Against protestations from Dr Smith that it was no such thing, the Attorney General continued; 'In my view, the more my learned friend states, the easier it will be to arrive at a conclusion as to the truth and falsehood of this case. I am bound to tell your Lordship that I shall treat it as a case of fraud, fabrication and imposture from beginning to end.' At least he had observed the courtesy of acknowledging Dr Smith's role, but then he not only prejudged the outcome but added insult to injury. 'It is comfortable to believe that

the guilt of the fraud may be excused by the insanity of one of the Persons principally concerned.' Dr Smith had been knocked to the canvas in round 2, but he was back in his corner and would come out fighting.

* * * * *

After the up-roar had died down, Dr Smith called his first witness, a handwriting specialist who was the leading figure in his field at that time. Mr Netherclift, 'a man whose good faith was above reproach', would have to be taken seriously by the court. He had examined the signatures on all the documents to be presented – 43 of Dr. Wilmot, 12 of John Dunning, 12 of George III and 8 of the Duke of Kent – and pronounced his considered opinion that they were all genuine, though he did admit, under cross examination, that he had a slight doubt about one or two of John Dunning's. He was particularly adamant about the signatures of George III and the Duke of Kent.

It was only with the 36 signatures of William Pitt, Earl of Chatham, that he expressed real concerns, when comparing these to a single, genuine example from Chatham's Will – written when he was suffering from acute gout. It was perhaps significant in regard to the marriage certificate of the Duke of Cumberland to 'Olive' that he 'could not adhere to the opinion that the signatures (Chatham and Dunning) produced by the appellant were genuine.'[445] When it was pointed out by the Attorney General that several signatures showed variations of style, Mr Netherclift declared that this was entirely natural and, indeed, a forger would probably have taken more care to make sure all signatures were precisely identical. [446] Round 3 to Dr Smith.

* * * * *

Dr Smith's next pieces of evidence were to have been the twelve affidavits sworn on oath in 1820 and 1821 to testify to the genuineness of certain of the signatures, but these were ruled to be inadmissible because the writers were dead and could not appear in court in person. And when he tried to introduce a portrait of Olive **(Plate 14)** to explain why so many people had commented on her likeness to George III, the judges became very animated and said that the jury must never be allowed to set eyes on it. Round 4 to the defence, but only by means of several punches below the belt.

The next three days were taken up with cross examination of Lavinia herself. She insisted on standing for the entire time she spent in the witness box, refusing all offers from the bench that she might be allowed to have a chair. She would 'stand for ever to protect the honour of her family.' This show of doughty defiance made a very favourable impact on the press. She told the story of her life during the period she lived with her mother. Their introduction to the Prince of Wales, how they had spent the summer of 1805 down at Brighton and how they had attended his birthday balls every year from then until 1810; how she had 'received many kindnesses from him', including 'a present of £5 to buy a doll.'. She expounded in great detail how the Earl

of Warwick 'visited me and my mother whenever he was in town … we always treated him as a relation'.

Then she reminisced about Edward Duke of Kent; 'I knew the late Duke from a very early age. He constantly visited me and my mother from 1805 until his death.' She described the meetings in 1815 when the Duke and the Earl of Warwick handed over the packets of papers that related to her mother's true origins, how the Duke 'acknowledged my mother as his cousin … and Princess of Cumberland', and how he had gone on to say that, in the event of the Earl's death, 'he would take on himself the sole protection of my mother and me.' After the death of both George III and the Duke of Kent in 1820, she recounted how her mother had consulted the Duke of Clarence on how she might best proceed, and how the documents she had 'inherited' from the late King had been inspected and verified by the Duke of Sussex.

Lavinia faced her greatest ordeal when she was cross examined about the various versions her mother had put forward to explain how she was descended from Henry Duke of Cumberland. Why had she claimed at one stage that her own mother had been Olive Payne, Dr Wilmot's *sister*, before transferring her parenthood to the mysterious 'Olive', the supposed *daughter* of Dr. Wilmot? And why at times did she claim to be *illegitimate* and at others *legitimate*? Lavinia admitted she was confused on this point, excusing her mother's behaviour on a misunderstanding of the Royal Marriages Act. The Attorney General even introduced the cheap jibe that Olive couldn't spell, quoting the line from a *Congratulatory Ode* she had written to the Prince Regent in 1812, describing him as the '*orfspring* of Heaven's smile'. When he nagged away at Lavinia for various inconsistencies in her story, she held her dignity. 'Although I am here with a good will and spirit, it is a task to go backwards and forwards in a hurry'.

Dr Smith now called his final witnesses, including a Mr Fletcher who verified the signatures of the Earl of Warwick on the basis of surviving correspondence between his grandfather and the Earl. Other genuine signatures from the Earl and the Duke of Kent, those on their official Wills were produced for comparison, but this tack rather misfired, because the Attorney General could point out that neither contained any bequests to Olive. A Dr. Fraser stated that he had attended Olive when he had been a young man and had never had any cause to doubt her sanity, and he had subsequently enjoyed a long career dealing with lunatics. With this character endorsement, Dr. Smith rested his case.

* * * * *

The Attorney General then rose to open his defence, declaring that 'a case of such rank and audacious imposture could not be too thoroughly exposed.' [447] He proceeded to interpret what he saw as the key facets of the case in terms of a theatrical entertainment, thereby putting the jury in a state of mind that they were being treated to fiction. Act 1 with the Polish Princess and her beautiful daughter; Act 2, the

romance of Prince George and Hannah Lightfoot; Act 3, the marriage of Dr. Wilmot's daughter to a Royal Duke. All these fictions, he argued at some length, sprang from the imagination of a woman of unsound mind, who had educated her own daughter to believe in the same fantasies.

He had not even finished when the foreman of the jury interrupted to say that his fellow jurors needed to hear no more, because they were already convinced that the signatures on the documents were forgeries. To loud protests from Dr. Smith, the Lord Chief Justice said 'You are quite right! You share the opinion which my learned brethren and I have entertained for a long time; that *every one of these documents is spurious!*'

It was with the greatest difficulty that Dr. Smith retrieved his right to address the jury himself before they reached a final verdict. He concentrated on the warm and cordial relationship between Olive and the Duke of Kent, the father of Queen Victoria. Did his esteem and affectionate letters, recognising Olive as his cousin, count for nothing in gauging the integrity of Mrs Ryves and her mother? 'Is it not a fact that she received an annual allowance of £400 from the Duke of Kent?' The Attorney General was well aware of this, and that the principal sum behind the loan had even been repaid by Queen Victoria, but he could be certain that the jury had no such information. He was prepared to perjure himself. 'It is a perfect fiction', he declared.

The Lord Chief Justice, Sir Alexander Cockburn, moved quickly to his summing up. [448] It was not unbiased. 'No man of *common sense*', he stressed to the jury, could believe that the contents of the key documents were genuine, even if the signatures attached to some of them might have been genuine in a few cases. It was, he continued, unimaginable that the documents, 'such outrages upon all probability', could have been examined in detail by members of the Royal Family. He ordered that all the documents presented by Dr. Smith should be impounded for one hundred years. And behind the scenes, the letters of Edward Duke of Kent to Olive, though never presented as evidence, could be returned to the Prime Minister's private safe – perhaps forever. (See Appendix C).

After this, the jury could be forgiven for reaching the verdicts that they did; first, that Henry, Duke of Cumberland, had not lawfully married 'Olive' in 1767, and secondly, that Olive Wilmot was not the legitimate daughter of Henry, Duke of Cumberland – by 'Olive'. [449] And of course these verdicts were absolutely correct, though for the wrong reasons. Not only was this a knockout blow to Lavinia's hope of establishing her regal legitimacy, but it put her in danger of being charged with very serious crimes of perjury and worse. Would the court now instigate such charges?

* * * * *

The trial was widely reported, not only in England but in publications like the *American Law Review,* which made some pungent comments on whether the plaintiff

had been given a fair hearing at all. Many reports expressed some surprise that Lavinia had been allowed to leave without, apparently, any aspersions on her own integrity. Reporters were even more intrigued as to why she left in a carriage emblazoned with the Royal coat of arms, a carriage that had conveyed her to and from the court on every day of the proceedings and which must have been supplied by some sympathetic member of the Royal family. [450] Curiosity had reached fever pitch when the Prince of Wales, later to become King Edward VII, had attended the trial on every day since the revelations about his great-grandfather and the beautiful young Quaker. Was his reason merely the titillation of comparing his ancestor's affair with some of his own? Or was he seriously concerned that his own right to the throne had been jeopardised by this youthful infatuation, one that might have led to a secret marriage? He must have been reassured by the judges' declaration that all the documents concerning Hannah Lightfoot were forgeries to perpetrate a fiction.

One might imagine that Lavinia, exhausted by her ordeal, would be grateful to have kept her freedom and would now give up and retire to lick her wounds. Not a bit of it. The case had brought her valuable publicity, more visitors and more supporters, people who offered her financial help to keep her cause alive. Later in 1866, a 16 page pamphlet – 'Ryves versus the Attorney General; Was justice done?' – was produced by her son-in-law, Edward West, which expanded on the points made in the *American Law Review*. Attached to it was a plea for subscriptions 'for her private benefit during the continuance of her arduous struggle for Right.' [451] Now the next phase of her struggle could be pitched at an even loftier level than the last one. To the amazement of the outside world, and doubtless to the dread of the Establishment, this elderly lady from a lodging house in Camden Town was about to present an Appeal, in person, to the highest court in the land.

On June 22, 1868, Lavinia Ryves, approaching her 70th birthday, stood before the bar of the House of Lords. The proceedings lasted less than three minutes. On a 'technicality', it was ruled that 'no Bill of Exceptions had been entered and no motion for a new trial had been made', and therefore the Lords were unable to hear the claims of the plaintiff. [452] This effectively signed the death warrant for Lavinia's crusade. There would be no more appeals, no more litigation; no more struggles to achieve what she believed with all her heart were the rights to which her mother had been entitled and which she should have inherited. For the last remaining years of her life, she was supported by a small pension granted her by the Royal Academy, 'in recognition of her father's eminence as an artist'. On the 16th of December, 1871, Lavinia Ryves, daughter of Olive Wilmot Serres, Princess of Cumberland and a legitimate, direct descendant of King George II, slipped into unconsciousness and died.

Neither Olive nor her daughter had been able to prove this legitimacy because of the wording on *one single document* among all those that had been produced at one time or another. This seemingly insurmountable stumbling block is the certificate

of Olive's birth, the certificate from which sprang the necessity to invent the mythical 'Olive' and all the so-called evidence about her, which had without doubt been fabricated by 'Fitz'.

The more one studies this piece of paper, the more one gets a feeling that something in the wording is wrong; something just does not fit. It contained an important secret, it may well have been written in haste and in poor lighting conditions. Had the people putting their signatures on it read it really thoroughly, or had they relied on Dr. James Wilmot to have drawn it up accurately? Is it possible that, in his haste to get the matter closed, Dr. James Wilmot had simply put two words in the wrong order? …

ENDNOTES

419 Olive Lavinia Noel d.unm 1892; Sophia Lavinia born 1825, later married to Edward West (1) and James Burchell (2); Lavinia Jeanetta died 1877; Anthony Thomas, died aged 19 in 1850; William Henry (1833-92); James Stafford, born 1835/6 and died after 1891. There may have been another child who died in infancy, Harriet Jane, though not traced by Camp.

420 Pendered & Mallett p144, quoting Lavinia's deposition in 1858.

421 In fact not all, but the robbers would not have known this. See Appendix E.

422 Pendered p188-9

423 Lloyd-Taylor.

424 Camp pp59-74

425 This phrase was omitted in his later recollections on George IV.

426 National Archives J77/44, docs. 49 (back), and 50 (back).

427 National Archives J77/44, doc. 79

428 Appendix to the Appellant's Appeal to the House of Lords, 1866. Items X and XI, Lavinia's affidavit. WRO CR1886 Box 674.

429 The grand-daughter of the late Captain Jordan, Paymaster General of the Forces in America.

430 Appendix to the Appellant's Appeal to the House of Lords, 1866, item XII, quoted in Pendered & Mallett, Appendix Q.

431 *Reports of Cases in the Rolls Court, Vol 9, pt 3*, (Beavan 1846)

432 Originally published as a series of letters in the *Morning Post* during 1848. It is believed that Lavinia certainly contributed the introduction and the closing paragraphs, while the body of the text, retracing the story of her mother's life and claims, was perhaps written by Commander Morrison R.N. (Pendered & Mallett p248.)

433 National Archives J77/44/R31. Paragraph 10 of Lavinia's affidavit of February 21, 1866.

434 Addendum to *An Appeal to Royalty*. Quoted Pendered & Mallett pp195-6

435 According to a press report of January 26, 1861, the total sum had been calculated at £1,004,644.

436 National Archives TS 18/112 Large folder, Box 2.

437 The case was officially tabled in the names of both Lavinia and her eldest son, Anthony Thomas Ryves.

438 Obituary notice in *London Daily Chronicle*, December 17, 1871.

439 Zion Cottage, Kentish Town Road. National Archives J77/44/R31. Lavinia's Affidavit February 21,1866, preamble. Paragraph 12 stated that a preliminary examination for a case against the Attorney General had taken place in 1859.

440 Obituary notice in *The Era*, December 17, 1871.

441 *American Law Review*, 1867. Quoted Pendered p202

442 *Harper's New Monthly Magazine*, May 1864. Conway was the Editor. Quoted in Pendered, p196

443 Sir James Wilde. Like Dr. James Wilmot, he believed that the plays attributed to William Shakespeare had been written by someone with an intimate knowledge of the law, e.g. Francis Bacon.

444 All quotations from the trial are taken from the report in the *Annual Register* and the verbatim reports, copies of which can be read in WRO CR1886 Box 677.

445 The Times June 7, 1866.

446 An interesting footnote would later emerge in the report of a trial in the *Derby Times* of April 1, 1871. Netherclift, the hand-writing expert, was asked in cross-examination; 'Do you think you have ever been wrong?' 'I think I might have been wrong in the Ryves case, but that was the only instance.'

447 The Times, June 14, 1866.

448 Cockburn was politically highly ambitious. His own private life was not without its own blemishes, being littered with illegitimate children.

449 They did however concur with the earlier ruling that Lavinia Ryves was the legitimate daughter of Olive and John Thomas Serres.

450 It was speculated at the time that this was the then Duke of Cambridge, recalling his late father's sympathetic interview with Lavinia in 1844.

451 The supporting signatories were those of John Allen, John Bartlett, Baltimore Clubb, William Frere, John Stabb and Edward West.

452 Pendered & Mallett, p224, quoting the *Annual Register*.

Chapter 19

The Twists in the Tail

'Some authors have told me that they are the last to do that work [proof-reading] for themselves. They know so well by heart what ought to be, that they run on without seeing what is.'
 King George III, in conversation with the diarist Fanny Burney.[453]

This quotation is particularly ironic, given the speaker and the subject. How many times have readers of this story made handwriting/typing errors, and how often, when proof-reading a document, have they read what they thought was written rather than the actual words and their sequence? Haste, urgency and poor illumination can exacerbate these common errors. I contend that just such a slip was inadvertently introduced into the certificate of Olive's birth (and not spotted by the witnesses); a simple reversal in order of the words 'his wife' and 'Olive'. The version below, the one that I believe was *meant* to have been written, makes complete sense. (Compare with **Plate 16**)

> **By his Majesty's command, we solemnly certify that Olive Wilmot, the supposed daughter of my brother Robert, is Princess Olive of Cumberland, the only child of Henry Frederick, Duke of Cumberland, and his wife. Olive born April 3, 1772 at my mother's, Warwick.**
> **Signed J Wilmot Brooke**
> **Witnessed by; J Dunning Robt. Wilmot**

But why had Olive not questioned this with either the Earl of Warwick or the Duke of Kent? When the Earl had given her the original document in the summer of 1815, he was already seriously ill. He had probably assumed that the identity of Olive's mother was self-evident and perhaps Olive had felt it was indelicate to query the evidence he had given her before he died the following spring. Olive had promised to let the Duke of Kent progress her claims 'behind the scenes'. Their last meeting alone before his premature death had been more than fully occupied with opening and examining the two packets of documents that were not supposed

to be opened until the death of George III. After that, the moment had passed for ever.

The implication of the first version of Olive's 'birth certificate', that her mother had been the mysterious 'Olive', *has absolutely no supporting evidence whatsoever.* There is, however, ample negative evidence to the contrary – Dr. James Wilmot's bachelorhood, the pedigree of the Polish Royal family and the Duke of Cumberland's well recorded dalliances in 1767, the year he was supposed to have married 'Olive'.

For the second version, there is abundant corroboration as discussed in chapter 6; Anne Horton's state of pregnancy in the winter of 1771, the urgent meeting of Lord North with the Duke of Cumberland in March 1772 and George III's pressure to force the Royal Marriages Act through Parliament and be given the Royal Assent before April 1772. Not to mention John Jesse's reference in his *Memoirs of the Life and Reign of King George III* to Anne Horton's 'conduct as a wife and mother'. [454] And if Olive was not the child that Anne was about to produce, what did happen to it?

The witnesses to Olive's birth certificate are plausible. Robert Wilmot must have been in on the act. The famous lawyer John Dunning had been a friend of Dr. James Wilmot, he had defended Henry Duke of Cumberland in his court case of 1770, and he was a political ally of William Pitt, Earl of Chatham, who had recommended his appointment as solicitor-general in Lord Grafton's administration, following the retirement of Edward Willes. [455] George Greville, Lord Brooke, would be a natural signatory given the Warwick connection and his family relationship with the Wilmots, while Dr. James Wilmot was the respectable, trusted cleric who had offered to arrange the adoption, knowing his sister-in-law's sad, coincidental situation. He would be an obvious choice if he was already in the 'special confidence' of the King for performing a previous, secret service on his behalf. Which brings us back to Hannah Lightfoot again.

* * * * *

Too many rumours and legends to be ignored suggest that the young Prince George was infatuated by the 'fair Quaker' and that he was assisted by Elizabeth Chudleigh in having some sort of a clandestine affair with her. This would have been perfectly natural for a potent, libidinous Hanoverian Prince, however gauche and unworldly his demeanour. It is a proven fact that Hannah Lightfoot went through a marriage ceremony with Isaac Axford at Keith's Chapel in 1753 – a wedding of questionable legality – and it is certain that this marriage was never consummated and lasted for a very short time indeed, maybe only a few minutes.

It also seems possible, even probable, that the affair between Hannah and young George, both riven with guilt, then continued for some time, with Hannah living in a number of secret addresses under the protection of Robert Pearne and members of his family. In spite of the gossip and the rumours, both at the time and subsequently, and the number of people whose families have claimed descent from the lovers, there

seems to be no positive evidence that Hannah and George ever had any children. Indeed, DNA testing of some of the more likely claimants has proved negative. [456]

* * * * *

Which leaves us with three open questions; did George and Hannah ever go through a form of marriage, when did Hannah die and who lies in an unmarked coffin in St Peter's church, Carmarthen?

It is this author's contention that the marriage did take place on April 17, 1759, in Kew Chapel and that the ceremony was conducted, in secret and never written in the church records, by Dr. James Wilmot, witnessed by William Pitt and Hannah's confidante, Anne Tayler. Copies of the 'marriage certificate' were kept by Dr. James Wilmot, with one set being passed to the safe keeping of the Earl of Warwick. He in turn donated it in 1815, in a sealed packet, to Olive, who opened it, in the presence of the Duke of Kent, in 1819. This, perhaps, was the only genuine document about Hannah, all the rest, including her so called Will and the mention of children, being fabricated by Fitz to make a good story. The very reason that the marriage document was genuine led Fitz to compose the supposed marriage certificate of Henry, Duke of Cumberland to the fictitious 'Olive' on the reverse side of one version.

There was, perhaps, an occasion when George III himself made an oblique reference to a previous marriage, during a time when he was undergoing his earliest spell of mental breakdown in 1788/9, later diagnosed as porphyria but more recently ascribed to bipolar disorder and clinical depression. [457] He indulged in 'an avalanche of sex talk: random sexual fantasy, disgust at the Queen and spicy allusions to Lady Pembroke.' [458] Interspersed were moments of clarity when he seemed to 'reach a hidden truth that served his amorous rambling'. [459] It was during one of these that he summoned one of his equerries who later reported that he had been asked 'to go and look for Paley's Philosophy, in which he told me that I should find that tho' the law said that Man might have but one wife, yet Nature allowed more.' [460] This equerry happened to be Robert Fulke Greville, the Earl of Warwick's uncle.

* * * * *

When did Hannah die? Was she still alive as late as 1765, perhaps dying in Philadelphia? It is difficult to ignore the coincidence of the date of the supposed 'second marriage' of George and Hannah and the date when she was rumoured to have been buried in Islington churchyard, in the grave marked Rebecca Powell – May 27, 1759. It seems possible, as suggested in chapter 2, that what was being 'buried' was the documentary evidence of her changed status, to be the wife and consort of the Prince of Wales.

But perhaps there is another explanation. What if Hannah had become seriously ill in early 1795, and that the sentimental George had succumbed to her sincere wish, driven by her religious convictions, that their relationship should be legalised for the

sake of her immortal soul in the event of her death? And what if her illness was caused by her being in the later stages of pregnancy, and that she believed she was being punished for having committed, in her eyes, a heinous sin? I believe it is possible that Hannah did in fact die in the third week of May 1759, presenting her protectors with the embarrassment of having to arrange a very private burial. By a helpful coincidence, the Rev. Brooke of Islington and a chaplain to George II, whose niece Rebecca had also just died, suggested that he would ensure that Hannah's coffin was slipped, under cover of darkness, into a 'double' grave.

If this scenario was the truth, Hannah's pregnancy would have been known to only a very few people, but enough to feed later rumours that she had indeed been a 'mother'. There is one significant piece of evidence. In December 1759, Lady Sophia Egerton wrote to her uncle William Bentinck, later Duke of Portland. [461]

> It has often been buzzed that HRH was not wholly insensible to the passion of Love; and I am assured that he kept a beautiful young Quaker for some years, that she is now dead and that one child was the produce of that intrigue.

I contend that there is a possibility that a child was delivered, a daughter known as Sarah, who was spirited away for adoption, perhaps to the Thomas Coram Foundling Hospital (where Hannah's uncle John Plant was an early benefactor [462]) and who was later kept under the eye of some family in the Royal confidence. Furthermore, I suggest that this family went by the name of Ritso, and for evidence to support that claim we have to indulge in one last flashback, one that takes us back to a courtier in the household of George III's parents.

* * * * *

Frederick Ritzeau had been the private secretary to George III's father, Prince Frederick, and had himself fathered a son, George Frederick (b 1742), by Sophia, the Head-dresser to Princess Augusta. George Frederick, now calling himself Ritso, married a German woman called Louisa Grimm in 1763, and they had several children who reached maturity. [463] He joined the Corps of Engineers in 1761, fought at the siege of Belle Isle that year and, although only a very junior officer, 'received more pay for his services than any other officer except the chief engineer'. [464] He retired as a Captain in 1776, became Paymaster of the Exchequer Bills and was given an appointment to India in 1787, where he was joined by his two younger sons; Edward and John. [465]

The Governor General of India, Lord Cornwallis, had registered irritation at having George Frederick Ritso foisted on him because of a recommendation from the Royal family. [466] In fact, his family did well. In a letter from Lord Wellesley, his son, Captain John Ritso, was highly commended for his services in the Mahratta wars, along with his son-in-law Dr James Dalton, of Carmarthen. [467] Dr James Dalton

had married a Catharine Augusta Ritso, who was born, according to her age at her burial, in 1780/1. [468] There has for a long time been a legend that *she* was the daughter of Prince George and Hannah Lightfoot, but this birth date makes that suggestion impossible, since Hannah would by then have been 51.

The simplest explanation for the origins of Catharine Augusta Ritso would appear to be that she was the youngest child of George Frederick and Louisa Ritso. There is, however, no record of her baptism – unlike her siblings. Nor was she mentioned in George Frederick's Will of 1810. [469] Intriguingly, this Will has an unusual rider, forbidding 'any tomb or monument to be erected over my grave'. George Frederick's family clearly enjoyed considerable Royal patronage, but was he taking deeper secrets to his grave? [470] Was Catharine Augusta Ritso only his *adopted* daughter?

* * * * *

St. Peter's church in Carmarthen traces its origins back to the 13th century and holds a number of remarkable secrets, mysteries that transport us almost into the world of Dan Brown and 'The DaVinci Code'. In September 2000, the floor of the chancel started to collapse under the weight of the magnificent organ, initiating a major programme of restoration. Excavations under the chancel revealed a large, previously unrecorded brick tomb, beside which was an inscribed stone memorial slab which had never before seen the light of day. [471]

Hasty investigations using an endoscope revealed that the tomb contained four coffins. According to the memorial, one is of a Dalton daughter, Charlotte Augusta Catharine, who died a spinster in 1832, while another is that of her 8 year old niece Margaret Augusta Prytherch, [472] But who are in the other two coffins, one of an adult, the other of a child? The history of the church claimed, [473] wrongly, that Dr James Dalton had married 'Sarah, the daughter of Prince George and Hannah Lightfoot', but had this 'Sarah' been Catharine Augusta Ritso's *mother*? (The dates for this possible 'missing link' fit quite well, if she had been born in 1759 and had given birth to a daughter around 1781.) Is it she who lies buried in this secret tomb? Of course there were pressures of time and cost to complete the rebuilding as soon as possible, but it is regrettable that the authorities were so insistent that it should be resealed in such haste under several feet of concrete without further investigation. Equally intriguing, one has to wonder what was the real motive behind a private visit to the church by His Royal Highness the present Duke of Kent in July 2001? [474]

There is yet another mystery. George III ordered a new organ for the Chapel Royal at Windsor from George Pike England in 1796, but in the event it was donated by the King to be installed elsewhere – at St Peter's, Carmarthen. [475] Was this a gift from a grieving father, a symbolic memorial to the love-child of his first romance?

* * * * *

If Prince George's marriage at Kew in April 1759 did take place, to some peoples' minds it might never have been accepted as a true marriage because Hannah's surname had been omitted from the 'certificate'. And to anyone wishing to use the George/Hannah relationship for leverage on the Royal family for other purposes, this might seem to present a problem. It is important to record that Olive herself never resorted to such blackmail, but 'Fitz', with his own agenda, had a definite motive, to make both money and mischief. Hence the forging/fabrication of the other Hannah documents including the 'second marriage certificate', the one that corrected Hannah's surname and gave a symbolic date that was unlikely to be challenged; also Hannah's supposed Will and suggestions that she had given birth to more than one child.

This hypothesis solves another problem which has dogged all previous researchers. One of the envelopes that contained a document from Dr. James Wilmot via the Earl of Warwick, 'not to be acted upon till the King's death' is tiny, measuring no more than 6 ¼ inches by 3 ½ inches. (Fig 3.) Unlike the massive collection of Olive-related documents accumulated by Lavinia and the Attorney General for the trial of 1866, which now lie in the National Archives, this cover has been handed down through Olive's descendants and is now in the Price family papers. [476] It is just big enough – and the folds on the two items coincide – to have contained the original marriage certificate, 'the scrap of paper', that consummated the love of a shy young Prince for his Fair Quaker.

Before we leave the open question of when Hannah died, brief mention should perhaps be made of any suggestions that she was still alive after 1759. Pendered and Mallett mention two in appendices to their book, one involving the Rex family of Pennsylvania and the other a marriage in 1762 of John Fry to Hannah Rex in East Pennard, Somerset. They seem to be inconsequential, with no more substance than the rumour that Hannah had died in 1765, which precipitated Queen Charlotte's request for a second marriage to King George III. Perhaps the only other mention that comes anywhere near being 'evidence' lies in a memorandum written by the Earl of Warwick to Olive three weeks before he died. [477] In this he recalled that Dr. James Wilmot had told him how he had attended George III's coronation in 1761 and that a woman in the crowd had 'thrown down a glove'. He had been convinced that this woman had been Hannah, 'the lawful but deserted wife of his Majesty'.

* * * * *

If we conclude that only one of all the 11 documents relating to Hannah that emerged at the trial of 1866 was genuine, what about those more specifically relating to Olive herself? We have already dismissed the supposed marriage of Henry Duke of Cumberland to 'Olive Wilmot', the imaginary daughter of Dr. James Wilmot and we must conclude that all the other documents that mention her in any way must be foolish productions by 'Fitz', expanding on and elaborating the pedigree invented by Olive.

Which leaves us with two categories; the letters written by the Duke of Kent to Olive and the 'letters of wishes' signed by George III, not to be opened until after his death.

It was never contended, except by extrapolation from the ruling of the Lord Chief Justice in 1866, that the letters signed by the Duke of Kent were not what they seemed, letters of support and good intentions from a man to a cousin for whom he had genuine affection and regard, one to whom he even offered a guarded proposal of marriage. (See Appendix C). The Duke's brothers certainly seem to have taken them very seriously – as did the Attorney General in 1866. Edward knew that Olive had been wronged by his Royal siblings and wished to exercise what influence he might have in order to rectify this injustice. This was extremely naive in respect of the Prince Regent/George IV and the Duke of York, both of whose legitimacy might well have been at stake, *but he could be confident that there was nothing whatever in Olive's armoury that could in any way affect the right of his own daughter, and her descendants, to inherit the throne.*

The documents signed by George III need not be contentious either. It seems perfectly reasonable to concur with the law officers in 1820 that the 'cover-up' declaration about Olive's baptism, the paper confirming his wish that she should be acknowledged as Princess of Cumberland, and Duchess of Lancaster, and his Will leaving Olive £15,000, were genuine. Why was Olive permitted to drive around London in a coach emblazoned with the Royal arms of the Duchy of Lancaster without being prosecuted? Why was she never accused of committing forgery? Whenever she tried to use these documents to establish her legitimacy, the Establishment had little to fear as long as she claimed at the same time that her mother had been the mythical 'Olive'.

The Will remains an enigma. It seems to have completely disappeared from the National Archives. (See Appendix D). It was over this that Olive perhaps suffered the greatest injustice, both in 1822 and when Lavinia revived the matter in 1844/6. Olive had produced utterly responsible affidavits, senior legal minds had endorsed the legitimacy of the claim, yet the proving of the Will was refused on a series of legal 'technicalities'. From the Establishment's point of view, because of the wording of the Will, any grant of probate could have been taken to confirm that Olive was indeed 'our brother of Cumberland's daughter'.

Which is precisely who she was, a legitimate Royal Princess, daughter of Henry Duke of Cumberland and his Duchess, Anne Horton, born in wedlock and outside the constraints of the Royal Marriages Act, a great-granddaughter of King George II and cousin to Queen Victoria. In her life, she was as infuriating and exasperating as she was beguiling and, to many men, intoxicating. She deserves to be given recognition as a pioneering authoress, journalist and artist who had to struggle to live an independent life with virtually no financial patronage. Above all, she was a fascinating, articulate and complex woman, never given her fair and honourable birthrights – because of a slip of the pen.

ENDNOTES

453 Quoted in Longford, p 317

454 Jesse, vol. 2, p6

455 ODNB, Cannon, J.

456 Discovery Channel 2002.

457 Peters, T. '*History Today*', September 2009.

458 Tillyard 1994, p133-4

459 Ibid.

460 Ibid.

461 Egerton MSS 1719, folio 81, British Museum, quoted in Storrar, p27

462 Private communication from Sheila Mitchell.

463 Frederick Henry, Barrister, (ca. 1770-1860); Henrietta Georgiana (married a Mr Cleator); Edward (died, unmarried, at sea 1805) and John Christopher (1772-1866).

464 Pendered & Mallett, p291. The siege of this island, off the west coast of France during the Seven Years War, had been initiated by William Pitt. After its capture, Dominic Serres was sent to paint a picture of it.

465 Edward became a Captain in the 73rd Regiment, stationed at Madras; John also became a Captain, but this time in the 76th Regiment.

466 Cornwallis Correspondence, quoted in *Notes & Queries* – Pendered p289.

467 Pendered & Mallett, p289. John Ritso was then ADC to Lord Wellesley. James Dalton was a surgeon in the Madras Medical Service, later buying the lunatic asylum at Kilpauk in 1807. (*History of the Indian Medical Service*, Vol 2, p416.)

468 Her marriage in Trichinopoly, Madras is in the records of the India Office N2/o/3/70, though only as Augusta Ritso. To complicate matters, there are records of *Charlotte* Augusta Ritso (the eldest daughter of George Frederick Ritso), who married an attorney, James Stark, in Bengal in May, 1791. India Office N1/4/123.

469 National Archives PROB 11/1545. He died on board ship – the 'Ansell' – on his way back to England in 1813, unaware that Catharine Augusta had died and been buried in Madras on March 6 that year.

470 Some authors have suggested – *Notes & Queries* 10S ix, 1908 – that there is another explanation for the Royal interest in the Ritso family, one that does not involve Prince George and Hannah Lightfoot at all. Perhaps the secret that George Frederick Ritso was so keen to preserve was that his father had not been Frederick Ritzeau at all, but Frederick, Prince of Wales.

471 Another surprise discovery was the head of Sir Richard Steele, founder of '*The Tatler*' journal.

472 Dr. James and Catharine Augusta Dalton had two daughters, Charlotte Augusta Catharine Dalton (born 1806) and Caroline Georgiana Catharine Dalton (b 1808). Caroline Georgiana married Daniel Prytherch, Mayor of Carmarthen, who then incorporated certain Royal elements into the armorials of his family. Their daughter, Margaret Augusta Prytherch, died aged 8 in 1839.

473 St Peter's church, Carmarthen, website 2010.

474 The Western Mail, July 20, 2001.

475 Some writers have suggested a quite logical, though more mundane, link via the architect John Nash. The organ was originally erected at the west end of the church and moved to its present location in the 20th century.

476 A further collection was made by William Henry Thoms after 1866 and passed by him to the then Earl of Warwick, papers that now reside in the Warwick Record Office. Thoms was Clerk and Librarian of the House of Lords and editor of 'Notes and Queries'. He developed a venomous antipathy to Olive and besmirched her memory in a series of articles in the 'Athenaeum' between May and August 1867, many of his points being rebutted by the Royal biographer John Heneage Jesse. He continued his vendetta in a slim book 'Hannah Lightfoot; Queen Charlotte and the Chevalier D'Eon; Doctor Wilmot's Polish Princess', 1867.

477 Bodleian Library, Oxford. Shelfmark MS. Eng. Hist c722, f60

APPENDIX A

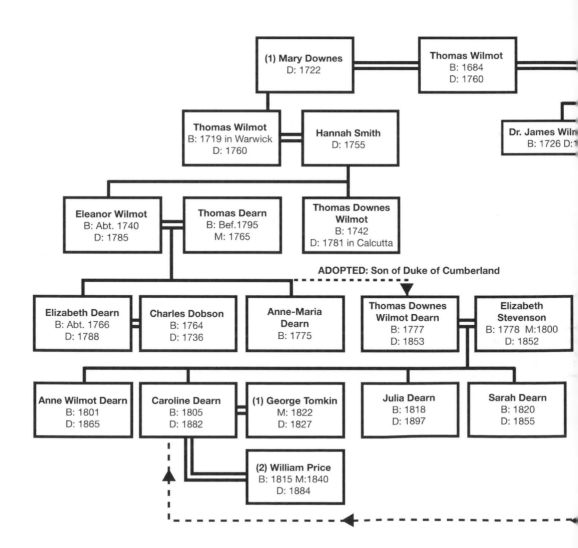

OMAS WILMOT (1684 - 1760)

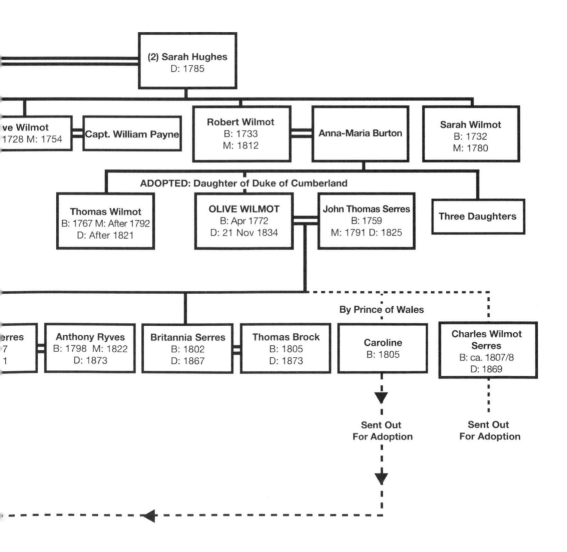

(2) Sarah Hughes
D: 1785

ve Wilmot
1728 M: 1754

Capt. William Payne

Robert Wilmot
B: 1733
M: 1812

Anna-Maria Burton

Sarah Wilmot
B: 1732
M: 1780

ADOPTED: Daughter of Duke of Cumberland

Thomas Wilmot
B: 1767 M: After 1792
D: After 1821

OLIVE WILMOT
B: Apr 1772
D: 21 Nov 1834

John Thomas Serres
B: 1759
M: 1791 D: 1825

Three Daughters

By Prince of Wales

erres
7
1

Anthony Ryves
B: 1798 M: 1822
D: 1873

Britannia Serres
B: 1802
D: 1867

Thomas Brock
B: 1805
D: 1873

Caroline
B: 1805

Charles Wilmot Serres
B: ca. 1807/8
D: 1869

**Sent Out
For Adoption**

**Sent Out
For Adoption**

APPENDIX B

SIMPLIFIED DESCENDANT CHART FOR C

Important Illegitimate Children;
† Caroline, by Olive Wilmot Serres .qv. =
†† William (Rev.) Groves, supposedly by daughter of Charles Stuart
††† Declared illegitimate under the Royal Marriages Act.

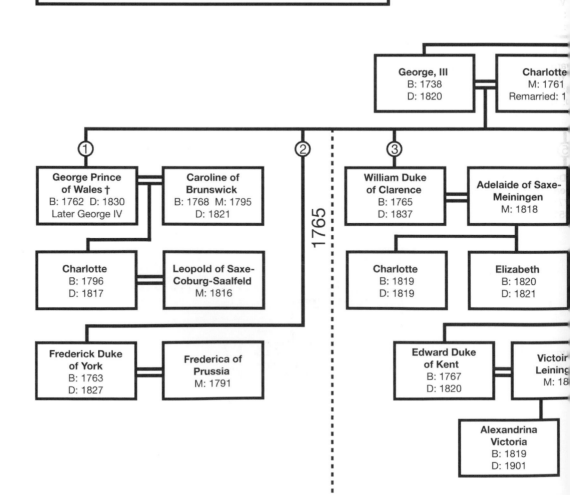

George, III
B: 1738
D: 1820

Charlotte
M: 1761
Remarried: 1

① **George Prince of Wales †**
B: 1762 D: 1830
Later George IV

Caroline of Brunswick
B: 1768 M: 1795
D: 1821

② 1765

③ **William Duke of Clarence**
B: 1765
D: 1837

Adelaide of Saxe-Meiningen
M: 1818

Charlotte
B: 1796
D: 1817

Leopold of Saxe-Coburg-Saalfeld
M: 1816

Charlotte
B: 1819
D: 1819

Elizabeth
B: 1820
D: 1821

Frederick Duke of York
B: 1763
D: 1827

Frederica of Prussia
M: 1791

Edward Duke of Kent
B: 1767
D: 1820

Victoir Leining
M: 18

Alexandrina Victoria
B: 1819
D: 1901

196

IT AFFECTED THE ROYAL SUCCESSION

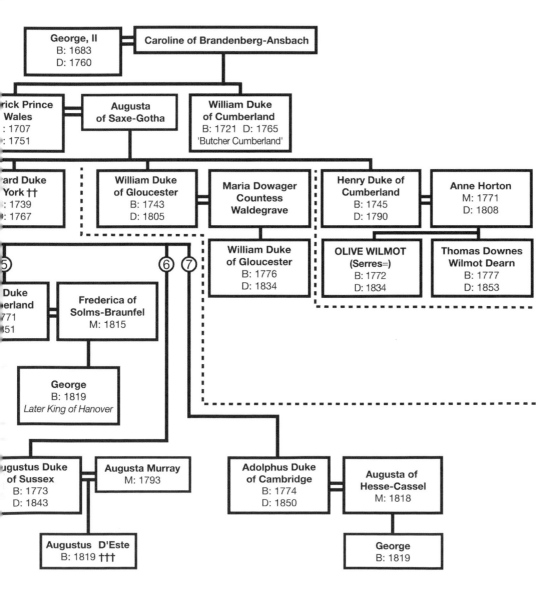

APPENDIX C

The letters of
Edward, Duke of Kent

THERE ARE over 30 letters written by Edward Duke of Kent to Olive Serres between 1809 and 1820 that survive, accessible for public scrutiny. The majority reside among the Modern Manuscripts in the Bodleian Library, Oxford. [1] But because they have been catalogued with the apparently authoritative and pejorative annotation of '*letters forged by Mrs Olive Serres*', they have been ignored or overlooked by previous biographers of both Olive and the Duke of Kent. Why were they deemed to be forgeries and what is the reason for this damning indictment?

Their provenance, working backwards, was a donation to the library in 1934 by Mrs Harriet Sanders, the widow of Joseph Satterfield Sanders (1853-1934) who had been the private secretary to Arthur Balfour and, in effect, the first person to occupy the role of Cabinet Secretary. Balfour inherited dossiers of particularly sensitive papers that had been accumulated by previous Prime Ministers, including Earl Russell who held that post in 1866. As described in Chapter 18, that was the year of the court-case Ryves vs. the Attorney General, at the conclusion of which the Lord Chief Justice gave a judgement that *all* the documents previously owned by Olive Serres, which had been presented as evidence by the appellant, were forgeries. With the benefit of hindsight, it is certain that some most definitely were, but this indiscriminate, blanket ruling should be viewed as being unsafe at best and vexatious at worst. Furthermore, the letters of Edward had not been presented as evidence by either side, so the ruling only applied to them *by inference*.

During Olive's lifetime, the letters she had received from Edward Duke of Kent had been kept among her most precious possessions, and were of sufficient importance to be abducted after her death by agents working for the Duke of Wellington in his role as executor to the late King George IV. (See Chapter 16.) The hand-written defence notes prepared for the Attorney General in 1866 and John Greenwood's letter to Earl Russell, which can be inspected at the National Archives, clearly suggest that these letters were then taken very seriously indeed. [2] (See Chapter 18.)

The style of all the letters is consistent, many written in haste with associated errors in spelling and syntax. They exude the informality of a man writing to a relation and trusted confidante, snatching a few moments from under the watchful eye of his mistress (and later his wife) to confide personal feelings and family secrets that he could not discuss with anyone else. Many events referred to can be corroborated from other sources. In many of the letters the writer expresses his sincere desire to help Olive obtain her rightful dues, when his eldest brother the Prince Regent was less antagonistic, yet the letters contain *no specific information* that would assist Olive to this end.

Thus there is no motive for Olive to arrange for any of them to be forged. Certainly the letters contained matters that were highly embarrassing to the Royal Family. There was, therefore, every incentive for the Establishment to denigrate the letters and sweep them under the carpet as far as possible. It is this lack of motive on Olive's part, along with the general construction of the letters and the fact that the Prime Minister's office kept them so long under lock and key, that leads me to the conclusion that they are utterly genuine. [3]

APPENDIX D

The Will of King George III, 1774

THERE REMAINS a considerable mystery about the present location of this important artefact in its original form.

It was not allowed to be produced as evidence in the Ryves trial of 1866, but appears to have been included among the mass of documents that the Court ordered to be confiscated from the appellant and kept from public view for one hundred years.

In March 1967, Richard Price asked to see it at the Public Record Office, then situated in Chancery Lane. This he did. However, when he later requested a photocopy of the document, he was informed that this was not possible because it was not in their archives. After a long and rather testy correspondence (and an affidavit declared by Richard Price on November 3, 1967, that he had indeed seen it and handled it), [4] in July 1968 he was sent two photocopies of items from the records of the Prerogative Court of Canterbury reference PCC exli 1822/661A. (Not the bulk of the Ryves documents that are in J77/44 Vol 3.) These two photocopies show slightly different versions of the Will with identical dates and text. In version 1, believed to be the original, it seems that the signatures of George R., Dunning, Chatham and Warwick are written in different hands (see **Fig. 3, chapter 11**), whereas in version 2 it would appear that all the signatures, as well as the text, are in the same handwriting, suggesting a copy.

When I requested sight of both documents at the National Archives in Kew in early 2009, I was informed initially that neither could be traced, but diligent work by a member of the Advice and Records Knowledge Dept. resulted in a letter being sent to me dated July 2, 2009. This stated that version 2 had been found among the records in PROB 31/1184, though this particular document had been filed out of sequence, which accounted for the initial failure. There was, however, absolutely no trace of version 1 and it was suggested that my research should be directed to the Royal Archives.

On August 21, 2009, I received a very polite reply from the Registrar at Windsor Castle informing me that the Royal Archives did not hold this document, adding the gracious note that they were sorry to give this disappointing reply. There is a further twist to this mystery. In 1988, the Public Record Office had published a booklet entitled 'Wills, Inventories and Death Duties – A Provisional Guide' by Jane Cox. On page 66 there is an entry for a Will of George III giving a reference of PROB 31/118661. I have been informed by the National Archives that no such reference ever existed.

APPENDIX E

The legendary children of Prince George & Hannah Lightfoot

APART FROM the Ritso family, discussed in chapter 19, one of the more credible of the other suggested candidates was George Rex, who claimed that he had been born in 1760. (His age does not appear on his gravestone at Knysna in South Africa.) He had acquired a good education, gaining a Proctorship at Doctors Commons by 1789 and arriving in South Africa in 1797 with the appointment of Marshal of the Admiralty Court. His Warrant of Appointment had been signed by George III, 'in consideration of the good and public service already performed and which shall hereafter be performed for us by George Rex, Gentleman, and for certain other good and lawful causes moving us on his behalf.'

Several writers have interpreted this as a secret agreement that he must never declare his true origins, never marry and have legitimate children, nor return to England. A Government official, a certain Mr Twistle, who worked with him in Cape Town, complained in letters home to his sister about the royal favours bestowed on George Rex; 'because he was the legitimate heir of our King, for his mother, the Quaker, and King George were joined in marriage before ever Queen Charlotte was thought of.' [5] In 1801, George Rex was granted a sizeable allowance by the Crown, allowing him to retire from public service. He acquired a large estate and built an imposing house at Knysna, about 150 miles east of Cape Town. A visitor in 1830 claimed that he had 'the exact resemblance in features to George III' [6]; guests reported that he used silver embossed with the Royal coat of arms – with no bar sinister – and, just before he died in 1839, the Duke of Edinburgh stayed with him for several months. It was also around this time that he is supposed to have burnt all his private papers.

Although George Rex never married, he did have children by two mistresses, four by the first and no less than nine by the second. Some of these married into the South African 'aristocracy' and there are still many families who cherish the fables of possible royal ancestry. Some of their descendants submitted DNA samples for a TV documentary made for the Discovery Channel in 2002, though the results, when

compared with a sample from the Earl of Munster, a proven descendant from an illegitimate son of William IV, suggested that there was no correlation.

Here the explanation probably lies in another well documented George Rex, the son of a gentleman gin distiller from Whitechapel in London. [7] This George Rex was indeed a Proctor at Doctors Commons (1789-1797) and appointed to the Admiralty Court in Cape Town that year. He had been born in 1765 and, moreover, had a brother called John (b. 1768) and a sister Sarah (b. 1770). [8] And this Rex family had links by marriage to the Perigoe/Perregaux banking family, whose Paris branch had handled a series of infamous and irredeemable bonds issued on behalf of the Prince of Wales to French citizens – referred to in 'The Authentic Records of the Court of England for the Last Seventy Years'. Perhaps a good enough reason for the Royal family to 'purchase' a vow of discretion. [9]

* * * * *

An even rarer surname than Rex is Mackelcan. (Some people claim it is an invented word meaning 'son of the white horse', the white horse being the family crest of the Guelph family.) A John Mackelcan was baptised on April 12, 1759 at the church of St Mary, Newington, supposedly the son of John and Sarah Mackelcan, but there are doubts about his true parentage. When he later married in 1803, the record, which names his bride's parents, is blank about his own. It seems that he was brought up by foster parents, a clergyman and his wife, and was educated at Christ's Hospital on an introduction by Lord Romney.

On March 31, 1773, he went 'to serve in His Majesty's Drawing Room in the office of ordinance in The Tower (of London)', and shortly afterwards was nominated as an ensign in the Royal Engineers at Woolwich by none other than William Pitt, Earl of Chatham. Traditions handed down through his descendants hint at other mysteries; that his wedding on Guernsey had to be performed by a French priest for fear of infringing the Royal Marriages Act; that George III visited him on Guernsey, and that he was a frequent visitor at Court and 'greatly loved by the Royal family'.[10] What is not in dispute is that in 1795, John Mackelcan was gazetted as a full General at the age of only 36, while in 1814 he was awarded an annuity of £700 a year by the Prince Regent, for spurious reasons that make no sense whatsoever. [11] He died in 1839 and all his papers disappeared, probably taken away by his secretary a Mr Young, whose sons, according to another family tradition 'received honours'. [12]

General Mackelcan left two daughters, one of whom became the mother of a Mr Alfred Vellacott, who in 1939 was in possession of a miniature of his great-great-grandmother – reputed to be Hannah Lightfoot. [13] Although DNA tests on one family in the USA, claiming that General Mackelcan was an ancestor, proved as negative a match to that of the Earl of Munster as the South African (and Australian) Rex connections, they leave the door open for other possible descendants.

If the surname Rex seems to imply Royal antecedents, the same applies to Fitzroy, and a Colonel Charles Fitzroy was certainly a popular young man around the court of King George III. Born in 1762 and brought up as the son of the Earl of Southampton, totally unsubstantiated rumours hinted that he was in fact a son of Hannah Lightfoot. [14] Irrespective of his parentage, there had been talk that he had had an affair with George III's youngest, and favourite, daughter Amelia (1783-1810), who made him her residual legatee in her Will of July 1810. Furthermore, it was hinted that the young couple had even possibly married in a secret ceremony, as referred to in one letter from Edward to Olive. [15] 'My poor sister Amelia's death and her marriage and children, the King has never recovered from'. If this was true, might there not have been damning documentation in the church records at Kew, and was this potential scandal the real reason for the Duke of Wellington to organise the theft and disposal of such records? Further credence to this theory came to light in 1938 when it was first shown that the 'missing' church records covered the period *after* 1783, not the period relevant to Hannah Lightfoot, or any children that might have been born as a result of her liaison with the youthful Prince George. [16]

ENDNOTES

1 Bodleian Library, Oxford. Shelfmark MS. Eng. Hist c722, folios 10-57. Folios 3-9 are relevant envelopes and wrappers with signed and initialled annotations. Folios 58-64 are letters from the Earl of Warwick to Olive, 1815/16, similarly categorised as 'forgeries', to which the same conclusions apply.

2 National Archives TS 18/112*

3 This view has been confirmed by a present-day handwriting expert, Simone Tennant-Smith, 2010. See also article in Bodleian Library Record, October 2011. ['A *Case against Forgery*', Macnair.]

4 Price family papers.

5 Lindsey, p296-7. Camp p61 concludes that Mr Twistle never existed.

6 Notes & Queries, Feb 1861, quoted in HR p125

7 Storrar.

8 Camp p74

9 Evidence that there was something to hide comes from the story of the Rev. Charles Bull. He had married one of George Rex's illegitimate daughters. His notes and documents were destroyed during an unexplained fire in his study in 1857, when he had returned to London. He was 'rewarded' by an appointment as Colonial Chaplain to the Falkland Islands. (Lloyd-Taylor.)

10 Lindsey, p287

11 Parkins, in his letter to the King in 1821, had mentioned that one of the supposed sons of Hannah and Prince George had been a General. (See chapter 13.)

12 Lindsey, p288

13 Lindsey, frontispiece. It bears no resemblance to the two portraits by Reynolds. Another illustrated miniature, supposedly of General Mackelcan but in Naval uniform, is perhaps an early study of Horatio Nelson.

14 Pendred p231, quoting Howitt and Melville.

15 Bodleian Library, Oxford. Shelfmark MS. Eng. Hist c722, 56/57

16 Correspondence in the *Sunday Times*, February 6, 20 and 27, 1937. In 1904, there had been a proposal to publish a collection of Amelia's love letters, but it was rumoured that King Edward VII had paid several thousand pounds to have them suppressed. (Pendred p233). The missing Kew parish records are; Baptisms 1791-1845, Marriages 1783-1828 and Burials, 1785-1845. (Surrey History Centre, Woking.)

Bibliography

Alger, J.G. *Englishmen in the French Revolution*, published in the USA, 1889.

ANON. *An Historical Fragment relative to her late Majesty, Queen Caroline,* 1824.

ANON, attributed to Parkins, *Memoir of the late J T Serres.* ca. 1827.

ANON. *Celebrated Claimants from Perkin Warbeck to Arthur Orton*, Echo Library, 2006, reprint of second edition, Chatto & Windus, 1874.

Aspinall, A. *Correspondence of George, Prince of Wales, 1770-1812,* 1963.

Aspinall, A. *The letters of King George IV, 1812-1830,* 1938.

Barton, S. *Monumental Follies*, Lyle Productions, 1972.

Bradlaugh, C. *Impeachment of the House of Brunswick*, 1874.

Burt, Col. W, *Ten Generations looking back in time.*

Byerley, *Recollections of Literary Characters and Celebrated Places*, 1854.

Camp, A. *Royal Mistresses & Bastards*, privately published, 2007.

Chambers, J. *Charlotte & Leopold*, Old Street Publishing, 2007.

Colville, F. *Worthies of Warwickshire 1500-1800,* 1870.

Coke, Lady Mary. *Letters and Journals of Lady Mary Coke*, 1889-96.

Compton Mackenzie. *The Windsor Tapestry*, Rich & Cowan, 1938.

Creevey. (See Maxwell.)

Cumberland, R. *My Impressions of the Mother Country*, Tilney, 1875.

Dearn, T. D. W. *Sketches in Architecture*, 1806.

Donovan, P. *Sporting the Oak*, Christine Swift Books, 2005.

Farington, J. *Diaries,* 1922.

Fox, H. *Memoir on the Events attending the Death of George II and the Accession of George III,* 1901.

Fraser, F. *The unruly Queen*, Macmillan, 1996.

Fulford, R. *Royal Dukes*, Collins/Fontana, revised version 1972.

Gattey, C. *Farmer George's Black Sheep,* The Kensal Press, 1985.

Gilbert, Alderman R, Bt. *'The role of the Sheriffs – compared to the Lord Mayor and the Aldermen'*, 1984.

Gillen, M. *The Prince and his Lady*, Sidgwick & Jackson, 1970.

Grant, Col. M. H. *A Chronological History of the Old English Landscape Painters.* Various editions, 1926-61.

Henning, C. *British Landscape Painters*, 1989.

Howitt, W. *The Aristocracy of England*, 1846.

Hudson, K. *A Royal Conflict; Sir John Conroy and the Young Victoria.* 1994.

Hughes, C. J. *Mr Treasurer – Warwickshire before 1889*, Journal of Local Government Vol. 59, No. 2, 1955.

Huish, R. *Life of George IV*, 1831.

Jesse, J.H. *Memoirs of the Life and Reign of King George III*, 1867.

Kreps, M. *Hannah Regina*, Cardinal Press, 2nd edition 2003.

Lindsey, J. *The Lovely Quaker*, Rich & Cowan, 1939.

Lloyd-Taylor, A. *Appendix to the Taylors of Kew*, published privately, 1975.

Longford, E. (Ed.) *The Oxford Book of Royal Anecdotes*, OUP, 1989.

Macauley, E. *Autobiographical Memoirs of Miss Macauley*, 1835.
Macnair, M. *William James (1772-1837)*, Railway & Canal Historical Society, 2007.
Maxwell, Sir H. *The Creevey Papers*, Murray, 1903.
Melville, L. *Farmer George*, 1907.
Miller, O. *Paintings in the Royal Collection; Later Georgian Pictures*, Phaedon, 1969.
Noel, G. *Sir Gerard Noel MP*, CADHAS, 2004.
Olive, [Serres, O. W.] *The Life of the Author of the Letters of Junius, the Rev. James Wilmot D.D.*, 1813.
Olive, [Serres, O. W.] *Letters of the late Right Hon. Earl of Brooke and Warwick*, 1819. [WRO Open shelves C920]
Olive, [Serres, O. W.] *Statement to the English Nation*, 1822. [British Library, 10826 d8.]
Oliver. V.L. *History of the Island of Antigua*. 1894, reprinted 2008.
Owen, R. *Recollections of Robert Owen Esq.*,1843
Pearce, E. *Pitt the Elder – Man of War*, Bodley Head, 2010.
Pendered, M. L. *The Fair Quaker – Hannah Lightfoot*, Hurst & Blackett, 1910.
Pendered, M. L. & Mallett, J. *Princess or Pretender?* Hurst & Blackett, 1939.
Phillips, C. J. *History of the Sackville family*, 1929.
Reaves, P. W. *The Ryves-Rives-Reaves Families*, published privately Alabama USA 1999.
Richardson, J. *The Disastrous Marriage,* 1960.
Russett, A. *Dominic Serres RA, War Artist to the Navy*, Antique Collectors' Club, 2001.
Russett, A. *John Thomas Serres*, Sea Torch Publishing, 2011.
Ryves, L. *An Appeal to Royalty*, 1858.
Shepard, M. *Princess Olive*, Drinkwater, 1984.
Simms, B. *Three Victories and a Defeat*, Allen Lane [Penguin], 2007.
Sobel, D. *Longitude*, Fourth Estate, 1996.
Storrar, P. *George Rex; death of a legend*, 1974.
Tegg, W. *Wills of their own; curious, eccentric and benevolent*, 1879.
Thoms, W. J. *Hannah Lightfoot, Queen Charlotte and the Chevalier d'Eon*, 1867.
Tillyard, S. *Aristocrats*, Chatto & Windus, 1994.
Tillyard, S. *A Royal Affair*, Vintage Books, 2007.
Tomalin, C. *Mrs Jordan's Profession*, Penguin 1995
Vancouver, J. *A Memoir*, 1825.
Walpole, H. *Memoirs of the Reign of George III*. 1845.
Wardroper, J. *Wicked Ernest*, Shelfmark Books, 2002.
Waterhouse, E. *Dictionary of British 18th Century Painters,* Antique Collectors Club, 1981.
Willis-Bund, J.W. *The life of the Rev. James Wilmot*, Worcester Historical Soc. 1904.
Wilson, B. *The Laughter of Triumph*, Faber & Faber, 2005.
Wilson, B. *Decency & Disorder*, Faber & Faber, 2007.
Young, Sir George. *Poor Fred*, OUP 1940.

Principal Primary Sources
National Archives, Kew. Mainly J77/44, HO 44/1 folios 116-184, PROB 31/1184 no.661A and TS 18/112. [Within the latter are summaries of 28 letters from the Duke of Kent to Olive, prepared by the Attorney General in 1866. References to this important document are denoted by TS 18/112*. The originals are in the Bodleian Library, see below.]
Bodleian Library, Oxford. Modern Manuscripts Eng. Hist. A. 21, c722 folios 10 -70. These folios constitute group A.4 among 'Royal Correspondence, 1809-1905'. They were catalogued as being *forged*, though it is the present author's case that there is every reason to believe that they are genuine. See Appendix C.
Warwick Record Office. Mainly C 920 and CR 1886, Boxes 452, 674/5/6 and 7.
Price family papers.

Index

Abbott, Judge 104, 125
Abington, Mrs; actress 41
Addington, Dr. Anthony 118
Addington, Henry [see Sidmouth, Lord]
Addiz, J 114, 136, 177
Adelaide, Princess of Saxe-Meiningen [later Queen] 75
Adolphus, Duke of Cambridge [son of George III] 72, 74, 76-7, 172, 185
Alexander, Tsar of Russia 137
Alexandrina, Princess [see Victoria, Princess and Queen]
Allen, William 88, 91
Amelia, Princess [daughter of George III] 42
Amelia, Princess [maiden aunt of George III] 42, 50
Amorbach 76
Anne, Duchess of Cumberland [see Horton, Anne]
Anne, Princess of Denmark 75
Archer, Lady 41
Archer, Lord 1, 25, 112, 114, 177
Archer, Mrs; procuress 50
Astley's amphitheatre 83
August, Prince of Prussia 59-60
Augusta Emma [daughter of Duke of Sussex] 73
Augusta, Princess of Hesse-Cassel [wife of Adolphus] 77
Augusta, Princess of Saxe-Coburg 12-13, 15, 17
Augustus, Capt, D'Este [son of Augustus, Duke of Sussex] 74
Augustus, Duke of Sussex [son of George III] 72-73, 81, 105-6, 142, 159, 180
Austen, Jane 39, 68
Austin, William 31, 142
Axford, Isaac 14-16, 187

Bacon, Sir Francis 26, 184
Bagot, Lord 23
Bailey, Mr. Justice 124-5
Baillie, Dr. 68
Baldwin, Stanley 54
Barfoot, Mr. [solicitor] 66
Bartlett, Miss 16

Barton-on-the-Heath 4-5, 25
Bathurst, Henry 2
Baylis family 101, 135
Beauclerc, Henry 2, 41
Beckford, William [son] 16-7, 40, 57
Beckford, William [father] 17
Bell, Henry Nugent 106, 115-20, 138
Bennett, Lady Camilla 50-1, 113
Bentinck, William [Duke of Portland] 189
Berkeley, Lady 75
'Bill of Pains & Penalties' 103-4
Binkes, Mrs 8
Blackheath 31, 61
Bloomfield, Sir Benjamin 37
Bourdillon, Mr [solicitor] 170
Brandler, John [gallery] 16
Brett, Rev. J 105, 117, 127, 142, 144-5
Brighton 11, 164
British Institute of Painting 7, 24
Brock, Thomas 158, 160
Brooke, Lord [see Warwick, 2nd Earl of]
Brooke, Rev. Zackary 16, 188-9
Broughham, Henry (Lord) 69, 103
Broughton, Lord Charles 105
Bulwer Lytton, Edward 148
Burdett, Sir Francis 81
Bushy Park 75
Bute, Lord 13, 14, 15
Byerley, Katherine 18

Campbell, Mr. 41
Canning, George MP 82
Canterbury, Prerogative Court of 128
Carey, Miss C E 145, 152
Carlton House 59, 103
Caroline, daughter of Olive [see Dearn, Caroline]
Caroline, Princess of Brunswick [wife of George IV] 11, 31-2, 39, 59-61, 69, 72-3, 76, 100, 104, 111, 120, 128-9, 141, 145
Castle Hill Lodge, Ealing 31, 88, 98-9, 102, 118
Castlereagh, Lord 75
Chapman, Dr. 25
Charlotte, Princess [daughter of George IV] 11, 31, 59-62, 66-72, 83, 127, 145

Charlotte, Queen [wife of George III] 11, 13, 16-7, 31, 34-6, 40, 67-8, 74, 77, 102-3, 145, 151-2, 178, 191
Chatham, Earl of [see Pitt, William (elder)]
Chudleigh, Elizabeth 14, 15, 187
Claremont 68-9
Clarence House 61
Clarke, Mrs. Mary-Anne 32-4, 39, 105
Claude Lorraine 22
Clive, Sir Robert 68
Cochrane, Lord 81-2
Cockburn, Sir Alexander viii, 176-181
Coke, Lady Mary 49, 53
Collier, Sir Robert 176
Combe, William 132-3
Conroy, Sir John 76, 99, 102
Cookes-Winford, Lady 1
Corn Laws 69
Corneley, Mrs 50
Cranbrook, Kent 163-5
Craven, Lady 41
Creevey, Thomas 18, 75, 106, 110, 141
Crespigny, Lady Sarah 26
Croft, Dr. Richard 68, 70, 145
Cruikshank, George 82, 104
Cumberland, Duke of [uncle of George III - see William]
Cumberland, Duke of [brother of George III - see Henry]
Cumberland, Duke of [son of George III - see Ernest]
Cumberland House 55
Czartoriska, Princess of Poland 41

Dalton, Charlotte Augusta Catherine 190
Dalton, Dr. James 189
Darnley, Lord 91, 117
Dearn, Anna-Maria 162
Dearn, Anne Wilmot 165
Dearn, Caroline [daughter of Olive] 12, 56, 73, 132
Dearn, Eleanor [see Wilmot, Eleanor]
Dearn, Elizabeth 163-5, 167

Dearn, Julia 166-7
Dearn, Sarah 166
Dearn, Thomas [snr.] 2, 56, 162-3
Dearn, Thomas Downes Wilmot
 [brother of Olive] 56, 137, 160,
 163-7
Delegarde, Mr. 144,
'Delicate Investigation' 31, 103
Desseaux, General 99, 128
Dickenson, John 105, 107, 127-8
Dodd, Major 31, 34
Dodson, Charles 163-4
Downes, Mary 1, 162
Downman, Joseph 26
Downshire, Marchioness of 1, 8
Dubus, Adelaide 30
Dunhoff/D'Onhoff, Countess [see
 Bennett, Camilla]
Dunning, John 2, 44, 46, 51, 97-8,
 114, 128, 136, 177, 179, 187

Eaglehurst, Hampshire 163
Edward Augustus, Duke of York
 [brother of George III] 17, 49, 87,
 152
Edward, Duke of Kent [son of
 George III] 12, 30-6, 43-7, 54,
 59, 61-3, 66-69, 72-76, 86, 88-93,
 98-100, 105-6, 117-8, 128, 142,
 145, 153-4, 170, 172, 174, 179-
 80, 186-8, 191
Edward, Prince of Saxe-Weimar 172
Edward, Prince of Wales [later
 Edward VII] 182
Edwardina [daughter of Princess
 Caroline] 31, 61, 100
Egerton, Lady Sophia 189
Eldon, Lord 105, 121
Elizabeth [daughter of George III] 101
Ellenborough, Lord 31
Elliot, Anne 49
Elphinstone, Mercer 75
Ernest, Duke of Cumberland [son of
 George III] 66, 72, 74, 77, 152
Erskine, Lord 31

Farrington, Joseph 10, 161
Field, George 7
Finch, Polly 112
Fitch, Septimus 124-5
Fisher, Major-General 76
Fitzclarence/Strathern, William
 ['Fitz'] 111-3, 118-9, 121-2, 127-
 8, 141, 143, 145-6, 152, 183, 188,
 191
Fitzherbert, Maria 11
Fitzroy, Charles [courtier] 42
Fitzroy, Charles [see Grafton, Duke of]
Fordyce, Lady Mary 52
Forgery, penalties for 65
Forster, Cooke & Frere (solicitors)
 63-4
Francis, Sir Philip 40

Fraser, Dr. 180
Frederick, Duke of York [second son
 of George III] 11, 30-4, 47, 59,
 72-3, 105, 117, 119, 121, 144-5,
 152, 183, 188, 191
Frederick, Prince of Wales [father of
 George III] 12-3, 141, 189, 192
Frederika, Princess of Prussia [wife of
 Duke of York] 32
Frederika, Princess of Solms 74
Freemasons, Order of 32, 160

Galloway, Earl of 23
Garrick, David 25
George Augustus [Prince of Wales,
 Prince Regent and later
 GEORGE IV] 8, 11-12, 18-9, 27,
 30-3, 36-40, 47, 55-6, 60-1, 68-
 70, 72, 78, 102-5, 119, 122, 126,
 139, 144-5, 148, 151-2, 158, 164,
 178, 192
GEORGE II 12-3, 16, 23, 134, 192
GEORGE III 2-3, 11-4, 16-7, 24, 26,
 30-1, 36, 40, 43-5, 49-50, 53, 55,
 59, 72, 78, 86, 94-6, 98, 102-5,
 107, 152, 171, 178-9, 181, 186-7,
 190-2
Gibraltar 30-1, 33
Gloucester Lodge, Weymouth 60
Gloucester, Duke of [brother of George
 III - see William]
Goodwin, Charles 172
Grafton, Duke of 2, 42, 52, 187
Graham. G W 148
Greenwich, Lady 53
Greenwood, John QC 174
Grenville, Lord 31
Greville, Charles [son of George, 2nd
 Earl] 23
Greville, Francis [father of George,
 2nd Earl] 22
Greville, George [2nd Earl of
 Warwick] 1, 4, 11, 18-9, 22-4, 37,
 40, 42-6, 54, 60-5, 86, 89-90, 96,
 104-5, 113-6, 128, 149, 172, 179-
 80, 187-8, 191
Greville, Henry Richard [son of
 George, 2nd Earl/ 3rd Earl] 23,
 65-6, 88, 119, 144
Greville, Robert Fulke 188
Grey, Earl 100, 104, 155, 170
Griffin, Samuel 128
Griffiths, Mrs. (midwife) 68
Grosvenor, Lady Henrietta 50
Grosvenor, Lord 50-1
Groves, Mrs 87-8
Groves, Rev. William ['Prince of
 Monaco'] 86-8, 104, 113, 118

Halford, Sir Henry 67-8
Hamilton, Duke of 105, 141
Hamilton, Lady Anne 82, 103, 112,
 120, 129, 141-3, 145, 150-2

Hamilton, Lady Archibald 12, 141
Hamilton, Lady Emma 110
Hamilton, Sir William 3
Harrowby, Earl of 129, 143
Hazlett, William 81
Henry, Duke of Cumberland [brother
 of George III] 11, 32, 41, 43, 46,
 49-53, 55-57, 63, 72, 86, 112-4,
 116, 121, 136, 149, 162-3, 172,
 174, 177-8, 180, 187, 192
Hertford, Countess of 68
Hertford, Lord 23
Hesse, Lt./Capt. Charles 59-60
Hillman, Anthony [footman to
 Edward Duke of Kent] 93
Hobhouse, Mr. 107, 115-6, 118, 139
Holland, Lady 68
Holland, Lord 13
Hone, William 80-3, 104, 137, 176
Horton, Anne [Duchess of
 Cumberland] 11, 46, 51, 54-6, 72,
 86, 113-4, 162-3, 178, 187, 192
Horton, Christopher 51
Horton, George Henry 51
Houghton [friend of J T Serres] 6, 7
Huish, Robert 101
Hume, Mrs. [housekeeper at
 Warwick Castle] 45
Hunt, Henry MP 82, 135, 138
Hunt, Thomas 116
Huntley, Mrs. 157-8, 161, 170, 174
Hutchinson, Lord 103

Isleworth 15, 26, 171, 188
Islington Church 16, 121, 123

James, William 23, 43, 64, 83
Jefferyes, John 26
Jersey, Lady 39
Jesse, John 52, 187
Johnson, Mrs 118
Jones, Polly 49-50
Jordan, Dora 74, 112
'Junius'/'Letters of Junius' 2, 40-1, 52-
 3, 151

Keith's Wedding Chapel/Rev.
 Alexander 15, 187
Kennett, John 119
Kensington Palace/'system' 35,
 102
Kent, Edward Duke of [see Edward]
Kew Chapel/Palace 13, 16-7, 26,
 42, 75, 95, 171, 188
King, Mr. 35-6
King's Bench/Rules 51, 120, 123-4,
 129, 132, 138, 145, 149, 157-8
Knight, Charles 116, 121, 125, 127-
 8, 145
Knight, Edward 4
Knighton, Sir William 37, 170
Knightsbridge 15, 149-50
Knowle, Kent 16

Lancaster, Duchy of 97-8, 116, 145, 149, 174, 177, 192
Lamb, Lady Caroline 148
Langdale, Lord 173
Leach, Sir John 105
Leicester House 14, 17, 49
Lennox, Lady Sarah 13, 14
Leon, Count 60
Leopold, Prince of Saxe-Coburg-Sallfeld 59-62, 67-8, 75, 83, 101
Lewis, Mr 88
Lightfoot, Hannah 3, 14-17, 26, 28, 40-1, 52, 56-7, 62, 72-3, 94-5, 100-1, 105, 114-5, 117-8, 133, 135-6, 139, 143-4, 148, 152, 157, 170-2, 174, 178, 181-2, 187-91
Lightfoot, Hannah [supposed children of] 171-2, 191, Appendix E (also Ritso family)
Lightfoot, Mary 14
Lightfoot, Matthew 14
Lightfoot, Rebecca 26
Liverpool 6
Liverpool, Lord PM 102, 104-5
Lloyd Taylor, Arthur 171
Lloyd, Thomas 128
London, Bishop of 120
Long, Miss Tilney 75
Lushington, Dr. MP 125, 128, 136
Lutterell, Anne [see Horton, Anne]
Lutterell, Capt. Temple Simon 52, 54, 163-4
Lutterell, Col. Henry Laws 52
Lutterell, Elizabeth 52, 55
Lutterell, Simon [Lord Irnam] 51, 133

Macauley, Elizabeth Wright 152
Madden, Maria/Lucretia 6
Mansfield, Lord 51
Marlborough, Sarah Duchess of 13
Marsh, Lord 49
McMahon, Col. 37
Money, Col. 3
Moore, Dr. [Bishop of Bangor] 17, 116
Moore, Peter MP 106
Murray, Lady Augusta 73, 81

Napoleon Bonepart 59-60, 76-7
Neale [footman to Ernest Duke of Cumberland] 66-8
Nelson, Admiral Horatio 75
Netherclift, Mr 179, 185
New Lanark 88
Newbottle, Lord 14
Newcastle, Duke of PM 42
Noel, Sir Gerard 104, 107, 110, 124, 129, 135, 137-9
Norfolk, Duke of 134
North, Lord PM 53-5, 187
Northumberland, Duke of 124
Norton, Major 61

OLIVE Wilmot/Serres. Olive features on almost every page so the main themes of her life are given in the relevant **CHAPTERS**. Artist **1, 5, 15**; Astrology **15**; Author **2, 5, 9, 10, 13, 15**; Baptism, first **Intro**; Baptism, second **12**; Children, legitimate **1, 16, 18**; Children, illegitimate **2, 3, 6, 16, 17**; Conclusions **19**; Death **16**; Documents, inherited **5, 11, 12, 18**; Fitzclarence, W **12, 14**; Groves, Rev. W **10**; Hamilton, Lady A **12, 14, 15**; Hannah Lightfoot papers **11, 12, 18**; Kent, Edward D of **4, 5, 7, 10, 11**; Lancaster, Duchy of **11**; Marriage & separation **1**; Noel Sir G **12, 13**; Parkins, Jos. **11, 12, 13, 14**; Parliament, Petitions **11, 13**; Pedigree, from Earl of W **5**; Pedigree, invented **12**; Prince of Wales/GIV **2, 4, 12**; Prisoner, King's Bench **12, 15**; Recognition of Rights **11, 12, 13**; Royal succession **8**; Upbringing **1**; Warwick, E of **3, 5, 6, 7, 10**; Will of GIII **10, 12**; York, D of **4, 11, 12, 15**
'Olive' Wilmot [fictional daughter of Dr. James Wilmot] 46, 86, 96, 112-5, 136, 171, 177-8, 180-1, 187-8, 191
Orange, Prince of 59
Owen, Robert 88-9, 91, 153, 172
Ormby-Hunter, Mrs. 158

Palmer, Sir Roundell [Attorney General] 176-80
Parker, William (solicitor) 63-4
Parkins, Joseph (Sheriff of City of London) 98-100, 102, 106, 118-9, 122, 124, 127, 132, 136-8, 141, 143-4
Payne, Olive [see Wilmot, Olive]
Payne, William 1
Peachey, Georgiana [Countess of Warwick] 3, 22, 41
Pearne/Perryn, also Capt. Robert 15, 26
Peckham 15, 95
Peel, Robert MP 126-7, 136-7, 177
Perceval, Spenser MP 32, 39
Pergami, Bartolomeo 103
Pesaro 102
'Peterloo Massacre' 82
Petrie, William [see Fitzclarence/Strathern]
Philips, J [publisher] 152
Phillimore, Sir Robert 176
Pickering, George Clarke 104-5, 113
Pitt, William [the elder, Earl of Chatham] 2, 16-7, 40, 44-5, 57, 95-8, 114, 118, 136, 177, 179, 187-8

Pitt, William [the Younger] 24, 65, 151
Plymouth, Earl of 1, 26
Poland, Kingdom of 6, 41
Pollock, Lord Chief Baron viii,
Poniatowski, Countess 144
Poniatowski, Princess of Poland 41, 177, 180
Poniatowski, Stanislaus [King of Poland] 50, 112, 136
Powell, Rebecca 16
Prerogative Court of Canterbury [see Canterbury]
Price, Alfred Ernest 167
Price, Inez 167
Price, Jabez 167
Price Mary 167
Price, Richard 168
Price, Robert 167
Price, Thomas Wilmot Dearn 167
Price, William Henry 167-8
Primrose, John (solicitor) 116-7
'Prince of Monaco' [see Groves, Rev. William]
Propert, Lucy 92

Quakers/Society of Friends 14-17, 116, 133

Redding, Cyrus 16
Rex family 191
Reynolds, Sir Joshua 5, 16, 41
Richmond, Duke of 13
Ritzeau, Frederick 188
Ritso, Capt. Edward 189
Ritso, Capt. John 189
Ritso, Catherine Augusta [Mrs Dalton] 190
Ritso, George Frederick 189-90
Robinson, Mary (actress) 56
Rochester, Earl of 1, 22
Rodney, Admiral 42
Royal Academy 3, 6, 158, 163, 182
Royal Coburg Theatre 'Old Vic' 83
'Royal Marriages Act' 11, 53, 55, 72-3, 86, 132, 134, 187, 192
Royal Thames Yacht Club 56
Russel, Earl PM 175, 181
Ryves, Anthony [husband of Lavinia] 132-3
Ryves, Anthony Thomas [son of Lavinia] 183
Ryves, Mrs. [mother of Anthony] 132, 134
Ryves, Olivia Lavinia Noel [daughter of Lavinia] 138
Sackville, Lord 40-1
'Sarah', [possible daughter of Hannah Lightfoot] 189
Sellis, Joseph (valet to Ernest Duke of Cumberland) 67, 152
Serres, Britannia [Brock]; (legitimate daughter of Olive) 7, 134, 145, 157-60

Serres, Charles Wilmot (illegitimate son of Olive) 25, 159
Serres, Dominic [Count] 3, 5, 24, 169
Serres, Dominic Michael 6
Serres, John Edmund Dominick 10
Serres, John Thomas [husband of Olive] 5-8, 24-5, 83-4, 134, 144-5, 177, 182
Serres, Lavinia Janetta Houghton [Ryves]; (legitimate daughter of Olive) 6, 11, 32, 44, 82, 88-9, 93, 113-4, 132, 134, 145, 157-8, 160, 168, 170, 172-6, 179, 180-1, 191
Serres, Mary Esther Olivia 10
Shakespeare, William 25
Shelburne, Lord 40-1
Shepherd, Richard 34
Sidmouth, Devon 94, 100
Sidmouth, Lord [formerly Henry Addington MP] 87, 103, 105, 110, 115, 117-8, 125-6, 134, 138
Simeon, Sir John 104, 125-6
Sims, Dr. 68
Smith, Dr. J Walter vii, 176-81
Smith, Robert 148
Smith, Sir Sydney 61
Sophia, Princess [daughter of George III] 47, 67, 74, 101-2
Spencer, Lady Diana 13
St. James's Market 14
St. James's Park 117
St. John's, Warwick 1, 3
St. Laurent, Madame [mistress of Edward Duke of Kent] 30-1, 47, 75
St. Nicholas, Warwick vii
St. Peter's, Carmarthen 188, 190
Stevens, Rev. W 52
Stevenson, Elizabeth [wife of T D W Dearn] 162, 164
Stockmar, Dr. 101
Strangways, Lady 13
Stuart, 'Bonnie Prince' Charles 55, 69
Stuart, Lady Louisa 52
Sussex, Duke of [see Augustus]

Tachbrook Estate 23
Tavistock, Marchioness of 41
Tayler, Anne 16-7, 95, 116, 188
Taylor, Sir Henry 117
Theodora, Princess 90
Thomas, D M 176
Thomas, William 163-4
Thoms, W 161, 194
Thurlow, Lord Edward 2
Tomkin, Caroline Augusta 166
Tomkin, George [husband of Caroline Dearn] 165
Tomkin, William 166
Tottenham 15
Trafalgar, Battle of 69
Trinity College, Oxford 2, 4, 25
Tucker, Dr. Anthony 138

Upper Ossory, Earl of 23, 43

Vancouver, John 23, 105, 128
Vansittart, Nicholas MP 106
Vauxhall Pleasure Gardens 83
Vernon, Caroline 50
Vernon, Lady Harriet 50
Vernon, Henrietta [Countess of Warwick] 18, 23, 89
Vernon, Richard MP 22-Mar
Victoire, Princess of Leinigen [Duchess of Kent] 75-6, 88, 90, 101-2, 145
Victoria, Princess [later Queen Victoria] 77, 89, 93, 101-2, 119, 142, 145, 173-4, 181-2
Villa d'Este 32, 60, 102, 141

Waldegrave, Dowager Countess 53
Walpole, Horace 52-3, 55
Walpole, Robert MP 13
Wardle, Colonel 32-4
Warwick Castle 1, 3, 19, 22, 43, 45, 52, 113
Warwick House, London 59
Warwick, 2nd Countess of [see Vernon, Henrietta]
Warwick, 2nd Earl of [see Greville, George]
Warwick, 3rd Earl of [see Greville, Henry Richard]
Waterloo, Battle of 69
Wellington, Duke of 74, 102, 158, 161, 170, 172-4
West, Benjamin 17
West, Edward 161, 182
Wetherall, General [ADC to Edward, Duke of Kent] 69, 99-100, 104, 116, 137
Wharton, Thomas 2
Wheeler, Henry [uncle of Hannah Lightfoot] 14, 17
White, Edward 174
Wilde, Sir James [judge] viii, 176, 184
Wilkes, John MP 2, 52
WILLs of George Greville, Earl of Warwick 63-5
WILL of Edward, Duke of Kent 102, 118
WILL of George III 97, 123, 126, 136, 149, 157, 170, 173, 177, 192, Appendix D
WILL of Hannah Lightfoot 157, 171, 188, 191
Willes, Lord Chief Justice 26, 187
Willes, Rev. Charles 26
William, Duke of Clarance [later King William IV] 72, 74-5, 77, 105, 112, 116, 118, 123
William, Duke of Cumberland [uncle of George III] 12, 49
William, Duke of Gloucester [brother of George III] 53, 72

Wilmot, Anna-Maria [wife of Robert Wilmot] 1, 4, 54, 176
Wilmot, Anna-Maria [daughter of Robert Wilmot] 3, 119, 136
Wilmot, Dr. James DD 2-6, 16, 25-7, 40-2, 44-7, 54, 56, 62, 89, 95, 112-3, 116, 120, 134, 171-2, 177, 179-80, 183, 187-8, 191
Wilmot, Eleanor [wife of Thos. Dearn Snr.] 1-2, 56, 161-3
Wilmot, John [2nd Earl of Rochester] 1
Wilmot, Lady Anne 22
Wilmot, Olive [Mrs Payne] 1, 26, 46, 87, 180
Wilmot, Olive [see OLIVE Wilmot/Serres]
Wilmot, 'Olive' [see 'Olive' Wilmot]
Wilmot, Robert 1-3, 25, 40, 44-6, 97, 121, 132, 136, 176, 187
Wilmot, Sarah [daughter of Robert] 3
Wilmot, Sarah [Mrs Read] 1
Wilmot, Sarah [wife of Thomas Wilmot Snr.] 1
Wilmot, Sir Edward [doctor to Royal family] 1, 172
Wilmot, Sophia 3
Wilmot, Thomas [son of Robert] 27, 119
Wilmot, Thomas 'Beau' [father of Robert, James etc.] 1, 56
Wilmot, Thomas Downes [uncle of Elizabeth Dearn] 162
Wilson, Richard RA 6
Windsor Castle 6, 14, 35, 56, 190
Wood, Alderman Matthew 100, 103, 105, 141
Woodfall, Mr. 40
Woolbrook Cottage, Sidmouth 94, 101
Wright, Miss 41
Wright, Sir James 25

Zamperini, Signorina Anna 49